LIVESTOCK BRANDS & MARKS

An Unexpected Bayou Country History

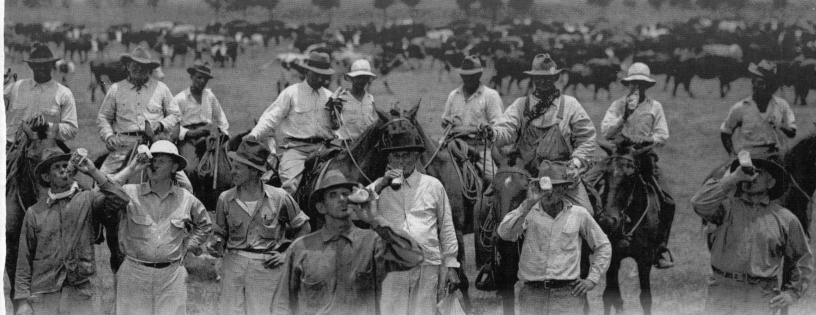

1822-1946 Pioneer Families Terrebonne Parish, Louisiana

By **Christopher Everette Cenac, Sr., M.D., F.A.C.S.**
with **Claire Domangue Joller** *Foreword by* **Clifton Theriot, C.A.**

LIVESTOCK BRANDS & MARKS

An Unexpected Bayou Country History

*12/9/15
Bobby
More history of Terrebonne
Enjoy*

1822-1946 Pioneer Families Terrebonne Parish, Louisiana

By **Christopher Everette Cenac, Sr., M.D., F.A.C.S.**
with **Claire Domangue Joller** *Foreword by* **Clifton Theriot, C.A.**

LIVESTOCK BRANDS AND MARKS:
An Unexpected Bayou Country History
1822–1946 Pioneer Families
Terrebonne Parish, Louisiana
Christopher Everette Cenac, Sr. M.D., F.A.C.S.

Copyright © 2013 by JPC, LLC
All Rights Reserved
Printed in the United States of America
First Edition - October 2013

Library of Congress Control Number: 2013913519

ISBN: 9780989759403

Book and cover design: Scott Carroll Designs, Inc., New Orleans, Louisiana

Book production by: Portier Gorman Publications, Thibodaux, Louisiana

Distributed by University Press of Mississippi

The hardcover firebrand is that of Edmond Fanguy, registered March 7, 1833. Mr. Fanguy is the great-great-great-grandfather of both Dr. Cenac and his collaborator Mrs. Joller, through two separate great-grandparent lineages—Dr. Cenac through Edmond's granddaughter Victorine Fanguy Cenac, daughter of Charles Fanguy, and Mrs. Joller through Victorine's brother William Fanguy, father to Elvire Fanguy Domangue.

Cover photo: Southeastern Louisiana cowboys at Bayou Blue, on the Terrebonne-Lafourche parishes boundary in 1925. On horses, counting from left: first, Alvin LeBlanc; second, Rene LeBlanc; fifth, Roy LeBlanc; seventh, Abel LeBlanc, Sr.; eighth, Abel LeBlanc, Jr. Standing second and third, state veterinarians; fourth from left, Ignas LeBlanc; fifth from left, Albert LeBlanc; seventh from left, Lovance Adams.

Front and back end sheets: An interior wall of Octave "Tete" Eschete's blacksmith shop he founded on West Main Street in Houma in the early 1900s (currently 7563 Main Street).

George Rodrigue
Louisiana Cowboys, 1987, oil on canvas, 95" x 65"
George Rodrigue Foundation of the Arts
747 Magazine Street, New Orleans, Louisiana

Relatives or anyone else who has photographs of any person listed in this volume as having registered a brand are requested to contact the Nicholls State University Archives at the Allen J. Ellender Memorial Library in Thibodaux, Louisiana, for photographs' submission. Phone: 985.448.4621

JPC, LLC
3661 Bayou Black Drive
Houma, LA 70360

"A brand is a cow's only return address."

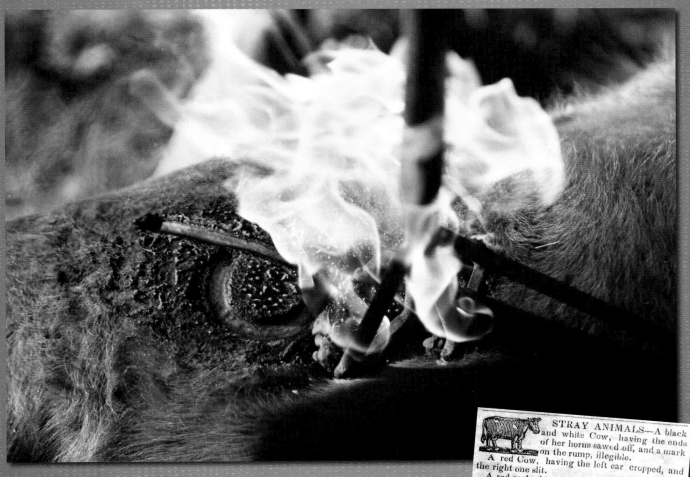

– Mike Strain DVM, Commissioner
 Louisiana Department of Agriculture and Forestry

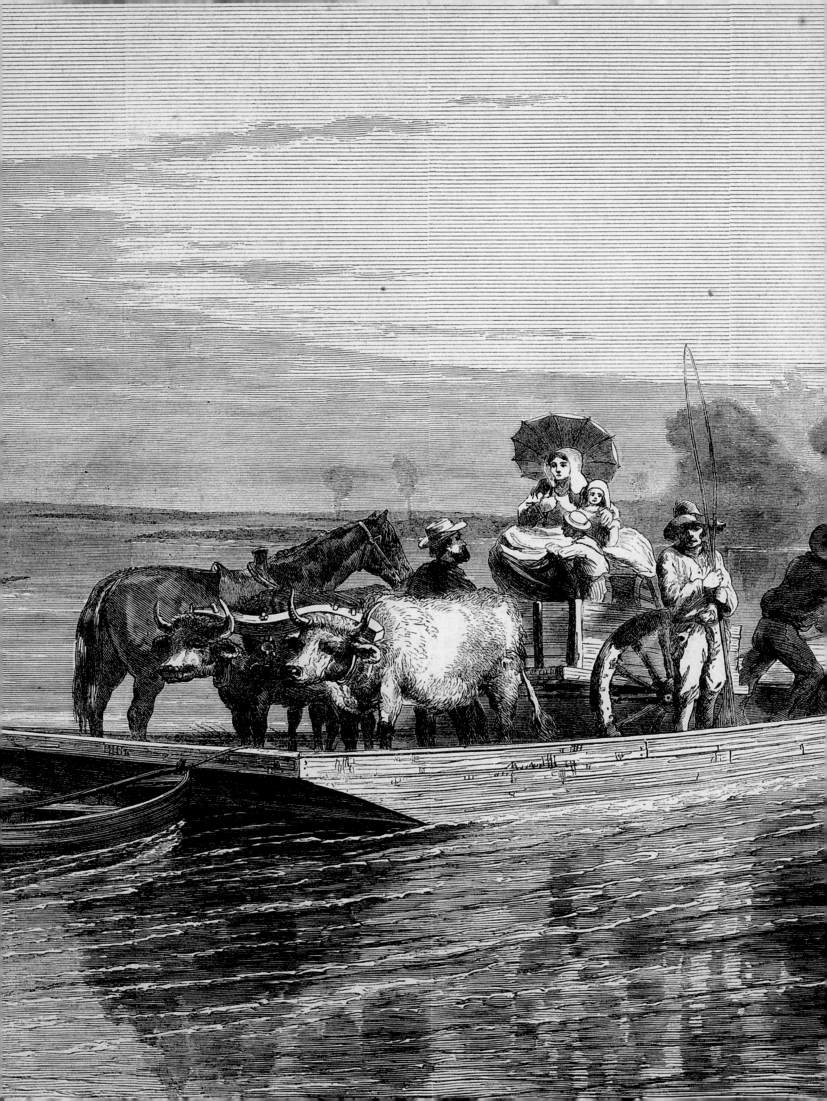

ACKNOWLEDGEMENTS

I gratefully acknowledge the following, who provided either information, resources, suggestions, services, or encouragement: I. Robert "Bobby" Boudreaux, former Terrebonne Parish Clerk of Court; Theresa A. Robichaux, current Clerk of Court, and staff; Al Levron and Charlette Poché of the Terrebonne Parish Consolidated Government; Clifton P. Theriot, Nicholls State University Archivist; Jim Davis of the Louisiana Secretary of State's Office; Vincent and Ying Kraemer for photographic services; Dr. Carl Brasseaux and Dr. Don Davis; Steve Yates of the University Press of Mississippi; Bayou Printing; Portier Gorman Publications; Scott Carroll and Erin Callais of Scott Carroll Designs, Inc; Shane K. Bernard, Ph.D., Historian and Curator for the McIlhenny Company; Florent Hardy, Jr., Ph.D., Louisiana State Archivist; Mary Lou Eichhorn of the Historic New Orleans Collection; Ken Wells, author; Carl Bennett, Louisiana Livestock Brand Commission Director; Elizabeth Wilcox of the Louisiana Livestock Brand Commission; Albert P. Ellender, D.D.S; R. Luke Bordelon, M.D.; Edmund McCollam, M. Lee Shaffer, Jr., M. Lee Shaffer III; William T. and Lynn Nolan; Jack Lamplough of Overlook Press; Jill Crane, Catalog Librarian at St. Mary's University, San Antonio, Texas; Ann Butler, author and Minor Family descendant; the George Rodrigue Foundation of the Arts and Wayne Fernandez; Connie Castille, documentarian; Stella Carline Tanoos, historian; genealogist Jess Bergeron; the Cenac medical office staff—Faye Parker, Peggy Darsey, and Mona Griffin; Judy Soniat of the Terrebonne Parish Library; Keith M. Whipple; Steve Ortego; Wayne and Dolly Duplantis; Garland and Gail Trahan; Marvin Marmande, Sr. and Marvin Marmande, Jr.; Warren Clement, Jr. and Alfred Clement; Marie LeBlanc Himel, her daughter Debbie Himel Triche, granddaughter Claire Triche Tabor, Betty LeBlanc and her son Randy LeBlanc; collaborators' spouses Emil Joller and Cindy Cenac. A special thank you to Arlen B. Cenac, Jr., for his efforts and contributions in making this book possible.

Ferryboat to Brashear (Morgan) City, on Berwick Bay, Louisiana, c. 1860s

FIVE GENERATIONS OF CENACS

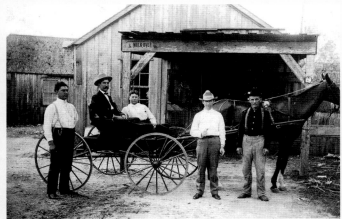

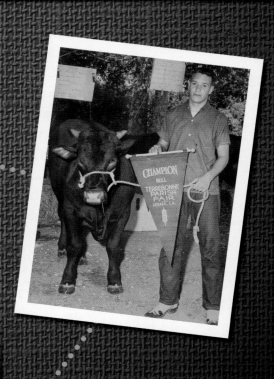

DEDICATION

To my children

Christopher E. Cenac, Jr., M.D.

Sarah Cenac Jackson, M.D.

Brent John Cenac

Henri Philippe Cenac

In memory of my uncle

Donald J. Cenac

and my friend

Thomas Blum Cobb

C.E.C., Sr.

Opposite page: Top left photo, from left: Russell Strada, Eddie Evest and Jean-Pierre Cenac in front of Cenac's livery stable, present day 7937 Main Street, c. 1900; top right photo, from left: William Jean-Pierre Cenac, Jean Charles Cenac, (Pierre's sons) Julius Blum, George Toups, and Alex Bergeron, c. 1910; middle left: Philip Louis Cenac (William Cenac's son), c. 1923; middle right: Christopher Everette Cenac (Philip's son) with his champion Terrebonne Parish Fair Santa Gertrudis bull, c. 1960; bottom photo: Christopher E. Cenac, Jr., Christopher E. Cenac, Sr., Sarah Louise Cenac, and Amanda Olivier at the 1979 Terrebonne Parish Fair

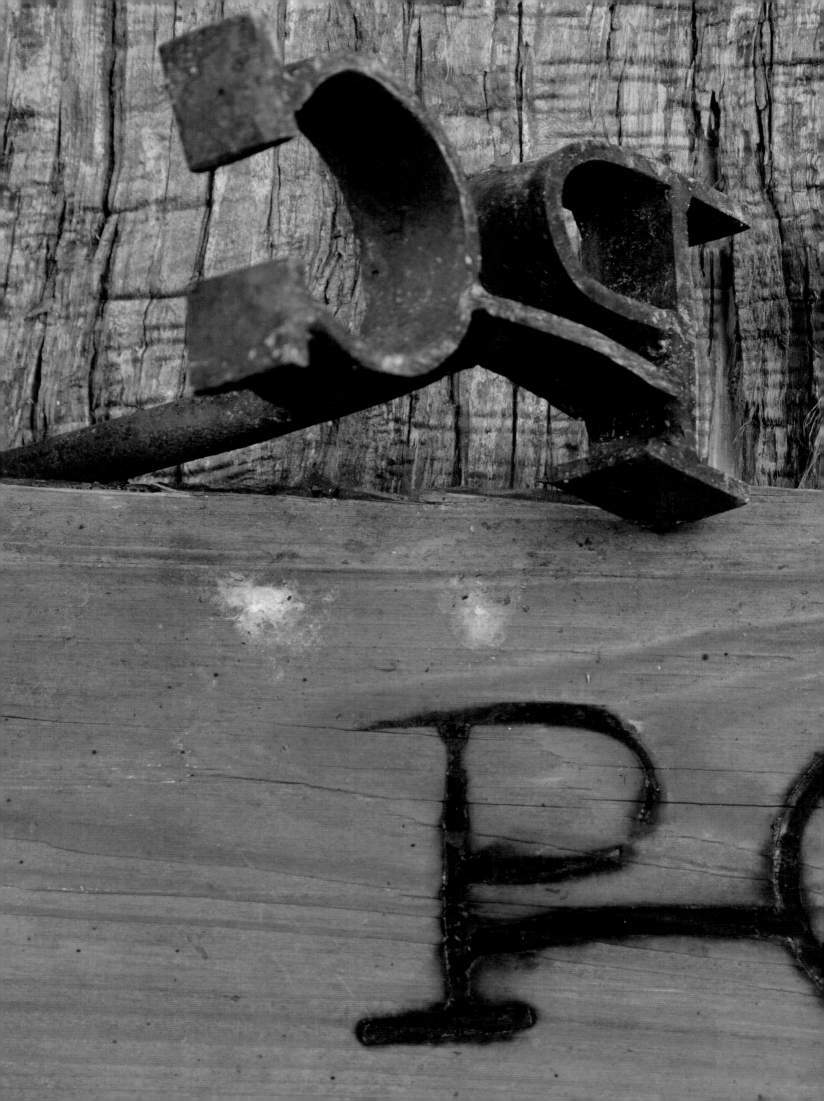

CONTENTS

Foreword	13
Introduction	14
Discovery	14
Livestock Laws	20
Purpose of the Book	28
History of Branding	28
Spread of Spanish Cattle	30
Southwest Louisiana's Acadian Savanna	34
Early Louisiana Cattle	38
To Market	44
Wild Cattle Conundrum	46
Kinds of Brands	47
The Iron Men	50
Geography of Brand Registrations	54
Terrebonne Farms at Schriever	56
Conclusion	62
Fire Brands Book One	69
Fire Brands Book Two	261
Fire Brands Book Three	361
Afterword	382
Appendix I:	
Louisiana Livestock Brand Commission	384
Appendix II:	
The Terrebonne-Lafourche Livestock & Agricultural Fair Association, Inc.	386
Appendix III:	
About the Authors	388
Index	390
Credits	398

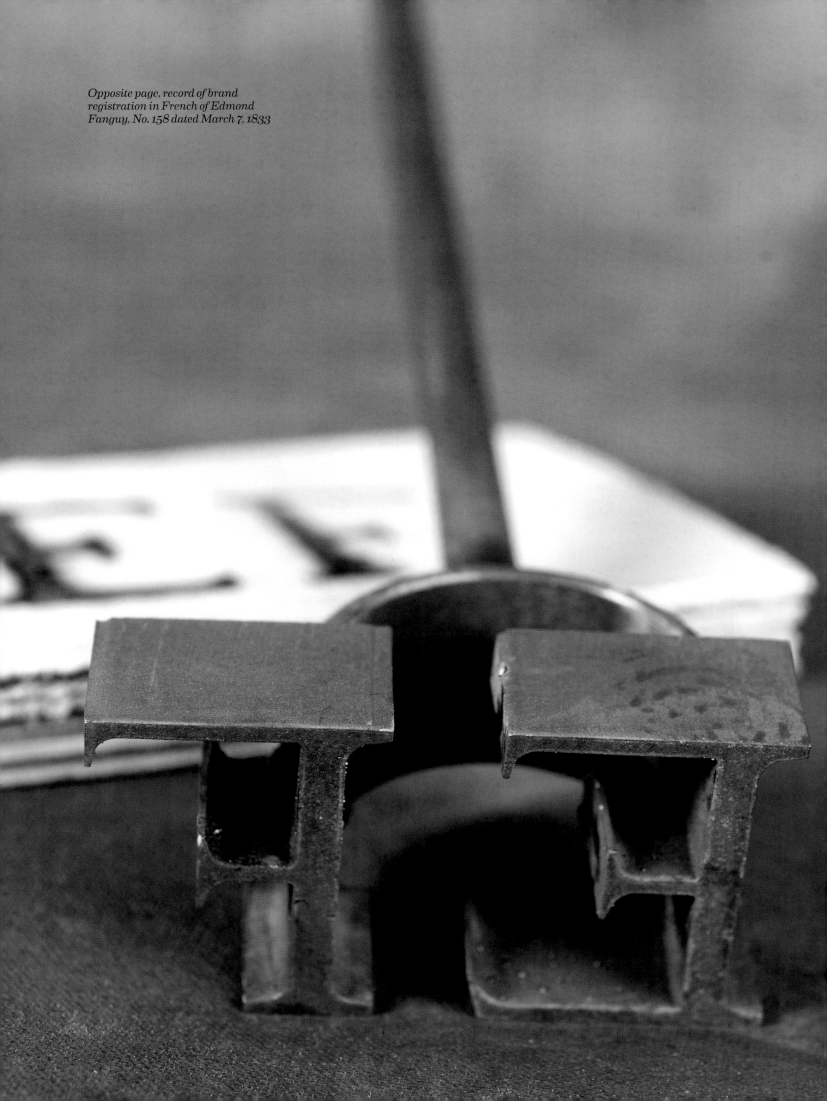

Opposite page, record of brand registration in French of Edmond Fanguy, No. 158 dated March 7, 1833

FOREWORD

As an Archivist, I am passionate about preserving local history and I am always excited to meet other like minded preservationists and historians. In 2005, a friend and fellow historian, Mr. Tommy Cobb, called me to arrange a meeting with Dr. Christopher E. Cenac, Sr. who had a few family documents that he wanted to preserve. After arriving at Dr. Cenac's medical office, I was shown several old family documents which included an original passport from 1860, related travel papers as well as several old family photographs. I was thrilled to offer advice on preservation of the documents as well as offer to establish a Cenac family collection in the Nicholls State University Archives. Little did I know that that first meeting would not only lead to establishing the Cenac Collection, but also to helping with Dr. Cenac's first book *Eyes of an Eagle*, a coinciding exhibit that went on to travel around the state, and now his second book on the livestock brands and marks of Terrebonne Parish.

While researching his first book, Dr. Cenac discovered that original firebrand ledger books dating back to 1822 were still in existence. After further research, he found that a relative had preserved an original firebrand that one of his ancestors had registered in 1885. After these discoveries, Dr. Cenac decided that he wanted to contribute to preserving these records by having them published. When Dr. Cenac first asked my opinion about publishing the fire brands, I said that I did not know of any other similar book and that it would be an excellent reference book for archives and libraries. As the book progressed, I came to realize that it would not only be a great reference book for genealogists, but it would also be a great book for anyone who appreciates or has an interest in local history. This book is a tribute to all of the early families of Terrebonne, many of whom still have descendants living in the parish. This work is also a record of the agricultural history of the parish from its beginning until the mid-1900s.

Anyone with roots in Terrebonne will enjoy having this work as part of his or her personal library. This book may even encourage people to check Grandpa's barn or the attic to find original firebrands that were registered in the brand ledgers. Terrebonne Parish is rich with history, and the publishing of these records greatly helps to preserve a little-known piece of that history. Hopefully more records such as these will surface in the future and be preserved in a similar way, enabling Terrebonneans to learn even more about the early history of the parish. I am glad to have been a part of this worthwhile project, and I am also glad to have met and worked with a friend and fellow historian on saving another piece of local history.

Clifton Theriot, C.A.

The first French-language brand, and thirty-fourth brand to be recorded, was for Pierre Bourque on February 27, 1826.

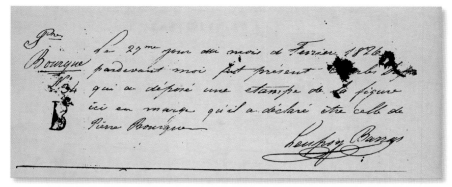

Above, E.C. Wurzlow's rendering of the first completed Houma Courthouse c. 1875

Above, a Houma parade, Courthouse Square, 1895. Below, the Terrebonne Parish Courthouse after an unusual snowfall on February 12, 1958.

INTRODUCTION
Discovery

Long-forgotten ledger books dating from the 1820s were found in the attic of Louisiana's Terrebonne Parish Courthouse in 2009. They proved to be a treasure trove of historical information relating to early parish residents and the Louisiana way of life at the time.

The books contain registrations for livestock firebrands including legalities written alternately in English and French. Parish Judge Francis M. Guyol recorded the first brands to be registered, in English. His successor as parish judge (and registrar) was Leufroy Barras, who recorded the first French-language brand registration, for Pierre Bourque on February 27, 1826. Beginning that date, brands were alternately recorded in French or English, seemingly in the language of the registrant rather than the recorder.

Parish judges continued to record registrations until the State Constitution of 1845 established the office of parish recorder. The newly-created office of recorder and their deputy recorders actually began the task of registering brands in 1846. This arrangement continued until 1880, when the parish Clerk of Court was assigned the task of recording such transactions. Thereafter, these clerks and deputy clerks were responsible for brand registrations. Brand number 588 was the first to be recorded under this new system. For each record, officials or their representatives also drew an illustration of the brand itself, as it would have appeared on an animal. When brands were transferred from one person to another, a notation of this transaction was written in the margin of the original registration, not as a separate entry; in later years, some transfers were recorded

LIVESTOCK BRANDS AND MARKS

as separate entries. This preservation provides a specific visual for researchers, especially family members, who want to know about their ancestors.

One thousand one hundred forty brands and registrants were preserved for the period 1822-1946. Although registrations were a necessary legality and never intended to serve strictly historical purposes, the books provide an accurate method of documenting the arrival and settling of the parish by early pioneers.

The first recorded Terrebonne brand, J B, was for Jean Bourk, Jr. on June 6, 1822, shown on right.

Other parishes kept such records as well, but complete original parish brand books such as Terrebonne's are a rarity in Louisiana. Evidence remains of brand registrations in the Attakapas Country of southwest Louisiana from as early as the mid-1700s. *The Brand Book for the Districts of Opelousas and Attakapas, 1760-1888* applied to the general area which developed into the parishes of St. Martin, St. Mary, St. Landry, Iberia, Lafayette, Vermilion, Acadia, Calcasieu, and Cameron.[1]

Of the 64 current Louisiana parishes, Lafourche is also known to have had brand records, dating from 1807. They are, however, incomplete. St. Tammany's extant complete brand registrations date from 1813. Pointe Coupee Parish has an incomplete set of brand records, dated 1846-1866.

Gender and race distinctions were recorded in some brand books. For example, a woman was identified as "wife of" or "widow of" when she registered for her brand. Other common designations before the Civil War were FMOC and FWOC—free man of color and free woman of color. After the Civil War, new designations were termed freedman and/or colored.

These early documents provide valuable chronologies of settlers in the local area, since most homesteads kept livestock. It was necessary for all owners to identify their animals by branding. In the early and mid 1800s, livestock were allowed to roam at will, even in the developing parish seat of Houma. Brand identifiers prevented confusion at the least, and thievery at the most.

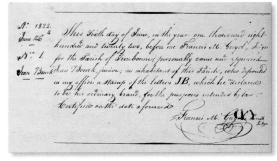
The very first brand to be recorded was for Jean Bourk, Jr. on June 6, 1822.

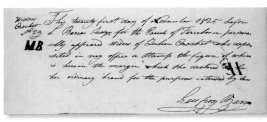
Brand No. 29, the record of Widow Crochet, dated November 21, 1825

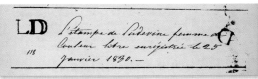
Brand No. 118, the record of Ludevine, free woman of color, dated January 25, 1830

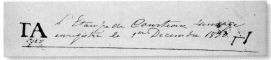
Brand No. 125, the record of Courteau, sauvage (Indian), dated December 1, 1830

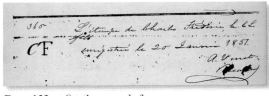
Brand No. 365, the record of Charles Frédéric, free man of color, dated January 20, 1851

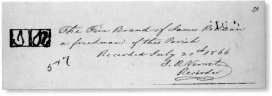
Brand No. 517, the record of James Redman, freedman, dated July, 20, 1866

St. Bridgitte, home of Henry Schuyler Thibodaux, by Adrien Persac 1861; at approximate current site of St. Bridget Catholic Church, Schriever

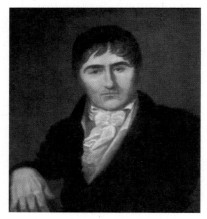

Portrait of Henry S. Thibodaux, onetime state senator (1812-1824) and Governor of Louisiana from November 15 to December 13, 1824.

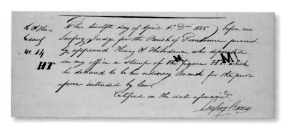

Brand No. 14, the record of Henry Schuyler Thibodaux, dated April 25, 1825

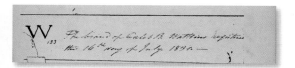

Brand No. 133, the record of Caleb Watkins, dated July 16, 1831

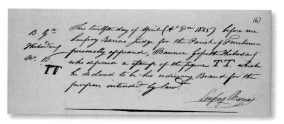

Brand No. 16, the record of Bannon Goforth Thibodaux, dated April 25, 1825

Livestock were vital to early settlers' survival. Along with kitchen gardens or more extensive farming, their animals directly and indirectly provided sustenance for families where markets were a thing of the distant future. Besides profiting from the sale of animal products, people of that period also relied on equine and bovine animals for both personal and commercial transportation.

Henry Schuyler Thibodaux, for whom the Lafourche Parish "county" seat is named (also called the Father of Terrebonne), made his home in Terrebonne Parish at St. Bridgitte Plantation, and was registrant of Brand Number 14 in Terrebonne's records. It is dated April 25, 1825. His son, Bannon Goforth Thibodaux, who lived across Bayou Terrebonne from his father at Balzamine Plantation, had his brand registered as Number 16 on the same date. The first sheriff of Terrebonne Parish, Caleb Watkins, registered his brand as Number 133 on July 16, 1831.

Lafourche and Terrebonne parishes in southeast Louisiana have an intertwined geographical and governmental history dating to 1805 when Lafourche County became one of 12 in the Louisiana-encompassing Territory of Orleans. In 1807, Lafourche Interior Parish became one of 19 civil parishes in the state, equivalent to counties elsewhere in the United States. According to Louisiana's Director of Archival Services Florent Hardy, Jr., Ph.D., "Parishes were first created in Louisiana in the late eighteenth century when Captain General Alejandro O'Reilly, an Irish-born governor ... in the service of Spain, divided the colony into twenty-one ecclesiastical parishes under the control of the Bishop of Santiago de Cuba. A single parish had been founded near New Orleans in 1723, but not until O'Reilly's administration were they organized on a widespread basis. After the Louisiana Purchase of 1803, these church parish borders served as the basis for the state's political subdivisions."[2]

Two hundred years after Louisiana achieved statehood, it continues to have distinctive status in the Union. Because of Louisiana's continental European heritage, use of the Napoleonic Civil Code remains operative in the state today, as opposed to English Common Law that is the basis for the other states of the U.S.

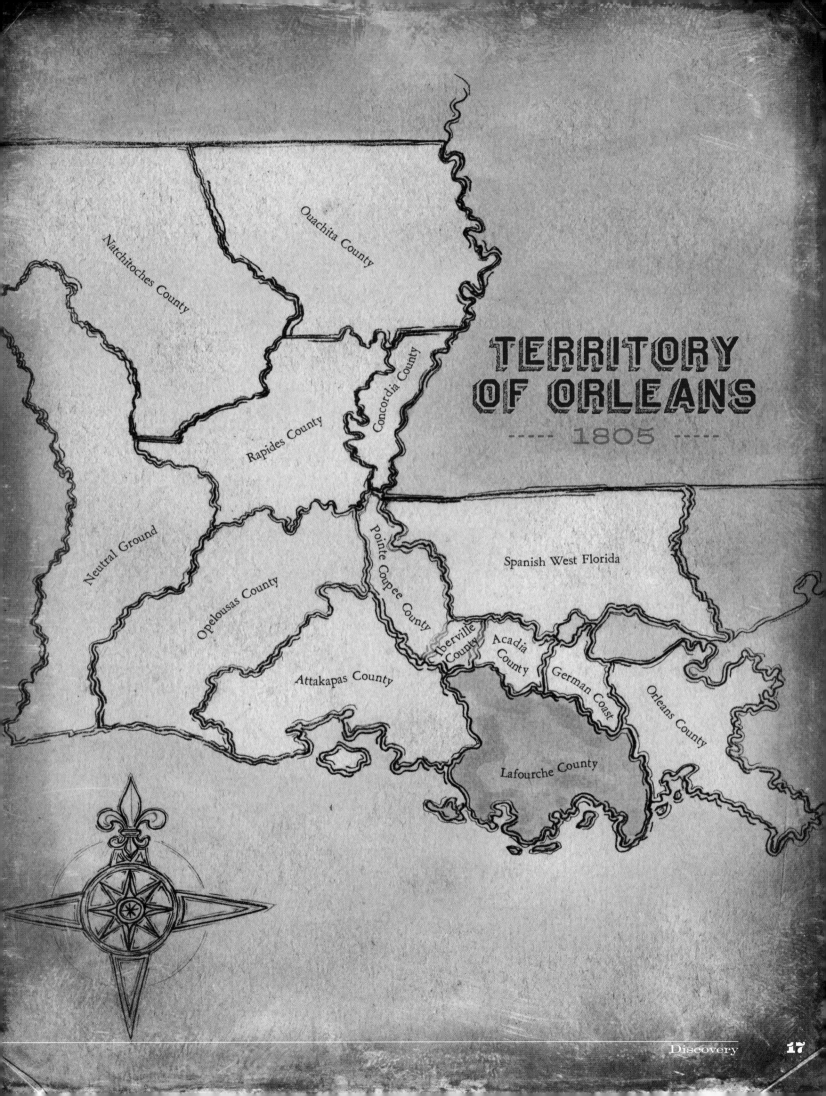

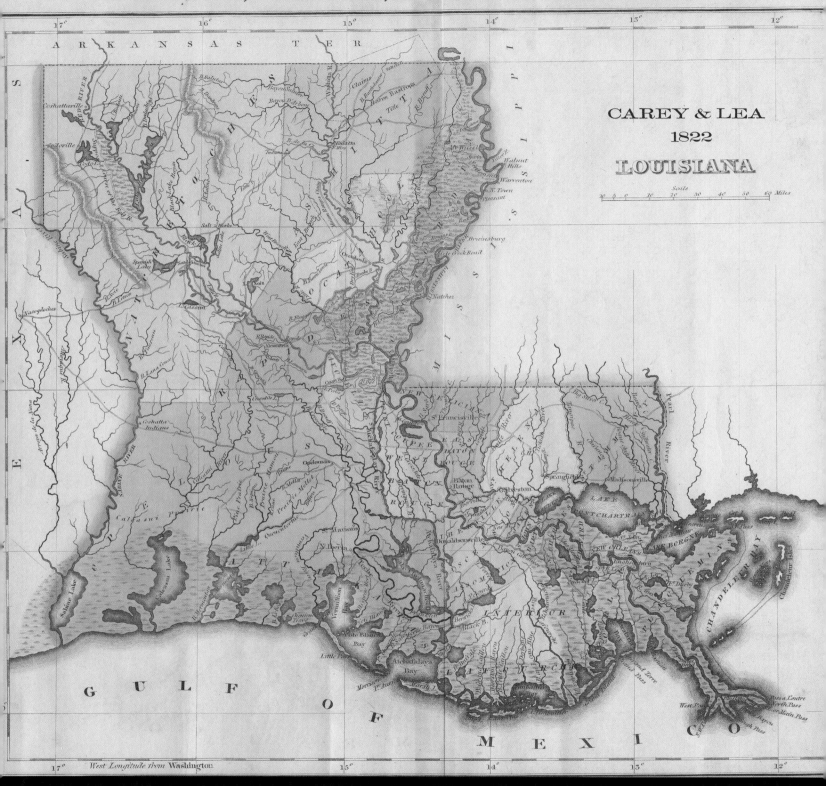

Two maps by Carey & Lea, the one above showing Lafourche Interior Parish before Terrebonne Parish's founding in 1822. Opposite page, the Carey & Lea map of 1827 distinguishing Terrebonne Parish from its parent parish.

GEOGRAPHICAL, STATISTICAL, AND HISTORICAL MAP OF LOUISIANA.

CAREY & LEA
1827
LOUISIANA

Livestock Laws

Terrebonne Parish was officially carved out of the Lafourche Interior Parish on March 22, 1822, becoming the 26th created Louisiana parish of an eventual 64. The earliest meeting of the Terrebonne Parish Police Jury after its formative meeting on April 6, 1822 was two days later, on April 8. Judging from those early meeting minutes, individual civil parish governmental divisions created their own rules for managing livestock.

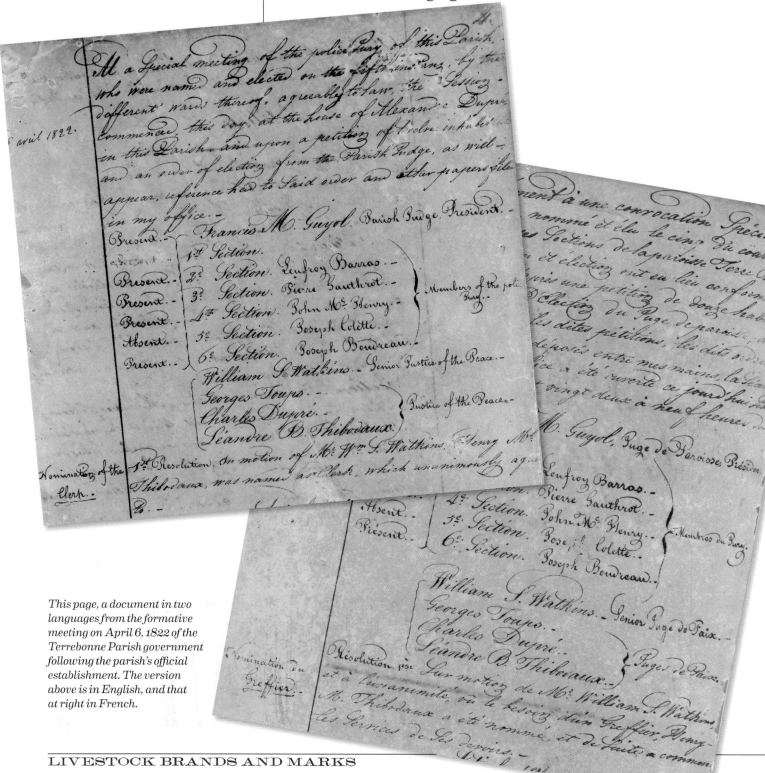

This page, a document in two languages from the formative meeting on April 6, 1822 of the Terrebonne Parish government following the parish's official establishment. The version above is in English, and that at right in French.

Terrebonne's governing authority kept minutes of its meetings in both French and English, on facing pages of the books. These early minutes books document that the Police Jury addressed a livestock issue only two months after its founding, in Resolution 16 of June, 1822. The resolution states:

Owners will pay a fine if their animal(s) break down a fence made according to the law. [Essential information summarized from original]

Resolution 16, in English (above) and French (below)

Livestock Laws

Not long afterward, only three months into the new governmental authority, the Police Jury found it necessary to pass Resolution 17.

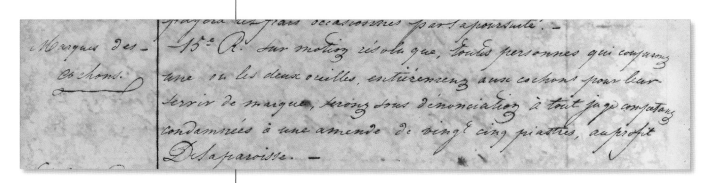

Resolution 17, in English (above) and French (below)

Hog owners will not be allowed to cut off both ears of the hog (destroying the markings). The fine shall be $25. Owners will record their brands (at a charge of $1) with the parish judge.

[Essential information summarized from original]

> Strayed animals
>
> 8th Rn. on motion of Mr. L. B. Thibodaux resolved that whenever a bull will come out of the woods without brand any body shall have the right to kill said bull and use him as he pleases in paying only the persons who will have been named to examine said animal as it is provided in the resolution passed the 30th November 1822. — but he shall have the right to give up the bull for the costs above mentioned. — and that the persons who shall be nominated appraisers as it is said shall have right to Demand & receive one Dollar for everytime they will be called to that effect. —

Two years later in July 1824, no doubt after considerable citizen debate about the topic, the Police Jury passed Resolution 30.

Whenever an unbranded bull comes out of the woods he may be shot by anyone. [Essential information summarized from original]

Resolution 30, in English (above) and French (below)

> Animaux égarés
>
> 8e Res. Art. 1er Sur motion de Mr. L. B. Thibodaux résolu que lorsqu'un Taureau sortira du Bois, es non étampé, toute personne aura le droit de le tuer es en disposer de la manière qu'il jugera convenable, en payant seulement les frais des personnes, qui auront été nommées pour l'examiner, comme il es Dit dans les résolutions passées le 30 novembre 1822; mais la personne qui aura tué le Taureau aura le droit de l'abandonner pour les frais ci-dessus mentionnés. —
> Art. 2e que les personnes qui auront été nommées estimateurs, comme il es dit ci-Dessus auront le Droit de Demander une piastre, pour chaque fois qu'ils seront appelés à cet effet.
> 9e R. Sur motion de Mr. Joachim Pinche, Résolu que —

Livestock Laws

Not all animals were domesticated. Wild cattle enjoyed their freedom in Terrebonne's extensive frontier land of the period. To help curb poaching, Resolution 57 was made law in June 1831.

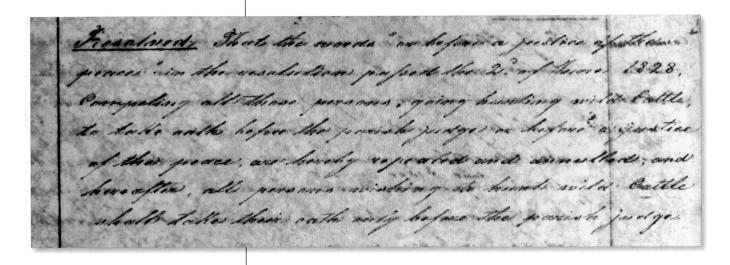

Resolution 57, in English (above) and French (below)

Anyone wishing to hunt wild cattle in the parish must first take an oath before the parish judge (not a justice of the peace).

[Essential information summarized from original]

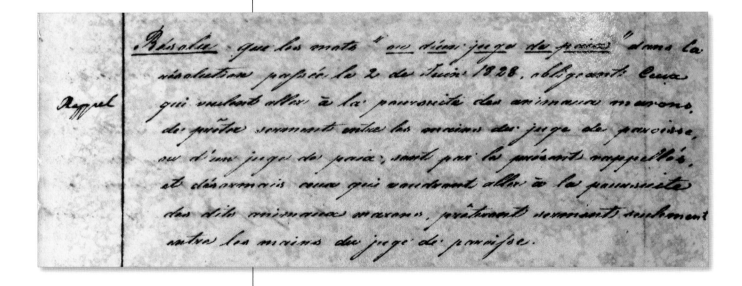

Local governments were relieved of these issues in 1944. America's food shortages in the years of the Second World War caused hardships for those left on the Louisiana home front. Because of the numbers of men away from their homes during World War II, cattle theft increased significantly.

LIVESTOCK BRANDS AND MARKS

As a result, the state legislature established the Louisiana Livestock Brand Commission in 1944, which centralized registrations and livestock concerns. Commission rules required that working brands be registered with the Commission in Baton Rouge every five years. However, Act 105 stopped short of establishing a state cohort to enforce livestock laws, and continued the authority of local sheriffs to arrest livestock poachers. The new state agency was not operative until 1946. Therefore, a 1946 brand recorded in Terrebonne Parish proved to be the final one registered under parish authority by J. Marian Yancey, cousin of the author.

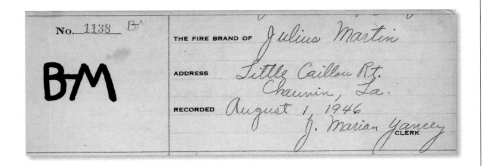

Brand number 1,138 was registered to Julius Martin of Little Caillou in the Terrebonne Parish Courthouse, and is dated August 1, 1946.

Act 352 of 1946 repealed all parish brand registrations. Even firmer grip on the process came for the state in 1950 with the passing of Act 245 which permitted the Louisiana Livestock Brand Commission to employ inspectors with police authority of their own.

Regulations further state that "the Brand Law does not provide for compulsory branding of livestock; however, it is a misdemeanor under the Law for anyone to brand livestock by burning into the hide of a living animal without first recording the brand" with the Commission in Baton Rouge.

2010 BRAND BOOK

LIVESTOCK BRAND COMMISSION

Opposite, present-day and recent owners of registered brands recorded from Terrebonne Parish in the Brand Books of the Louisiana Livestock Brand Commission

Brand	Owner	ID	Side	No.
CF	Cenac Farm Inc, 3648 South Down Mandalay, Houma LA 70360	81235	LEFT SIDE	29
HM	Debbie H Triche et al., 287 Company Canal Rd, Bourg LA 70343	79176	RIGHT SIDE	28
82	Colleen Marie Triche, 287 Company Canal Rd, Bourg LA 70343	79177	RIGHT SIDE	36
DF	Dustin L Fournier, 5405 W Park Ave, Houma LA 70364	80658	RIGHT SIDE	39
◇C	Cody Christopher Cenac, 3648 Southdown Mandalay, Houma LA 70360	80425	RIGHT SIDE	21
LA	Adley P Landry Jr, 2508 Coteau Rd, Houma LA 70364	76975	LEFT SIDE	39
Q80	Alfred Marvin Quatrevingt, 301 Valhi Blvd, Houma LA 70364	81552	LEFT SIDE	7
M	Allen J Marie, Box 653 Hwy 58, Montegut LA 70377	81748	RIGHT SIDE	34
BM	Barney Mazarac, 1612 Verna Street, Houma LA 70364	83392	RIGHT SIDE	31
UD	Matherne Farms, 553 Lake Long Drive, Houma LA 70364	78713	RIGHT SIDE	16
⊕	Dr. Philip L. Cenac, 322 Grinage St., Houma		L	42
J	Emile Jaccuzza, 623 Academy St, Houma LA 70360	59618	RIGHT SIDE	33
HH	Herbert J. Himel, Rt. 2, Box 210, Houma		R	
WF	Dr D C Walther, 1205 St Charles, Houma LA 70360	71276	LEFT SIDE	35
CR	Claire Rene' Triche, Route 2, Box 211-D, Houma		R	
⌀B	Druby Neil et al., 665 Hwy 665, Montegut LA 70377	82975	LEFT SIDE	31
L13	Lester Neal, P O Box 452, Montegut LA 70377	82940	LEFT SIDE	14
JT	Lloyd J. Triche, Route 2, Box 205, Houma		R	
U	Michael Jude Authement, 678 Bayou Blue Rd Lot 2, Houma LA 70364	57394	RIGHT SIDE	23
T	Eddie Thibodaux, 104 Duet Street, Houma LA 70360	67237	LEFT SIDE	8
♠	Ivay Himel, Rt. 2, Box 196, Houma		R	
4B	Howard Barker, 3902 Southdown Mandalay Rd, Houma LA 70360	78786	RIGHT SIDE	28
△	Lloyd J. Triche, Route 2, Box 205, Houma		R	
JM	Jackie A Marie, P O Box 218, Chauvin LA 70344	83555	LEFT SIDE	19
◇J	Jessie John Triche, Box 314 Bayou Blue Rd, Houma LA 70360	56297	RIGHT SIDE	25
JDT	JDT Partnership, 165 Back Forty Lane, Gray LA 70359	81794	LEFT SIDE	5
K	Mike Aucoin et al., 133 Klondyke Road, Bourg LA 70343	83573	LEFT SIDE	11
JKR	Rudolph J Liner et al., 547 Bayou Dularge Road, Houma LA 70363	82456	LEFT SIDE	5
S/T	Steve A Thibodeaux, 123 Hebert Street, Houma LA 70364	82481	RIGHT SIDE	25
2M	Marvin Marmande Jr, 1306 Dr Beatrous Rd, Theriot LA 70397	74799	LEFT SIDE	21
LA	Richard F Landry, 2422 Coteau Rd, Houma LA 70364	76976	RIGHT SIDE	38
R	Russell J Lovell, 2873 Bayou Dularge Road, Theriot LA 70397	82462	LEFT SIDE	39
/T	Tyler Prejean, 318 Ashburn Drive, Schriever LA 70395	83405	LEFT SIDE	16
SC	Sidney S Callahan, 305 Hialeah Ave, Houma LA 70363	53316	RIGHT SIDE	25
⊂S⊃	Ouide J. Cenac, 217 Cenac St., Houma		R	3

Impression brand

Above, witness tree stamped with identification marks found by T. Baker Smith in 1914

Below, Williams Lumber Company impression brand used on cypress logs

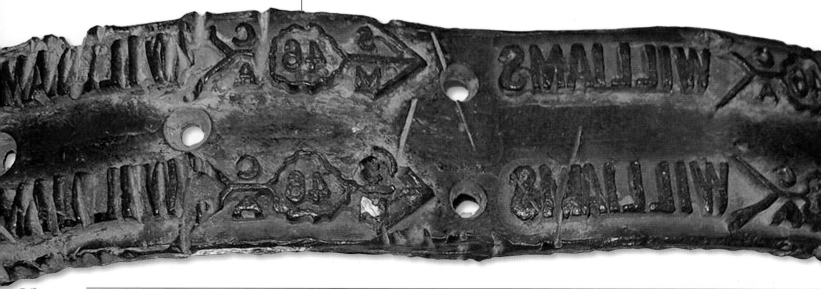

Purpose of the Book

This book reproduces the full texts of the early brands discovered in 2009, and introduces the reader to a short history of branding. From the individual records, countless descendants of early Terrebonneans will be able to recover a little of their family stories. From the history, readers will receive glimpses into a particular widespread culture in which Louisiana shares.

History of Branding

Branding has an association not only with livestock, but also with marking property boundaries and the logging industry. Hot-iron branding on trees marking property boundaries was common in American Colonial times— along the perimeters of owners' land and especially at the "corners" of property lines. Trees marked in such a manner are called "witness" trees. In the lumber industry such as in Louisiana's cypress harvesting, impression brands were knocked onto, rather than burnt into, logs being sent by each owner for identification at a mill where multiple suppliers sent their cut trees.

Spanish *conquistador* Hernando Cortes is credited with creating the oldest cattle brand on record in North America as early as the 1520s, the Three Christian Crosses. The culture of cattle through the subsequent centuries spread to and has become commonly associated in the United States with the American West.

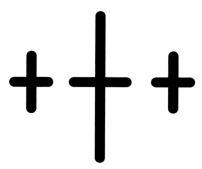

But the branding of livestock apparently began thousands of years ago, illustrated by drawings in Egyptian tombs.[3] Those drawings show oxen branded with hieroglyphics. It is also documented that Romans and Greeks branded their human slaves. Throughout time, in all cultures where one's livestock had to be identified easily, fire and flesh brands have been the method to prove ownership and to guard neighbors' trust of one another.

By the Middle Ages in Europe, the practice of burning marks into the hides of animals was used to identify ownership under *animus revertendi*, which is a Latin phrase that means "with intention to return." This concept was created to protect the rights of livestock holders who had free ranging animals. Without establishment of this mandate, animals that strayed away from "home" onto public land could be taken without compensation to the original holder (owner or caretaker) of the animals.

Prior to 1492, brands were unnecessary on the North American continent. Horses and cattle were not introduced in the Americas until European explorers and settlers brought them over, beginning with Christopher Columbus's voyages.

Impression brand

History of Branding

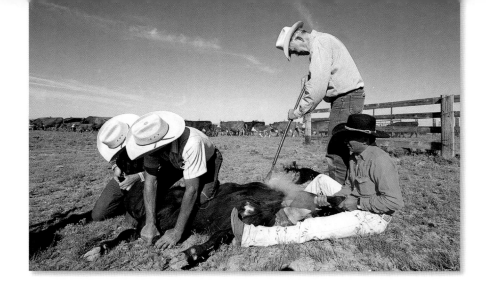

American cowboys branding calves in the West, c. 2013

Spread of Spanish Cattle

When Spaniards moved into Texas from Mexico, they imported herds of horses, cattle, sheep, and swine. According to the book *Louisiana Cowboys* by Bill Jones, "They intentionally stocked the land with horses and cattle as they traveled, turning out one stallion and one mare, and one bull and one cow, at each major river crossing."[4]

Louisiana's earliest French inhabitants in the New Orleans area kept domesticated livestock, but "there appears to be no connecting link between the Louisiana system of raising cattle and any comparable system in France."[5] In comparison to the early cattle industry in the *vacheries* (ranches) of southwest Louisiana beginning in the 1760s, French cattle culture has the distinct difference that "only in the Camargue in southern France do Frenchmen tend wild cattle."[6]

Scenes of Texan or Coloradoan or Oklahoman cowboys wrestling cattle to the ground to apply firebrands to a calf's hindside are no doubt most common American images conjured by mention of branding. It is likely that few would mention Louisiana in the same breath as cattle ranching.

Yet one particular area of Louisiana became a paradise for keepers of large commercial herds, as early as the 1700s. And unlike movie cowboys with names such as Pete, Jack, and Tom, Louisiana herders were more likely to answer to the names of Gustave, Jacques, and Alphonse.

Welsh, Louisiana, c. 1915. Working vachers *on the prairie. All packed the short-handled whip.*

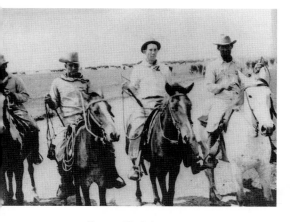

George Rodrigue
Louisiana Cowboys, *1987,
oil on canvas, 95" x 65"
George Rodrigue Foundation
of the Arts
747 Magazine Street,
New Orleans, Louisiana*

LIVESTOCK BRANDS AND MARKS

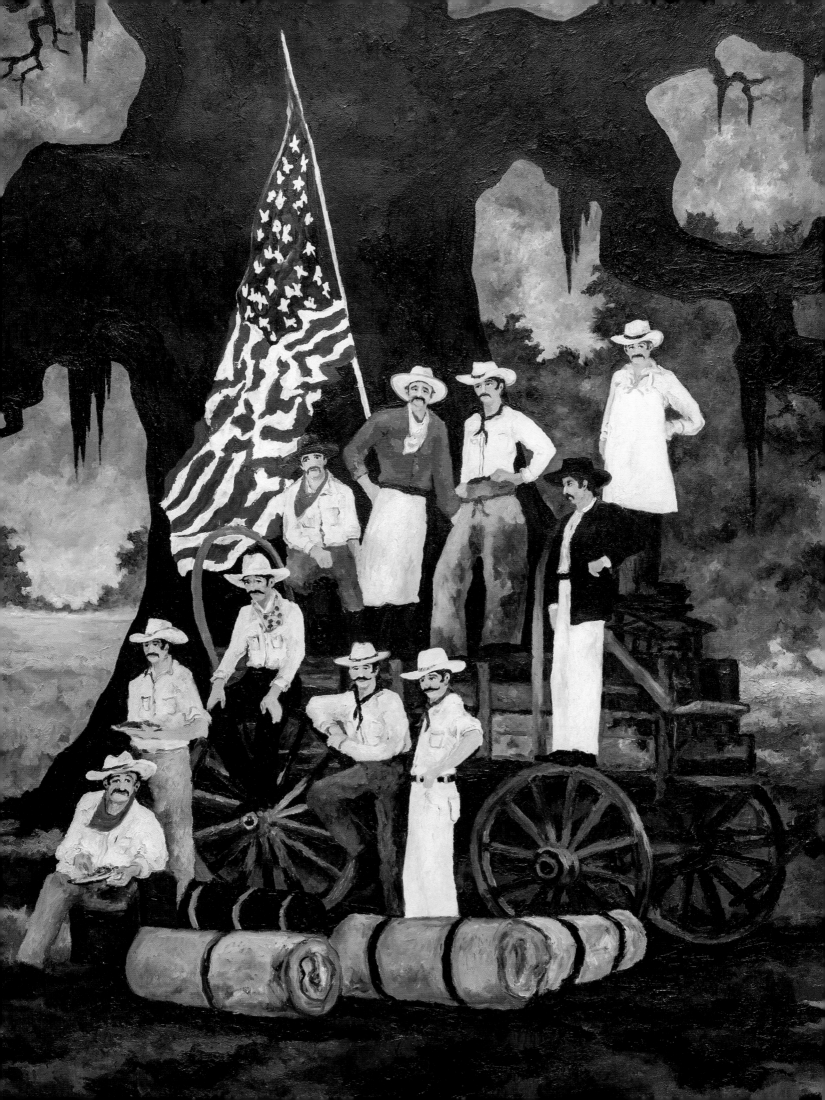

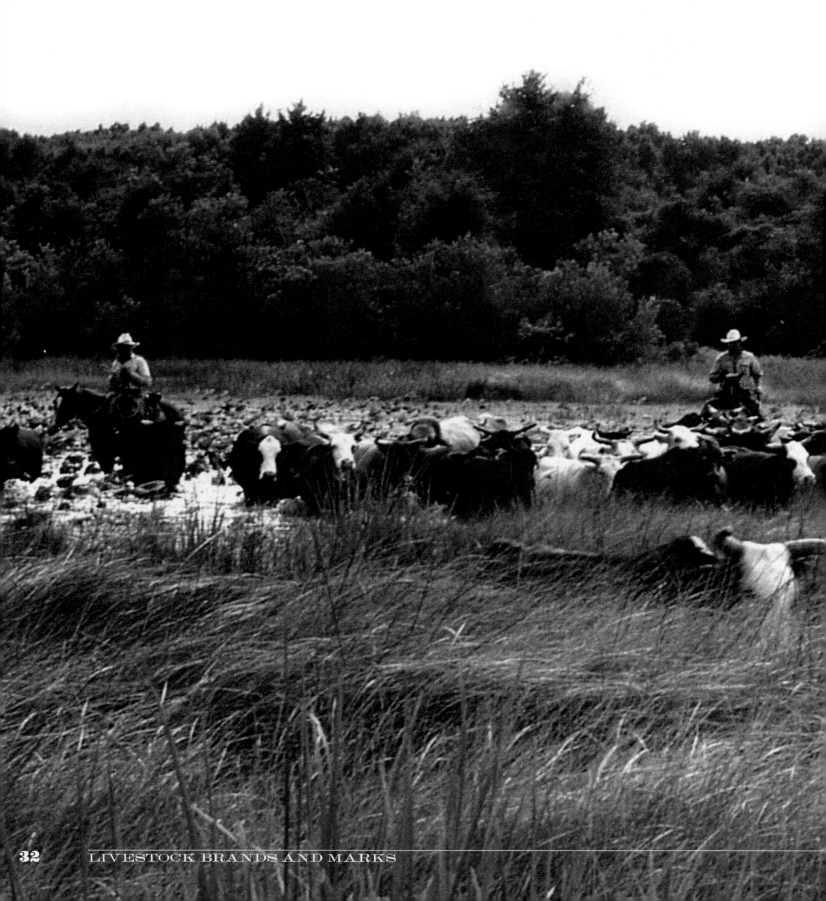

Perry Ridge, Southwest Louisiana, c. 1993. Cattle being trailed to the pens on the coastal dunes through Louisiana's sea of grass.

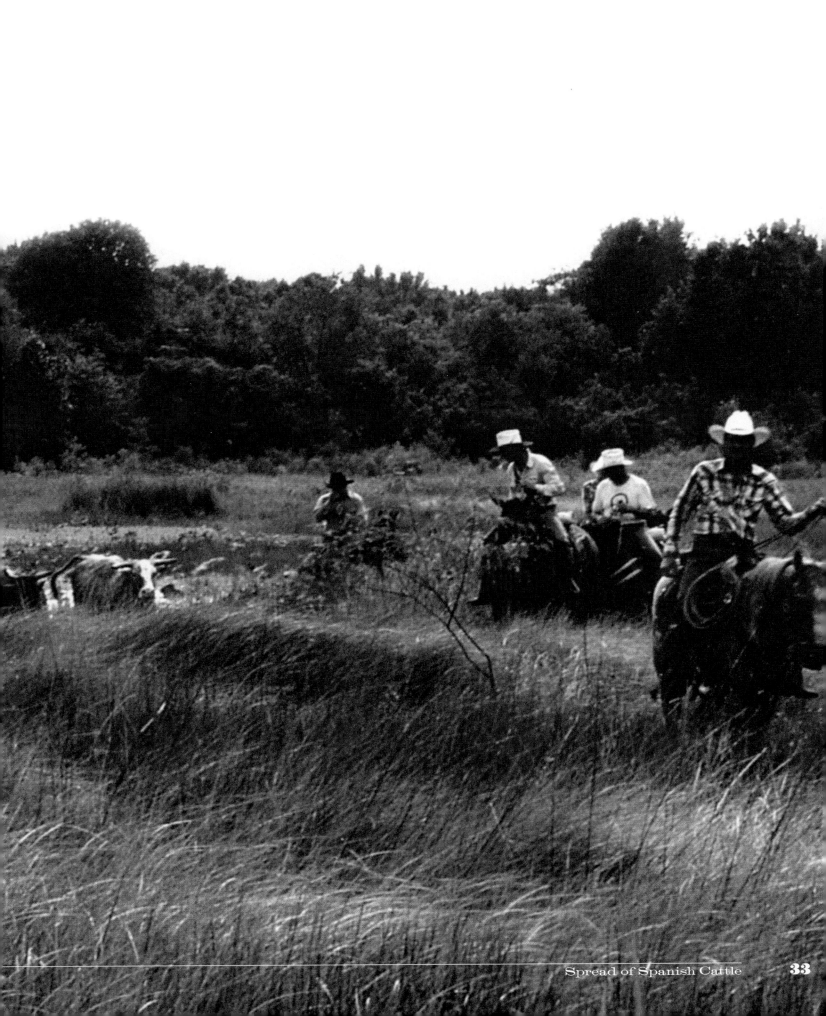

The Ludlow Map c. 1817 showing the County of Attakapas

Southwest Louisiana's Acadian Savanna

When Acadian exiles from Nova Scotia reached southwest Louisiana in 1765, they discovered a virtual sea of grass, perfect for grazing cattle. This natural asset was described by American surveyor William Darby in 1805, two years after the Louisiana Purchase. One of his first impressions of the terrain was that "The face of the earth exhibits an expanse of grass, interrupted only by an occasional clump of oak or pine trees ... The winds breathe over the pathless waste of savanna. The wild fowl is seen flitting or the deer skimming over the plain."[7]

Darby described the Attakapas prairie as "certainly one of the most agreeable views in nature, to behold from a point of elevation, thousands of horses and cows, of all sizes, scattered over the interminable mead, intermingled in wild confusion. ... If the active horsemen who guard them would keep their distance ... it would transport us backwards in the pastoral ages. When we estimate the extent of ground that must forever remain covered with grass, it is no extravagant declaration to call this one of the meadows of America."[8]

By the time Darby saw these natural wonders in the early 19th century, Acadians had come to dominate the southwest Louisiana cattle culture. The Acadian-cattle connection dates from 1765 when Antoine Bernard Dauterive, a former infantry captain residing in New Orleans, made an agreement with "Acadian chiefs" Joseph Broussard called Beausoleil, Alexandre Broussard, Joseph Guilbeau, Jean Duga, Olivier Thibodaux, Jean Baptiste Broussard, Pierre Arsenaud, and Victor Broussard. Louisiana historian Dr. Shane K. Bernard describes Dauterive as owning extensive lands on the east bank of Bayou Teche near present-day St. Martinville.

In a document called the Dauterive Compact dated April 4, 1765, Dauterive proposed "to furnish five cows with calves and one bull to each of the Acadian families during each of six consecutive years ... " in return for the Acadians' care for the cattle. "At the end of said six years," the

document reads, "they will each return the same number of cows and calves of the same age and kind ... " as they originally received, and "the increase surviving at that time will be divided equally between said Acadians and Mr. Dauterive." (Translation by Grover Rees)

Although this is often regarded as the foundation of the Acadian cattle industry, in reality the contract failed, according to Dr. Carl Brasseaux in his book *Founding of New Acadia*. The Acadian exiles chose instead to buy cattle from one of the Grevemberg families who owned a large ranch in the area the Acadians settled. Regardless, before it fell apart, the Dauterive compact had the effect of enticing a seminal group of Acadian exiles to settle in south-central Louisiana—a region that to the present remains the geographical center of Acadian culture. And, once in the region, those exiles still chose to raise cattle, even if they ultimately acquired them from a source other than Dauterive.

Governor Ulloa of Spanish Louisiana at the time had wanted the Acadians to be farmers along the Mississippi north of New Orleans, but this early contingent chose instead to settle in southwest Louisiana. Only four years after they arrived, Acadians were reported to the new Spanish governor Alejandro O'Reilly as beginning to become prosperous as ranchers. By 1803, branded cattle in the Opelousas district numbered more than 50,000 head.[9]

Grassland resources of southwest Louisiana provided the perfect environment for the ranchers' success. Southeast Louisiana, on the other hand, as well as the rest of the state, lacked such terrain. Instead, coteaus, French *coteaux* (higher-than-marsh land) and brulees, French *brulées* (burned-out wooded areas, usually on bayou headlands), provided only limited habitat for Terrebonne's and surrounding bayou parishes' inhabitants to pasture mostly homestead herds. Even so, brands were a necessary fact of life. Those early Terrebonne brands were simple in design, many of them just the owners' initials.

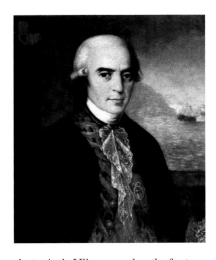

Antonio de Ulloa served as the first Spanish governor of West Louisiana from 1866 to 1868. He was a scientist as well as a naval officer and public servant for the Spanish in the New World. Ulloa and his fellow Spaniard Jorge Juan discovered the element platinum while on a scientific expedition to Ecuador for the French Academy. On his voyage back to Spain from Ecuador, he was captured by the British and made a prisoner in England. Through his scientific accomplishments, he was later made a Fellow of the Royal Society of London. After his release from England, he attained further prominence as a scientist, establishing the first museum of natural history, the first metallurgical laboratory in Spain, and an observatory at Cadiz. For a time he served as governor of a province of Peru, then in Louisiana. He served the remainder of his life as a naval officer. He was also an author, publishing geographical and historical volumes. His name was given to the meteorological term for the phenomenon known as Ulloa's halo.

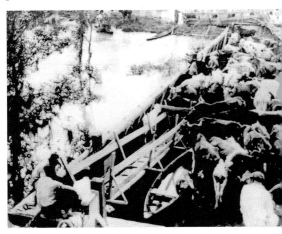

Transporting livestock to high ground after the 1927 flood

The Dauterive Compact: The Foundation of the Acadian Cattle Industry

In the morning of this, the fourth day of April, 1765, before us, the undersigned royal notary of the province of Louisiana residing in New Orleans, there personally appeared *Antoine Bernard Dauterive*, a former infantry captain residing in this city, and *Joseph Broussard called Beausoleil, Alexandre Broussard, Joseph Guilbeau, Jean Duga, Olivier Tibaudau, Jean Baptiste Broussard, Pierre Arcenaud,* and *Victor Broussard,* Acadian chiefs also residing in this city.

In the presence of Mr. Charles Philip Aubry, knight of the Royal and Military Order of St. Louis and commandant of this colony, and of Mr. Denis-Nicolas Foucault, acting *commissaire-ordonnateur* and first judge of the Superior Council of said colony, they have agreed to the following:

Mr. Dauterive promises and obliges himself to furnish five cows with calves and one bull to each of the Acadian families during each of six consecutive years beginning on the day the animals are first delivered to their corral. The said Mr. Dauterive will bear the risk of loss of said cattle by death during the first year only, and he will replace them, if at all possible, without requiring the Acadians to share in this loss.

The said Mr. Dauterive reserves the right to terminate this partnership with the Acadians after three years counted from the date the Acadians first receive the animals and a division of the animals and their increase will then be made, sharing them equally.

The said Mr. Dauterive consents that the Acadians may sell a few cows or bulls, if they deem advisable, provided they keep an account of those they sell, which shall be verified by one of them [one of the eight Acadians].

This the said Acadians have accepted purely and simply and they have promised and obliged themselves to take care of said cattle. At the end of said six years, they will each return the same number of cows and calves, of the same age and kind, that they received initially; the remaining cattle and their increase surviving at that time will be divided equally between said Acadians and Mr. Dauterive.

The above named Acadians, acting individually and for their associates, obligate themselves and hypothecate their present and future property, individually and jointly, and Mr. Dauterive does likewise, hypothecating his property.

The above act was made and passed in New Orleans at the office of said Mr. Aubry on the above-mentioned day, month, and year in the presence of Messrs. Leonard, Mazange, Couturier, the surgeon, witnesses residing here who have signed with Mr. Dauterive, the Acadians having declared that they did not know how to sign. This inquiry was done pursuant to the ordinance.

(signed) Aubry, Foucault, Dauterive, Couturier, L. Mazange, de la Place [councillor assessor], and Garic, Notary

Dauterive Compact: The Foundation of the...

This, the fourth day of April, 1765, before us, the undersigned royal notary of the p... ...ng in New Orleans, there personally appeared Antoine Bernard Dauterive, a for... ...siding in this city, and Joseph Broussard called Beausoleil, Alexandre Brous... Jean Duga, Olivier Tibaudau, Jean Baptiste Broussard, Pierre Arcenaud, and ...dian chiefs also residing in this city.

...e of Mr. Charles Philip Aubry, knight of the Royal and Military Order of St. Lo... ...f this colony, and of Mr. Denis-Nicolas Foucault, acting commissaire-ordonnateur a... ...uperior Council of said colony, they have agreed to the following:

...ive promises and obliges himself to furnish five cows with calves and one bull ...families during each of six consecutive years beginning on the day the anima... ...their corral. The said Mr. Dauterive will bear the risk of loss of said cattle by death ...ly, and he will replace them, if at all possible, without requiring the Acadians to...

...d Mr. Dauterive reserves the right to terminate this partnership with the Acadi... ...nted from the date the Acadians first receive the animals and a division of th... ...crease will then be made, sharing them equally.

...aid Mr. Dauterive consents that the Acadians may sell a few cows or bulls, if the... ...d they keep an account of those they sell, which shall be verified by one of them.

...s the said Acadians have accepted purely and simply and they have promised and ...ke care of said cattle. At the end of said six years, they will each return the same n... ...es, of the same age and kind, that they received initially; the remaining cattl... ...will be divided equally between said Acadians and Mr. Da... ...ually, and for their associates, obl... ...d Mr. Da...

A wild horse on Cumberland Island, Georgia, descendant of the first Spanish horses in the New World

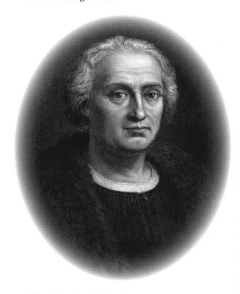

Pine Tacky horse

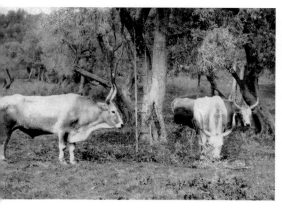

Christopher Columbus

Early Louisiana Cattle

When Acadians first arrived in Southwest Louisiana in the mid-1700s, they discovered in the unfenced grasslands both a few thousand branded cattle and more numbers of wild cattle running free. The so-called Texas cattle then most numerous in the area were "high, clean limbed and elegant in appearance," according to an 1817 statement by the surveyor Darby. Horses, of Andalusian or Nubian descent, were "like their ancestors, small, compactly built, and inconceivably durable."[10]

An earlier description of the cattle had been written by a traveler in the Attakapas country in 1799, Charles Sealsfield. He wrote, "Our cattle in Attakapas differ from those in France very materially by their extraordinary fine horns, which are generally about two and a half feet long, so that with these and their long shanks and feet, when seen from a distance, they look more like deer than like cows and oxen— their usual red-brown color heightens the illusion."[11] Herds of different owners ran together in the open prairie.

What Sealsfield and others saw were Longhorn cattle of Spanish ancestry. These Spanish cattle first arrived in the New World (in Hispaniola, today Haiti and Santo Domingo) with Christopher Columbus as early as 1493. Among explorers who were important to moving Spanish cattle onto the mainland were Hernando Cortes, who in 1521 stocked his Mexican ranch with cattle from Cuba and Santo Domingo. Francisco Coronado is said to have brought Mexican cattle into the area that is now Texas in 1541. In 1685 Robert de LaSalle "planted" cattle on near what is now Lavaca Bay (Cow Bay) in modern-day Texas. Ponce DeLeon's four expeditions 1687-1690 brought Spanish cattle to Texas, also.

They entered Texas in great numbers centuries ago when Mexican ranchers undertook *entradas* (cattle drives) into what became the Lone Star state.

In a history of the most famous Lone Star state bovine, the Texas Longhorn Breeders Association of America asserts that the first Longhorns on what would be U.S. terrain were sent to a mission near the Sabine River. "The early missions and ranchers would not survive all of the elements. But

Early Texas Longhorns

the Texas Longhorn would. By the time of the Civil War, nearly 300 years after setting foot in America, millions of Longhorns ranged between the mesquite-dotted sandy banks of the Rio Bravo to the sandbeds of the Sabine. Most of the Longhorns were unbranded, survivors of Indian raids, scattered by stampedes and weather, escaped from missions or abandoned after ranch failures."

The earliest group of Spanish breeds was called *Criollo*. In some parts of Mexico, the terms *Criollo* and *Chinampo* are used for the same cattle that are called *Corriente* in other areas. All three terms mean "common cattle" or "cattle of the country." The term *Criollo* is similar to "Creole" for humans (meaning of European origin, but born in the New World).

The Texas State Historical Association has written that the Texas Longhorn of today "is a hybrid breed resulting from a random mixing of Spanish *retinto* (*criollo*) stock and English cattle that Anglo-American frontiersmen brought to Texas from southern and Midwestern states."

Over the centuries, those descendants of Spanish cattle developed into present-day breeds, including the Louisiana Pineywoods cattle and Florida Cracker cattle—close relatives of the Corriente breed and Texas Longhorns.

Early wild cattle on the Cajun grasslands differed from those commonly seen today. They were "more like Longhorns and the ... (common) cattle from old Mexico than the Angus or Herefords"[12] familiar to us now. During the colonial period the Spanish Longhorn was the common breed in Louisiana as well as in Texas.

Shorthorns, which originated in northeastern England, first made an appearance in America, in the state of Virginia, as early as 1783. This breed was reliable for meat, milk, and use with wagons and plows. It was easily bred with Spanish Longhorns, and the desirable characteristic of natural hornlessness occurred from time to time in horned herds. Polled Shorthorns were the first major beef breed to be created in the United States. The Hereford breed reached the United States from the United Kingdom in 1817 with the initial import of the breed in Kentucky. Angus cattle, which

Corriente cow and calf

JP Rio, a present-day Longhorn bull

Pineywoods cows

Florida Cracker cow and calf

Polled Shorthorn

Zebu bull (Bos Indicus)

Early Louisiana Cattle

Robert Hilliard Barrow II of Rosale Plantation

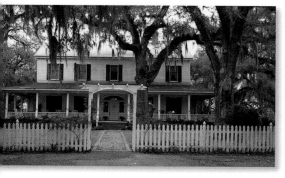

Rosale Plantation, St. Francisville, Louisiana

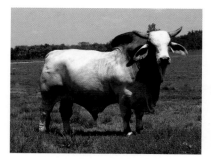

Brahman bull

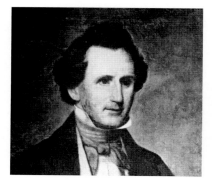

Robert Ruffin Barrow, owner of multiple Terrebonne Parish plantations

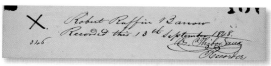

Brand No. 346, the record of Robert Ruffin Barrow dated September 10, 1848

Right, Brand No. 791, the record of R. R. Barrow, Jr. dated August 18, 1914

began in northern England, came to the U.S. in 1873 and were shown at the 1873 Missouri Exposition.

In 1859, however, an important change occurred when planter Robert Hilliard Barrow II of Rosale Plantation in St. Francisville found out about a breed of cattle from India. (Robert Hilliard was a relative of extensive Terrebonne landowner Robert Ruffin Barrow, onetime owner of Residence, Caillou Grove, Honduras, Myrtle Grove, Crescent Farm, and Point Farm plantations.) Barrow saw an engraving of the cattle from a drawing by Thomas Landser, and read a description of them in an English book. The Zebu (Brahmans), he read, were tick resistant and impervious to severe heat.

Barrow ordered a male and female of that breed, but after they arrived in Louisiana the female died. Barrow bred the bull to his Ayrshire cows, and found that his hybrids retained the desirable resistances of the Zebu.

Barrow's large, tall bulls with humped backs and long ears thrived in the hot climate of Louisiana, and he developed a herd that was called "Barrow Grade" cattle. He crossbred his Brahmans with Mexican and/or English breeds. Barrow's improved breed spread across south Louisiana and into Texas. The hardy animals prospered despite heat, humidity and insects. From the Brahman strain they inherited the capacity to cover vast stretches of rough terrain, as well as the ability to dissipate body heat because, unlike other breeds, they possessed sweat glands. The mixed breed also added poundage to Louisiana's native cattle. The introduction of the Brahman to North America resulted in the present-day breeds Santa Gertrudis (Shorthorn), Brangus (Angus), and Braford (Hereford), among others.

In the pursuit of producing ever-improved strains, cattlemen continued to hybridize European breeds with

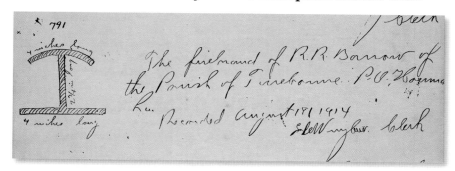

LIVESTOCK BRANDS AND MARKS

Brahmans and others. One example is the introduction to America of Charolais cattle from the provinces of Charolles and Nievre in west-central to southeastern France. Mexican industrialist of French ancestry Jean Pugibet saw the white cattle during his World War I service as a French army volunteer. In 1930 he imported the first Charolais, which are excellent beef producers, to his ranch in Mexico. They were allowed to enter the U.S. in the 1960s, and began to be crossed with English breeds, and eventually with Brahmans. Charbray are offspring of Charolais crossed with Brahmans.

Another European breed, the Simmental, entered the U.S. in 1967. They originated in the valley of the Simme River in western Switzerland, and were recorded as early as the Middle Ages. The red and white cattle grow rapidly and produce desirable dairy qualities. Simmentals crossbred with Brahmans resulted in the Simbrah hybrid, known for rapid growth and quality of beef.

Drawings estimated to be 20,000 years old in the Lascaux Cave near Montignac, France, bear a marked resemblance to the Limousin breed of cattle. Golden-red and natives of the south central part of France in the regions of Limousin and Marche, Limousins originated in rugged terrain with rocky soil and harsh climate. Because of their homeland environment, Limousin cattle evolved into a breed of unusual sturdiness, health, and adaptability. They became valuable both as beasts of burden and beef cattle. The cows calved year round, outdoors. As French breeders improved the breed through natural selection, the Limousin became an efficient, hardy, adaptable animal that produced excellent meat.

North American cattlemen who traveled to France in the 1960s began an interest in the breed on this continent, but the first Limousin bulls were not imported into the United States until the fall of 1971. From initial concentrations in Oklahoma, Texas, South Dakota and western Canada, the golden-red Limousin breed has spread across the continent.

Greater knowledge of the science of genetics has prospered hybridization of different breeds' desirable characteristics. Research and development is an ongoing process in improving beef and dairy production of all breeds.

Santa Gertrudis heifers

Brangus bulls

Simmental bull

Simbrah cow and calf

Limousin bull

The Old Spanish Trail Highway Association formed in 1915 had the immediate aim to build a highway system along the coastline from Mobile to New Orleans, to more or less duplicate the route of existing railroads alternating with water routes. The subsequent more grandiose goal to build a highway that would connect St. Augustine, Florida to San Diego, California was never actualized, but part of the U.S. Highway 90 system followed old cattle trails, at least through parts of Louisiana and Texas. The Old Spanish Trail itself was a misnomer for long segments of the proposed highway, such as from Mobile to New Orleans, where there had been no such trail, but instead a water route. On November 17, 1925, the Old Spanish Trail was designated U.S. Highway 90. In August 1928, bridges and highways at last formed the first ferryless ride from New Orleans to Mobile. East-west Interstate 10 now makes the Old Spanish Trail designation along Highway 90 almost forgotten except in some small towns' signage. Map, c. 1917

To Market

Getting cattle to market, primarily to New Orleans, early on involved a trek all the way across south Louisiana east to the Mississippi River port. "Years before the Civil War, Texas cattle were assembled in Beaumont, Texas, to be driven across Southwest Louisiana to the New Orleans market. ... The Old Beef Trail, also called the Opelousas Trail, crossed the Sabine River ... and thence to the Calcasieu River ... into Lake Charles. From there the cattle folowed the Old Spanish Trail where rivers and bayous proved no hindrance."[13]

The magnitude of numbers of cattle driven, at least part way, to market is evident by an eyewitness to an 1890 drive through Calcasieu Parish. He reported seeing a herd of Texas longhorns "which he estimated at 5,000 head driven past his property ... on their way to market. According to his account the herd required over four hours before the last steer was seen."[14]

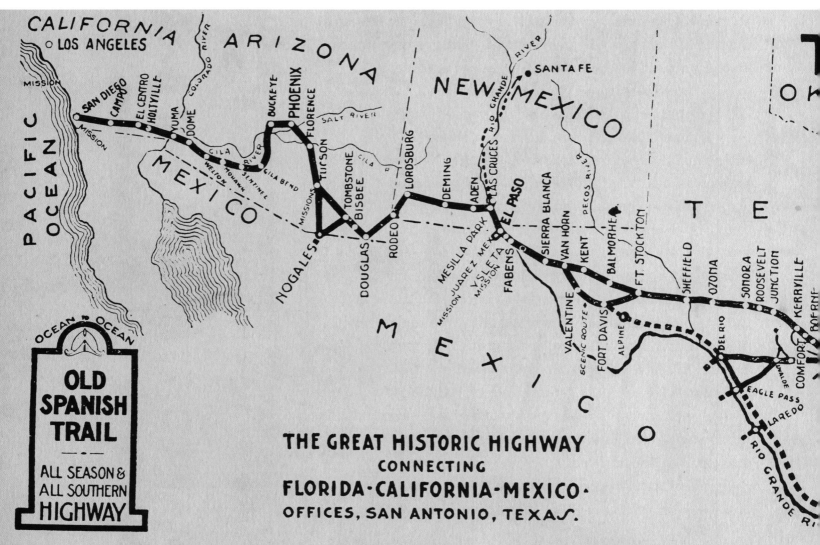

The Old Spanish Trail eastward from Lake Charles followed a route through and near the towns of (west to east) Jennings, Crowley, Lafayette, New Iberia, Jeanerette, Franklin, Morgan City, Houma, Raceland, Boutte, Luling, and on to New Orleans.

Some cattle were shipped by steamers (Pharr's Line from New Iberia to New Orleans) and by rail (Morgan's Louisiana and Texas Railroad).[15] When the railroad was completed through southwest Louisiana in 1880, faster and more efficient transport became available.

Alternate routes from the southwest part of the state to the east were 1) overland to Breaux Bridge on Bayou Teche, to the Mississippi River to Baton Rouge and then downriver toward New Orleans; 2) along the banks of the Teche downstream to Berwick for loading on cattle boats called "round boats—they went 'around' down the Atchafalaya, Red and Mississippi rivers to New Orleans."[16]

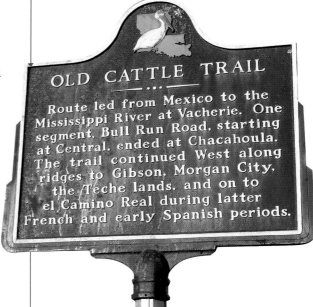

Roadside marker near St. Lawrence Catholic Church in Chacahoula, Terrebonne Parish

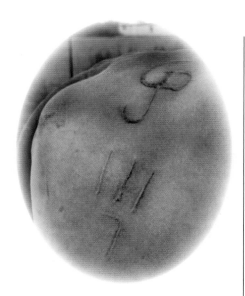

Standard stamped brands

Pineywoods cattle

Historian Dr. Shane K. Bernard noted that there were many other routes, all of which headed in a generally eastward direction across the Atchafalaya to the Mississippi River and down to New Orleans.

Growth of the industry can be estimated when considering that the 1890 census "showed a cattle population of 141,939 for the six parishes then constituting Southwest Louisiana, while the Census of 1900 registered a substantial increase to 191,479."[17]

Wild Cattle Conundrum

Although the presence of wild cattle at first seemed a boon, they later posed a problem specifically because they mingled with branded ones. Aggressive wild cattle lured tamed ones to wander away from the herd with them just as often as tamed, gentle cattle attracted wild ones into branded herds.

Therefore, Governor O'Reilly published a 1770 edict to defend legitimate owners' rights having to do with branding. The very earliest brand documentations were in St. Martinville books, the first dated (or back-dated) 1739, long before O'Reilly's laws calling for more enforcement of uniform rules regarding branding.[18] Considering researched inconsistencies in those early brand books (Lauren C. Post in *The McNeese Review* academic journal, 1958 and Dr. Shane K. Bernard in *Bayou Teche Dispatches* blog, 2011) the 1739 date may be a scribe's accidental transposing of numbers, which should have been 1793.

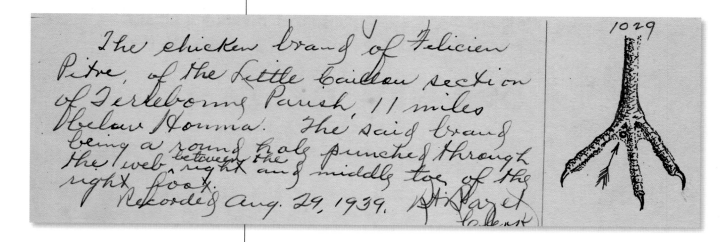

Kinds of Brands

For centuries, brands and marks were for the most part standard: fire-heated brands that were applied to the animal by stamping them to the flesh, or marks such as personalized cuts in parts of animal anatomy, as in ears and tails.

Hot-iron branding by a stamp iron burns away the animal's hair and scars the flesh, that scarring becoming permanent proof of ownership. With a running iron, a device used by thieves, an impression can be burnt on an original brand to alter its configuration. Possession of such branding irons, of course, is illegal in many states.

Heated brands were applied to the haunches of bovines and equines, and to other animals such as sheep, which received jaw brands. Rams and bulls are still sometimes fire branded on their horns for permanent individual identification. Horses may also be branded on their hooves, but this is not a permanent mark. Dogs, mostly chase-hunting dogs, still receive hot brands today.

Even lowly chickens, so important to every household in the past, were given identification marks—unique slits and holes in web spaces between toes. Swine are marked by slicing or cropping the ears.

Beginning in the 20th Century, forms of branding other than hot irons began to be devised. Today, freeze brands first created in 1966 by Dr. R. Keith Farrell at Washington State University can also be used. Nitrogen or dry ice is used to freeze the iron; its application to the animal does not scar the animal's flesh, but instead results in a discoloration of the hair itself,[19] by destroying the hide's pigment-producing cells. Brands are sometimes flesh only, or a combination of flesh and fire brands.

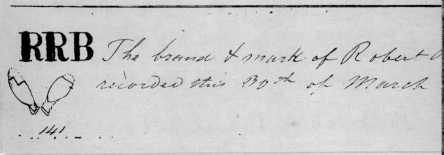

Brand No. 141, the record of Robert R. Barrow, dated March 20, 1832

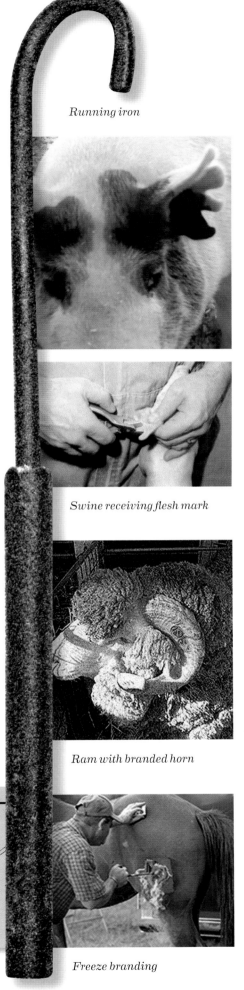

Running iron

Swine receiving flesh mark

Ram with branded horn

Freeze branding

Ear tattoo implement

Horse lip tattoo

Horse with jaw brand

Applying ear identification tags

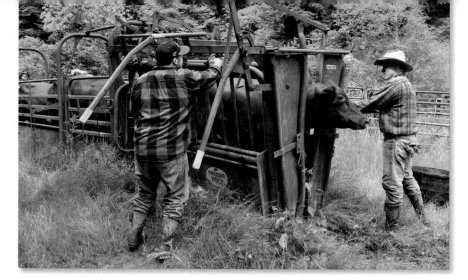

Squeeze chute

One image that nearly every American of a certain age has about branding is a cowboy roping and throwing a calf to the ground to brand it. Today, most livestock are herded into squeeze chutes, which stabilize the upright animals enough for the branding iron to be applied and/or other forms of identification to be used.

Some of those forms of identification for calves in the past used to be ear and jaw tattoos. Inner lip or ear tattoos are frequently used today on sheep and race horses. In fact, state racing commissions require lip tattoos for identification at race tracks.

Brands on horses are two to four inches high, with two inches being standard. Cattle brands are from four to six inches, with four inches being standard. In addition to the ownership brand, modern branding techniques often include additional letters or numbers at another location on the animal for bookkeeping purposes.[20]

New technology such as plastic tags and microchips are recent innovations in animal husbandry identity. Even in view of these recent livestock identification methods, it must be said that eartags can fall off and microchips can be removed. Use of the time-tested hot-iron brand remains the gold standard in permanent proof of ownership.

The latest technology adopted by the Louisiana Livestock Brand Commission is a state-of-the-art tracing system for livestock, instituted in 2012. With an industrial handheld device, agents can record metal eartag and backtag numbers, insert and record electronic eartags and record numbers, and identify brand, sex, breed, color, and owner information. All recorded data is then uploaded to a laptop computer.[21]

Collected information is handled only by the Louisiana Department of Agriculture and Forestry (LDAF). An authorized user can use the data to track any animal reported sick, missing or stolen. The system's use began after a United States Department of Agriculture mandate for all states to create tracking programs for any animal entering interstate commerce. The electronic livestock check-in system's ultimate goal is protection of the American food supply.[21]

The reading of brands is a language unto itself. Brands are read from left to right, top to bottom, or outside in. As an example of the first case, brands that consist only of initials are read as they are said normally, left to right. From top to bottom, a line over a B and a Q would be Bar BQ. The letter D with a circle around it would be Circle D.

A brand character is sometimes given a flourish such as wings, in which case whatever a letter might be, it would be called "flying": an example would be Flying A. An A with simple-line feet added would be read Walking A. Another variation using letters would be that an R, for example, with a crescent under and connected to its upright line, is called a Rocking R. The word "crazy" is read if the letter is upside-down, one slanted approximately 45 degrees is read "tumbling," and one lying on its side through a 90-degree rotation from upright is termed "lazy."

Other variations can be created by joining characters together, such as two H's joined by the first letter's second upright line to the second H's first upright line; another would be the number 7 stylistically connected to the word UP to create a brand that would be read 7 Up.

Any discussion of brands would be incomplete without one brand-related term that has been adopted into American English, the word *maverick*. The 19th century Texas politician and rancher Samuel A. Maverick refused to brand his cattle. His surname has since lent itself to the term that identifies a person who refuses to follow the precepts of social order.

Since a brand on an animal was and is considered *prima facie* proof of ownership, Mr. Maverick's flouting of this convention in ranch country was, to his contemporaries, an especially astounding transgression of order.

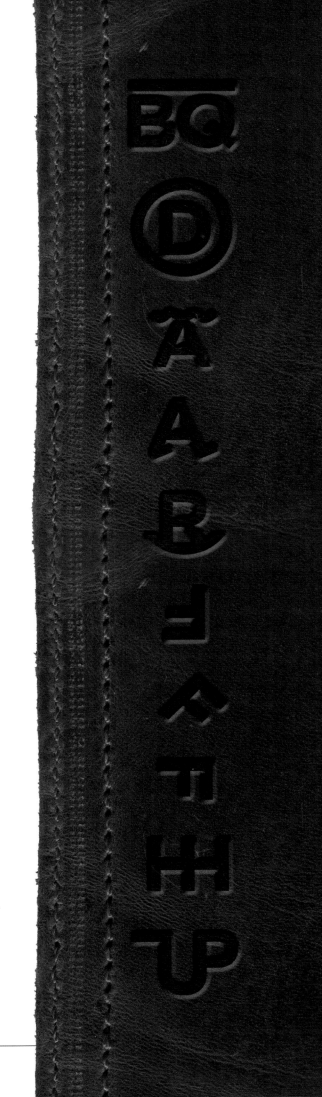

Top ad from Houma Ceres *of December 25, 1858; middle ad,* Houma Civic Guard *of June 9, 1866; bottom ad, Houma* Ceres *of December 25, 1858*

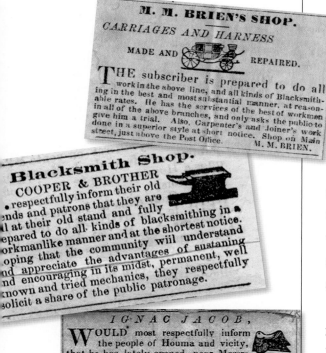

Henry Charles Kappel and family

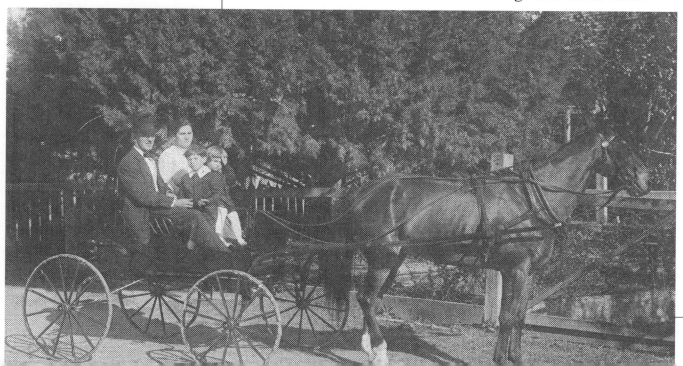

The Iron Men

During the 1800s and early 1900s, livestock owners may have designed their own brands, but it was left to the blacksmith to actually fashion the hot-iron brand that the owner was to use for decades.

The blacksmith pounded away with hammer on anvil, the superhot forge providing his brand-in-progress with necessary malleability while he shaped and molded the finished product. Oftentimes blacksmiths doubled as farriers, who made horseshoes and actually shoed the equines in their shops. Sometimes a third type of workman, a wheelwright, also had a place in the smith's shop, or the smith and farrier plied this trade, too. Besides the wheels having to be built, they also had to be fitted with metal rims. These versatile craftsmen often were also accomplished carpenters who could build an entire wagon and rim the wheels as well.

Because of the large number of animals that needed tending on plantations in Terrebonne Parish, almost every such large farm had a resident blacksmith/farrier/wheelwright. The largest concentration of smithy shops, however, seems to have been in Houma, many of them at the town's center.

The first smith of record in Houma was Hirman McGraw. His shop was strategically located near the end of the railroad line that reached the western end of Main Street. M. M. Brien advertised in a Houma *Ceres* 1858 issue that he did "all kinds of Blacksmithing" as well as other

related work at his shop on Main Street, "just above the Post Office."

Two other advertisers in that same issue of December 25, 1858 were A. Cooper & Son and Ignac Jacob. The Coopers did blacksmithing and "all business in their line in all its various ramifications" in Houma, in a shop formerly occupied by A. S. Rose. Ignac Jacob made and repaired saddles, harness, carriages and buggies "near Messrs. A. Cooper & Son." Seven years later, in Houma's June 9, 1866 *Civic Guard* newspaper, B. Cooper & Brother informed "friends and patrons" that they were "still at their old stand" doing blacksmithing.

A related business with an advertisement in the April 25, 1868 *Civic Guard* was the freight wagons line of J. B. Ploton, who served the parish, "running from the Terrebonne Station to all parts of the parish," for planters and others who needed goods transported.

O. J. Theriot advertised in 1887 that he did "all kinds of wood and iron work" at Residence Plantation. Jean Baptiste Ploton of the freight line also owned a shop for which he hired smithies in the vicinity of what were the Southern Pacific railroad tracks. He sold the shop to Emile Daigle in 1891. By 1897 Charles Dumiot also had a shop on Main near the railroad station on Main Street. John Foolkes also advertised as a blacksmith, in the *Terrebonne Times* of August 21, 1897.

Just after the turn of the century, in 1905, Leo Parr advertised as a blacksmith and wheelwright. Henry Charles Kappel's smithy, farrier, and wheelwright workplace opened on the bayouside of the then-600 block of Main Street in 1910.

William Wright, Jr. had a blacksmith shop in his livery stable on Court Street, now Belanger Street. Henry Beauregard Marquette first worked in Wright's business, then opened his own at the corner of School and Canal streets. Charles Marquette, seemingly not related to Henry, was a smith in his place at Lafayette Street and Wood Street, specializing in horseshoeing.

Another blacksmith shop near Marquette's was that of the Porche brothers George and James. Along with their brother John, they later founded Porche Brothers Motor Company. Their uncle Henry Clay Porche had been a blacksmith, as

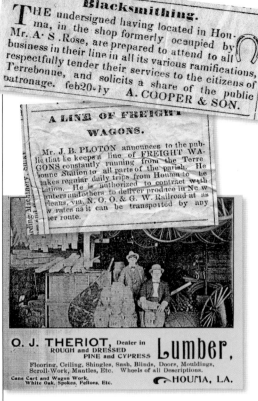

Top ad from Houma Ceres *of December 25, 1858; middle ad, Houma* Civic Guard *of April 25, 1868; bottom ad, Waterways Edition of 1910*

Emile Daigle

Charles Dumiot

George Porche

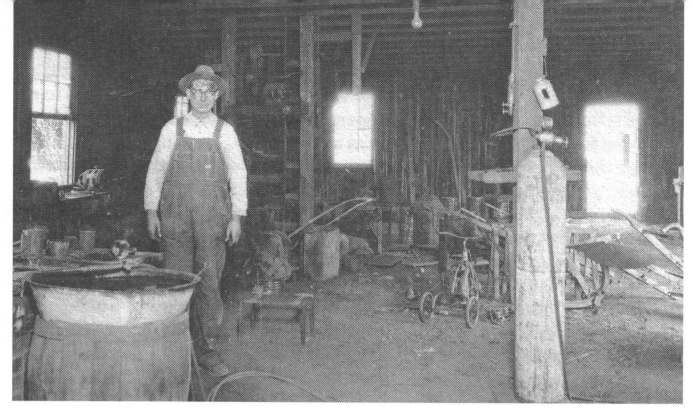

Octave "Tete" Eschete

Henry Clay Porche, Pvt. Co. H, 26th Regt., LA Inf., CSA

Ezra Crochet at left, and Elmer Crochet

well, above the railroad depot. George worked with this uncle before establishing his and James' shop.

Octave "Tete" Eschete served an apprenticeship at Southdown Plantation, and later moved to Houma to be a smith for Porche Brothers Motor Company which was founded in the 19-teens. He then worked for many years in a shop he opened on West Main Street, at present-day 7563 Main Street. Rene (Clement) the Tinner occupied a space in Eschete's shop beginning in the mid-1920s.

Brothers Ezra and August Crochet had a blacksmith establishment as early as 1897, on the side of Bayou Terrebonne at number 58 Main Street, later 600 block of Main Street. When August had to give it up, Ezra moved to Barrow Street near the Dupont bridge. Ezra's son Elmer occasionally worked as a blacksmith with his father at the Barrow Street location. Later, Ezra practiced his trade on East Park and Palm, at a shop in his yard.

In what is now East Houma, Johnny Walker had a place on the side of Bayou Terrebonne across the street from Holy Rosary Catholic Church. Also located on the east side of the Gulf Intracoastal Waterway was the business that blacksmith Willie Hamilton established in 1909. He was a blacksmith, farrier, and wheelwright who had been a smith at the Terrebonne Sugar Refinery in Montegut and at the St. Louis Cypress Company sawmill in Houma. His sons Peter

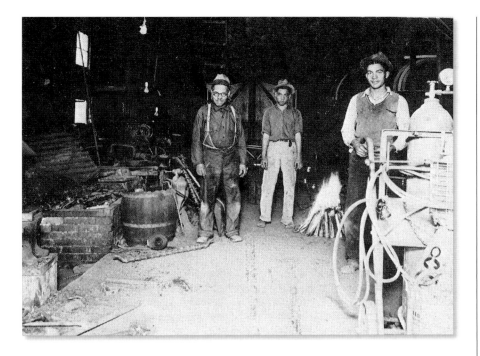

and Allen continued the shop as Hamilton Brothers' Machine Shop until well past halfway into the 20th Century. Another blacksmith in East Houma was George Nixon, who worked in the Dug Road area, on the bayou side.

James J. Dill was a blacksmith at Southdown. Timothy Brady became one of the plantation blacksmiths, at Ashland Plantation, and before that worked for the St. Louis Cypress Company sawmill and for William Wright. Another tradesman at Ashland was Joida Domangue, who worked as a wheelwright there.

Left: Willie, Peter, and Allen Hamilton, c. 1930

Second photo: Rene J. Clement (August 11, 1896 – October 26, 1965); his brand, below

Bottom left: ad from Terrebonne Times *of August 21, 1897*

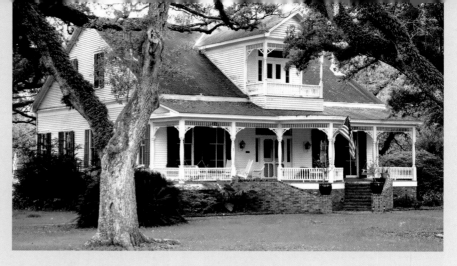

Right, Argyle in 2013
Brand No. 782

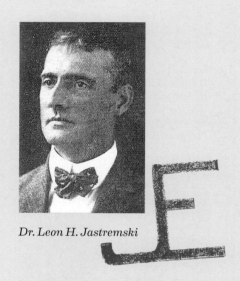

Dr. Leon H. Jastremski

Brand No. 1001, record of the estate of L. H. Jastremski, registered at the request of J. D. Jastremski, dated March 27, 1936

Geography of Brand Registrations

Terrebonne Parish brand registrations included particulars about owners and where they were located, by plantation name or name of the area of the parish (some of which are no longer in common usage).

If the owner resided in another parish but owned property in Terrebonne Parish upon which his or her brand was used, officials recorded the place of residence. For example, residents of New Orleans, St. Charles Parish (Des Allemands), Lafourche Interior Parish, Lafourche Parish, Orleans Parish, St. Mary Parish (Berwick), and as far away as Jefferson County, Texas, registered and used their brands in Terrebonne. Registrations were also accepted by estates as well as for individuals.

Registrations by plantation:
- Ardoyne
- Argyle
- Ashland
- Bull Run
- Ellendale
- Isle of Cuba
- Nameoka
- Southdown
- Woodlawn

Registrations by area of Terrebonne Parish:
- Bayou Black
- Bayou Blue
- Bayou Cane
- Bayou Coteau
- Bayou Dularge
- Bayou L'Ourse
- Bayou Salé
- Bayou Terrebonne (Upper and Lower)
- Boudreaux Canal
- Canal Bellanger and Bourg
- Chacahoula
- Chauvin
- Daigleville
- Donner
- Dulac
- Ellendale
- Gibson
- Grand Caillou
- Humphreys (on Big Bayou Black)
- Montegut
- Point au Barré
- Pointe-aux-Chenes
- Schriever
- Theriot
- Tigerville
- Timbalier Island
- Town of Houma

LIVESTOCK BRANDS AND MARKS

Second house at Woodlawn, c. 1900
Brand No. 787

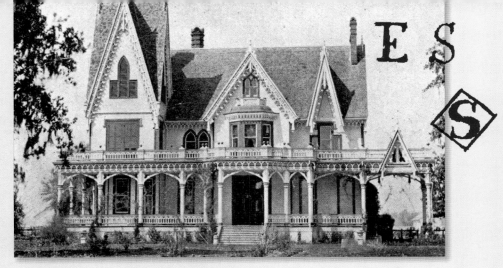
Ardoyne c. 1900, with the porte cochère (literally, coach door), later destroyed by Hurricane Betsy in 1965. Brand Nos. 211 & 502

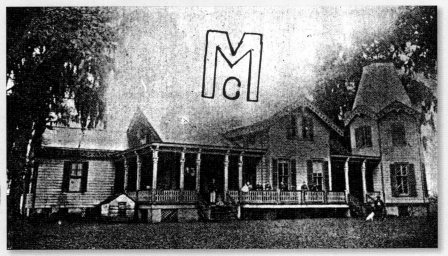
Ellendale c. 1900, with the turret in place before its destruction by an early 1900s hurricane. Brand No. 1054

Joseph Dover, Jr. of New Orleans, Brand No. 1071 dated April 28, 1943

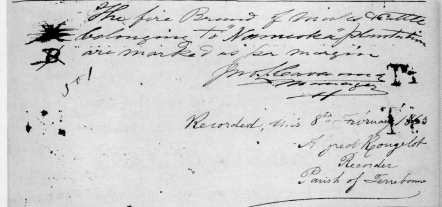
Brand No. 501, record of Nameoka Plantation, dated February 8, 1865

Ashland at the turn of the 20th Century
Brand Nos. 801 & 807

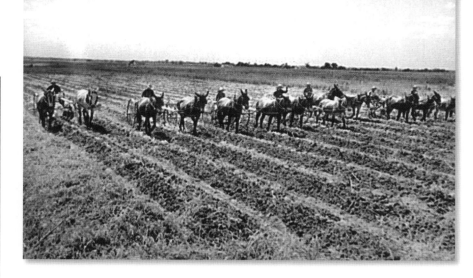

Terrebonne Farms at Schriever[23]

During the 1940s, brand registrations, regulation, and enforcement were being transferred from local to state authorities in Louisiana. The decade before had seen federal government efforts to provide incentives to farmers and to experiment with different methods of farming models. It was a time when mechanization increasingly began to replace beasts of burden on farms, before eventually supplanting those animals entirely in the farm industry.

President Franklin D. Roosevelt's New Deal extended to the agricultural community through so-called resettlement programs. Schriever in northern Terrebonne was designated such a site, where the government spent federal funds to build homes, roads, create jobs, promote community activities, and establish social services for a group of homogeneous families which the government selected to take part in the project.

"Terrebonne Farms" was organized as "an incorporated, cooperative farm," unlike other resettlement communities across the United States, which did not utilize the collective-farm element.

At these other sites, the federal Resettlement Administration initiated "ordinary farming resettlements, in which the government built simple homes, erected a few public facilities such as schools, cotton gins, and meeting houses, and leased farm land to individual families."

In only three American communities would that model be circumvented in favor of cooperative farm communities. Besides the Terrebonne Parish community, the others were located in Pinal County, Arizona; and Jefferson and Arkansas counties, Arkansas. In these three sites, "the

Waubun in 1938

majority of farm land was leased and worked cooperatively."

The concept was both praised and criticized, depending upon ideology. Historian Sidney Baldwin wrote about the Farm Security Administration, "To some of its foes, it was a dangerous radical, an un-American experiment in governmental intervention, paternalism, socialism, or communism. ..." To others it was a practical method to meet the needs of farmers who lacked the resources to become successful on their own.

Regardless of the politics involved, the Terrebonne Farms project attracted many families—specifically French Catholics, who had a reputation for mutual assistance.

The land they would inhabit consisted of 5,603 acres that had formed all or parts of four plantations along Louisiana Highway 24 on the right descending bank of Bayou Terrebonne. They were the adjacent lands of Waubun, St. George, and Isle of Cuba, plus Julia separated from the others by Ducros Plantation. Waubun and St. George plantation houses served as homes and offices for project administrators.

The project at Schriever was an incorporated cooperative. "The corporation, rather than its members, would hold a ninety-nine year lease on the land from the government; members would work the land cooperatively as a single, large sugarcane and vegetable farm. In addition, they would rent small, four-acre tracts for family cultivation."

Seventy-one of a projected 80 houses were built, using four different floor plans. They were all bungalow style,

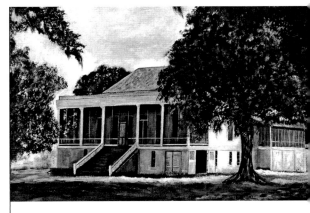
St. George in 1930

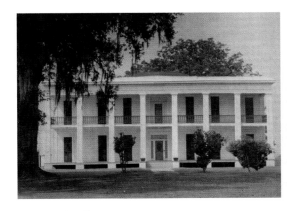
Present-day Ducros, 2013

Main Project Road, c. 1940s

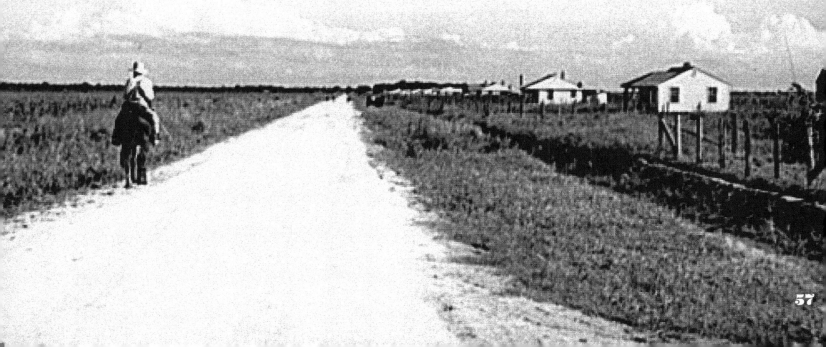

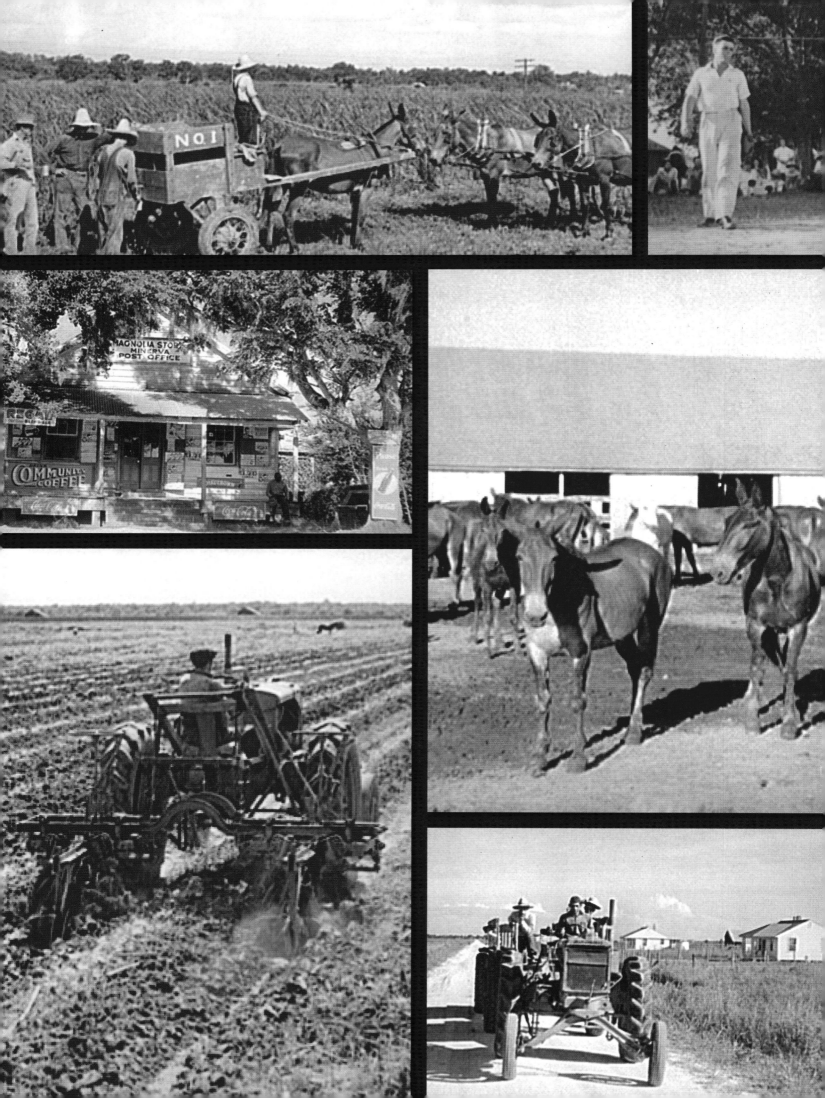

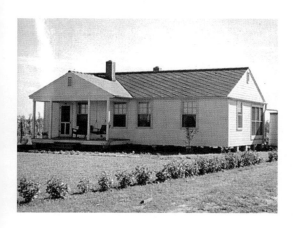

all painted white with yellow trim. They each stood on six acres, two of which were rent free and held the house and outbuildings—privy, poultry house, and barn. The government charged $30.00 yearly rent on the other four acres, which were for the family's orchard, garden, and livestock.

On the one hand, residents had access to medical care, social service, and other learning opportunities at the project. They were able to buy from the government products they needed. They participated in ball games and sing-alongs together besides working together. On the other hand, delays and denials often discouraged residents as when, for example, requests for purchases or simple home improvements had to go through a bureaucratic chain of command.

The federal government purchased land for the project in 1936. Mrs. Allen J. Ellender, wife of the longtime Louisiana senator and native of Terrebonne Parish, turned the first spade of dirt at the official ground breaking ceremonies on January 14, 1939.

Congress passed the Agricultural Appropriation Act in 1943, which authorized no money for ... "experiments in collective farming except to liquidate them." The same legislation of 1944 and 1945 ordered all projects to be sold as quickly as possible. In March of 1945, the U.S. Government formally cancelled its long-term lease with Terrebonne Association, Incorporated, making the cancellation retroactive to December 31, 1944. The project ceased to exist.

By June of 1945, 52 of 55 subdivided farmsteads on TAI land had sold, but only 20 of the buyers were members of Terrebonne Farms.

Today, two roadways are left to bear mention of what was once Terrebonne Farms in Schriever—Main Project Road and Back Project Road.

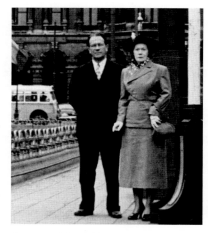

Senator Allen Ellender and his wife, Helen Calhoun Donnelly Ellender, c. 1949

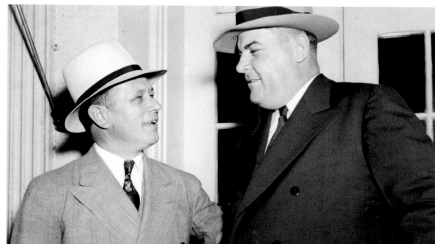

Senator Allen Ellender and Governor Richard Leche visited Washington, D.C. to present a Louisiana program for federal assistance, in 1939.

Terrebonne Farms Member List

Edgar Adams, Jr.	Louis Daigle	Conrad LeBlanc, Sr.	William Pelligrin
Frederick Adams	Calvin Deroche	Harry LeBlanc	Claude Percle
Armand Andra	Louis Duet	Nelson LeBlanc	Alva Perero
Ivy Badeaux	Wallace Dupre	Enese LeBoeuf	Charleston Pertuit
Alvin Barrilleaux	Wickles Dupre	Reola LeBoeuf	Edmond Pertuit
Edward Benoit	Israel Este	Troy LeCompte	Smith Prejeant
Valcour Benoit	John J. Fernandez	Columbus Ledet	Beady Roddy
Rene Bergeron	Eddie Frederics, Sr.	McLean Ledet	Joseph Roddy
Emile Blanchard	Joseph Gagliano	Norman Leonard	Augustin Rodrigue
Henry Blanchard	Alfred Gaudet	Phillip Martin	Robert Rogers
Wilbert Blanchard	Abel Gros	A.J. Martinez	Joseph Savoy
Clay Boudreaux	Alex Gros	Yvest Melancon	Robert Schouest
Logan Boudreaux	Benny Gros	Joachim Morvant	Leonney Simmoneaux
Clarence Bourg	Edwin Guidry	Louis Morvant	Willie Sonier
Alcide Brunet	Armand Guidry	Clarence Navarre	Norman Tenney
Louis Brunet	Herbert Guillot	Louis Navarre	Cleferphe Thibodaux
Luke Callagan	Emile Herbert	Leslie Naquin	Joseph Thibodaux
Curtis Causey	Neville Himel	Oneil Naquin	Robert Thibodaux, Sr.
Joseph Chauvin	Albert Hue	Oneil Naquin, Jr.	Milton Toups
Morris Chauvin	Earl Jacob	Vanny Naquin	Ivy Trahan
Agna Chiasson	Brierre Kliebert	Curtis Olivier	Harry Usey
Anatole Chiasson	Andrew Landry	Junius Oncale	Nelson Usey
Morris Chiasson	George Landry	Maurice Oncale	Oliver Usey
Robert Chiasson	Junius Landry	Adam Ordoyne	Davis J. Vicknair
Sterling Crochet	Clay LeBlanc	Noray Ordoyne	Amilcas Waguespack
Early Clement	Andrew LeBlanc	Lynn Ourse	Clement Waguespack
Ursin Daigle			Fanard Waguespack

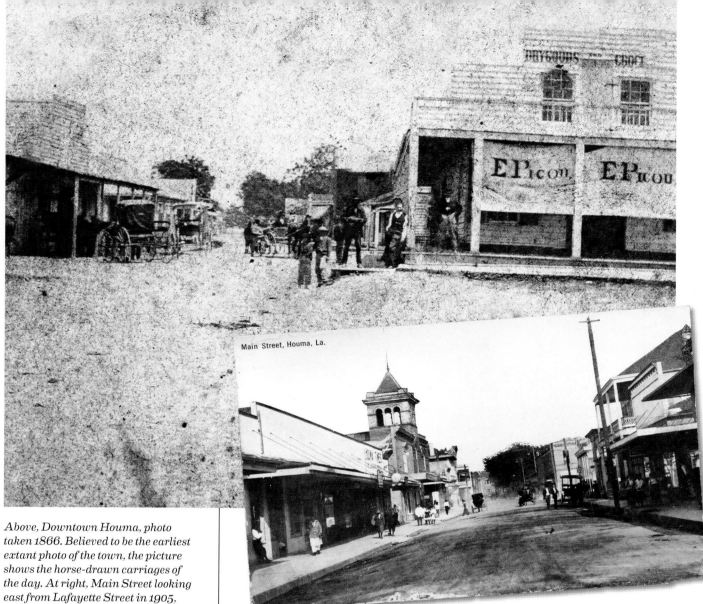

Above, Downtown Houma, photo taken 1866. Believed to be the earliest extant photo of the town, the picture shows the horse-drawn carriages of the day. At right, Main Street looking east from Lafayette Street in 1905, Courthouse oaks in the distance.

Four-wheeled wagon drawn by oxen c. late 1800s

Conclusion

For the first settlers and later inhabitants of Terrebonne Parish and the entire Louisiana Gulf Coast, dependence on livestock was a necessity—from the 1700s through the early 1900s. Henry Ford's 1908 Model T, mass produced on an assembly line and more affordable than earlier automobile models, transformed personal transportation from horsedrawn carriages to "horseless carriages." Personal-use and goods-transport vehicles drastically curtailed reliance on equines. Around 1910, gasoline powered tractors began to revolutionize farming with agricultural mechanization, thus curtailing reliance on equines and bovines for that kind of work.

Bovines, equines and other livestock continue to be part of the landscape of the region on ranches and farms where they are still used the way they always have been, but reliance

Above: horse-drawn four-wheeled carriages on a paved road, c. 1940
Below: early horseless carriages, c. 1907

Conclusion 63

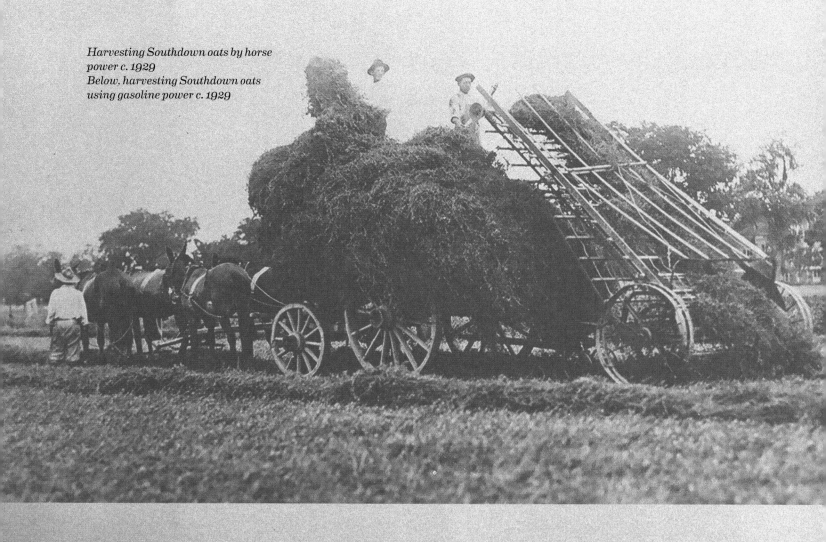

Harvesting Southdown oats by horse power c. 1929
Below, harvesting Southdown oats using gasoline power c. 1929

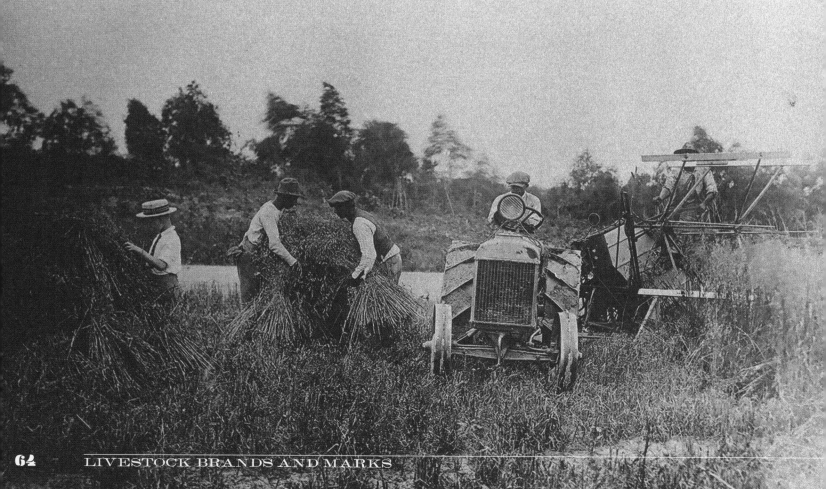

on these animals is no longer a constant in the lives of the majority of the people who live there.

But the work of protecting owners' livestock continues, albeit under state, instead of parish, authority. The work of the Louisiana Livestock Brand Commission is every bit as relevant as, and on a much larger scale than, the work of local sheriffs of long ago in preventing misidentification or theft of livestock. (Appendix I)

When Terrebonne Parish was formed in 1822, livestock owners were required by law to register brands and marks. Whereas loss of a single cow, chicken, horse, mule, or hog may have been a routine complaint in Terrebonne Parish before the 1940s, World War II years saw an increase in the occurrence of livestock crime, and its sheer volume necessitated state intervention by establishing state authority to deal with major farm-related crime and costly losses to livestock owners.

Registered brands, now as well as in the past, play a time-honored role in keeping livestock ownership safe, and in righting unjust claims.

Top, ad from Houma Courier *of February 18, 1899*
Above, horse-drawn land leveler

Main Street, Houma, looking west; wooden banquettes and three types of horse-drawn conveyances, c. 1905

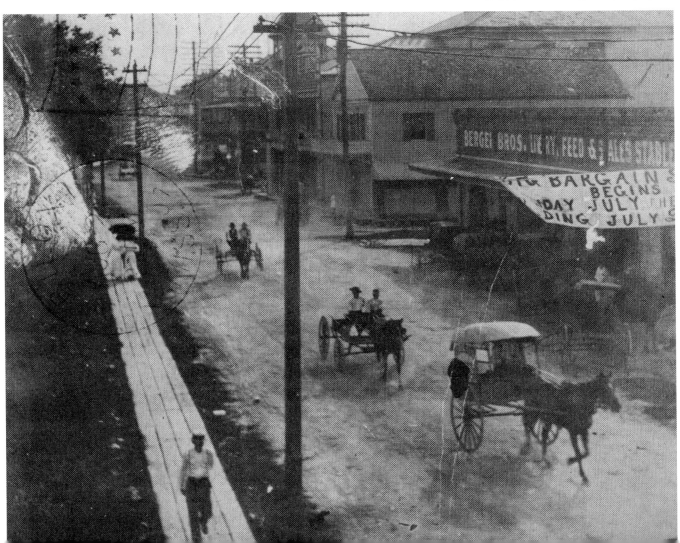

NOTES

1, 3, 5, 6, 10, 16, 18. Lauren C. Post, *Cajun Sketches from the Prairies of Southwest Louisiana*, Louisiana State University Press, 1962

2. Louisiana Director of Archival Services Florent Hardy, Jr., Ph.D., excerpt of *Louisiana 2012: A Bicentennial Celebration of History, Culture and Natural Resources* published in the *Louisiana Bar Journal*, Volume 59 Number 5

4, 7, 8, 9, 11, 12. Bill Jones, *Louisiana Cowboys*, Pelican Publishing Company, 2007

13, 14, 15, 17. Donald J. Millet, *Cattle and Cattlemen of Southwest Louisiana 1860-1900* in the Louisiana History Journal, 1987 (courtesy Louisiana Director of Archival Services Florent Hardy, Jr., Ph.D.)

19, 20. Carl Bennett, Louisiana State Brand Commission, interview 2012

21. Louisiana Department of Agriculture and Forestry *Market Bulletin*, June 28, 2012

22. Much of the information in The Iron Men section about blacksmiths is from Helen Wurzlow's *I Dug Up Houma-Terrebonne*, Volume III

23. All information, and some wording, about the Terrebonne Farms at Schriever section are from Lisa Kay Adam, *Terrebonne Farms, Louisiana: An Anthropogeographic Study of a New Deal Resettlement* (dissertation for the graduate faculty of Louisiana State University), December 2000

Herding cattle in Colorado, c. 1870

Fire Brand Books
Terrebonne Parish
1822-1946
I, II, & III

FIRE BRANDS

JUNE 6, 1822

APRIL 1, 1907

―――

1

―――

1 - 729

―――

R.A. Bazet, Clerk

Parish of Terrebonne

Recorders of Brand Registrations

From Terrebonne Parish's founding in 1822 until 1846, it was the duty of the parish judge to record public records. The first four names of the list were the judges, who recorded brand registrations.

The State Constitution of 1845 established the office of parish recorder. These officials and their deputy recorders took over registrations in the year 1846, and continued until the duty was transferred by law to the parish Clerk of Court and his/her deputies in 1880. Dates indicate their terms, or the beginning of their terms of office.

	
Francis M. Guyol	**1822-1824**
Leufroy Barras	**1824-1845**
Henry Claiborne Thibodaux	**1845-1846**
Evariste Porche	**1846-1856**
Voltaire Thibodaux	September 1846
A. Verret	April 1848
Joseph Adrien LeBlanc	January 1854
Alfred Joseph Delaporte	March 1856
Alfred Joseph Delaporte	January 1862
John Robert Verret	December 1862
Alfred Rougelot	August 1864
John Robert Verret	April 1865
John Robert Verret	May 1866
John J. Mushaway	September 1868
J.M. Burguieres, deputy	September 1871
John J. Mushaway	October 1872
H.M. Johnson, deputy	1873
Gabriel Montegút, deputy	October 1874
Isham Pollard	December 1876
Adolphe Verret, deputy	June 1877
N.M. Calhoun, deputy	June 1878
Edward W. Condon, Clerk	1876-1892
Christian L. Powell, deputy	December 1876
Hugh Maxwell Wallis, Jr., deputy	1884-1887
Aubin Bourg, Clerk	1892-1898
Edwin C. Wurzlow, deputy	July 1892
Henry M. Bourg, deputy	March 1898
Francis X. Bourg, Clerk	1898-1900
Charles Amedee Celestin, Clerk	1900-1904
Henry M. Bourg, deputy	June 1900
Edwin Clarence Wurzlow, Clerk	1904-1919
Robert P. Blanchard, deputy	1918
Robert P. Blanchard, Clerk	1919-1920
Adam O. Hebert, Clerk	1920-1924
Randolph August Bazet, deputy	1920
Lois Belanger, deputy	1922
Randolph August Bazet, Clerk	1924-1964
H.C. Wurzlow, deputy	1925
H.J. Bodin, deputy	1939
Marie W. Culli, deputy	1945
J. Marian Yancey, deputy	1946

Parish of Terrebonne. State of Louisiana.

Brand Book A

Be it remembered that on the Sixth day of June, in the forty Sixth year of the Independence of the United States of A. (A.D. 1822) We, William J. Watkins Senior Justice of the Peace, within and for said Parish, and Leandre B. Thibodaux, a justice of the peace, also within and for said Parish, have this day numbered this Book from number first on this page to number One hundred and Seventy to be the Register of Brands in this Parish of Terrebonne.

In testimony whereof we have hereunto set our hand and Seal on the in this behalf before written.

Ne varietur: Wm. J. Watkins Senr. Justice

L. B. Thibodaux

Ao. 1822.
June the 6th

No. 1.
Jean Bourk

This Sixth day of June, in the year one thousand eight hundred and twenty two, before me Francis M. Guyol, Judge for the Parish of Terrebonne, personally came and appeared Jean Bourk, junior, an inhabitant of this Parish, who deposited in my office a stamp of the letters JB, which he declared to be his ordinary brand, for the purposes intended by law. Certified on the date aforesaid.

Francis M. Guyol Parish Judge

This Sixth day of June, in the year one thousand

PG

No. 2:
Pierre Gregoire Gauthrot

♡

No. 3:
Hubert Bellanger

CD

No. 4:
Charles Dupré

A.° 1822
June the 6.th
N.° 2.
Pierre Gregoire Gauthrot.

PG

eight hundred and twenty two, before me Francis M. Guyol, judge for the Parish of Terrebonne, personally appeared Pierre Gregoire Gauthrot, an inhabitant of this Parish, who deposited in my office a stamp of the letters PG, which he has declared to be his ordinary brand for the purposes intended by law.

Certified on the date aforesaid

=Francis M. Guyol P.J. Parish Judge

A.° 1822
June the 15.th
N.° 3.
Hubert Bellanger.

♡

This Fifteenth day of June, in the forty sixth year of the Independence of the United States of America (A: D.n 1822) before me Francis M. Guyol, Judge for the Parish of Terrebonne, personally appeared Hubert Bellanger an inhabitant of this Parish, who deposited in my office a stamp of the figure and forme of a ♡, which he has declared to be his ordinary brand for the purposes intended by law.

Certified on the date aforesaid

=Francis M. Guyol P.J.

A.° 1822.
July the 6.th
N.° 4.
Charles Dupré

CD

This Sixth day of July in the forty Seventh year of the independence of the United States of America (A: D.n 1822) before me Francis M. Guyol, Judge for the Parish of Terrebonne, personally appeared Charles Dupré an inhabitant of this Parish, who deposited in my office a stamp of the letters CD, which he has declared to be his ordinary brand for the purposes intended by law.

Certified on the date aforesaid

=Francis M. Guyol

Fire Brands Book One, pages 2 & 3

A.º 1825
February the 5.th
N.º 5.
Jean B.te
Duplanti

This fifth day of February in the forty ninth year of the independence of the United States of America (A.º D.ni =1825) before me Leufroy Barras Judge for the Parish of Terrebonne personally appeared J. B.te Duplanty of this Parish who deposited in my office a Stamp of the figure and form of **JD** which he has declared to be his ordinary brand for the purposes intended by law.—

Certified on the date aforesaid

Leufroy Barras Parish Judge

JD

No. 5:
Jean Baptiste Duplanti

A.º 1825
Antoine
Baye
N.º 6.

This thirtieth day of March A.º D.ni 1825 before me Leufroy Barras Judge for the Parish of Terrebonne personally appeared Antoine Baye of this Parish who deposited in my office a Stamp of the figure and form of **AB** which he has declared to be his ordinary brand for the purposes intended by law.—

Certified on the date aforesaid

Leufroy Barras
Judge

AB

No. 6:
Antoine Baye

Marie
Reine
Chatanier
N.º 7

This thirtieth day of March A.º D.ni 1825 before me Leufroy Barras Judge for the Parish of Terrebonne personally appeared Marie Reine Chatanier of this Parish who deposited in my office a Stamp of the figure and form of **RC** which she has declared to be her ordinary brand for the purposes intended by law.—

Certified on the date aforesaid

Leufroy Barras Judge
for the Parish of
Terrebonne

RC

No. 7:
Marie Reine Chatanier

J. Jacques
Leboeuf
N.º 8.

This first day of April A.º D.ni 1825 before me Judge for the Parish of Terrebonne personally

JJL

No. 8:
J. Jacques Leboeuf

Jacques Leboeuf of this Parish who deposited in my office a stamp of the letters **JJL** which he has declared to be his ordinary brand for the purposes intended by law.

Certified on the date aforesaid

Leufroy Barras
Parish Judge

R

No. 9:
Renaud Boudreaux

Renaud Boudrau – N° 9 –

Removed from the State –

This second day of April A° D'ni 1825 before me Leufroy Barras Judge for the Parish of Terrebonne personally appeared Renaud Boudrau who has deposited in my office a stamp of the letter **R** which he declared to be his ordinary Brand for the purpose intended by law. —

Certify on the date aforesaid.

Leufroy Barras
Parish Judge

H 3

No. 10:
Guillaume Celestin Henry

Guillaume Celestin Henry. N° 10

This second day of april A° D'ni 1825 before me Leufroy Barras Judge for the Parish of Terrebonne personally appeared Guillaume C° Henry who deposited in my office a stamp of the letter and figure **H 3** which he has declared to be his ordinary Brand for the purpose intended by law. —————

Certified on the date aforesaid.

Leufroy Barras Judge
of the Parish of Terreb.

Ʊ

No. 11:
Mrs. Joseph Boudreaux

Widow Joseph Boudreau N° 11

Pelegrin Boudrot Transfered from Widow Boudrot 16th —

This fourth day of April A° D'ni 1825 before me Leufroy Barras Judge for the Parish of Terrebonne personally appeared Widow Joseph Boudrau who deposited in my office a stamp of the figure **Ʊ** which she declares to be her ordinary Brand for the purpose intended by law.

Certified on the date aforesaid.

The said Brand this 9th March transfered to Pelegrin Boudrot by said Widow Boudrot

Leufroy Barras

Leandre B. Thibodaux No. 12.

This fourth day of April (A.D. 1825) before me Leufroy Barras Judge for the Parish of Terrebonne personally appeared Leandre B. Thibodaux who deposited in my office a stamp of the figure T1 which he declared to be his ordinary Brand for the purpose intended by Law.

Certified on the date aforesaid.
Leufroy Barras

Henry M. Thibodaux No. 13.-

This twelfth day of April (A.D. 1825) before me Leufroy Barras Judge for the Parish of Terrebonne personally appeared Henry M. Thibodaux who declared those figures T4 to be his ordinary Stamp or Brand for the purpose intended by law.

Certified on the date aforesaid
Leufroy Barras

H S Thibodaux No. 14
HT

This twelfth day of April A.D. 1825 before me Leufroy Judge for the Parish of Terrebonne personally appeared Henry S Thibodaux, who deposited in my office a stamp of the figure HT which he declared to be his ordinary Brand for the purpose intended by law.

Certified on the date aforesaid.
Leufroy Barras

C. Thibodaux No. 15.
T7

This twelfth day of April (A.D. 1825) before me Leufroy Barras Judge for the Parish of Terrebonne personally appeared Claiborne Thibodaux who deposited in my office a stamp of the figure T7 which he declared to be his ordinary Brand for the purpose intended by law.

Leufroy Barras

No. 13: Henry M. Thibodaux

No. 16: Bannon Goforth Thibodaux

TT

B. G.
Thibodaux
No. 16

TT

This twelfth day of April (A.D. 1825) before me Leufroy Barras Judge for the Parish of Terrebonne personally appeared, Bannon Goforth Thibodaux who deposited a stamp of the figure TT. which he declared to be his ordinary Brand for the purpose intended by law.

Leufroy Barras

No. 17: Elmire Thibodaux

T6

Elmire
Thibodaux
No. 17

T6

This twelfth day of April (A.D. 1825) before Leufroy Barras Judge for the Parish of Terrebonne personally appeared Elmire Thibodaux who deposited a stamp of the figure T6. which she declared to be his ordinary Brand for the purpose intended by law.

Leufroy Barras

No. 18: François Malborough

FM

François
Malborough
No. 18

FM

This twelfth day of April A.D. 1825 before me Leufroy Barras Judge for the Parish of Terrebonne personally appeared François Malborough who deposited in my office a stamp of the letters FM which he declared to be his ordinary Brand for the purposes intended by law.

Leufroy Barras

No. 19: Magdelaine Malborough

IG

Magdelaine
Malborough
Vve. ph. Leblanc
No. 19

IG

This 20th day of April A.D. 1825 before me Leufroy Barras Judge for the Parish of Terrebonne personally appeared Magdelaine Malborough widow of Charles Leblanc who deposited in my office a stamp of the figure IG which she declared to be her ordinary Brand for the purpose intended by law.

Leufroy Barras

Transféré la présente Estampe à Jn. Bte. Robichaux le 6 avril 1836.

Pierre
M.
Daigle
No. 20

MD

This ninth day of Jun A.D. 1825 before me Leufroy Barras Judge for the Parish of Terrebonne personally appeared Pierre Michel Daigle who deposited a stamp in my office of the letters MD which he declared to be his ordinary brand for the purpose intended by law.

Leufroy Barras

Jacques
Verret
No. 21

JV

This tenth day of Jun A.D. 1825 before me Leufroy Barras Judge for the Parish of Terrebonne personally appeared Jacques Verret who deposited a stamp in my office of the figure JV which he declared to be his ordinary brand for the purpose intended by law.

Leufroy Barras

Eugenie
Thibodaux
No. 22

T3.

This tenth day of Jun A.D. 1825 before me Leufroy Barras Judge for the Parish of Terrebonne personally appeared Eugenie Thibodaux wife of J. J. Bourgeois who deposited a stamp in my office of the figure T3 which she declared to be her ordinary Brand for the purpose intended by law.

Leufroy Barras

Auguste
Roger
No. 23

This fifteenth day of August A.D. 1825 before me Leufroy Barras Judge for the Parish of Terrebonne personally appeared Auguste Roger an inhabitant of the Parish of Lafourche interior who deposited in my office a stamp of the figure ♡ which he declared to be his ordinary Brand for the purpose intended by law.

Leufroy Barras

No. 24: J. Guillaume Malborough

Guillaume Malborough
N° 24

This eighteenth day of August A.D. 1825 before me Leufroy Barras Judge for the Parish of Terrebonne personally appeared J. Guillaume Malborough who deposited a stamp of figure GM which he declared to be his ordinary brand for the purposes intended by law.

Leufroy Barras

No. 25: Brigite Guerin Thibodaux

Mme François Thibodaux
N° 25

This eighteenth day of August A.D. 1825 before me Leufroy Barras Judge for the Parish of Terrebonne personally appeared Brigite Guerin wife of François Thibodaux who deposited a stamp of the figure BT which she declared to be her ordinary brand for the purposes intended by law

Leufroy Barras

No. 26: François Maronge

François Maronge
N° 26

This eighteenth day of September A.D. 1825 before me Leufroy Barras judge for the Parish of Terrebonne personally appeared François Maronge who deposited in my office a stamp of the figure herein the margin which he declared to be his brand for the purposes intended by law

Leufroy Barras

No. 27: Aubin Thibodaux

Aubin Thibodaux
N° 27

This 24th day of September A.D. 1825 before me Leufroy Barras judge for the Parish of Terrebonne personally appeared Aubin Thibodaux of the Parish of Lafourche Interior who deposited in my office a stamp of the figure herein the margin which he declared to be his brand for the purpose intended by law.

Leufroy Barras

J. Bte Bergeron
No. 28.
BB

This twenty first day of November 1825 before me L. Barras Judge for the Parish of Terrebonne personally appeared Jn Bte Bergeron who deposited in my office a stamp the figure of which is in the margin which he declared to be his ordinary brand for the purposes intended by law.—

Leufroy Barras

Widow Crochet
No. 29.
MB

This twenty first day of November 1825 before L. Barras Judge for the Parish of Terrebonne personally appeared Widow of Julien Crochet who deposited in my office a stamp the figure of which is herein the margin which she declared to be her ordinary brand for the purposes intended by law

Leufroy Barras

John Roddy
No. 30.
JR

This twenty first day of November 1825 before me L. Barras Judge for the Parish of Terrebonne personally appeared John Roddy who deposited in my office a stamp the figure of which is herein the margin which he declared to be his ordinary brand for the purposes intended by law.—

Leufroy Barras

Jean Comau
No. 31.
MC

This twenty first day of November 1825 before me L. Barras Judge for the Parish of Terrebonne personally appeared Jean comau who deposited in my office a stamp the figure of which is herein the margin which he declared to be his ordinary brand.—

Leufroy Barras

No. 32: Marcelin Bergeron

Marcelin Bergeron
N° 32

This twenty second day of November 1825 before me Leufroy Barras Judge for the Parish of Lafourche personally appeared Marcelin Bergeron who deposited in my office a stamp in my office the figure of which is in the margin which he declared to be his ordinary brand for the purposes intended by law.

Leufroy Barras

No. 33: Jean Baptiste Beausergent

J. B.
Beausergent
N° 33
Trempé à Plaidre
Guidry le
10 Oct.
1895

This sixth day of January 1826 before me Leufroy Barras Judge for the Parish of Terrebonne personally appeared Jean baptiste Beausergent who declared that the Brand herein the margin was his ordinary stamp for the purposes intended by law

Leufroy Barras

No. 34: Pierre Bourque

P^{re}
Bourque
N° 34

Le 27me jour du mois de Février 1826 pardevant moi fut présent Charles Dupré qui a déposé une étampe de la figure ici en marge qu'il a déclaré être celle de Pierre Bourque

Leufroy Barras

No. 35: Mathurin Fortune Dupré

Mathurin
Fortuné
Dupré
N° 35

Le 27me jour du mois de Février 1826 pardevant moi fut présent Charles Dupré qui a déposé une étampe de la figure ici en marge laquelle il a déclaré être celle de Mathurin fortune Dupré

Leufroy Barras

Joseph
Boudrot
No 36
J8

Le 27ᵐᵉ jour du mois de Fevrier 1826 pardevant moi fut présent Joseph Boudrot qui m'a déposé une étampe [illegible] il a déclaré être la sienne [illegible] figure ici en marge.

Leufroy Barras

Isidore
Boudrot
No 37
YB

Le 27ᵐᵉ jour du mois de Fevrier 1826 pardevant moi soussigné fut present Isidore Boudrot Lequel m'a déposé une Etampe de la forme et figure comme en marge et laquelle il a déclaré être la Sienne.

(Transféré à Mr. C. I. Dupré.)

Leufroy Barras

Alexandre
Dupré
No 38
A

Sold and transferred to Jerrod Adams 9ᵗʰ May 1865

Le [illegible] du mois de Mars 1826. pardevant moi soussigné fut present Alexandre Dupré qui a déposé une Etampe de la forme et figure comme en marge laquelle il a déclaré être la sienne pour l'usage ordinaire.

Leufroy Barras

Pierre
Billot
No 39
PB

Le 23 du mois Mars 1826 pardevant moi soussigne fut present Pierre Billot qui a déposé une Etampe de la forme et figure comme en marge laquelle il a déclaré être sa marque pour l'usage ordinaire.

Leufroy [Barras]

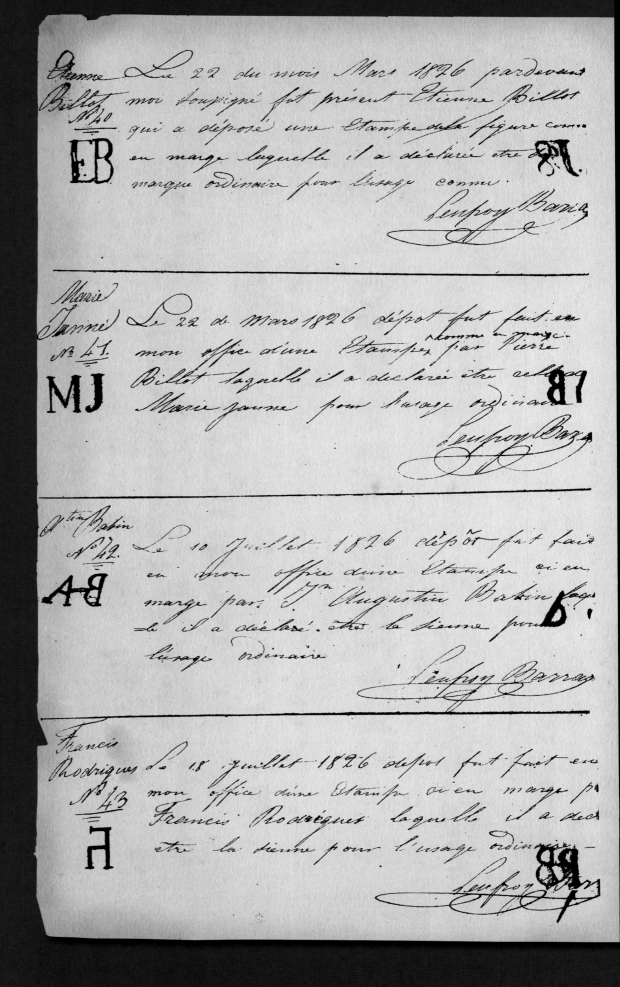

Joseph Benoit
N° 44

Le 18 juillet 1826. dépôt fut fait en mon office d'une Étampe, ci en marge, par Joseph Benoit laquelle il a déclaré être la sienne pour l'usage ordinaire — transféré à J. Bte Guydri le 26 mai 1828.

Leufroy Barras

Philippe Melancon
N° 45

Le 18 juillet 1826. dépôt fut fait en mon office d'une Étampe ci en marge par Philippe Melancon laquelle il a déclaré être la sienne pour l'usage ordinaire.

Leufroy Barras

Delaporte N° 46 / Marguerite Barret

Le 18 juillet 1826. dépôt fut fait en mon office d'une Étampe comme en marge par Jn Delaporte laquelle il a déclaré être la sienne pour l'usage ordinaire. Le 25 mars 1827 ladite Étampe transportée à Marguerite Barret.

Leufroy Barras

Mme Sebastien Tivet N° 47

Le 8 Août 1826 dépôt fut fait en mon office d'une Étampe ci en marge par Mme Sebastien Tivet laquelle elle déclare être la sienne pour l'usage ordinaire. —

Leufroy Barras

Jn Charles Naquin N° 48

Le 8 Août 1826 dépôt fut fait en mon office d'une Étampe ci en marge par Jn Charles Naquin laquelle est la sienne. —

Leufroy Barras

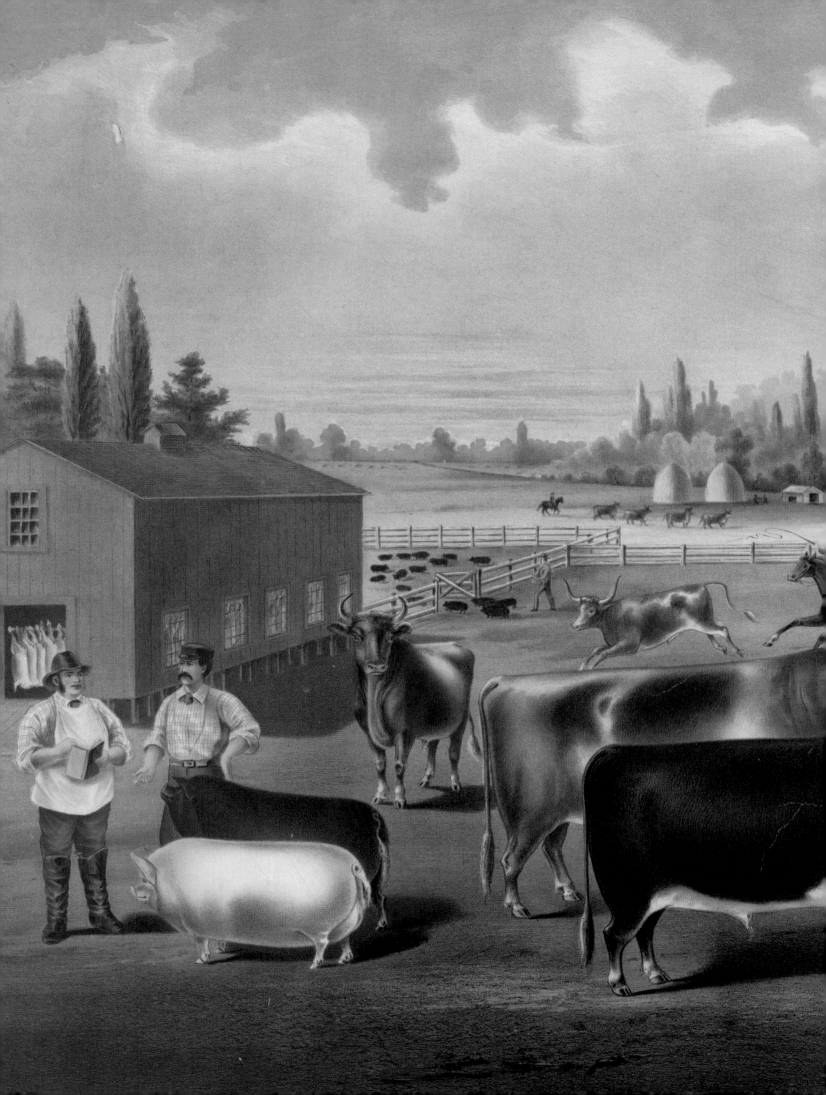

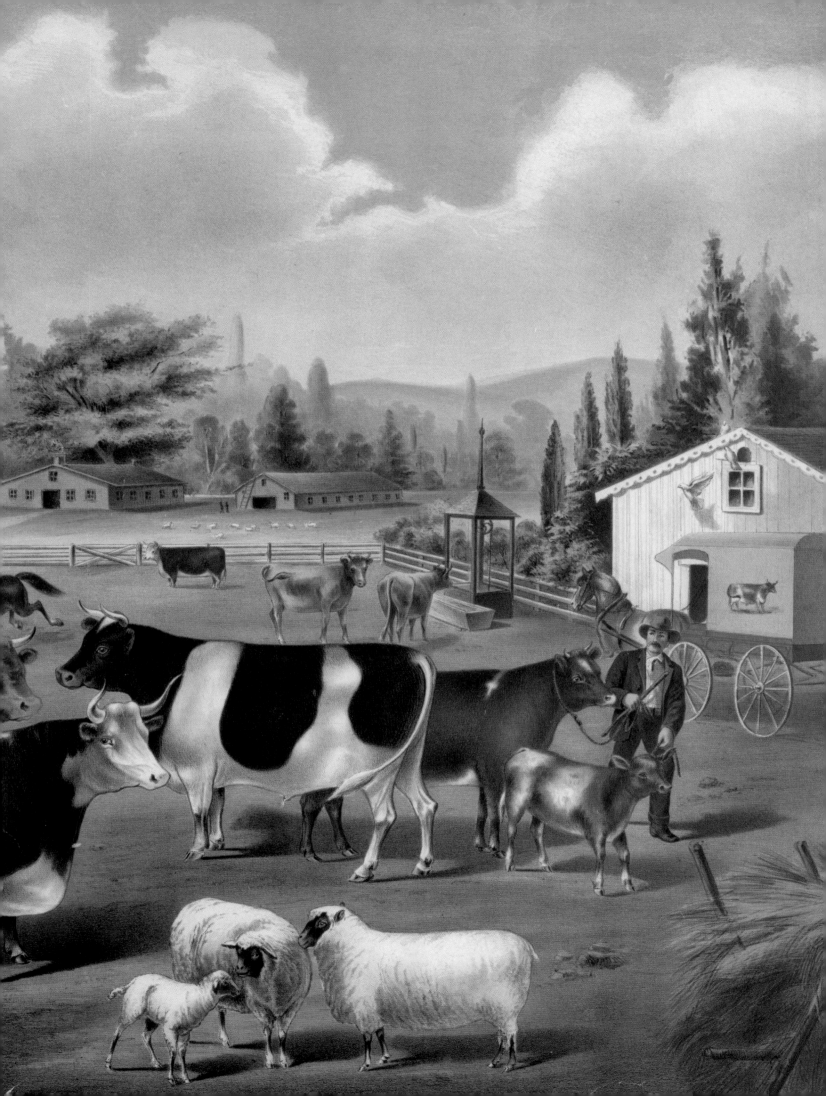

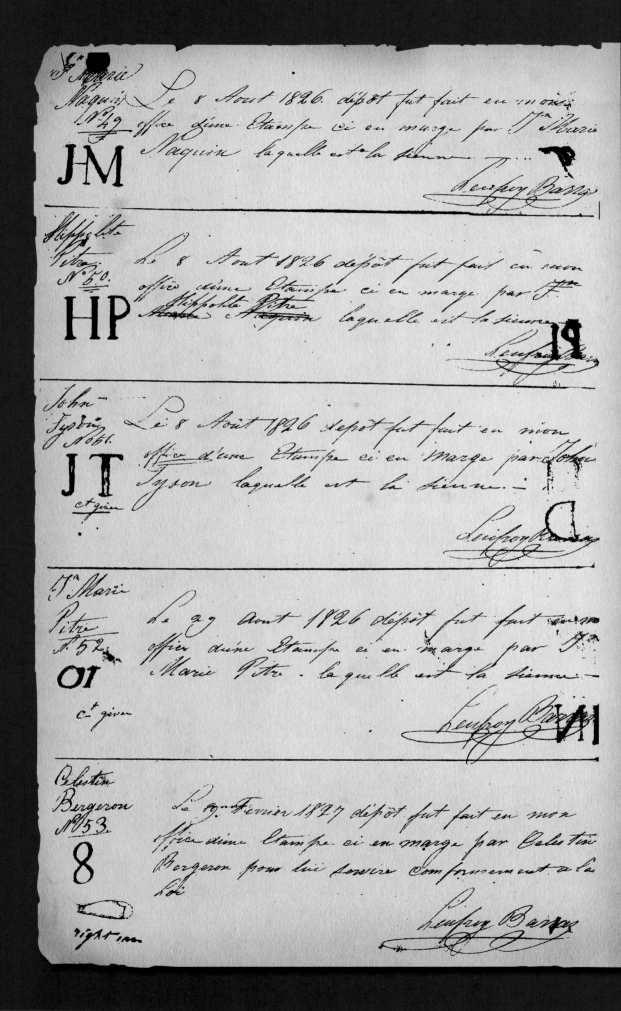

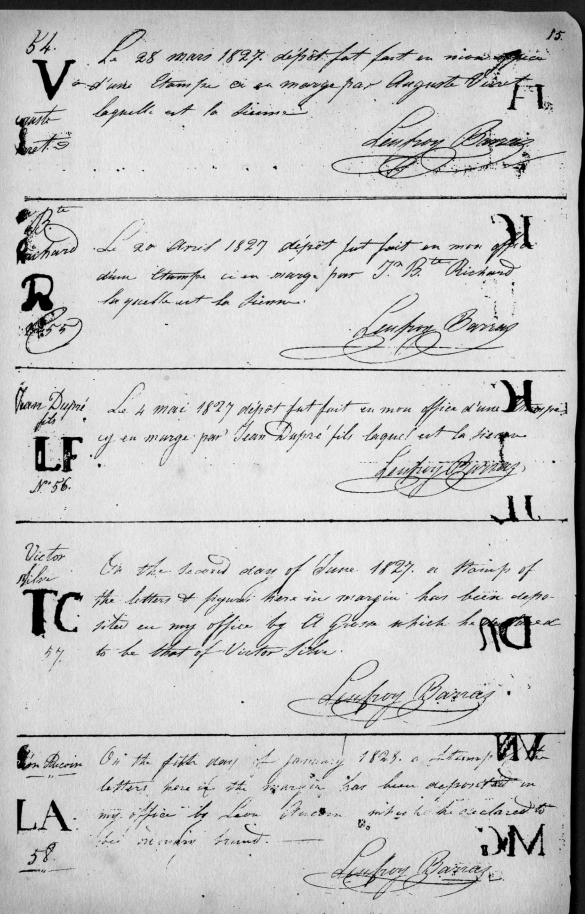

54.
V
Auguste
Verret

Le 28 mars 1827. dépôt fut fait en mon office d'une Étampe cy en marge par Auguste Verret laquelle est la sienne.

Linfroy Barras

J^te B^te
Richard
R
N° 55.

Le 20 Avril 1827 dépôt fut fait en mon office d'une Étampe cy en marge par J^n B^te Richard la quelle est la sienne.

Linfroy Barras

Jean Dupré
fils
LF
N° 56.

Le 4 mai 1827 dépôt fut fait en mon office d'une Étampe cy en marge par Jean Dupré fils laquel est la sienne.

Linfroy Barras

Victor
Silvi
TC
57.

On the second day of June 1827. a Stamp of the letters & figures here in margin has been deposited in my office by A Green which he declared to be that of Victor Silvi.

Linfroy Barras

Léon Aucoin
LA.
58

On the fifth day of January 1828. a Stamp of the letters here in the margin has been deposited in my office by Leon Aucoin which he declared to be his own brand.

Linfroy Barras

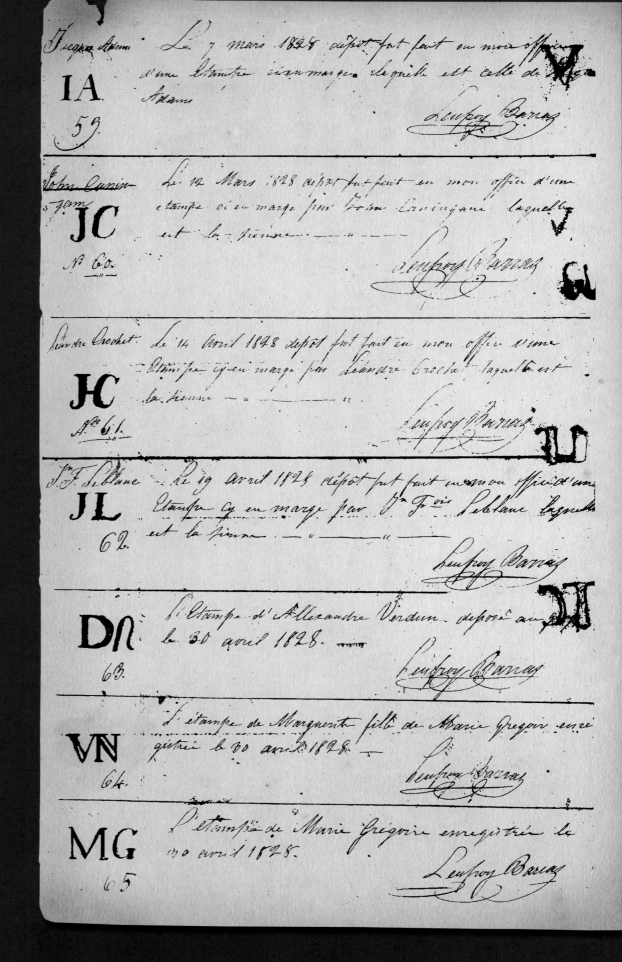

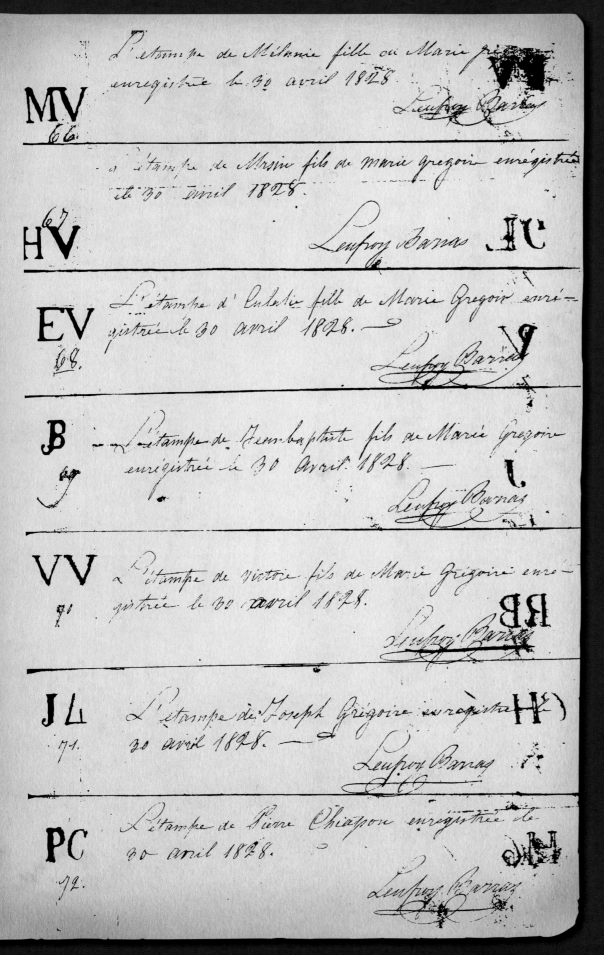

MV
No. 66: Mélanie (Verdin) Gregoire

HV
No. 67: Ursin (Verdin) Gregoire

EV
No. 68: Eulalie (Verdin) Gregoire

JB
No. 69: Jean Baptiste (Verdin) Gregoire

VV
No. 70: Victor (Verdin) Gregoire

JL
No. 71: Joseph Gregoire

PC
No. 72: Pierre Chiasson

PV

No. 73:
Pauline (Verdin) Gregoire

JL

No. 74:
Pierre Gracien LeBlanc

V

No. 75:
Pierre Verret

J

No. 76:
Jean Charles Bergeron

RB

No. 77:
Rosette Billiot

CH

No. 78:
Jean Baptiste Henry Jr.

⊎6

No. 79:
Jean Baptiste Theodore Henry

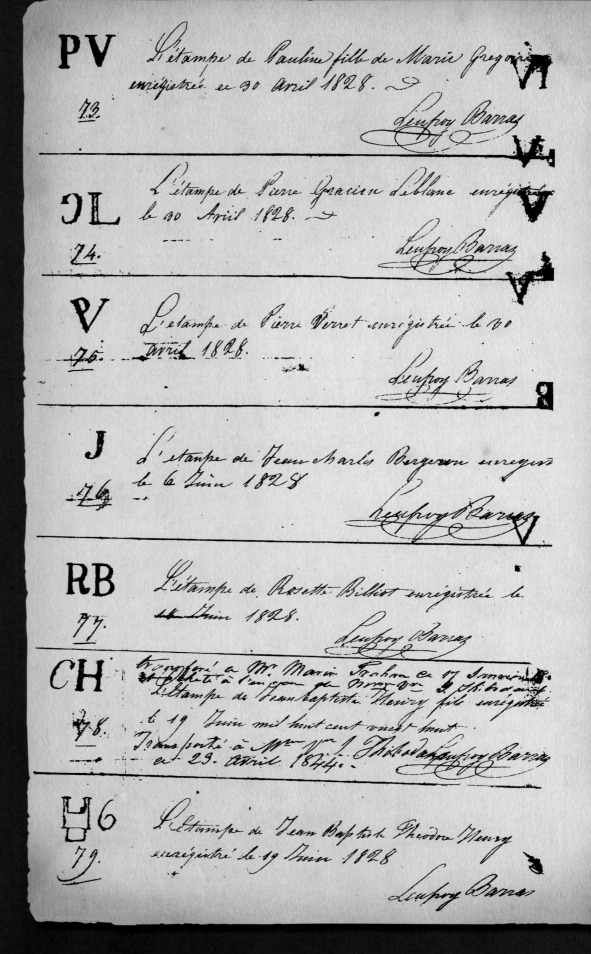

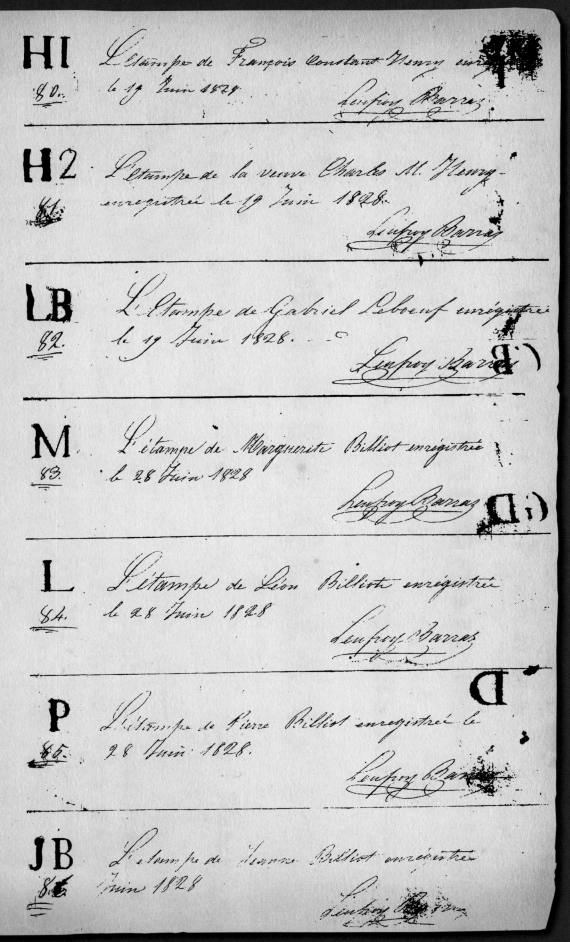

H1 — **No. 80:** François Constant Henry
L'étampe de François Constant Henry enregistrée le 19 Juin 1828.
Lenfroy Barras

H2 — **No. 81:** Mrs. Charles M. Henry
L'étampe de la veuve Charles M. Henry enregistrée le 19 Juin 1828.
Lenfroy Barras

LB — **No. 82:** Gabriel Leboeuf
L'étampe de Gabriel Leboeuf enregistrée le 19 Juin 1828.
Lenfroy Barras

M — **No. 83:** Marguerite Billiot
L'étampe de Marguerite Billiot enregistrée le 28 Juin 1828.
Lenfroy Barras

L — **No. 84:** Leon Billiot
L'étampe de Léon Billiot enregistrée le 28 Juin 1828.
Lenfroy Barras

P — **No. 85:** Pierre Billiot
L'étampe de Pierre Billiot enregistrée le 28 Juin 1828.
Lenfroy Barras

JB — **No. 86:** Jeanne Billiot
L'étampe de Jeanne Billiot enregistrée Juin 1828.
Lenfroy Barras

No. 87: Etienne Billiot

E 87. L'etampe d'Etienne Billiot enregistrée le 28 Juin 1828. — Lenfroy Barras

No. 88: Joseph Milhomme

JC 88. L'etampe de Joseph Milhomme enregistrée le 16 Aout 1828. Lenfroy Barras

No. 89: Charles Bourque

Transferé —
CB 89. L'etampe de Charles Bourque enregistrée le 16 Aout 1828. Transféré à Jacinth Bourg 29 Decembre 1836. — Lenfroy Barras

No. 90: Gérome Dupré

GD 90. L'etampe de Gérome Dupré enregistrée le 22 Septembre 1828. Lenfroy Barras

No. 91: Adolphe Verret

D 91. L'etampe d'Adolphe Verret enregistrée le 4 Octobre 1828. — Lenfroy Barras

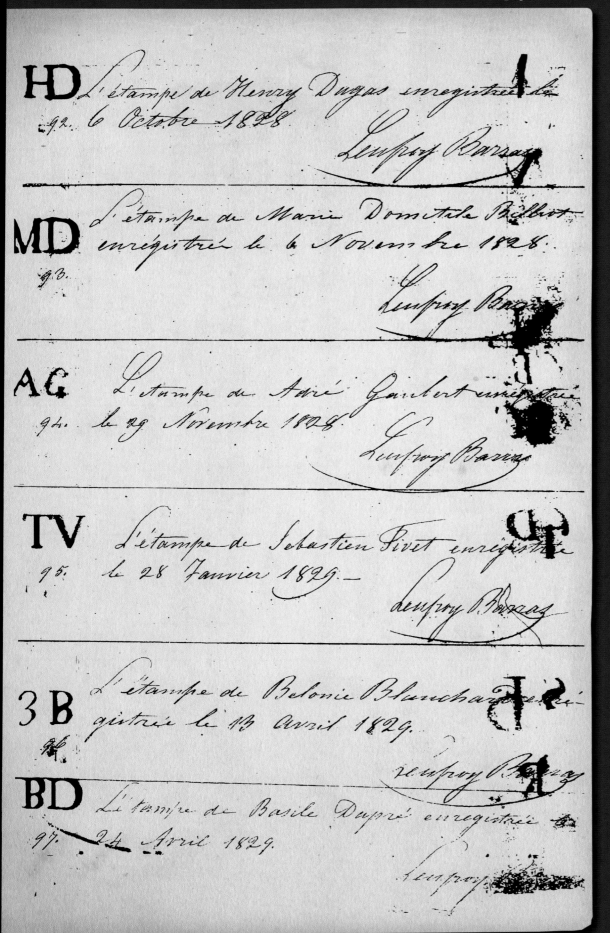

No. 92: Henry Dugas

No. 93: Marie Domitile Billiot

No. 94: André Gaubert

No. 95: Sebastien Tivet

No. 96: Belonie Blanchard

No. 97: Basile Dupré

LIVESTOCK BRANDS AND MARKS

No. 98: Hippolite Naquin — HN

No. 99: William Ashly — W

No. 100: Mrs. Nicholas Lirette — N

No. 101: Pierre Bergeron — BC

No. 102: Leufroy Barras — T5

No. 103: Stanislas Fontenot — SF

No. 104: Jean Robichaux — JR

HN 98. L'étampe de Hippolite Naquin enregistrée le 24 Avril 1829.

W 99. L'étampe de William Ashly enregistrée le 27 Avril 1829. — gone out of the Parish

N 100. L'étampe de Mde Vve Nicolas Lirette enregistrée le 6 Juin 1829.

BC 101. L'étampe de Pierre Bergeron enregistrée le 23 Juin 1829.

T5 102. L'étampe de Leufroy Barras enregistrée le 23 Juin 1829.

SF 103. L'étampe de Stanislas Fontenot enregistrée le 23 juin 1829.

JR 104. L'étampe de Jean Robicho enregistrée le 2 de Juillet 1829.

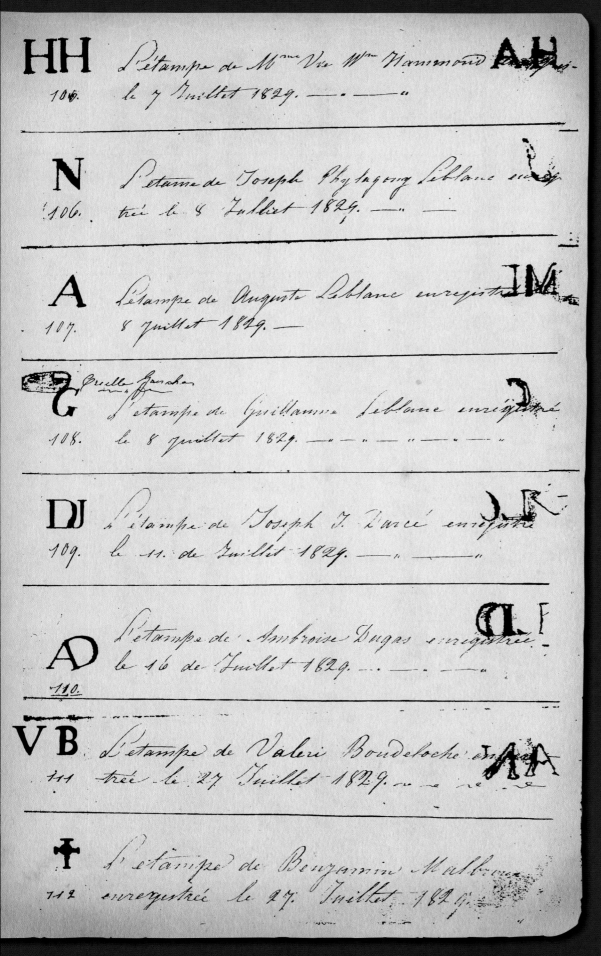

No. 105: Mrs. William Hammond

No. 106: Joseph Phylagony Leblanc

No. 107: Auguste Leblanc

No. 108: Guillaume Leblanc

No. 109: Joseph J. Darcé

No. 110: Ambroise Dugas

No. 111: Valeri Boudeloche

No. 112: Benjamin Malbrough

Brand	No.	Name
HA	No. 113	Huberville Arsenaux
J	No. 114	Antoine Malbrough
ML	No. 115	Mathurin Daigle
C	No. 116	Celestin Baptiste Bergeron
TLC	No. 117	Jean Baptiste Hebert
LD	No. 118	Ludevine, *Free woman of color*
AN	No. 119	Adrien Naquin

HA 113 — L'étampe d' Huberville Arsenaux enregistrée le 14 Septembre 1829.

J 114 — L'étampe d' Antoine Malbrough le 7 Octobre 1829.

ML 115 — L'étampe de Mathurin Daigle enregistrée le 17 Octobre 1829.

C 116 — L'étampe de Celestin Baptiste Bergeron enregistrée le 26 Decembre 1829.

TLC 117 — L'étampe de Jean Baptiste Hebert enregistrée le 26 Decembre 1829.

LD 118 — L'étampe de Ludevine femme de Couleur libre enregistrée le 25 Janvier 1830.

AN 119 — L'étampe d' Adrien Naquin enregistrée le 25 Fevrier 1830.

LIVESTOCK BRANDS AND MARKS

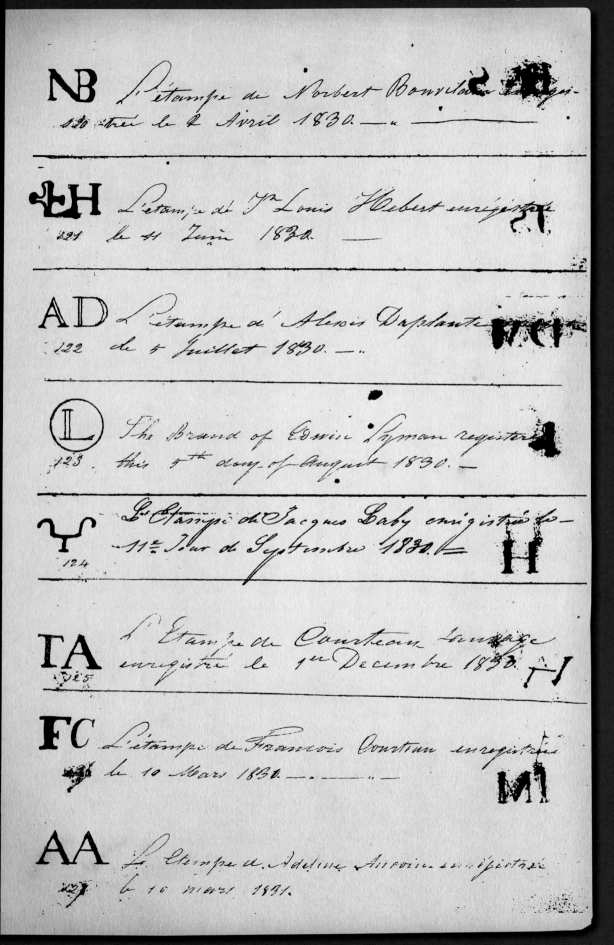

Brand	Registrant
NB	**No. 120:** Norbert Bonvillain
⌘H	**No. 121:** Jean Louis Hebert
AD	**No. 122:** Alexis Duplanti
Ⓛ	**No. 123:** Edwin Lyman
⋔	**No. 124:** Jacques Labit
ΓA	**No. 125:** Courteau *Indian*
FC	**No. 126:** François Courteau
AA	**No. 127:** Adeline Aucoin

Brand	No.	Owner	Entry
B&S	128	Bisland & Shields	The Brand of Bisland & Shields recorded this 2d day of April 1831.
JS	129	Joseph Leblanc Jr.	L'Etampe de Joseph Leblanc fils enrégistrée le 30 Avril 1831.
DM	130	Damien Martin	L'Etampe de Damien Martin enrégistrée le 30 Avril 1831.
F	131	Joseph Duplanti	L'Etampe de Joseph Duplanti enrégistrée le 26 mai 1831.
H	132	Jean Napoleon Leblanc	L'Etampe de Jean Napoleon Leblanc enrégistrée le 17 de Juin 1831.
W	133	Caleb B. Watkins	The Brand of Caleb B. Watkins registered this 16th day of July 1831.
IM	134	Jean Martin Leblanc	L'Etampe de Jean Martin Leblanc enrégistrée le 1 Aout 1831. Transferé ladite Etampe à Ambroise Jn. M. Leblanc le Juillet 1836 par les héritiers de Jn. M. Leblanc. Transférée à Michel N. Leblanc le 15 Avr. 1840.

JP
135 — L'Etampe de Joachim Porche enregistrée 21 Août 1831.

⊃C
136 — The brand of Isaac Corbit recorded this 5th November 1831.

HC
137 — L'Etampe d'Hyppolite Chatanier enregistrée le 16 Décembre 1831.

LP
138 — L'Etampe de Louis Pitre enregistrée le 21 Janvier 1832.

VC
139 — L'Etampe de Valentin Sevin enregistrée le 4 de mars 1832. Cette Etampe vendue à Jph Marcelin Landry par acte sous seing privé.

PS
140 — The brand of P. M. Sargent recorded this 24th day of March 1832.

RRB
141 — The brand & mark of Robert R. Barrow recorded this 30th of March 1832.

HL
No. 142:
Henry Lirette

HL L'Etampe d'Henry Lirette enregistrée
142 le 4 Avril 1832.

D
No. 143:
Joseph Daigle Jr.

D L'Etampe de Joseph Daigle fils de Jre
143 Daigle enregistrée ce 11 Avril 1832

VW
No. 144:
Van Winder

VW The brand & mark of Van Winder recorded
144 this 17th day of May 1832.

WC
No. 145:
Walker & Clifton

WC The brand & mark of Walker & Clifton
right ear recorded this 21st May 1832
145

FB
No. 146:
Frasie Billiot

FB L'Etampe de Frasie femme d'Etienne Billiot
146 enregistrée le 26 Mai 1832

O
No. 147:
Pierre Brunet

O L'Etampe de Pierre Brunet enregistrée le
147 23 Juin 1832.

LV
No. 148:
Louis Verret

LV L'Etampe de Louis Verret enregistrée
148 le 26 Juin 1832.

AP L'Etampe d'Adolphe Pelegrin enregistrée le
149 29. Juin 1832.

FB L'Etampe de François Babin enregistrée
150 10 de Juillet 1832. transféré à Maximien
Babin ce 17 Juillet 1840. — par ordre de ...

FN L'Etampe de François Naquin
151 enregistrée le 3 Août 1832

FL L'Etampe de Felonise Naquin
152 enregistrée le 3 Août 1832.

LP L'Etampe de Laurent Pelegrin enregis-
153 -trée le 1er Septembre 1832.

SL L'etampe de Saturnin Levron enre-
154 -gistrée le 6 Decembre 1832.

TD L'étampe de Théotisse Dugas enre-
155 -gistrée le 18 Decembre 1832.

FD L'etampe de Francisco Domingo enre-
156 -gistrée le 15 Janvier 1833. —

1830 TERREBONNE PARISH CENSUS

The Fanguy (Fanguille) name was one of only 167 family names listed in the 1830 parish census. Of those, seven households bore the same surname, the most numerous in repetition. Family names were: Adams, Albararo, Arsineaux, Arseneaux, Ashley, Aucoin, Babin, Baille, Barras, Bastane, Batey, Barrow, Boudoin, Belanger, Belangier, Benjamin, Benois, Berjean, Bergeon, Bell, Billeaux, Blanchard, Bonvillien, Boudreaux, Boudloche, Bourgue, Brasowell, Brunet, Buford, Burrett, Butler, Calotte, Casson, Calvey, Carl, Carr, Chambers, Charpentier, Chataignier, Chaisson, Clark, Clifton, Cazeau, Collette, Comeajain, Comos, Collinsworth, Crochet, Daigle, Dazy, Darses, Davis, Dubois, Dugas, Duplanty, Dupre, Eaken, Ecliff, Ellis, Fanguille, Field, Fontineaux, Foster, Fuqua, Gans, Gautier, Garey, Gautreaux, Gauber, Gibson, Goodwin, Green, Gregoire, Greenage, Guidery, Hauk, Hammond, Haynes, Hebert, Henry, Hinar, Holdman, Hunter, Imelle, Keys, King, Laby, Laflin, Lancon, LeBlanc, LeBouef, Lejeune, Lum, Lambert, Lapeiruse, Leday, Leroux, Lirette, Lyman, Maiseille, Marlborough, Malbrough, Maronde, Marone, Marrow, Martin, Mars, Mead, Medrano, Miller, Millehomme, Mellor, Moncon, Monier, Montogudean, Moore, Moreau, McCoy, McLaughlin, McWilliams, Naquin, Osbern, Payne, Phipps, Pichauf, Picou, Pitre, Porche, Porter, Ratcliff, Ready, Richard, Robichaud, Roddy, Rodrigues, Richardson, Rountree, Rousseau, Sathens, Savoy, Shelden, Shield, Signe, Squeyers (Squires?), Sterit, Tyvet, Tabour, Tanner, Thibodeaux, Tirguy, Toups, Torrero, Tulaire, Tyson, Veret, Verdin, Vannoman, Wade, Waggoner, Wakbespask (Waguespack), Watson, Watkins, Welsh, Westbrook, Wood, Wright. List is from Sherwin Guidry's Explorin' Terrebonne, a collection of newspaper articles by Mr. Guidry.

Another source, the publication "Pioneers" edited by Phoebe Chauvin Morrison in 1984, gives the following statistics for 1830: 237 household heads listed; population of 1,063 whites, 25 free Negroes and 1,033 slaves, for a total of 2,121. Number of families by origin: 74 Acadian French; 74 American; 29 French (apart from Acadian and Canadian); 19 German; 18 Canadian French; 8 Irish; 4 Spanish; 4 Indian; 3 English; 2 Scots; 1 Swedish; 1 Canary Islands family.

Edmond Fanguy's brand is this book cover's image because of his relationship to the writers of this volume. Mr. Fanguy is the great-great-great-grandfather of both Dr. Cenac and his collaborator Mrs. Joller, through two separate great-grandparent lineages—Dr. Cenac through Edmond's granddaughter Victorine Fanguy Cenac, daughter of Charles Fanguy, and Mrs. Joller through Victorine's brother William Fanguy, father to Elvire Fanguy Domangue.

Edmond Fanguy

Edmond Fanguy and his family were among the earliest French residents of Terrebonne Parish. The Fanguys' early arrival is evidenced in the fact that Fanguille families accounted for more households than any other surnames in the first census of Terrebonne Parish in 1830.

Edmond was the son of Vincent Fanguy, the first immigrant of his family from Montpellier, Languedoc, France. Vincent's father Antoine was a china maker (*fabricant de porcelaine*) in Montpellier, and his grandfather was a miller (*meunier*); they were of Basque lineage. Vincent married Marie Magdeleine Laporte of New Orleans.

Edmond was the couple's ninth, and youngest, child, born circa 1791. He married Heloise Falgout of St. Charles Parish on May 9, 1814 in Plattenville, northwest of Terrebonne in present-day Assumption Parish.

His name is recorded as having received a land grant on Bayou Terrebonne. Edmond's occupations were sailor, soldier, and farmer, the second of which may explain the grant. He probably served in the War of 1812, the only military conflict for which he would have been age appropriate; veterans of that war received grants of property from the federal government.

However Edmond acquired his land, his two sons Charles and Vincent in 1842, some years after Edmond's 1833 death, were recipients of a patent dated September 20, signed by U.S. President John Tyler. This was pursuant to an Act of Congress of April 24, 1820, making provisions to grant the sale of public land (in the spirit of the Swamp Act of 1804). After Louisiana became a state in 1812, the federal government legalized for the republic previous grants of public land to individuals, or sold land at a reasonable rate to patent holders. Charles and Edmond Fanguy, however, were given the land stipulated in the patent of 1842.

At some point his family moved from lower Bayou Terrebonne to Bayou Grand Caillou. He is listed on the paid parish tax list of 1831, and registered his cattle brand on March 7, 1833.

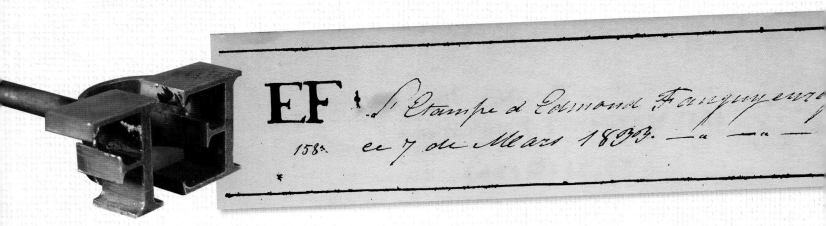

Opposite page, patent of Charles and Vincent Fanguy dated September 20, 1842

PF
No. 157:
Patterson Fletcher

PF The Brand of Patterson Fletcher recorded
157 this 22 February 1833

EF
No. 158:
Edmond Fanguy

EF L'Etampe d'Edmond Fanguy enregistrée
158 ce 7 de Mars 1833

M
No. 159:
Pierre Marcelin Bonvillain

M L'Etampe de Pierre Marcelin Bonvillain
159 enregistrée le 26 Mars 1833

PBR
No. 160:
Pierre B. Roussel

PBR L'Etampe de Pierre B. Roussel enregis-
160 trée le 20 Mai 1833

AL
No. 161:
Alexandre Lirette

AL L'Etampe d'Alexandre Lirette enregistrée
161 le 29 Juin 1833

P
No. 162:
Pierre Amand Lejeune

P L'étampe de Pre Amand Lejeune
162 enregistrée le 10 Juillet 1833

H
No. 163:
Firmin Blanchard

H L'Etampe de Firmin Blanchard
163 Enregistrée le 24 Aout 1833

FP
No. 164:
Fortune Pelegrin

FP L'Etampe de Fortuné Pelegrin enregistrée le 10
164 Septembre 1833

Brand	Description
EM No. 165	Etienne Malbrough
PUE No. 166	Pierre Urbain Engeron
M2 No. 167	Michel Billiot
EM No. 168	Euphroisine B. Magnon
CLD No. 169	Charles Lemichel DuRoy
PHD No. 170	Philippe H. Darcé
PI No. 171	Philerome Billiot
DD No. 172	Paulin Dardart
BP No. 173	Jean Baptiste Placide Dugas

No. 165: L'Etampe de Etienne Malbrough enregistrée le 6 Novembre 1833.

No. 166: L'Etampe de Pre Urbain Engeron enregistrée le 4 Mars 1834.

No. 167: L'Etampe de Michel Billiot enregistrée le 9 Avril 1834.

No. 168: L'étampe de Euphroisine B. Magnon enregistrée le 9 Avril 1834.

No. 169: L'Etampe de Charles Lemichel Du Roy enregistrée le 9 Avril 1834.

No. 170: L'étampe de Philippe H. Darcé enregistrée le 7 de mai 1834.

No. 171: L'Etampe de Philerome Billiot enregistrée le 30 mai 1834.

No. 172: L'Etampe de Paulin Dardart enregistrée le 23 Juillet 1834.

No. 173: L'Etampe de Jean Baptiste Placide Dugas enregistrée Le 31 Juillet 1834.

Brand	No.	Name	Entry
SL	174	Henri Surville Labit	L'Etampe de Henri Surville Labit enregistrée le 16 Août 1834.
Ab	175	Alexis Blanchard	L'Etampe d'Alexis Blanchard enregistrée ce 14 Sept. 1834.
BH	176	Bertelemi Henry	L'Etampe de Bertelemi Henri Enregistrée le 15 Octobre 1834. Transferred to Mad. Augustin Authement Sept. 3, 1870
LS	177	Severin Lapéruse	L'Etampe de Severin Lapéruse enregistrée le 15 Octobre 1834.
BH	178	Jean Baptiste Hebert	L'étampe de Jean Baptiste Hébert enregistrée le 22 Janvier 1835.
FI	179	Florentin Boudreaux	L'Etampe de Florentin Boudreaux enregistrée ce 8 Avril 1835.
UD	180	Usébe Dugas	L'Etampe d'Usébe Dugas enregistrée le 19 Mai 1835.

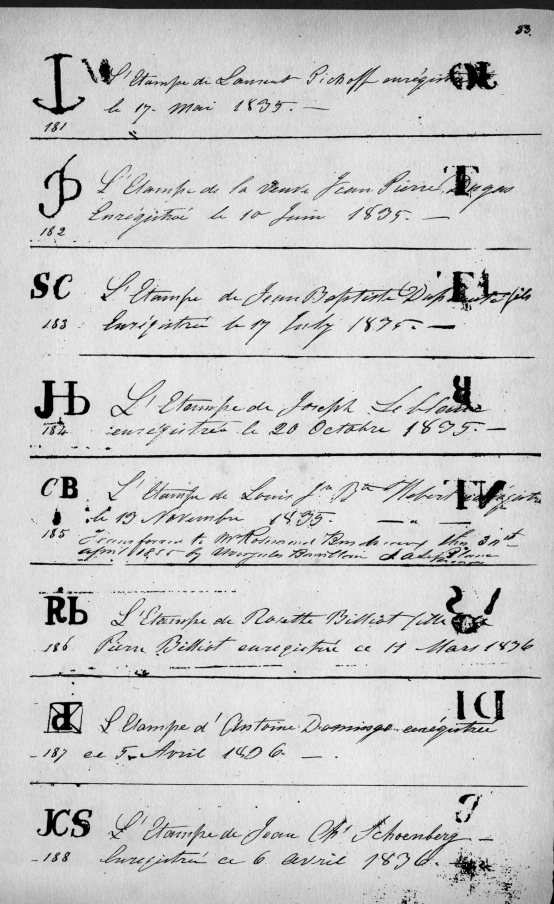

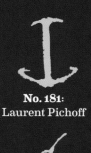

No. 181:
Laurent Pichoff

No. 182:
Mrs. Jean Pierre Dugas

No. 183:
Jean Baptiste Duplanti Jr.

No. 184:
Joseph Leblanc

No. 185:
Louis Jean Baptiste Hebert

No. 186:
Rosette Billiot

No. 187:
Antoine Domingo

No. 188:
Jean Charles Schoenberg

Brand	No.	Owner
JO	189	Pierre Thibodaux
T	190	Benjamin Thibodaux
ƒT	191	Leufroy Thibodaux
B	192	Jean Baptiste Bergeron
NT	193	Nicolas Thibodaux
VS	194	Valentin Sevin
DI	195	Jean Baptiste Babin Sr.
AB	196	Auguste Bourg

JO 189 L'étampe de Pierre Thibodaux enregistré le 8 aout 1836 — transferé à Morris Dumont Juillet 19th 1844.

T 190 L'étampe de Benjamin Thibodaux le 8 aout 1836.

ƒT 191 L'étampe de Leufroy Thibodaux le 8 aout 1836.

B 192 L'étampe de J.n B.te Bergeron le 9 Aout 1836.

NT 193 L'étampe de Nicolas Thibodaux enregistré le 10 Septembre 1836.

VS 194 L'étampe de Valentin Sevin enregistrée le 18 Octobre 1836.

DI 195 L'étampe de Jean Baptiste Babin le 18 Octobre 1836.

AB 196 L'étampe d'Auguste Bourg le 22 Octobre 1836.

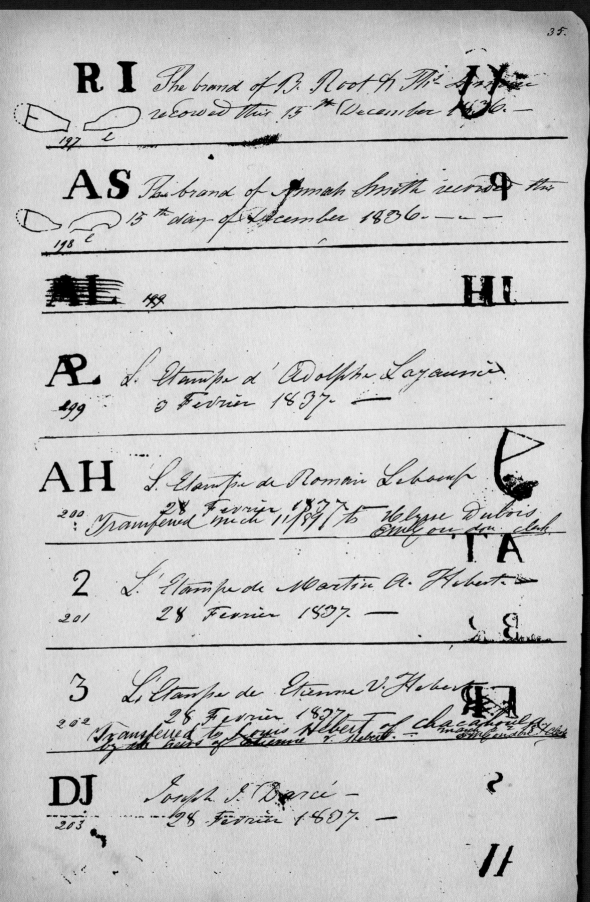

R I The brand of B. Root & Thos. Inman recorded this 15th December 1836.
197

A S The brand of Annah Smith recorded this 15th day of December 1836.
198

A L 199

AL L'Etampe d'Adolphe Lajaunie 3 Février 1837.
199

A H L'Etampe de Romain Leboeuf
200 Transferred March 11, 1897 to Ulysse Dubois Emly [?] dou club

2 L'Etampe de Martin A. Hebert
201 28 Février 1837.

3 L'Etampe de Etienne V. Hebert
202 28 Février 1837. Transferred to Louis Hebert of Chacahoula by the heirs of Etienne V. Hebert.

D J Joseph J. Darcé
203 28 Février 1837.

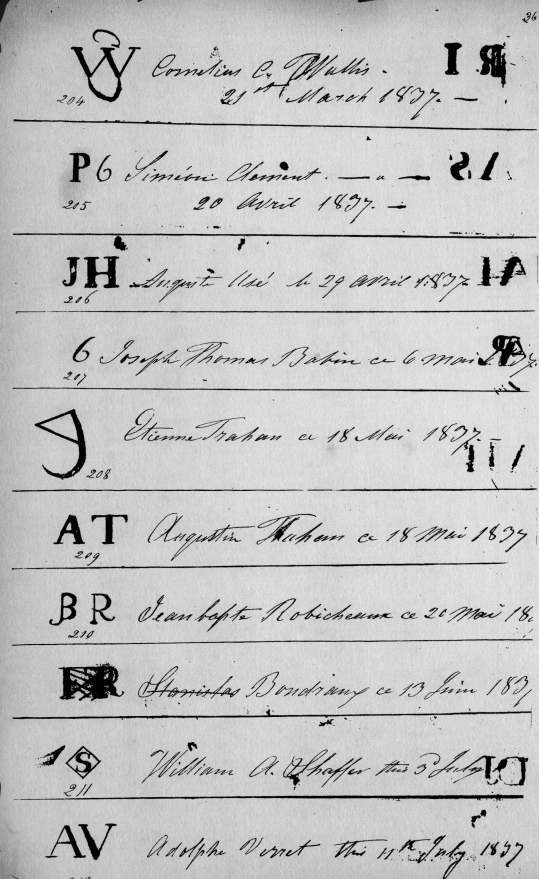

Livestock Brands and Marks

No. 204: Cornelius C. Wallis — 21st March 1837

No. 205: Siméon Clement — 20 Avril 1837

No. 206: Auguste Usé — le 29 avril 1837

No. 207: Joseph Thomas Babin — ce 6 Mai 1837

No. 208: Etienne Trahan — ce 18 Mai 1837

No. 209: Augustin Trahan — ce 18 Mai 1837

No. 210: Jean Baptiste Robicheaux — ce 20 Mai 1837

Deleted. See No. 215. — Staristes Boudreaux ce 13 Juin 1837

No. 211: William A. Shaffer — this 3 July 1837

No. 212: Adolphe Verret — this 11th July 1837

Fire Brands Book One, pages 36 & 37

Brand	Entry	No.	Name
C6	Pierre Charpentier ce 6 Août 1877	213	Pierre Charpentier
DL	Delphin Lecompte ce 6 Août 1877	214	Delphin Lecompte
RF	Stanislas Boudreaux ce 6 Août 1877	215	Stanislas Boudreaux
AI	Antᵉ M. Lejeune ce 29 Février 1838	216	Antoine M. Lejeune
d	Dominique Briand ce 25 Février 1838	217	Dominique Braud
AC	Jᵖʰ André Chiasson 7 Mars 1838	218	Joseph André Chiasson
LT	Gabriel Chiasson 7 Mars 1838	219	Gabriel Chiasson
OC	Onésime Champagne 4 avril 1838	220	Onésime Champagne
F	Paul Forest le 7 Avril 1838	221	Paul Forest

SHAFFER

William A. Shaffer
(1797 – April 15, 1887)
Brand No. 211
dated July 3, 1837

John Dalton Shaffer's unregistered brand

John Jackson Shaffer
(April 27, 1831 – September 24, 1918)
Captain Co. F, 26th LA Inf., CSA

Four Generations, 1916 - The Shaffers pose for a family photo on the lawn of their plantation home. Adults from the left are: Etta Lee Shaffer, John Jackson Shaffer II, Julia Shaffer, John Dalton Shaffer, Minerva Shaffer, and Captain John J. Shaffer. The two youngsters in the photo are Milhado Lee Shaffer, left and John Jackson Shaffer III.

Crescent Farm stencil for sugar hogshead barrels. Below, Ardoyne Plantation c.

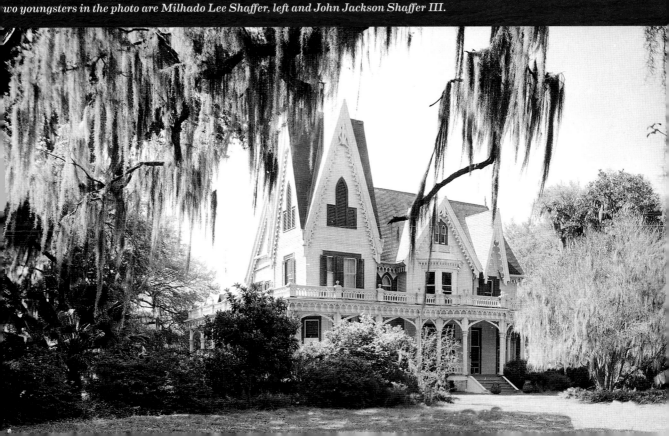

Brand	Name	Date
oh 222	Joseph O. Hebert	10 avril 1838
⌐B 223	V⁰ᵉ Celestin Hebert	10 avril 1838
Z 224	Joseph Broussard	le 20 avril 18__
D2 225	Charles Dardart	le 20 juin 18__
22 226	Justin Daspit	le 6 Août 1838
⚏ 227	Modeste Billiot f. de c. l.	ce 6 __ 1838
ȣ 228	Olivier Dubois	7 Août 1838 — transféré le 31 D__ 1852 à J. R_____ par __
5 229	Faussard Trahan	21 Août 1___
EH 230	Eugénie Hains	17 Août 1838
Jh 231	John Hains	17 Août 1838

No.	Brand	Name	Date
232	FH	Franklin Hains	17 Août 1838
233	GH	Gilford A. Hains	17 Août 1838
234	Eh	Edouard Hains	17 Août 1838
235	BH	Bernard E. Hains	17 Août 1838
236	H	Marcelus Daspit	5 Septembre 1838
237	CM	Chrejustin Martin	26 Septembre 1838
238	CL	Lewis Cassan	3 October 1838
239	fP	Francois Pitre	16 Nov. 1838
240	HR	Henry Roddy	19th Nov. 1838
241	GR	George Roddy	28th Nov. 1838

Brand	Name	Entry
V G	No. 242: Pierre Gerbeau	V G 242 — Pierre Gerbeau le 13 Decembre 1838.—
WR	No. 243: Joseph Duplanti	WR 243 — Joseph Duplanti 28 Janvier 1839.—
N	No. 244: Beloni Blanchard	N 244 — Beloni Blanchard ce 17 Février 1839.—
ԹT	No. 245: Auguste Giroir	245 — Auguste Giroir ce 9 Mars 1839.—
Pd	No. 246: Hypolite Blanchard	Pd 246 — Hyppolite Blanchard le 23 Avril 1839.—
S B	No. 247: Silvere Blanchard	S B 247 — Silvere Blanchard le 23 Avril 1839
W	No. 248: Philippe Walther	W 248 — Philippe Walther 10 Mai 1839.
J I	No. 249: Marcelin Thibodaux	J I 249 — Marcelin Thibodaux 24 Mai 18—
E	No. 250: Eugène Toups	E 250 — Eugène Toups 6 Juin 1839.

Fire Brands Book One, pages 40 & 41

No. 250: Marie Dupré
No. 251: Eustache Comeaux
No. 252: Joseph Verret
No. 253: Celesie Verret
No. 254: Alexandre Verret
No. 255: Melasie Verret
No. 256: Heloise Verret
No. 257: Jean Similien Bourg
No. 258: William Ross
No. 259: Hubert Bonvillain

Brand	No.	Name	Entry
62	260	Marie Bazilise Leboeuf	62 Marie Basilise Leboeuf femme de Francis Rodrigues ce 19 Octobre 1839
F	261	Jean Baptiste Aucoin	F Jean B^te Aucoin 8 November 1839
JI	262	Jackson Imlay	JI Jackson Imlay 14 Feb: 1840
SI	263	Suzane Imlay	SI Suzane Imlay 14 Feb: 1840
FI	264	Franklin Imlay	FI Franklin Imlay 14th Feb: 1840
CJ	265	Charles Jinkins	CJ Charles Jinkins 24th March 1840
MD	266	Marcelin Duplanti	MD Marcelin Duplanti 6. May 1840
GA	267	Gaspard Authément	GA Gaspard Authément 18 Mai 1840
JCW	268	Jesse C. Wallis	JCW Jesse C. Wallis 20th May 1840
AM	269	Alexander McMaster	AM Alexander McMaster 5th June 1840

Fire Brands Book One, unnumbered pages

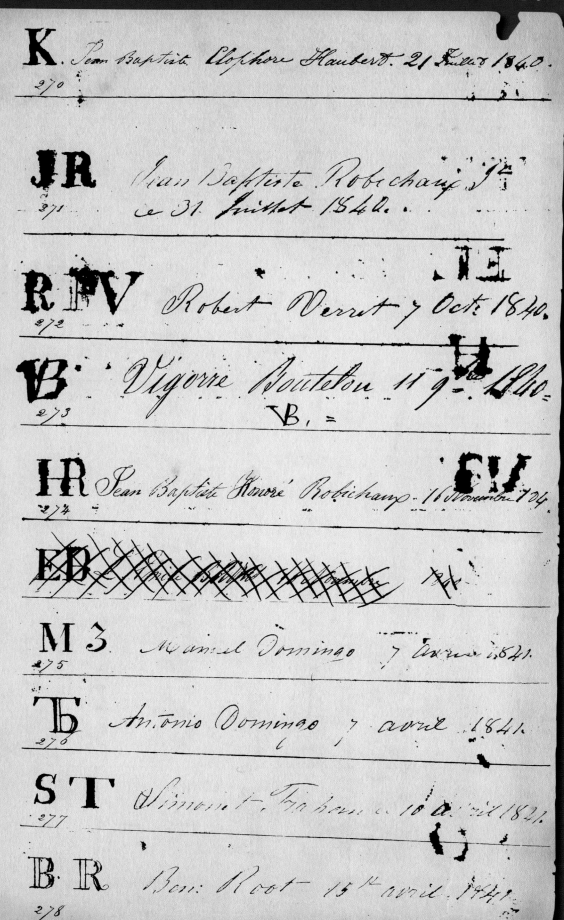

No. 270: Jean Baptiste Clophore Haubert

No. 271: Jean Baptiste Robichaux

No. 272: Robert Verret

No. 273: Vigorre Boutelou

No. 274: Jean Baptiste Honoré Robichaux

No. 275: Manuel Domingo

No. 276: Antonio Domingo

No. 277: Simonet Trahan

No. 278: Benj Root

Brand	No.	Name	Entry
RI	279	Thomas Inman	15th April 1841
TE	280	Thomas Elinger	17 May 1841
EL	281	Elias Linostrom	the 22 Mai 1841
H	282	James Hail	22 Mai 1841
M·T	283	Michel Thériau	le 24 Mai 1841
T	284	Michel Thériau fils	le 24 Mai 1841
OT	285	Michel Orelien Tejeau	21 Juin 1841. The above Brand belongs to M. J. Theriau June 3rd 1861
7	286	Justilien Teriau	21 Juin 1841
EO	287	Etienne Ordroneau	Août 1841

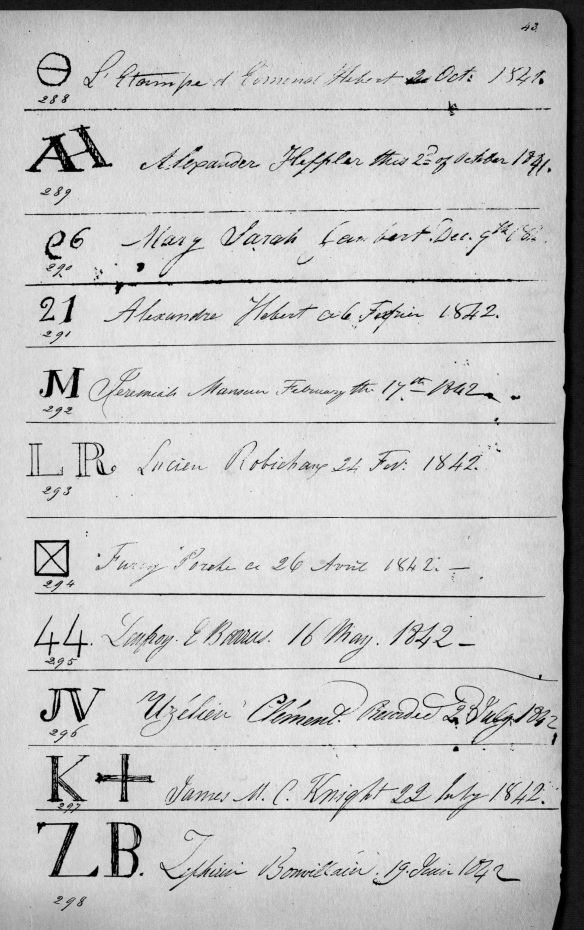

No. 288: Edmond Hebert

No. 289: Alexander Heppler

No. 290: Mary Sarah Gaubert

No. 291: Alexandre Hebert

No. 292: Jeremiah Mansun

No. 293: Lucien Robichaux

No. 294: Furcy Porche

No. 295: Leufroy E. Barras

No. 296: Uzélien Clément

No. 297: James M.C. Knight

No. 298: Zephirin Bonvillain

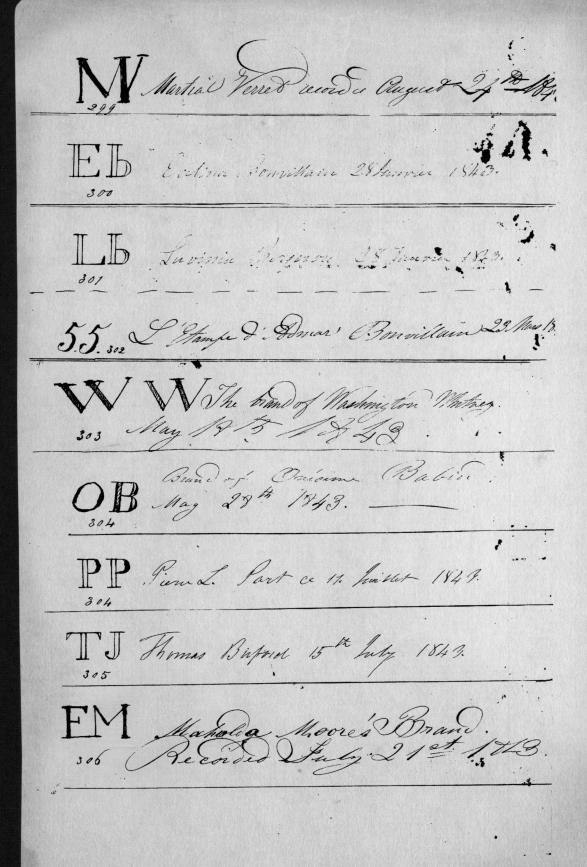

No.	Brand	Owner
299	MV	Martial Verret
300	Eb	Evelina Bonvillain
301	Lb	Luvinia Bergeron
302	5.5	Admar Bonvillain
303	WW	Washington Whitney
304	OB	Onésime Babin
304	PP	Pierre L. Part
305	TJ	Thomas Buford
306	FM	Maholda Moore

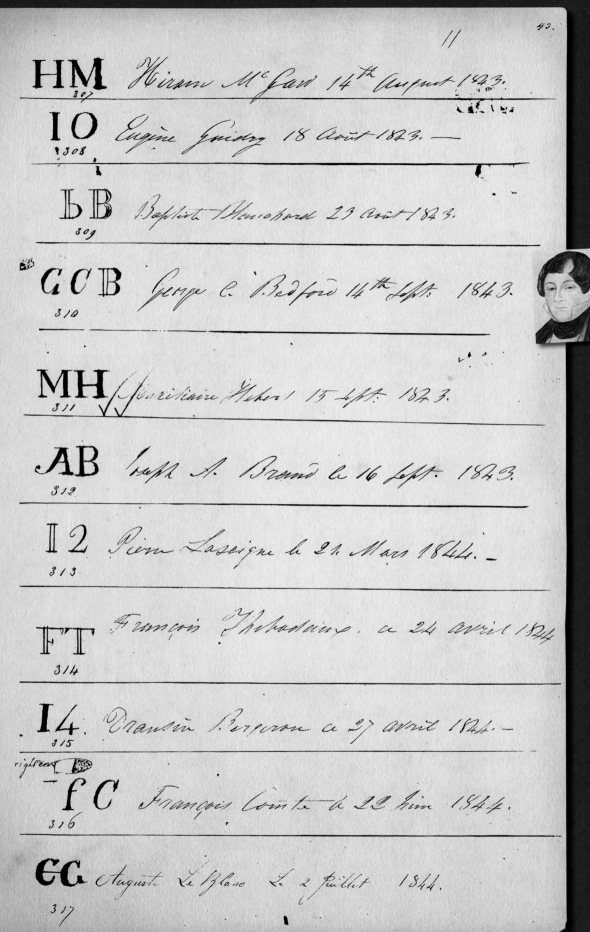

Brand	Name	Date	No.
HM	Hiram McGaw	14th August 1843	307
IO	Eugène Guidry	18 Août 1843	308
bB	Baptiste Blanchard	29 Août 1843	309
GCB	George C. Bedford	14th Sept. 1843	310
MH	Maxiliaire Hebert	15 Sept. 1843	311
AB	Joseph A. Braud	le 16 Sept. 1843	312
I2	Pierre Laseigne	le 21 Mars 1844	313
FT	François Thibodaux	ce 24 avril 1844	314
I4	Drausin Bergeron	ce 27 avril 1844	315
fC	François Comte	le 22 Juin 1844	316
EG	Auguste Leblanc	Le 2 Juillet 1844	317

JBB
No. 318:
Jean Baptiste Boudreaux

HP
No. 319:
Hypolite Pitre

L
No. 320:
Solomon C. Lawless

C.N.
No. 321:
Jean Charles Navarre

S.N.
No. 322:
Sylvère Navarre

Z.I.
No. 323:
Zénon Chauvin Jr.

M.
No. 324:
Maurice Leboeuf

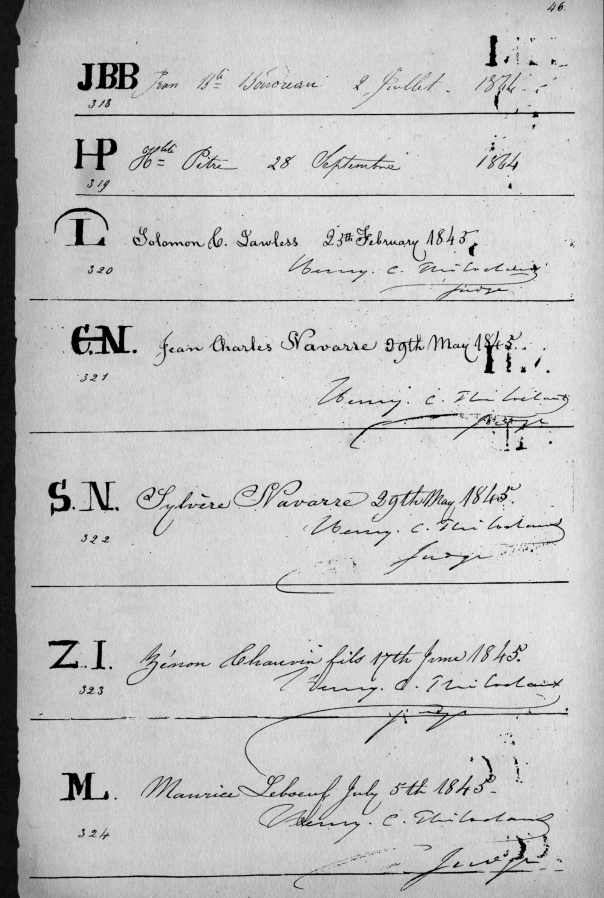

Brand	Owner	Date
A No. 325	Eléonore Nattalie Thibodaux	July 14th 1845
L2 No. 326	Julien Lenain	July 16th 1845
G.P. No. 326	Oville Pontiff	July 16th 1845
W.R. No. 327	William Roundtree	September 17th 1845
PM No. 328	Louisa C. Howard Widow Isaac M. Price	recorded this 22nd of October 1845
G No. 329	Auguste Babin	22nd October 1845
J.A. No. 330	Jean Valery Gautreaux	2nd November 1845
MF No. 331	Florentin Moutardier	5th November 1845

Signed: Henry C. Thibodaux, Judge

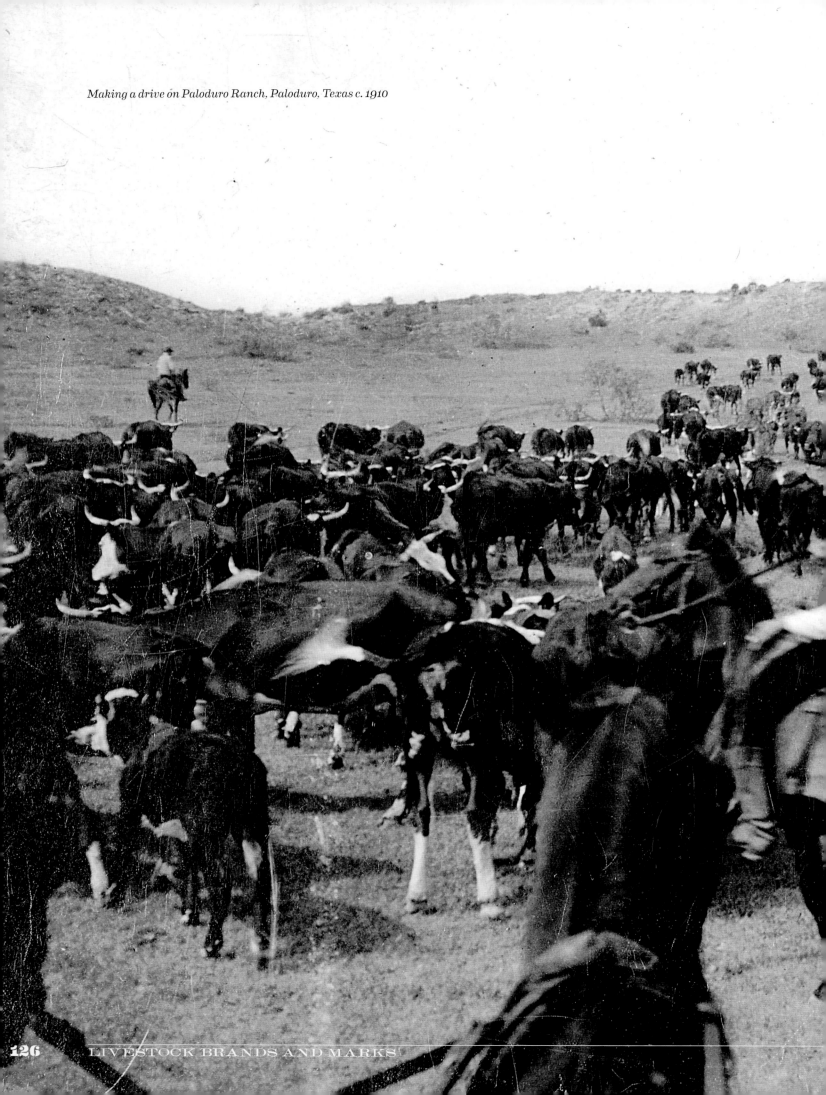

Making a drive on Paloduro Ranch, Paloduro, Texas c. 1910

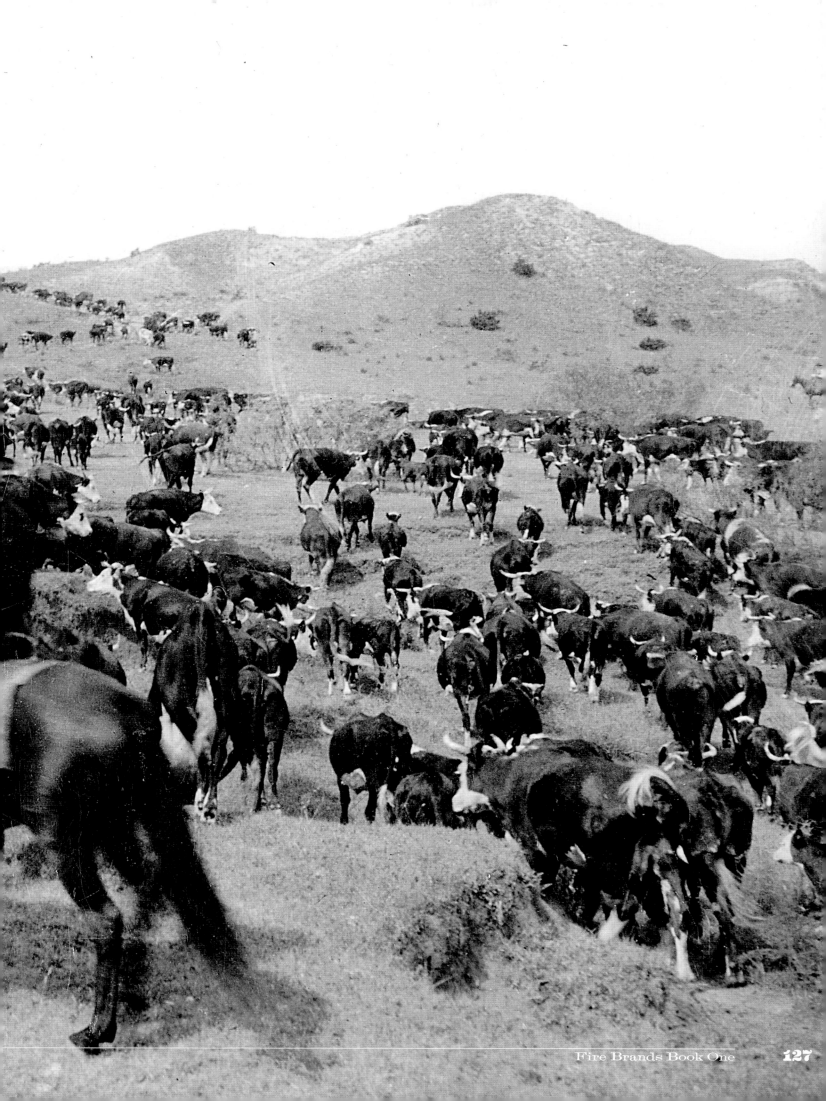

YB
No. 332:
Charles Isidore Dupré

NB
No. 333:
Nicolas Bellanger

ZD
No. 334:
Zéphirin Isaac Dupré

MH.
No. 335:
Martin Hebert

JU.
No. 336:
John D. Umberfield

P.D.
No. 337:
Pierre B. Dugas

YB 332 — Charles Isidore Dupré, 10th November 1845. Henry C. Nicolas, Judge

NB 333 — Nicolas Bellanger recorded this 20th day of January 1846. Henry C. Nicolas, Judge

ZD 334 — Zéphirin Isaac Dupré recorded this 27th day of January 1846. Henry C. Nicolas, Judge

MH. 335 — Estampes de Martin Hébert. Enregistrée le 24 Mars 1846. En. Pôché, Judge

JU. 336 — John D. Umberfield. Recorded this 30th of March 1846. En. Pôché, Judge

P.D. 337 — Estampes de Pierre B. Dugas. Enregistrée le 19 Novembre 1846. A. Thibodaux, Recorder

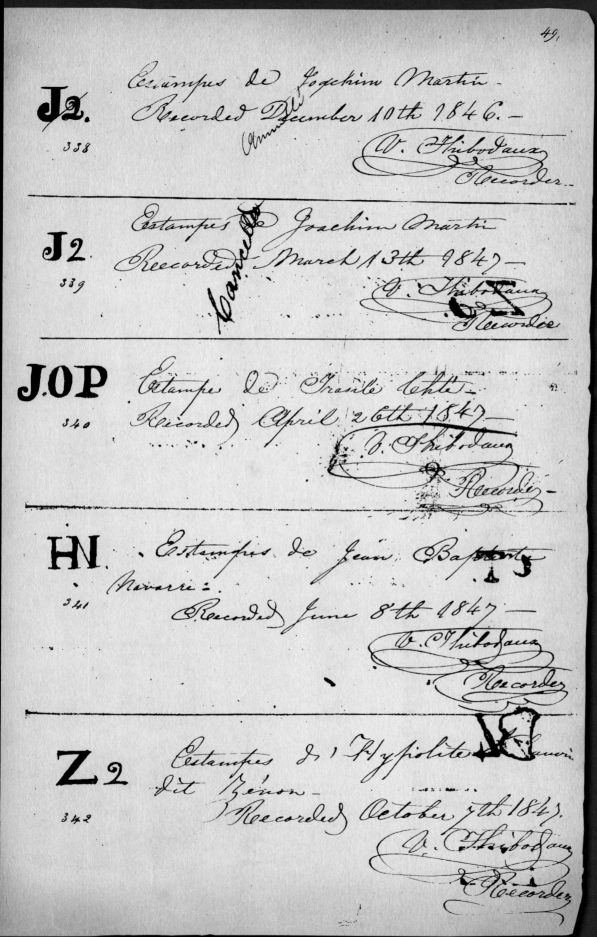

J2 No. 338: Joachim Martin *cancelled*

J2 No. 339: Joachim Martin *cancelled*

J.OP No. 340: Trasile Chté

HN No. 341: Jean Baptiste Navarre

Z2 No. 342: Hypolite (*dit Zénon*) Chauvin

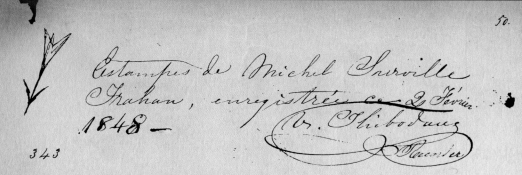

343 — Estampes de Michel Surville Trahan, enregistrées ce 2 Février 1848 — V. Thibodaux, Recorder

344 — Estampes de Louis Bourg ce 13 Mars 1848 — V. Thibodaux, Recorder

345 — L'Etampe d'Ultere Chauvin enrigistré le 18 Août 1848 — V. Thibodaux, Recorder

346 — Robert Ruffin Barrow Recorded this 13th September 1848 — V. Thibodaux, Recorder

347 — L'Etampe de Charles Theriot enrigistré le 14 September 1848 — V. Thibodaux, Recorder

348 — left year — L'Etampl de Drausin Braud enrigistré le 13 Octobre 1848.

349 — L'Etampe d'Eugène Engerran enrigistré le 20 Octobre 1848.

Fire Brands Book One, pages 50 & 51

NA
No. 350:
Armogène Louviere

PP.
No. 351:
Jean Baptiste Adrien Part

J.G.
No. 352:
Joachim Guéno

No. 353:
Blanchard & Ranson

T
No. 354:
Rosalie Billiot

No. 355:
Jean Charles Soigné

No. 356: Robert Daspit

356. L'étampe de Robert Daspit
R3
Enregistré le 2 Août 1849.
A. Verret
Recorder

No. 357: Jean Marie Leboeuf

357. L'étampe de Jean Marie Leboeuf
L3
Enregistré le 8 Septembre 1849.
A. Verret
Recorder

No. 358: Rosémond Foret

358. L'étampe de Rosémond Foret
F2
Enregistré le 21 Septembre 1849.
A. Verret
Recorder

No. 359: Tatus L. Simpson

359. Tatus L. Simpson's Brand-Iron
TS.
Recorded October 8th 1849.
A. Verret
Recorder

No. 360: François Thériot

360. L'étampe de Mr. François Thériot enrg.
77 le 5 Avril mil huit cent cinquante.
Recorded April 5th 1850
A. Verret
Recorder

LIVESTOCK BRANDS AND MARKS

361 **JCT** — L'étampe de Mr. Casimir Tremoulet enregistrée le 17 Avril 1850
Recorded April 17 1850
A. Vinet, Recorder

362 **25** — L'étampe de Mr. Comie Blaise Deoux enregistrée le 17 Avril 1850
Recorded April 17 1850
A. Vinet, Recorder

363 **3** — L'étampe de Mr. Léandre Henry enregistrée le 17 Avril 1850
Recorded April 17 1850
A. Vinet, Recorder

364 **CL2** — L'étampe de Mr. Hilaire Carlin Enregistrée le 18 Octobre 1850
A. Vinet, Recorder

365 **CF** — L'étampe de Charles Frédéric, h.c.l. fils, enregistré le 20 Janvier 1851.
A. Vinet, Recorder

No. 361: Casimir Tremoulet

No. 362: Comie Blaise Deoux

No. 363: Léandre Henry

No. 364: Hilaire Carlin

No. 365: Charles Frédéric, *Free man of color*

366

T. 4. L'Étampe de Joseph Théogène Thériot
enregistré ce 19 Juin 1851.
A. Vinet
Recorder

P l'étampée de P. F. Michel,
enregistrée ce 1er Juillet 1851
A. Vinet
Recorder

367

368

TP Thomas Paye's Brand Iron
Recorded July 10th 1851
A. Vinet
Recorder

369

 Cette figure est l'étampe de Gédéon
Calham, enregistré le 19 Juillet 1851.
A. Vinet
Recorder

370

88 L'étampe de Mr. Joseph Adrien Leblanc
enregistré le 27 Août mil huit cent cinquante
transféré à Mr. Dominique
Lalonde dès ce jour pour son
service — Mars 5, 1855
A. Vinet
Recorder
J. A. Leblanc

Fire Brands Book One, pages 54 & 55

371 — **Y** — L'Etampe d'Anachette Labit enregistrée a 20 Decembre 1851

A. Vind, Recorder

No. 371: Anachette Labit

372 — **GS** — L'Etampe de Marcellin Navarre Enregistrée @ 25 Mars 1852

A. Vind, Recorder

No. 372: Marcellin Navarre

373 — **JCN** — L'Etampe de Jean Charles Navarre Enregistrée @ 25 Mars 1852

A. Vind, Recorder

No. 373: Jean Charles Navarre

374 — **QO** — L'Etampe d'Emile P. Bascle Enregistrée le 15 Avril 1852

A. Vind, Recorder

No. 374: Emile P. Bascle

375 — **IJ** — L'Etampe de Rémi Bourgeois Enregistrée le 6 Mai 1852

A. Vind, Recorder

No. 375: Rémi Bourgeois

376 — **HS** — L'Etampe de Calice Ceniquaire Enregistrée le 11 Mai 1852

No. 376: Calice Ceniquaire

377 — **CP** — L'Etampe d'Adolphe Pontiff Enregistrée le 9 Juin 1852

A. Vind, Recorder

No. 377: Adolphe Pontiff

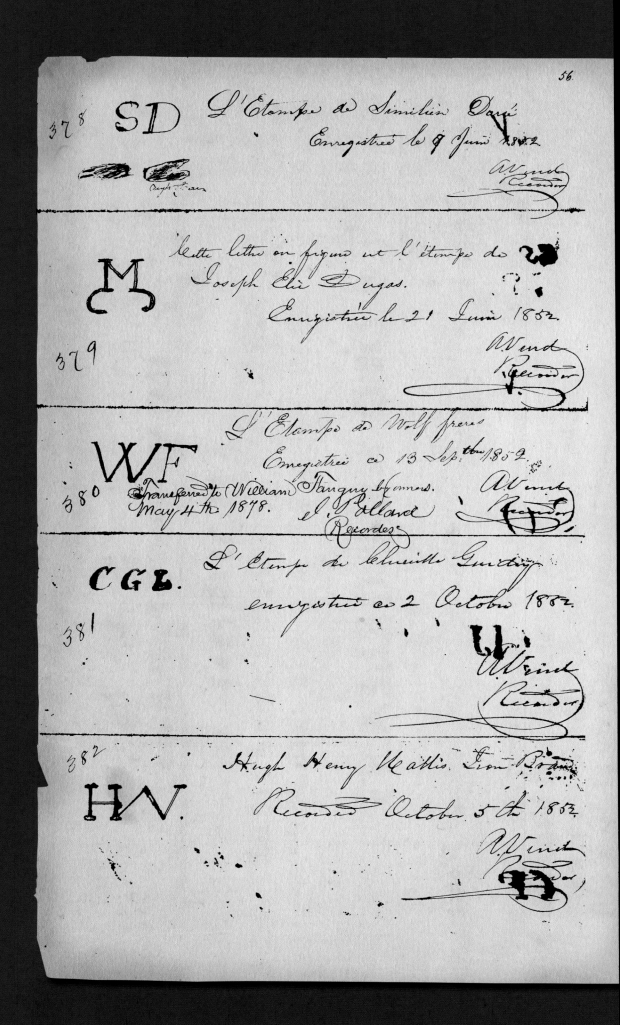

No. 378: Similien Darcé

No. 379: Joseph Elie Dugas

No. 380: Wolf Brothers

No. 381: Clerville Guidry

No. 382: Hugh Henry Wallis

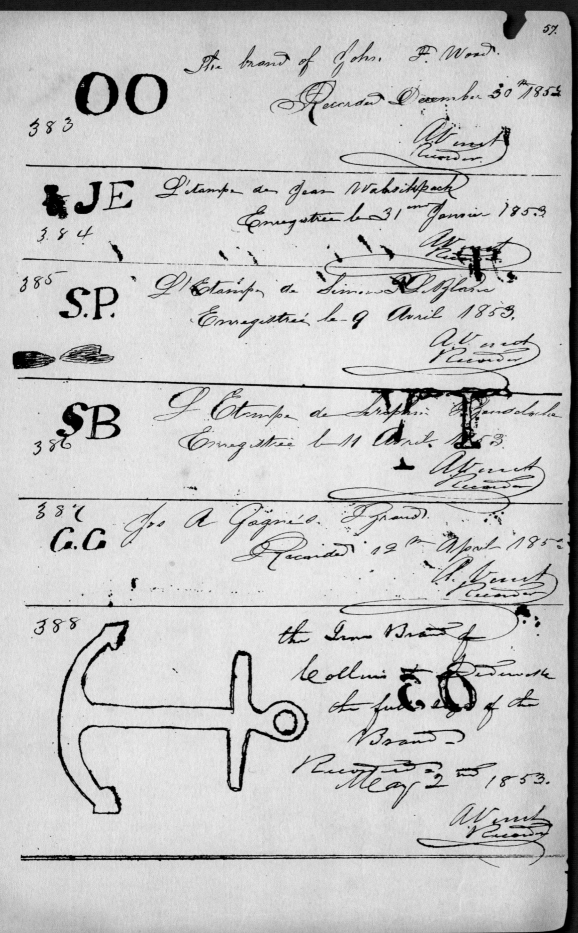

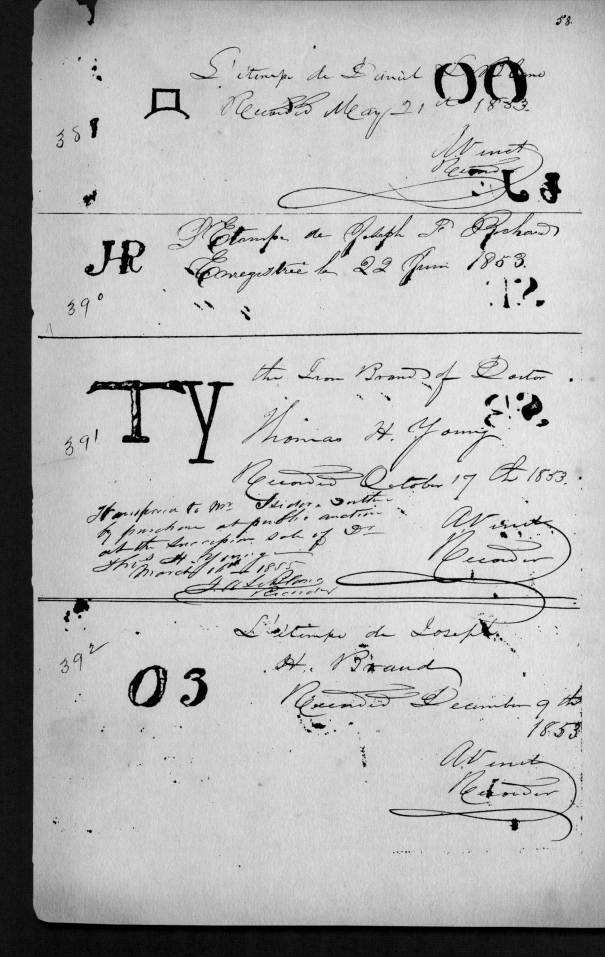

Fire Brands Book One, pages 58 & 59

393 — Brand of Edwin R. Field. Recorded February 11th 1854. J. A. LeBlanc, Recorder.

394 — L'Étampe d'Emilien Theriot. Enregistré le 9 Mars 1854. J. A. LeBlanc, Recorder.

395 — L'Étampe de Pierre Braud. Enregistré le 18ème Mars 1854. J. A. LeBlanc, Recorder.

396 — L'Étampe de J. Bte Leonard. Enregistré le 10 Mai 1854. J. A. LeBlanc, Recorder.

397 — L'Étampe de Jacques Halbert Dugas. Enregistré le 30 Mai 1854. J. A. LeBlanc, Recorder.

398 — L'Étampe de Leon Darcé. Enregistré le 5 Juin 1854. J. A. LeBlanc, Recorder.

399 — The brand of Albert Stansberry. Recorded June 14th 1854. J. A. LeBlanc, Recorder.

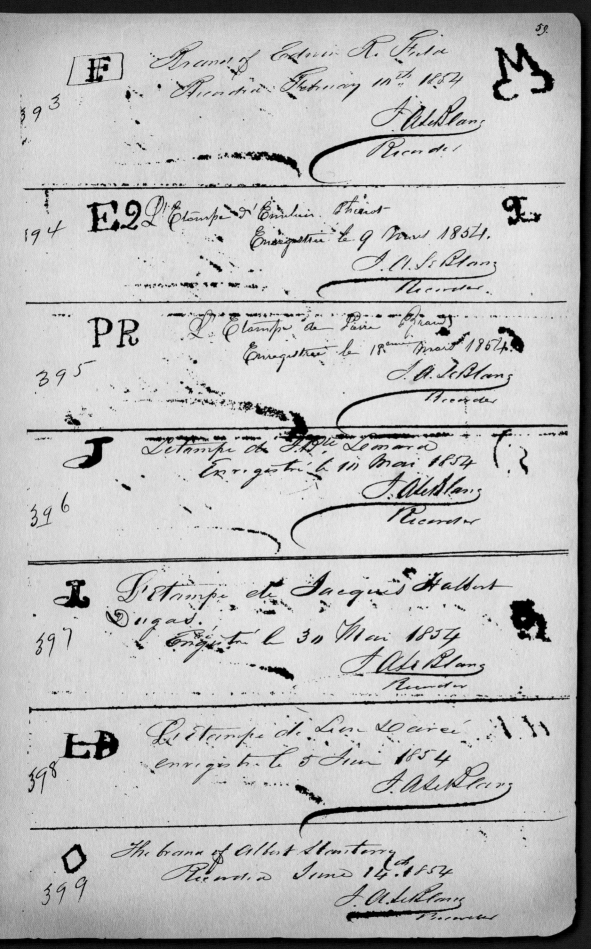

BERGER

John Berger arrived in Houma in the mid-1840s as John Kepienberger from Kendenheim, Bavaria in southern Germany. He had shortened his surname by the time he became Houma's fifth mayor in 1865.

The Berger family had a long record of public service and in the areas of transportation and sugar production. John Berger established a hotel that faced Front Street and a livery stable in the 500 block of Main Street, dubbed Berger Block. From their livery stable to the northern Terrebonne railroad station at Schriever, the Bergers also ran a "bus" line for train passengers until the Houma branch line arrived in 1872.

Sons Peter and John ran Berger Brothers livery stable after their father's death, as well as owning five plantations: Argyle, Crescent, Greenwood, Waterproof, and Waubun. From their livery stable on Main Street, the Bergers provided horses to ride and various types of buggy rentals, until it later, ironically, became an early automobile dealership under new ownership.

*John Berger
February 22, 1815 -
September 25, 1867*

*Below, The 500 block of Main Street, facing east, also called Berger Block, c. 1906
Inset, Berger Brothers Livery and Feed brought this rental motor car to Houma, presumably to disprove its superiority to horses and buggies on muddy local roads.*

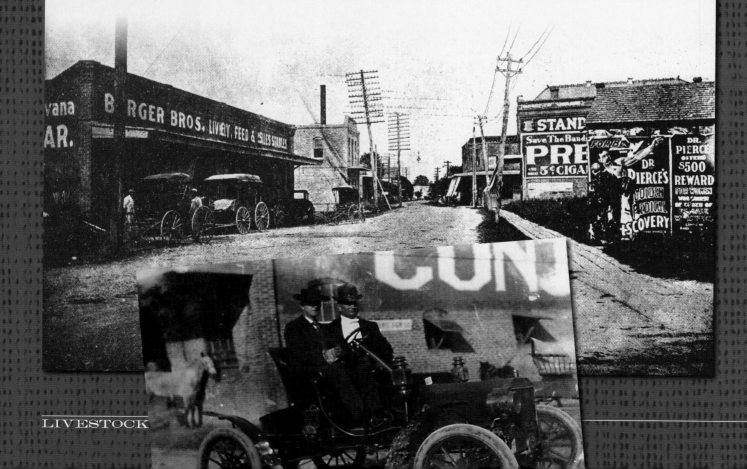

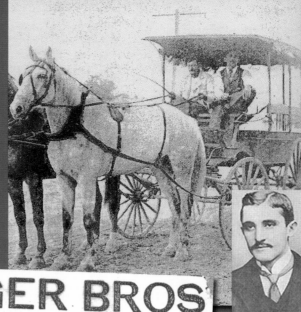
Henry Berger's fringed surrey c. 1918

*Henry Berger
September 13, 1872 -
September 28, 1951*

Top left ad from Terrebonne Times *of September 29, 1900; ad above from* Houma Courier *of April 13, 1901; ad at left from Houma* Civic Guard *of October 28, 1865*

*Peter Berger
July 8, 1837 - August 2, 1907*

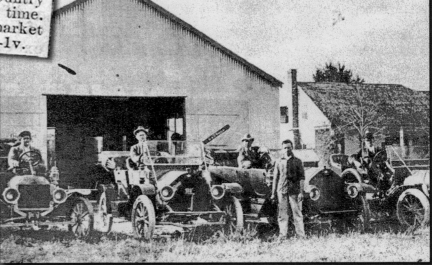

Early Houma auto owners on Berger Block, c. 1911-12. From left, John Shinn, Dr. J.W. Warren, Emile Dupont, Anthony V. Picone, Dr. J.B. Duval

Fire Brands Book One

No. 400:
Joseph Elie Dugas
& Stephanie Verret

No. 401:
Robertine Barrow

No. 402:
Irene Hebert

No. 403:
Alexandre Dardau

No. 404:
Lucien Bourgeois

No. 405:
Charles Boudreaux

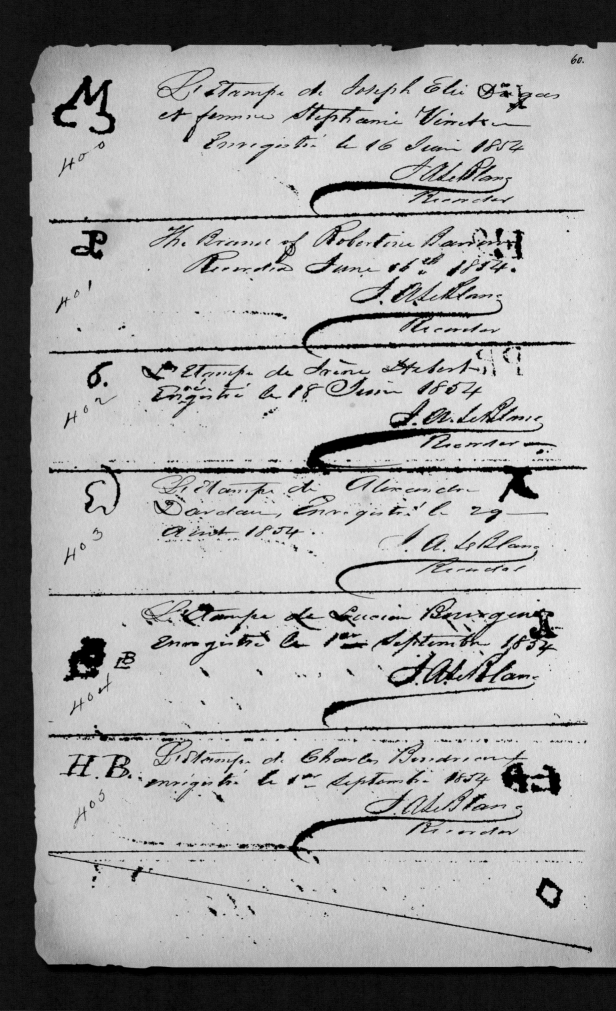

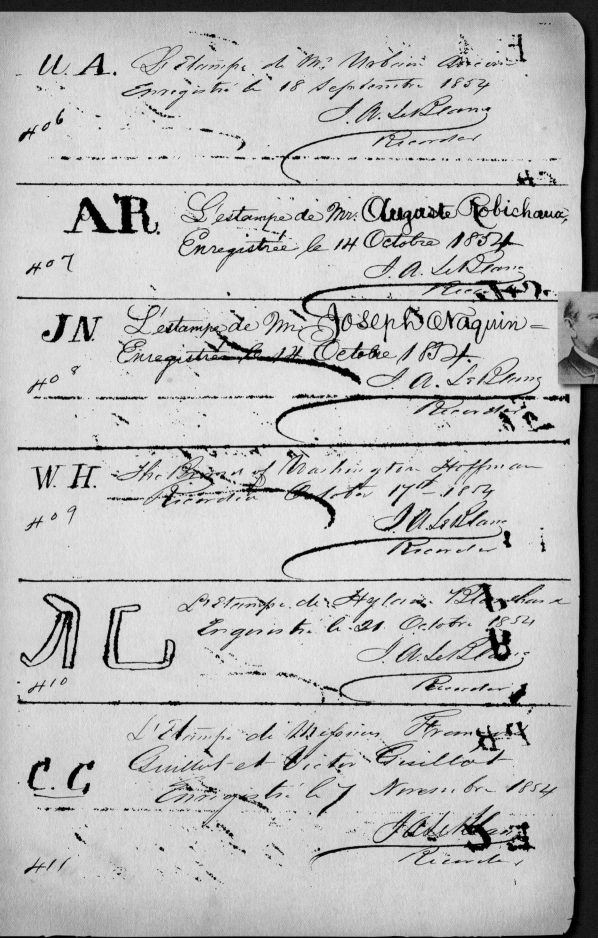

No. 406: Urbain Aucoin

No. 407: Auguste Robichaux

No. 408: Joseph Naquin

No. 409: Washington Hoffman

No. 410: Hylair Blanchard

No. 411: Francois Guillot & Victor Guillot

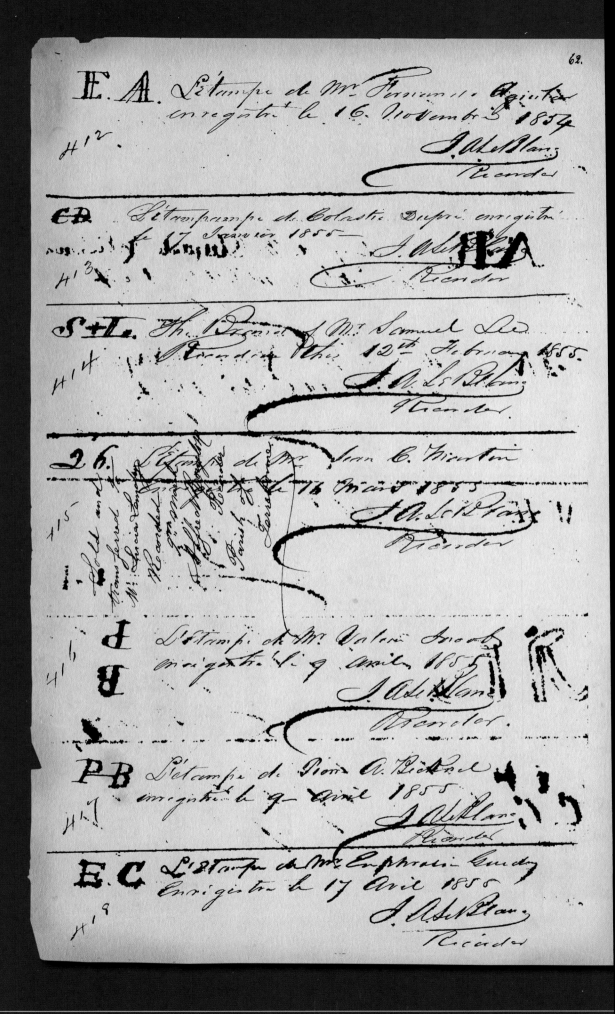

419. N-B L'étampe de Mr. Narcisse Boudreaux enregistré le 4 Mai 1855.
J. A. LeBlanc
Recorder

420. P.O. The brand of Louis Jacques Pontiff Recorded May 14th 1855.
J. A. LeBlanc
Recorder

421. D.F. L'étampe de Mr. Drausin Folse enregistré le 21e Mai 1855.
J. A. LeBlanc
Recorder

422. H. The Brand of Herman Loevinstein Recorded May 22nd 1855.
J. A. LeBlanc
Recorder

423. NR L'étampe de Joseph Narcisse Robichaux enregistré le 29 Mai 1855.
J. A. LeBlanc
Recorder

424. EB. The Brand of Eugène Badeaux Recorded July 30th 1855.
J. A. LeBlanc
Recorder

425. JB The Brand of Joachim Boudreaux Recorded August 4th 1855.
J. A. LeBlanc

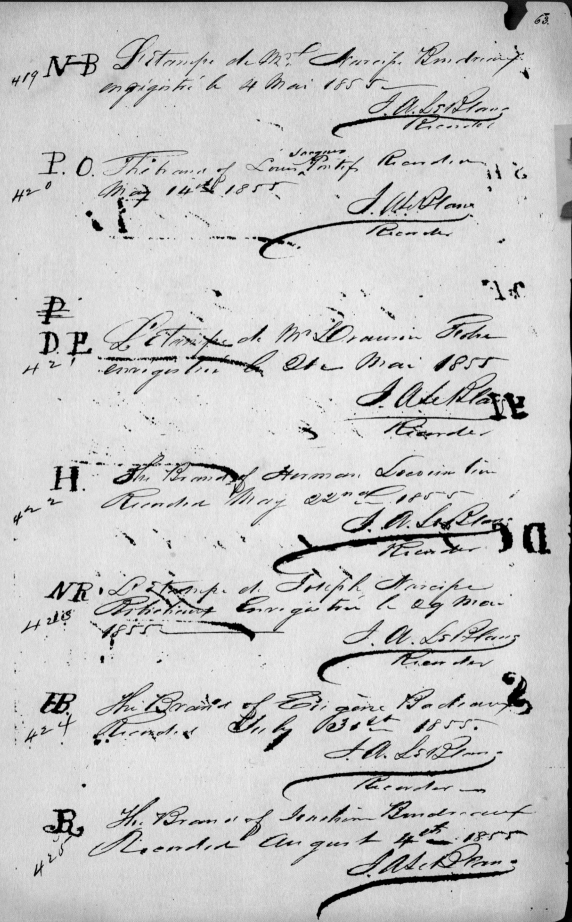

No. 419: Narcisse Boudreaux

No. 420: Louis Jacques Pontiff

No. 421: Drausin Folse

No. 422: Herman Loevinstein

No. 423: Joseph Narcisse Robichaux

No. 424: Eugène Badeaux

No. 425: Joachim Boudreaux

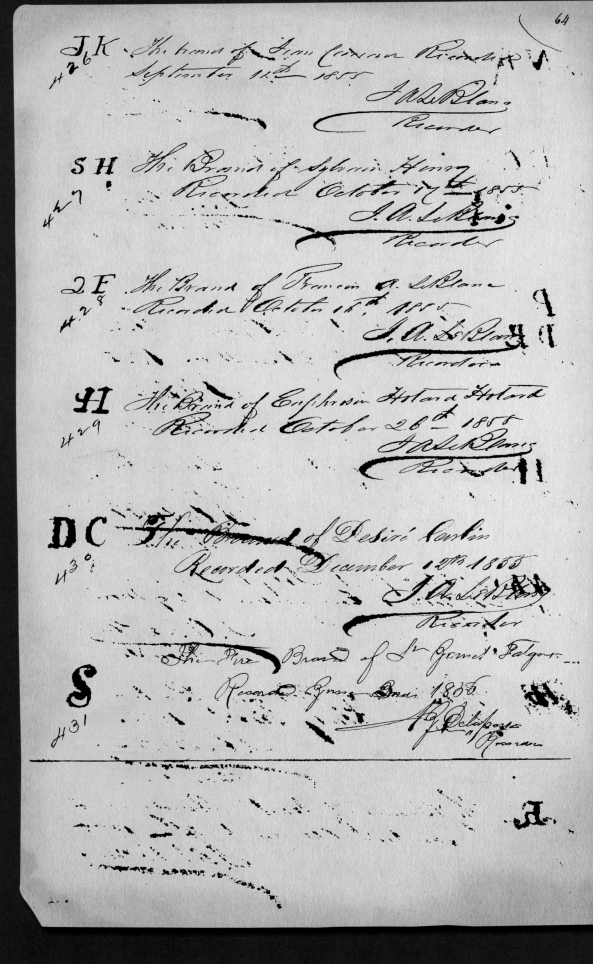

No. 426: Jean Carian

No. 427: Sylvain Henry

No. 428: François A. Leblanc

No. 429: Euphrosin Hotard

No. 430: Desiré Carlin

No. 431: St. James Falgout

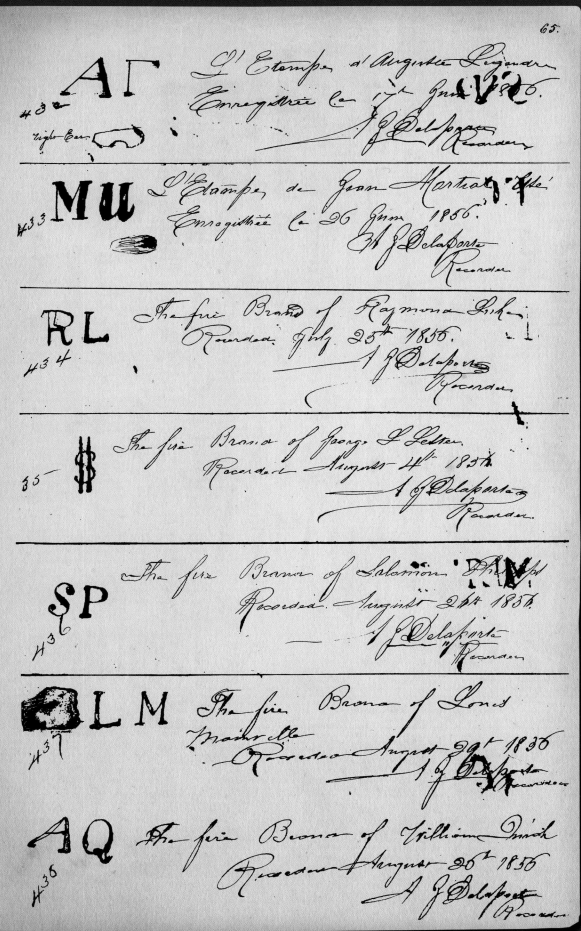

No. 432: Auguste Legendre

No. 433: Jean Martial Usé

No. 434: Raymond Luke

No. 435: George L. Lester

No. 436: Salomon Philipps

No. 437: Louis Mainville

No. 438: William Quick

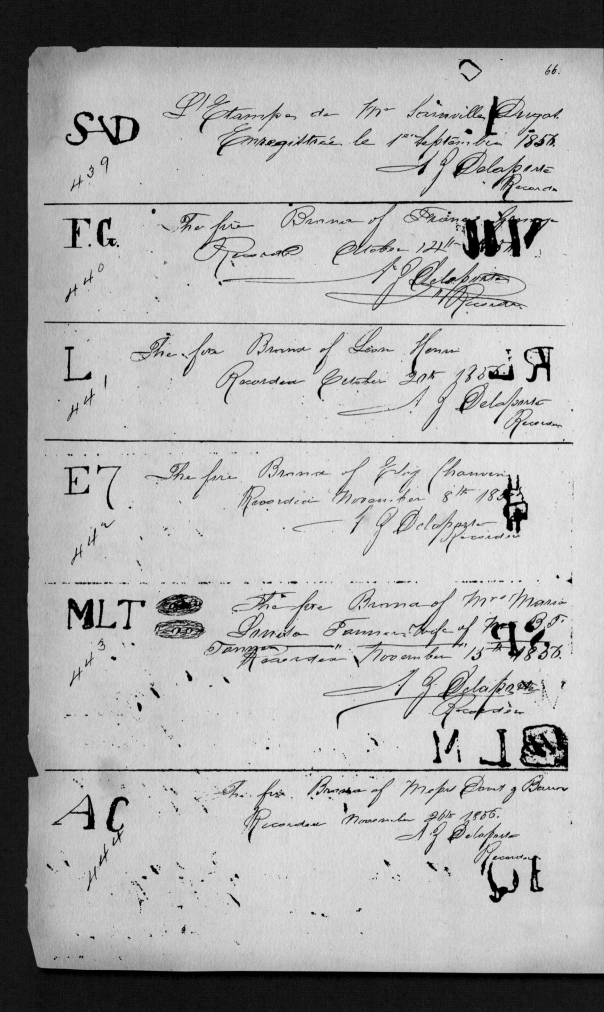

445 **Q** The fire Brand of Mr Jean Mars
Recorded December 4th 1856.
A. J. Delaporte
Recorder

446 **LE** The fire Brand of Louis Exnisios
Recorded March 17th 1857
A. J. Delaporte
Recorder

447 L'estampe de Mr Leufroy Lambert
Enregistrée April 14th 1857
A. J. Delaporte
Recorder

448 **WP** The fire Brand of Mr William F. Perce
Recorded June 4th 1857.
A. J. Delaporte
Recorder

449 **AAR.** The fire Brand of Mr Augustin Alfred Rougeleot
Recorded July ninth 1858
A. J. Delaporte
Recorder

No. 450: Adele W. Guidry

U.G. L'estampe de Mademoiselle Adèle W. Guidry (fille de Jean Bte. Guidry) Enrégistrée le 9 Septembre 1857.
A. J. Delaporte

No. 451: Marcellin Falgout

70 The fire Brand of Marcellin Falgout Recorded March 29th 1858.
A. J. Delaporte

No. 452: Joseph Guidry Jr.

R.3. The fire Brand of Joseph Guidry fils Recorded May 22nd 1858.
A. J. Delaporte

No. 453: Emilie Bonvillain

MR. The fire Brand of Emilie Bouvillain, widow of Joseph Guidry Sr. Recorded May 22nd 1858.
A. J. Delaporte

No. 454: Children of Hyppolite Eymard

FE. The Fire Brand of Hyppolite Eymard's Children — Recorded June 17th 1858.
A. J. Delaporte

No. 455: John C. Potts

J.C.P. The Fire Brand of John C. Potts Recorded June 17th 1858.
A. J. Delaporte

No. 456: Marcellin Dupré

AA The fire Brand of Marcellin Dupré Recorded October 4th 1858.
A. J. Delaporte

No. 457: Thomas Singleton

TW The fire Brand of Thomas Singleton Recorded April–June 1859.
A. J. Delaporte

No. 458: John Harland

JxH The fire Brand of John Harland Recorded April–June 1859.
A. J. Delaporte

459 ᎫO The fire Brand of Sylvanie Olivier
 Recorded April 14th 1859
 A. G. Delspine

460 ♭ The fire Brand of Charles Maxile
 Boudreaux
 Recorded June 21st 1859
 A. G. Delspine

461 O The fire Brand of Norbert Bergeron
 Recorded June 24th 1859
 A. G. Delspine

462 CI The fire Brand of Moise Guidry
 Recorded July 13th 1859
 A. G. Delspine

463 4 The fire Brand of Joseph Florentin
 Boudreaux Recorded August 5th 1859
 A. G. Delspine

464 C The Fire Brand of Jean Baptiste Boudreaux
 Recorded February 18th 1860
 A. G. Delspine

465 ▽S The fire Brand of Valentin
 Saulé
 Recorded March 14th 1860

466 UV The fire Brand of Ursin Verdin
 Recorded March 14th 1860

Among all equine species, the distinction between donkeys and mules is probably the most difficult for non-livestock-savvy people to make.

Donkeys, or asses, are descended from the African wild ass, *E. africanus*. Donkeys are domesticated members of the horse family, and have been used as working animals for at least 5,000 years.

The term *jackass* is a reasonable term derived from the fact that the male donkey is called a jack—so the term means, literally, a male donkey. The female donkey is called a jenny or a jennet.

Mules are the product of a male donkey breeding with a female horse. Very few female mules in the history of the animal have borne viable offspring, and male mules are sterile.

The crossbreeding of a male horse and a female donkey is called a hinny, which is a more difficult hybrid to obtain than is a mule.

Physically, donkeys' ears are much longer than horses' ears in proportion to their size. The back is straighter than a horse's, and a donkey's tail resembles a cow's tail. Donkey hooves are rounder and more upright than those of horses; most donkeys don't need shoes, except if they work primarily on hard surfaces.

Mules, on the other hand, usually have smaller ears than do donkeys, and longer but the same shape ears as the horse parent's ears. Mules' tails are more like horses' tails, but their hooves are harder than horses' hooves, and are more resistant to disease and insects.

In temperament, the mule usually exhibits the even temper, patience, endurance and sure-footedness of the donkey, as well as the vigor, strength and courage of the horse. What is often termed stubbornness in both donkeys and mules is instead attributed to a strong sense of self preservation from things the animal perceives to be dangerous to itself.

Hardworking animals of farm and field, donkeys and mules of the Louisiana coastal parishes would certainly have received the marks and brands described herein.

Mules at Bowie, Louisiana c. 1910

Opposite page, donkey, at Southdown, c. 1930

Below, mule-drawn trolley, c. 1918

467 JTD The fire Brand of Théophile Daunis.
 Recorded April 13th 1860
 A J Delespine Recorder

468 MO The fire Brand of Emerile Olivier.
 Recorded April 13th 1860
 A J Delespine Recorder

469 A2 The fire Brand of Alexandre Billiot
 Recorded April 16th 1860
 A J Delespine Recorder

470 TA The fire Brand of Antoine Tardy
 Recorded May 1st 1860

471 CAB The fire Brand of Evariste Bertheaud Recorded July 23rd 1860

472 H The fire Brand of Jean Larrieu Recorded October 9th 1860.

473 ET The fire Brand of Elphège Thériot Recorded February 12th 1861.

474 ZP. The fire Brand of Amédée Porche Recorded May 8th 1861 —

475 AT The fire Brand of Augustin Thériot Recorded June 1st 1861 —

476 F8. The fire Brand of Felix Thériot Recorded August 21st 1861 —

VT
477

The fire Brand of Auguste Victor Trahan —
Recorded September 12 7bre 1861

478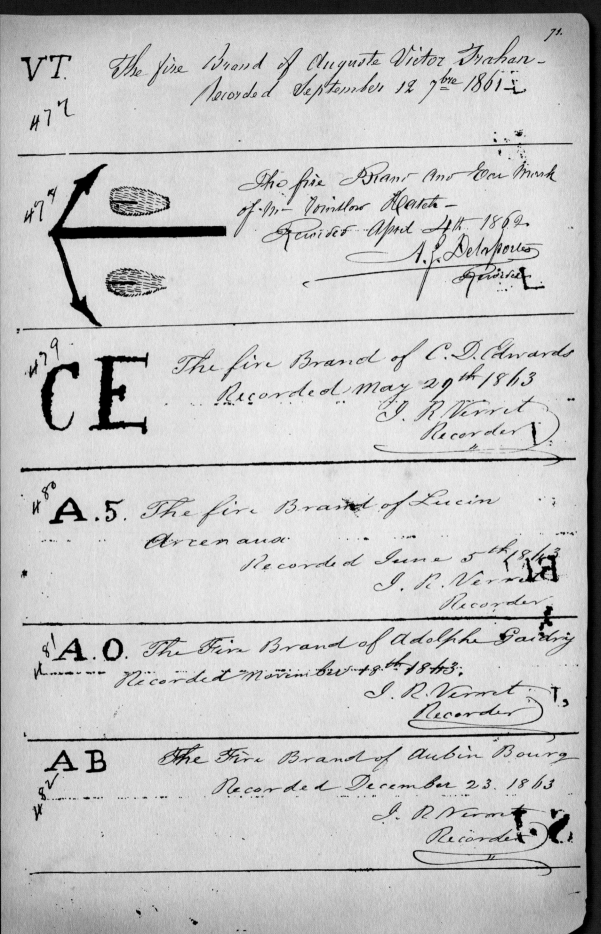

The fire Brand and Ear Mark of Mr Winslow Hatch —
Recorded April 4th 1862
A. J. Delaporte
Recorder

479 **CE**

The fire Brand of C. D. Edwards
Recorded May 29th 1863
J. R. Verret
Recorder

480 **A.5**

The fire Brand of Lucin Arcenaux
Recorded June 5th 1863
J. R. Verret
Recorder

481 **A.O**

The Fire Brand of Adolphe Gaidry
Recorded November 18th 1863
J. R. Verret
Recorder

482 **AB**

The Fire Brand of Aubin Bourg
Recorded December 23. 1863
J. R. Verret
Recorder

No. 483: Fannie A. Bisland

BF — The fire Brand of Mrs Fannie A. Bisland.
Recorded March 3d 1864
J. R. Verret
Recorder

No. 484: L.M.T. McClung

M — The fire Brand of Mr. L. M. T. McClung
Recorded April 7th 1864
J. R. Verret
Recorder

No. 485: William Dill

D — The fire Brand of Mr. William Dill
Recorded April 13th 1864
J. R. Verret
Recorder

No. 486: Bernard Myer

BM — The Fire Brand of Bernard Myer.
Recorded April 27th 1864
J. R. Verret
Recorder

No. 487: Léon Roger

J.3. — The Fire Brand of Léon Roger
Recorded July 19th 1864
J. R. Verret
Recorder

No. 488: Joseph Oleus Duplantis

SJ — The fire Brand of (J. O.) Joseph Oleus Duplantis.
Recorded, September 15th 1864
Alfred Rougelot
Recorder

LIVESTOCK BRANDS AND MARKS

Fire Brands Book One, pages 72 & 73

73.

ZC
N°89

The fire Brand of Zénon Pompulus Chauvin
Recorded, September 17th 1864
Alfred Rougelot
Recorder

ZC
No. 489:
Zénon Pompulus Chauvin

OD
N°90

The fire Brand of Oscar Daspit.
Recorded, September 23d 1864
Alfred Rougelot
Recorder

OD
No. 490:
Oscar Daspit

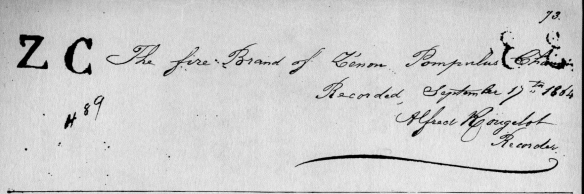

GVB
N°91

The fire brand of Célestin Vital Bergeron, of Bayou Blue.
Recorded November 6th 1864
Alfred Rougelot
Recorder

GVB
No. 491:
Celestin Vital Bergeron

HM **HM**
N°92
HM

The fire brand of Henry Malborough, of Bayou Terrebonne.
This fire Brand is transferred to Mr Wade B. Bowie this day November 5th 1866.
J. R. Verret
Recorder

Recorded, November 8th 1864
Alfred Rougelot
Recorder

HM
No. 492:
Henry Malborough

FBJ
N°93

The fire brand of François Babin Jr., of Bayou Little Caillou.
Recorded, 5th December 1864
Alfred Rougelot
Recorder

FBJ
No. 493:
François Babin Jr.

33 The fire Brand of Justin Martin of Bayou Little Caillou.

Recorded, 5th December 1864

Alfred Rougelot
Recorder

T F The fire Brand of Eugène Fields of Bayou Terrebonne.

Recorded, 22nd December 1864

Alfred Rougelot
Recorder

C O The fire Brand of Patrick Coleman of Houma, Parish of Terrebonne.

Recorded, 2nd January 1865

Alfred Rougelot
Recorder

A P The fire Brand of Adam Troxclair of Bayou Salé, Parish of Terrebonne, &c.

Recorded, 3rd January, 1865

Alfred Rougelot
Recorder

S+C The fire Brand of Jean Baptiste Duplantis Jr. Recorded on this Book Page 33. No. 183, but not signed by the Recorder.

Recorded, this 23rd January 1865

Alfred Rougelot
Recorder

Fire Brands Book One, pages 74 & 75

499

The fire Brand of Pierre Cenac
Houma, TerreBonne.
Recorded, 31st January 1865
Alfred Rougelot
Recorder
Parish of TerreBonne.

No. 499: Pierre Cenac

500

The fire Brand of Michel Hébert
of Bayou TerreBonne.
Recorded, this 8th February 1865
Alfred Rougelot
Recorder
Parish of Terrebonne.

No. 500: Michel Hebert

The fire Brand of Mules & cattle
belonging to "Nameoka" plantation
are marked as per margin
Jno Heavanne
Manager

501

Recorded, this 8th February 1865
Alfred Rougelot
Recorder
Parish of Terrebonne

No. 501: Nameoka Plantation

502 The fire brand of Mules
and cattle on Ardoyne Plant.
is a "W" as per margin, with
a "crop" on right ear.

Recorded, this 8th February 1865
Alfred Rougelot
Recorder

No. 502: Ardoyne Plantation

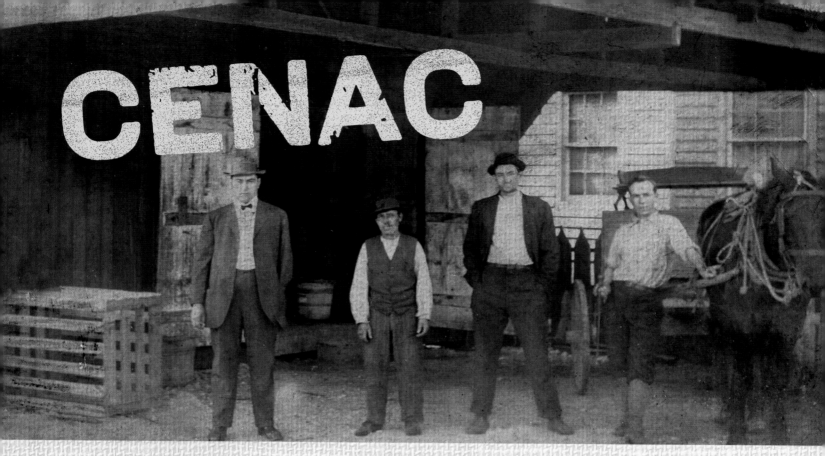

In front of C. Cenac & Co., c. 1920, from left, William Jean Pierre Cenac, Russell Strada, Jean Baptiste Cenac, Jean Pierre Carrere

CENAC

Jean-Pierre Cenac of the High Pyrenees village Barbazan-Debat settled in Terrebonne Parish after emigrating from France as a young man in 1860. He married Victorine Fanguy of Grand Caillou and the couple established their home and family in that lower parish bayou community, in Dulac. Pierre's brand registration is No. 499, dated January 1865.

The couple had eight sons and six daughters who were reared in Dulac. Early on, Pierre was in the fur business, cane planting, and owned a large number of oyster beds. He had a wooden sugar house and used the open-kettle method to produce sugar at Bayou Salé.

After his initial and largest purchase of land from Robert Ruffin Barrow along Bayou Grand Caillou, Pierre continued to expand his property holdings by buying land outright and by purchasing patents, in 1868 and 1871. Later, he traded for land, and acquired other tracts via quitclaim and at tax sales. At the time of his death in 1914, he had accumulated approximately 4,000 acres.

Pierre Cenac and his sons operated the plantation, a syrup mill and grocery store at Dulac. He also owned a grocery store and shucking factory in lower Little Caillou at Boudreaux Canal. Besides these businesses, he owned a livery stable and a bakery in the 600 block of Main Street, and a broom factory on Park Avenue, in Houma.

On his rural land, he and his family had pigs, cattle, chickens, and other livestock. In his younger years, he began his long-lived occupation of trading and selling horses and mules. His family's domestic lives were closely tied to the fertile soil and the productive waters surrounding their land. Thus they also owned a number of one-mast luggers and a two-masted schooner as well.

For a family that planted, raised, and caught much of what they ate—as well as through Pierre's long association with trading and selling horses and mules—livestock brands were a necessity. His and his sons' and other family members' brands are among those recorded in Terrebonne Parish's earliest registration ledger books.

Jean-Pierre Cenac
(June 12, 1838 – April 29, 1914),
Brand No. 499
dated January 31, 1865

Albert Cenac, son of Jean-Pierre Cenac,
Brand No. 833 dated October 16, 1917
Ad from The Southern Manufacturer,
Terrebonne Edition, 1901

Ovide J. Cenac, son of Albert Cenac, photo c. early 1960s. Brand registered c. 1950s

Alphonse J. Cenac, Sr. with mule, c. late 1930s

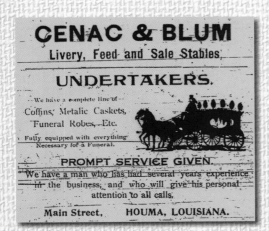

Ad from the Terrebonne Times of October 8, 1910.

Grandchildren of Albert Cenac: Arlen B. Cenac Sr. on pony, Felix A. Delatte, Jr. third from right, Clark C. Cenac second from right, Ernest Albert "Butch" Cenac, Jr., at far right c. late 1930s

A.R. Cenac, Jr. on left, and A.J. Cenac, Jr. c. 1939-40

Cody Christopher Cenac, son of Clark C. Cenac, and grandson of Ovide J. Cenac. Brand registered 2006

Cody Christopher Cenac, brand registered 2002

Fire Brands Book One

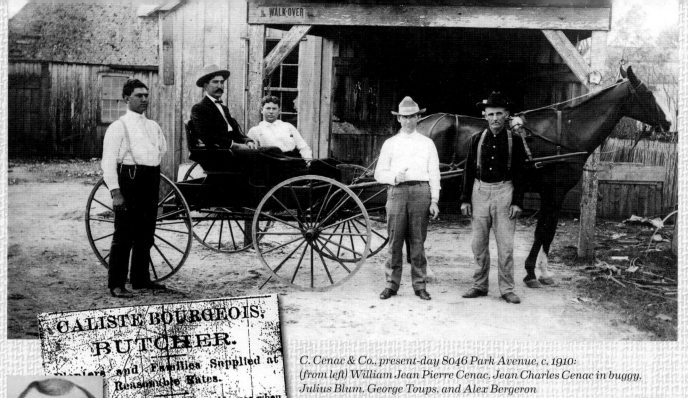

C. Cenac & Co., present-day 8046 Park Avenue, c. 1910: (from left) William Jean Pierre Cenac, Jean Charles Cenac in buggy, Julius Blum, George Toups, and Alex Bergeron

Ad from Houma Courier, *February 26, 1897*

Caliste Charles Cenac, son of Jean Charles Cenac, c. 1905

Bernard Jean-Pierre Caliste Bourgeois, father of Gertrude Laurentine Bourgeois Cenac (Jean Charles) and Marie Madeleine Bourgeois Cenac (William Jean-Pierre) No. 610 dated June 26, 1885

Dr. Philip Louis Cenac, Sr., son of William Jean-Pierre Cenac, three-pointed star brand c. early 1950s

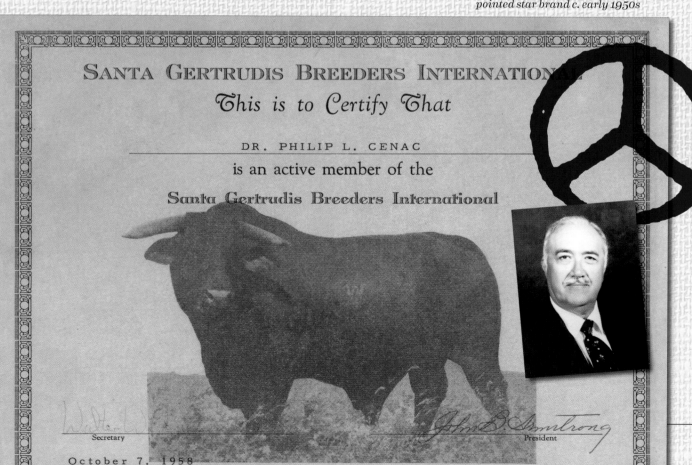

Paul M. Cenac, son of Jean-Pierre Cenac, No. 861 dated November 28, 1919

Jean-Pierre Cenac, Jr., Brand No. 938 dated July 28, 1926

Justilien Carrere, son of Victorine Aimée Cenac and Jean Pierre Carrere, Sr., Brand No. 947 dated October 23, 1928

John Hubert (var. Herbert) Carlos, son of Marie Cenac and Salvador Carlos, Sr. Brand No. 887 dated May 10, 1921

Rodney J. Roddy at right and Gene Roddy, son-in-law and grandson of Marguerite Cenac Carlos, c. 1905

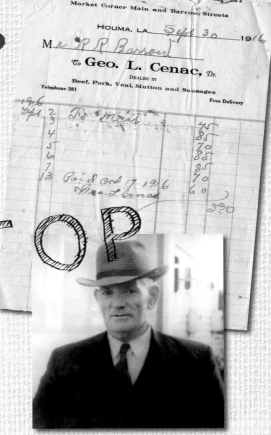

George L. Cenac, son of Jean Baptiste Cenac, Brand No. 796 dated March 16, 1916

Fire Brands Book One

GO
No. 503:
Antoine Gassien Authément

W.K.
No. 504:
William H. Knight

fT
No. 505:
Ferdinand Thériot

2 6
No. 506:
Jean C. Martin

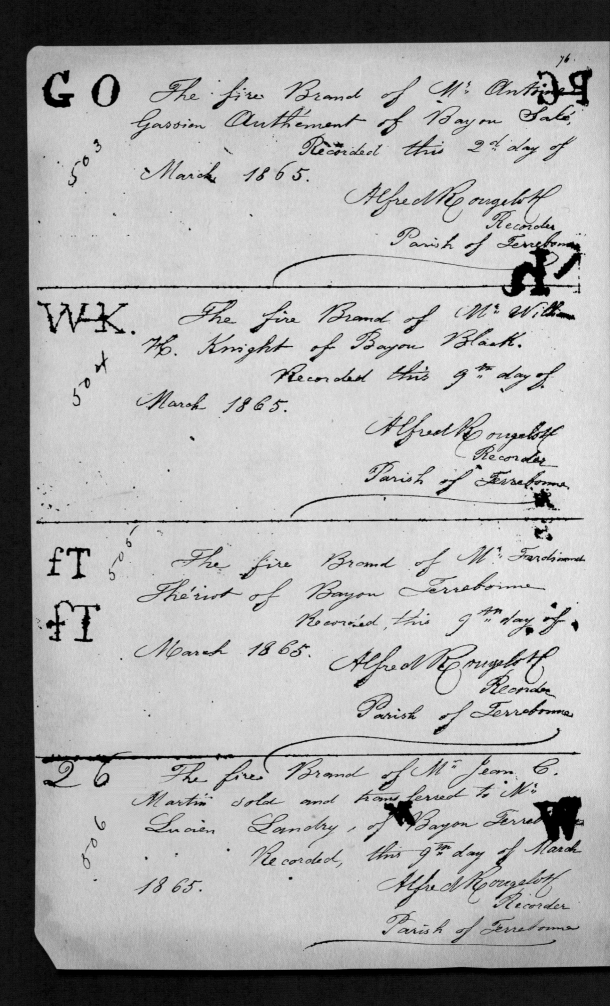

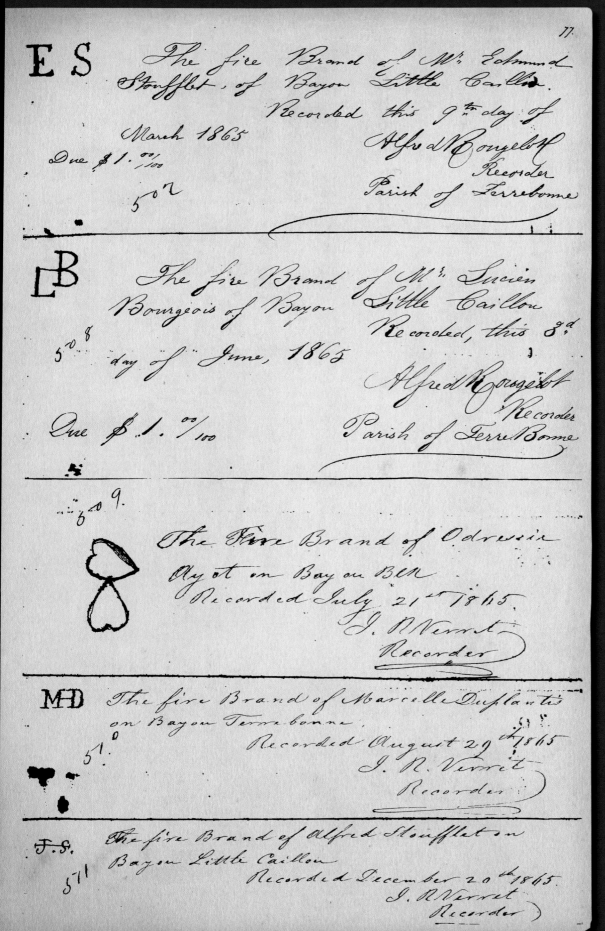

ES

The fire Brand of Mr. Edmund Stoufflet, of Bayou Little Caillou.
Recorded this 9th day of March 1865

Due $1.00/100

Alfred R. Bougelot
Recorder
Parish of Terrebonne

502

No. 507: Edmund Stoufflet

LB

The fire Brand of Mr. Lucien Bourgeois of Bayou Little Caillou
Recorded this 3d day of June, 1865

508

Alfred R. Bougelot
Recorder
Parish of Terrebonne

Due $1.00/100

No. 508: Lucien Bourgeois

509

The Fire Brand of Odressie Ayot on Bayou Black.
Recorded July 21st 1865.

J. R. Verret
Recorder

No. 509: Odressie Ayot

MD

The fire Brand of Marcelle Duplantis on Bayou Terrebonne.
Recorded August 29th 1865

510

J. R. Verret
Recorder

No. 510: Marcelle Duplantis

A·S·

The fire Brand of Alfred Stoufflet on Bayou Little Caillou
Recorded December 20th 1865.

511

J. R. Verret
Recorder

No. 511: Alfred Stoufflet

O G
No. 512:
Trasimond O. Gautreaux

O G. The Fire Brand of Trasimond O. Gautreaux of this Parish.
Recorded March 12th 1866.
J. R. Verret
Recorder

B. I.
No. 513:
Léo Félicien Babin

B. I. The Fire Brand of Léo Félicien Babin on Bayou Little Caillou in this Parish.
Recorded April 21st 1866.
J. R. Verret
Recorder

B. O.
No. 514:
François Omer Babin

B. O. The Fire Brand of François Omer Babin on Bayou Little Caillou in this Parish.
Recorded April 21st 1866.
J. R. Verret
Recorder

S. S.
No. 515:
Estelle Saulet

S. S. The Fire Brand of Estelle Saulet of this Parish, on Pointe aux Chiens.
Recorded May 17th 1866.
J. R. Verret
Recorder

3 O.
No. 516:
Dominique Henry Billiot

3 O. The Fire Brand of Dominique Henry Billot of Pointe aux Chiens, in this Parish.
Recorded May 21st 1866.
J. R. Verret
Recorder

Fire Brands Book One, pages 78 & 79

The Fire Brand of James Redman a freedman of this Parish
Recorded July 20th 1866
J. R. Verret
Recorder

517

No. 517:
James Redman
Freedman

The fire Brand of Messrs W. R. T. M. & G. W. Cage of this Parish.
Recorded February 5th 1867
J. R. Verret
Recorder

518

No. 518:
W. R. Cage, T. M. Cage, & G. W. Cage

The Fire Brand of Dr. Alexander S. Helmick of this parish.
Recorded March 2d 1867
J. R. Verret
Recorder

519

No. 519:
Dr. Alexander S. Helmick

The Fire Brand of Joseph Picou of this Parish
Recorded March 20th 1867
J. R. Verret
Recorder

520

No. 520:
Joseph Picou

The Fire Brand of Onézipe Robichaux of this Parish, on the lower Terrebonne.
Recorded October 30th 1867
J. R. Verret
Recorder

521

No. 521:
Onézipe Robichaux

Cajun children fishing in Bayou Terrebonne near Andrew Price School, Schriever, Louisiana, June 1940

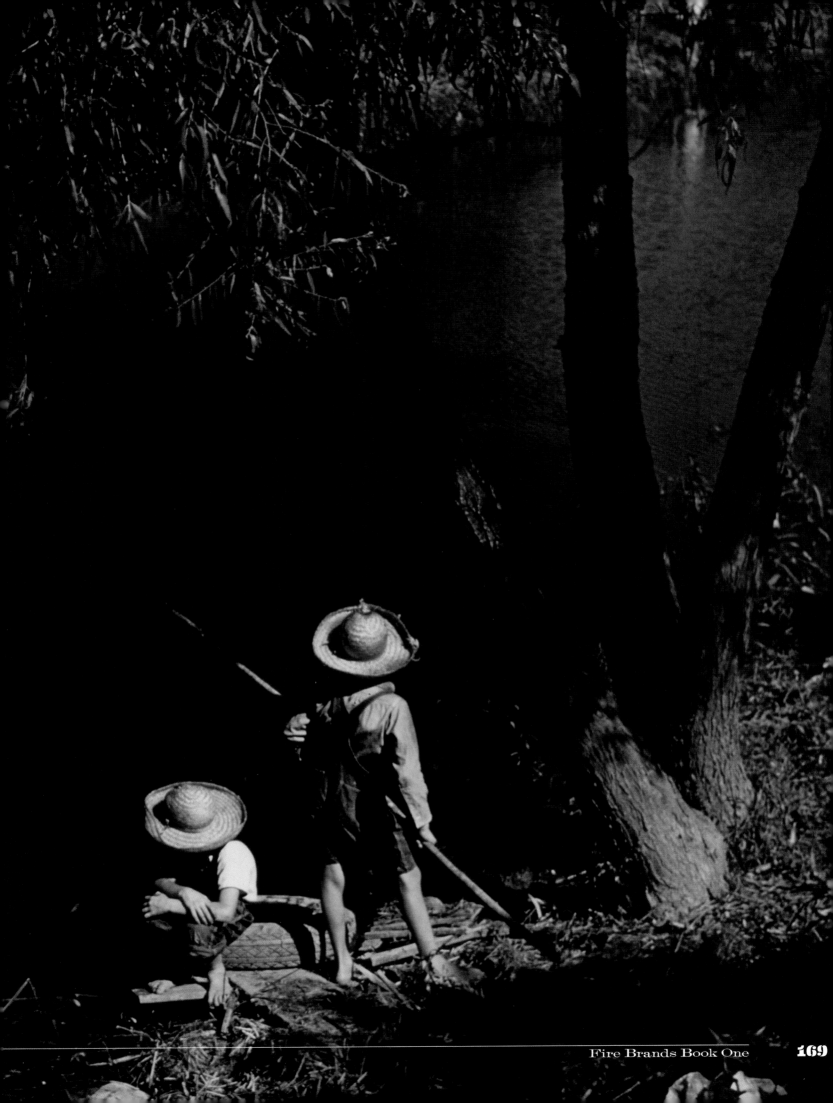

CDM. The Fire Brand of Mr. Clinton D. Middleton of the Parish of Terrebonne.

Recorded March 9th 1868.

J. R. Verret
Recorder

NN. The Fire Brand of Carter Braxton a freedman of the Parish of Terrebonne

Recorded March 9th 1868

J. R. Verret
Recorder

MA. The Fire Brand of Mrs Marie Arsenaux, wife of Huberville Arsenaux of the parish of Terrebonne

Recorded May 1st 1868

J. R. Verret
Recorder

HB. The Fire Brand of Henry Franklin Belanger of the Parish of Terrebonne

Recorded July 2nd 1868.

J. R. Verret
Recorder

JMB The Fire Brand of Jules Martial Burguieres of the Parish of Terrebonne

Recorded July 2nd 1868

J. R. Verret
Recorder

No. 522: Clinton D. Middleton
No. 523: Carter Braxton *Freedman*
No. 524: Marie Arsenaux
No. 525: Henry Franklin Belanger
No. 526: Jules Martial Burguieres

LIVESTOCK BRANDS AND MARKS

V. 527 — The fire Brand of Leufroy Burguieres of the Parish of Terrebonne.
Recorded July 2d 1868.
J. B. Verret
Recorder

PT 528 — The Fire Brand of Trasimond Portier of this Parish.
Recorded July 3d 1868.
J. B. Verret
Recorder

GW 529 — The Fire Brand of George Washington of this Parish.
Recorded, Jany. 16" 1869.
Jno. J. Musharay
Recorder

C2 530 — The fire brand of Arthur W. Connely of this parish.
Recorded, Mch. 5" 1869.
Jno. J. Musharay
Recorder

B3 531 — The Fire Brand of Bannon Bonvillain of this parish.
Recorded April 3" 1869.
Jno. J. Musharay
Recorder

DW 532 — The fire brand of Denis Washington of this parish.
Recorded May 26" 1869
Jno. J. Musharay
Recorder

G.W. 533 — The fire brand of Granville Woolens of this parish.
Recorded July 12" 1869.
Jno J Musharay
Recorder

C.F.
No. 534:
Clement Fletcher

C.F. 534 The fire brand of Clement Fletcher of this parish.
Recorded July 24" 1869
Jno. J. Shushaway
Recorder.

T.G.
No. 535:
Tilghman Gordon

T.G. 535 The fire brand of Tilghman Gordon of this parish of Terrebonne.
Recorded, Sept. 11" 1869.
Jno. J. Shushaway
Recorder

WI
No. 536:
William Wright

WI 536 The fire brand of William Wright of the parish of Terrebonne, on Bayou du Large is "W.I."
Recorded Oct. 22" 1869
Jno. J. Shushaway
Recorder

ES
No. 537:
Jean Baptiste Gendron

ES 537 The fire brand of Jean Baptiste Gendron of the parish of Terrebonne on Bayou Little Caillou.
Recorded Nov. 22" 1869.
Jno. J. Shushaway
Recorder

A T
No. 538:
Augustave Theriot

A T 538 The fire brand of Augustave Theriot of the parish of Terrebonne.
Recorded Nov. 24" 1869.
Jno. J. Shushaway
Recorder

7
No. 539:
Philip Dick

7 539 The fire brand Philip Dick, colored, residing on Bayou Dularge in this Parish.
Recorded. Feby. 11" 1870.
Jno. J. Shushaway
Recorder

E.
540

The fire brand of Mrs. Louisa W. Francis wife of Richard N. Francis, of the Parish of Terrebonne.
Recorded, March 29" 1871.
J. J. Mucharray
Recorder

N.C.
541

The fire brand of Nat. Clark of Houma, Parish of Terrebonne.
Recorded, Sept. 16" 1871.
J. Mucharray
Recorder

7!.
542

The fire brand of Philip Merrit of Bayou Black, Parish of Terrebonne.
Recorded January 3" 1872
J. M. Buquieres dy
Recorder

T.H.C.
543

The fire brand of Theophile H. Chauvin a resident of the Parish of Terrebonne, and State of Louisiana.
Recorded, March 28" 1872.
J. Mucharray
Recorder

H.B.
544

The fire brand of Arthur Joseph Bourg a resident of the Parish of Terrebonne, and State of Louisiana
Recorded April 17" 1872
J. M. Buquieres Dy
Recorder

A
545

The fire brand of Abraham Vickers, resident of the Parish of Terrebonne, and State of Louisiana
Recorded April 18" 1872
J. M. Buquieres
Dy Recorder

C.V.A.
No. 546:
Ernest L. Aycock

546 C.V.A. The fire brand of Ernest L. Aycock, of the Parish of Terrebonne.
Recorded June 3rd 1872.
JM Buquieres dy
Recorder

No. 547:
Alcide C. Knight
& William O. Knight

547 The fire brand of Alcide C. Knight & William O. Knight, residents of the Parish of Terrebonne.
Recorded, August 12" 1872.
J.J. Minshaway
Recorder

N.L.
No. 548:
Narcisse Labat

548 N.L. The fire Brand of Narcisse Labat, a resident of the Parish of Terrebonne
Recorded August 24th 1872
JM Buquieres dy
Recorder

C.P.
No. 549:
Carmelite Plessent

C.P. The fire Brand of Carmelite Plessent, 549 a resident of the Parish of Terrebonne.
Recorded August 31st 1872
JM Buquieres dy
Recorder

72
No. 550:
Amedeé Hebert

72. The fire Brand of Amedeé Hebert, 550 a resident of the Parish of Terrebonne.
Recorded September 14th 1872
JM Buquieres dy
Recorder

The brand was transferred to Harry Hebert Houma 9/2/15

S.A.D. The fire-brand of Sosthene A. Darcé Jr.
551 of this Parish.
 Recorded, December 3" 1872.
 J. J. Minshaway
 Recorder

J.J. The fire brand of Jackson Jones
552 of this Parish.
 Recorded, March 8" 1873.
 J. J. Minshaway
 Dy Recorder

▽ The fire brand of David McClelland
553 of the Parish of Terrebonne
 Recorded, April 23" 1873.
 J. J. Minshaway
 Dy Recorder

554
T.O. The fire brand of Thomas Anderson
a resident of the Parish of Terrebonne,
State of Louisiana.
 Recorded, June 3" 1873.
 J. J. Minshaway
 Dy Recorder

B.J. The fire brand of Babtiste Jule
555 a Resident of the Parish of
Terrebonne State of Louisiana
 Recorded August 11" 1873
 H. M. Johnson
 Recorder

556. **C.L.D.** The fire brand of Charles W. DuRoy of the Parish of Terrebonne

Recorded June 24th 1875

G. Montegut
Dy Recorder

557. **2** The fire brand of Mathilde Devillers transient resident of the Parish of Terrebonne

Recorded February 9th 1876

G. Montegut
Dy Recorder

558. **MN** The fire brand of Alfred J. Naquin a resident of this parish, exhibited to me this day. May 3rd 1876.

Recorded May 3rd 1876

G. Montegut
Dy Recorder

559. **GN** The fire brand of George Nixon, a resident of this parish.

Recorded May 31st 1876

G. Montegut
Dy Recorder

560. **A** The fire brand of Tiburse Barras a resident of this Parish

Recorded August 17th 1876

G. Montegut
Dy Recorder

561 A.W. The fire brand of Arthenea Rebecca White, of this Parish; together with an under half crop in the left Ear. made thus

Recorded August 26th 1876.

G. Montegut
Dy Recorder

562 E.1. The fire Brand of Emeline Campbell and the ear mark — the right ear.

Recorded July 5th 1877.

A. V—
Dy Recorder

563 R.5. The fire Brand of Major Man, and the right ear cut and split.

Recorded June 14th 1877.

A. V—
Dy Recorder

564 H.S. The fire Brand of Jerry Harris, getz Sarah of Edwardsburg, together with an under half crop in the left ear, and split in the right ear —

Recorded August 20th 1877.

A. V—
Dy Recorder

B.N.
No. 565:
Alcé Naquin

No. 566:
Malgloire Barriolet

B.A.
No. 567:
Pierre Blanchard

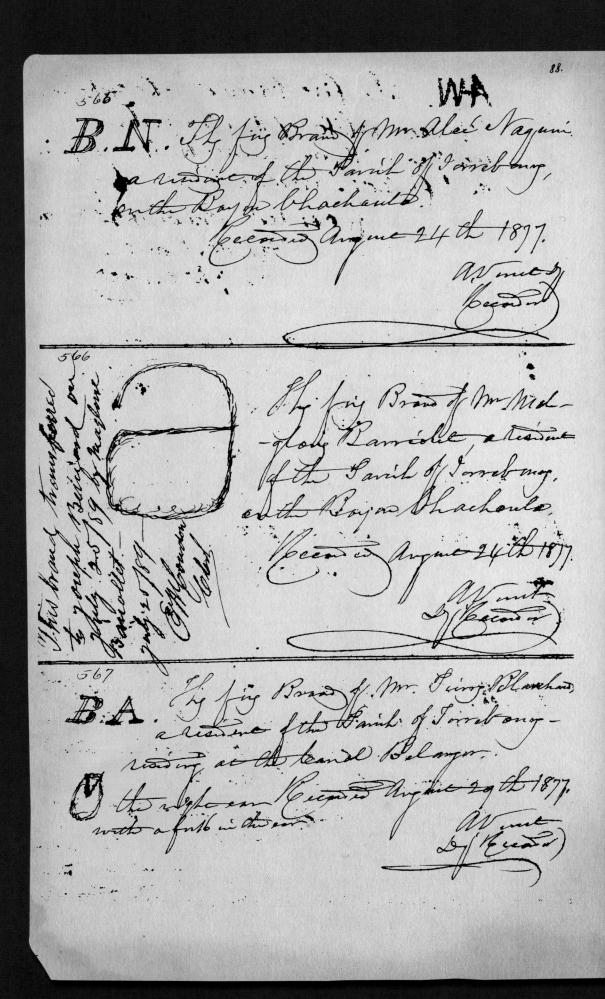

Fire Brands Book One, pages 88 & 89

568

H.W. The fire Brand of Henry Walther a resident of the Parish of Terrebonne at Tigerville.

Recorded September 13th 1877.

A. Verret
Recorder

H.W.

No. 568:
Henry Walther

569

H.O.R. The fire Brand of Hugh O. Rourke, a resident of the Parish of Terrebonne at Tigerville La.

Recorded September 13th 1877.

A. Verret
Recorder

No. 569:
Hugh O. Rourke

570

P.6. The fire Brand of Henry Clay Porche a resident of this Parish, on the Bayou Black.

Recorded September 21st 1877.

O the left ear with a crop under.

A. Verret
Recorder

P. 6.

No. 570:
Henry Clay Porche

571

L.O. The fire Brand of L. A. Leriche a resident of this Parish, below the Town of Tigerville on the Bayou Black.

Recorded October 6th 1877.

A. Verret
Recorder

L.O.

No. 571:
L. A. Leriche

WALTHER

Philippe Walther
(May 23, 1822 – January 1906);
Brand No. 248 dated May 10, 1839

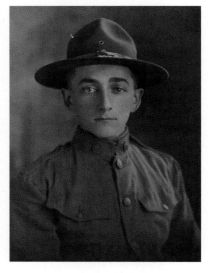

Stanley Walther, Dr. Walther's father, in World War I uniform c. 1918

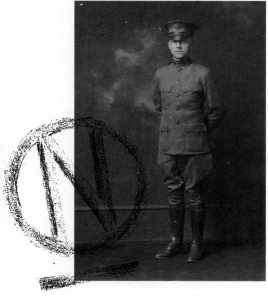

Owen Walther, Dr. Walther's uncle, in World War I uniform c. 1918 Brand No. 963 dated November 20, 1930

Dr. Dick C. Walther was the first native son of Terrebonne Parish to have graduated from college in veterinary medicine to return home to practice. A 1947 graduate of Terrebonne High School and 1951 graduate of Louisiana State University, he completed his education at Texas A&M. He returned to his home parish in June 1955, and three days later was confronted with an anthrax outbreak in the cattle herd of E.T. Brady, Sr. on Bayou Dularge.

He was to deal with this scenario nine times in the seven-parish practice area he served from 1955 until 1975. Each case was along the high ridges of the individual parishes; the anthrax spore had lain dormant in the soil of former cattle trails since the late 1800s and early 1900s. At that time, cattle that died were left unburied on the trails, and the spores leached from their corpses into the land beneath. After a safe subcutaneous vaccine became available in the late 1950s, no more known outbreaks of the disease have occurred in those seven parishes.

Dr. Walther was reared in Gibson in a family founded by Philip (originally Philippe) Walther, an immigrant from Alsace-Lorraine in France, but of Germanic ancestry. When he arrived in Louisiana in the late 1830s, he first lived in Thibodaux, then moved to what was then known as Tigerville. He was a carpenter by trade.

The Walthers were among the early inhabitants of present-day Gibson, and their families developed strong agrarian ties to the northwestern area of Terrebonne Parish. Philippe was an early registrant of his brand, No. 248, in 1839. His son Henry's brand was recorded in 1877 as No.568. Dr. Walther's father Stanley was Henry's seventh son.

Two of Dick Walther's sons continue to work with livestock in agriculture today. John is the deputy assistant commissioner of the Louisiana Department of Agriculture and Forestry, and director of the Veterinary Health Division. Glenn is a veterinarian practicing in Terrebonne Parish. Dan and Ben work in other fields, both locally.

Dr. and Mrs. Walther live on the W-4 Farm along Little Bayou Black in Terrebonne Parish. Dr. Walther has his own brand, registered in Baton Rouge by the Louisiana Livestock Brand Commission.

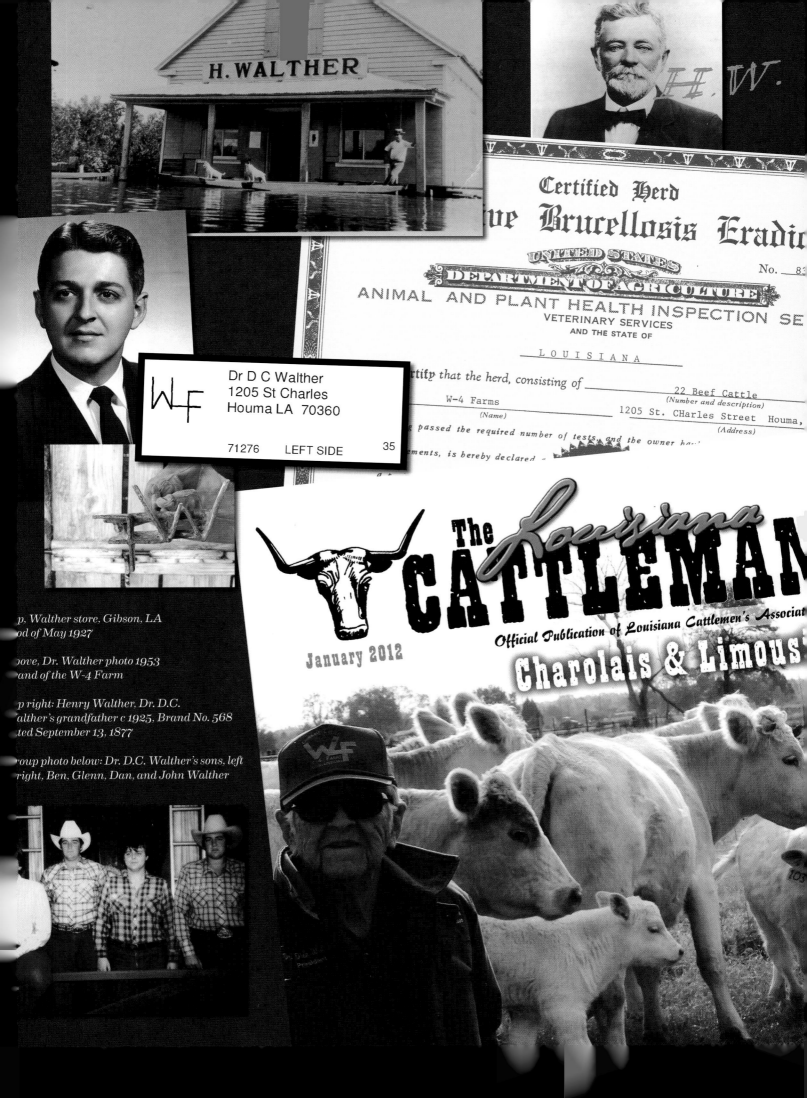

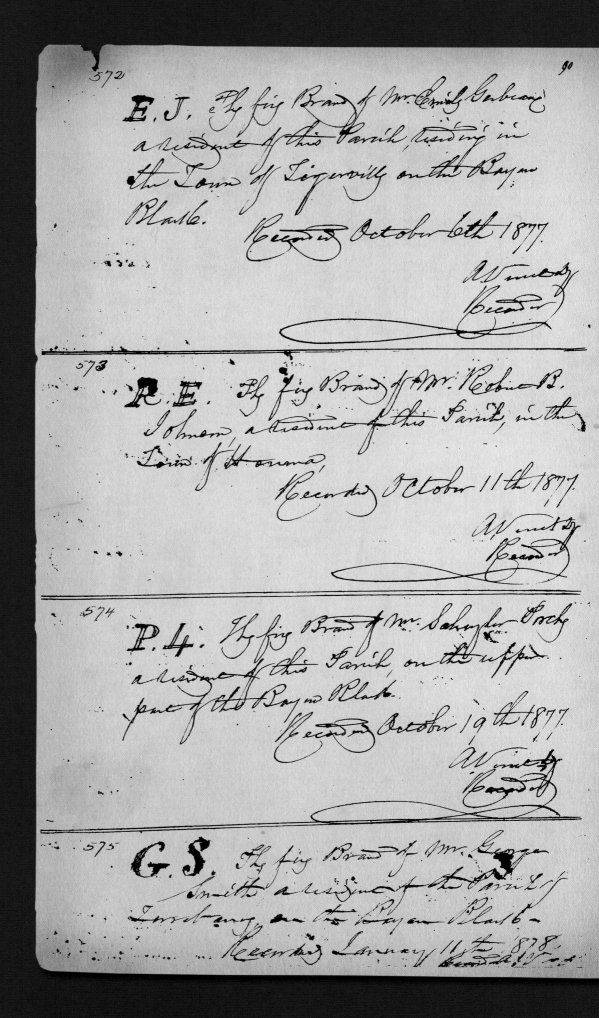

No. 572: Emile Gerbeau

572. E.J. The fig Brand of Mr. Emile Gerbeau a resident of this Parish, residing in the Town of Tigerville on the Bayou Black.
Recorded October 6th 1877.

No. 573: Robert B. Johnson

573. R E. The fig Brand of Mr. Robert B. Johnson, a resident of this Parish, in the Town of Houma.
Recorded October 11th 1877.

No. 574: Schuyler Porche

574. P.4. The fig Brand of Mr. Schuyler Porche a resident of this Parish, on the upper part of the Bayou Black.
Recorded October 19th 1877.

No. 575: George Smith

575. G.S. The fig Brand of Mr. George Smith a resident of the Parish of Terrebonne, on the Bayou Black.
Recorded January 11th 1878.

J — 576

The fire Brand of Mr. Jupiter Taylor a resident of the Parish of Terrebonne
Recorded June 10th, 1878
N. M. Calhoun
Dy Recorder

AJB — 577

The Fire Brand of A. J. Bascle, resident of the parish of Terrebonne, 9 miles below Houma.
Recorded July 20th, 1878.
N. M. Calhoun Dy Recorder

O2 — 578

The Fire Brand of Francois Roger, a resident of Terrebonne Parish, 9 miles below Houma.
Recorded 20th July, 1878
N. M. Calhoun Dy Recorder

UT — 579

The Fire Brand of Ulysse Theriot, a resident of the Parish of Terrebonne in the State of Louisiana; on Bayou Terrebonne, about three miles below Houma.
Recorded August 19th, 1878.
N. M. Calhoun
Dy. Recorder of Terrebonne Parish
La.

Request for transfer from Jean Mars to Walter Whipple; see Brand No. 445 on page 149.

STATE OF LOUISIANA,
PARISH OF TERREBONNE.

 Before me, the undersigned authority, this day personally came and appeared Walter Whipple, personally known to me, who upon being by me first duly sworn, did depose and say: That he is the grand-son of Jean Mars, who died in the parish of Terrebonne about the year 1885; that the said Jean Mars caused to be registered in his name, a certain Fire Brand, designated as the Number "2", which was duly recorded on December 4th, 1856, in Fire Brand Book "A", under the number 445; that affiant has been using said brand on his own cattle for the past 36 years; that he wishes to have said brand registered in his name.

Walter Whipple

 Sworn to and subscribed before me at Houma, Louisiana, this 11th day of October, A. D. 1928.

Deputy Clerk of Court.

580

J2 The Fire Brand of Madame Evariste Martin, resident of the Parish of Terre=bonne, on Bay Terrebonne at Canal Bellanger, about ~~three~~ nine miles below the Town of Houma.

Recorded in this Office August 19th A.D. 1878.

N. M. Calhoun
Dy Recorder of
Terrebonne Parish
La

581

Left Ear } The Flesh mark of
Right Ear } Madame Evariste Martin

A crap off of the left Ear and two slits in same; and a crap off of the right Ear only.

Recorded August 19th, 1878
N. M. Calhoun
Dy Recorder of
Terrebonne
Parish

Abel LeBlanc, Jr.
Brand No. 1130
dated April 26, 1946

582 "O" The Fire brand of Columbus Brown, Timbelier Island, Parish of Terrebonne, Louisiana.

Recorded February 17th, 1879

A. M. Calhoun
Deputy Recorder for
Terrebonne Parish
Louisiana

583 "A O R" The Fire Brand of Andrew O'rourke a Resident of the Parish of Terrebonne

Recorded April 3rd 1879

J. Pollard
Recorder

584 ND The Fire Brand of Noah Dedrick a resident of Parish of Terrebonne

Recorded April 17th 1879

J. Pollard
Recorder

J.F.
No. 585:
Justillien Fields

H
No. 586:
Herrick Nash

DBC
No. 587:
Daniel Batiste Celestin

J.F. 585

J.F. The Fire Brand of Justillien Fields of Terrebonne,

Recorded this the 12th day of June, A.D. 1879.

N. M. Calhoun
Deputy Recorder

H 586

H The Fire Brand of Mr. Herrick Nash of the Parish of Terrebonne, State of Louisiana.

Recorded June 28th, 1879.

N. M. Calhoun,
Deputy Recorder

DBC 587 The fire brand of Daniel Batiste Celestin, of the Parish of Terrebonne, State of Louisiana.

Recorded January 6th, 1886

N. M. Calhoun
Recorder for the
Parish of Terrebonne
La.

588 The State of Louisiana
 Parish of Terrebonne

G.B. The fire brand of
George Bisland, a resident
of this parish
 Recorded April 12th 1880
 G Monteque
 Dy Clerk 19th Jud. Dist
 Ex Officio Recorder
 Terrebonne

 The State of Louisiana
 Parish of Terrebonne

589 **W.R.** The fire brand of Wilson
Rollins, a resident of this parish.
 Recorded June 5th 1880
 G Monteque Dy Clerk
 19th Jud. Dist Court Ex Officio Recorder Terrebonne

 The State of Louisiana
 Parish of Terrebonne

590 **4T** The fire brand of John Taylor
Theriot, a resident of this parish
 Recorded Aug 4th 1880
 G Monteque Dy Clerk
 19th Jud. Dist Court Ex Officio Recorder
 Terrebonne

WRIGHT

Holden Wright settled in Terrebonne after moving from Wrightsville, Pennsylvania in 1829. Holden became a sugar planter, and once owned Waterproof, Myrtle Grove and Roberta Grove plantations. He and his wife, Nancy Griffin, had 13 children, the eighth of whom was William who entered public service as Houma alderman. Holden's son Abraham also served in that position. William's son Thomas Elward became parish assessor, and Thomas Elward's son Elward was elected mayor of Houma in 1929. Thomas Elward and William Wright, Jr. both served as postmasters. William Wright, Jr. ran a livery stable for many years on the corner of Belanger and Grinage streets. This was torn down in 1935, but the Wrights continued dealing with equines on the outskirts of town at the southern end of Barrow Street by operating a riding establishment from which horses could be rented, until the mid-1900s.

Holden E. Wright (1792 – August 14, 1868), photo probably taken at Concord Plantation on Bayou Black c. 1850

Jasper K. Wright, Jr., Brand No. 943 dated June 1, 1928

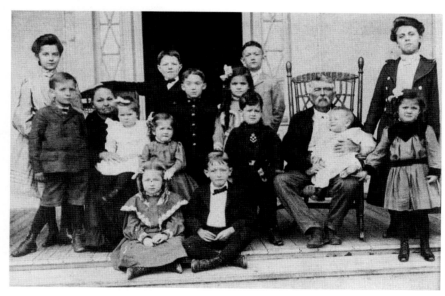

Abraham Wright and Mary Callahan Wright with their twelve children and two others c. 1886 (in no special order) Eva Marie, Ida, Holden Otis, Joanne Laura, Laura, Abraham Elisha, John Edward, Nancy Charlotte, Margaret Florence, Maria Elia, Lester E., and Ellen. Below, Wright's Livery Stable c. 1910 at the corner of Belanger and Grinage streets in Houma

William A. Wright, Sr., Brand No. 536 dated October 22, 1869

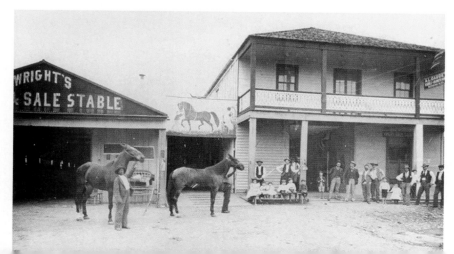

William A. Wright, Jr. c. 1896

541 The State of Louisiana
Parish of Terrebonne

J.W. The fire brand of Mrs John Wright a resident of this parish

G. Montegut Dy Clerk 19th Judt Dist Court & Ex Officio Recorder
Terrebonne

Recorded Augt 7" 1880.

J.W.

No. 591:
Mrs. John Wright

592 The State of Louisiana
Parish of Terrebonne.—

G the fire brand of Mr. Ernest Guidry a resident of this parish.—

Shipp Condon
Clerk 19th D'rit. Court
& Ex-officio Recorder.—
Terrebonne.

Recorded Sept 9 / 80
J.W. Condon
Clerk.—

G

No. 592:
Ernest Guidry

593 Z The State of Louisiana
Parish of Terrebonne

The fire brand of Mrs Josephine M. Knight wife of Lawful age of Valfroid M Bourgeois a resident of this parish —

G. Montegut Dy Clerk
Terrebonne

Recorded September 17th 1880.

Z

No. 593:
Josephine M. Knight

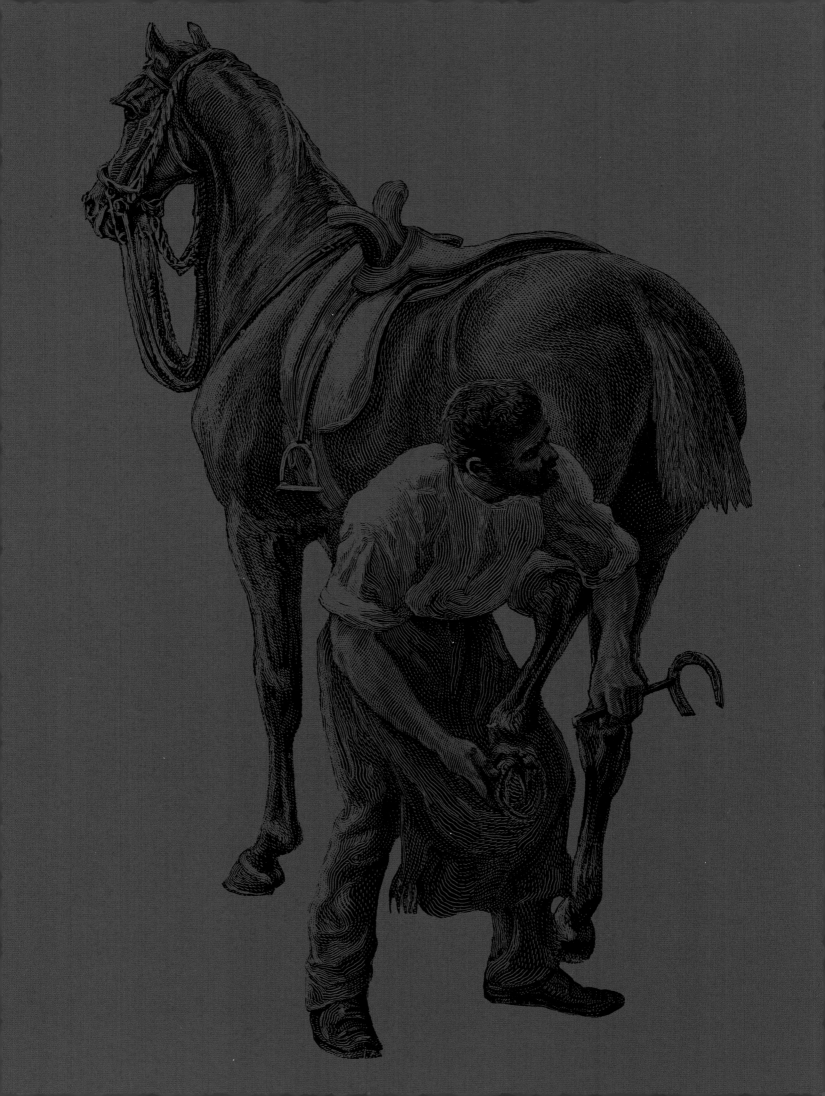

594

OP

The State of Louisiana
Parish of Terrebonne

The firebrand of Oberton Payne a resident of this parish is O.P.

Recorded October 14th 1880

G. Montegut
Dy Clerk, Terrebonne

No. 594: Oberton Payne

595

₸ L

The State of Louisiana
Parish of Terrebonne

The fire brand of Mrs Mary R. Schwing a resident of this parish

Recorded October 15th 1880

G. Montegut
Dy Clerk Terrebonne

No. 595: Mary R. Schwing

596

S-S

The State of Louisiana
Parish of Terrebonne

The fire brand of Stafford Smith of the parish of Terrebonne is, S-S

Recorded October 27" 1880

G. Montegut
Dy Clerk Terrebonne

No. 596: Stafford Smith

597

L^c

The State of Louisiana
Parish of Terrebonne

The fire brand of Sylvain LeBlanc of the parish of Terrebonne, is L^c

Recorded Nov. 23/80

G. Montegut
Dy Clerk

No. 597: Sylvain LeBlanc

The State of Louisiana
Parish of Terrebonne

544

OP The fire brand of Chester Joyce
 a resident of this parish is OP

Recorded October 14th 1880

 J. J. Marteau
 Dy Clerk, Terrebonne

The State of Louisiana
Parish of Terrebonne

545

TE The fire brand of Mrs Mary R Asbury
 a resident of this Parish

Recorded October 14th 1880

 J. J. Marteau
 Dy Clerk Terrebonne

The State of Louisiana
Parish of Terrebonne

546

SS The fire brand of Stafford Smith
 of the parish of Terrebonne is
 - SS -

Recorded October 14th 1880

 J. J. Marteau
 Dy Clerk
 Terrebonne

The State of Louisiana
Parish of Terrebonne

547

E The fire brand of Ephraim McKlare
 of the parish of Terrebonne, is E

Recorded Nov 3, 1880

 J. J. Marteau
 Dy Clerk

HB 598 The State of Louisiana
Parish of Terrebonne
The fire brand of Henderson Bennett
of the parish of Terrebonne, State aforesaid,
is HB
Recorded Dec. 20th 1880.
A. J. Monteque
Dy Clerk Terrebonne

599 **A.B** The State of Louisiana
Parish of Terrebonne.—
The fire brand of Alexander
Butler of the parish of Terrebonne,
State aforesaid is A.B.
Recorded April 11th 1881.
J. W. Condon
Clerk of Court
Terrebonne.

600 **F.R.** The State of Louisiana
Parish of Terrebonne
The fire brand of Felice
Ross of the Parish of Terrebonne,
State aforesaid is F.R.
Recorded Sept 17 81.
J. W. Condon
Clerk

HB
No. 598:
Henderson Bennett

A.B
No. 599:
Alexander Butler

F.R
No. 600:
Felice Ross

S. H. Jr.
No. 601:
Thedrick Harvey Jr.

601 S. H. Jr. State of Louisiana.
Parish of Terrebonne.
The fire brand of Thedrick Harvey Junior of the Parish of Terrebonne, State aforesaid is S. H. Jr.
Recorded June 12th 1882.
E. H. Condon
Clerk.

"S. P"
No. 602:
Samuel Parker

602 "S. P" State of Louisiana
Parish of Terrebonne.
The fire brand of Samuel Parker, of the Parish of Terrebonne, State aforesaid is "S. P."
Recorded June 26th 1882.
E. H. Condon
Clerk

J. P.
No. 603:
John Pharr

603 J. P. State of Louisiana
Parish of Terrebonne.
The fire brand of John Pharr, of the Parish of Terrebonne, State aforesaid is J. P.
Recorded July 31st 1882.
E. H. Condon
Clerk

604

State of Louisiana
Parish of Terrebonne

The fire brand of William Barrow of the Parish of Terrebonne State aforesaid is

Recorded Aug 1st &c
E M Gordon
Clerk

605

State of Louisiana
Parish of Terrebonne

The fire brand of Armand St Martin of the Parish of Terrebonne, State aforesaid is ST

Recorded November 19th 1883
E M Gordon
Clerk

606

State of Louisiana
Parish of Terrebonne

The fire brand of Roberson Edward of th the parish of Terrebonne State aforesaid is L.J.

Recorded December 11th 1883
C L Powell
Dy Clerk

E.P.
No. 607:
Ernest Picou

T-K
No. 608:
Thomas H. Casey

607.

E.P. The State of Louisiana
Parish of Terrebonne

The fire brand of Ernest
Picou of the Parish of Terrebonne
is E.P.

Recorded Dec. 21/ 83 —

E. W. Condon
Clerk.

608

T-K State of Louisiana
Parish of Terrebonne.
The fire brand of
H. Casey of the Parish of
Terrebonne. La. is T-K

Recorded Jany 1/85. —

E. W. Condon
Clerk

LIVESTOCK BRANDS AND MARKS

609

State of Louisiana,
Parish of Terrebonne.
The fire brand of T. H.
Sampson, of the Parish
of Terrebonne is "𝒮".

Recorded March 2, 1885.
H. M. Wallis, Jr.
Deputy Clerk.

No. 609:
T. H. Sampson

610
"C.4.B"

State of Louisiana
Parish of Terrebonne.
The Fire brand of
Caliste Bourgeois of
the Parish of Terrebonne
is C. 4. B.

Recorded June 26/85.
J. H. Gondray
Clerk

No. 610:
Caliste Bourgeois

"C. & B."

State of Louisiana
Parish of Terrebonne.
The fire brand of
Calyxe Bourgeois, of
the Parish of Terrebonne
is C. & B.

Recorded June 26, 1885.
J. W. Gouday
Clk

Bernard Jean-Pierre Caliste Bourgeois
Brand No. 610 dated June 26, 1885

LIVESTOCK BRANDS AND MARKS

611

J.ᵃ.B.

State of Louisiana
Parish of Terrebonne.

The fire brand of James Brown of the Parish of Terrebonne is J.ᵃ.B.

Recorded Oct. 4/86.
H. M. Wallis, Jr.
Dy. Clerk.

612

DT

State of Louisiana
Parish of Terrebonne.

The fire brand of Daniel C. McIntyre of the parish of Terrebonne is "DT"

Recorded Nov. 8/86.
H. M. Wallis Jr.
Dy. Clerk

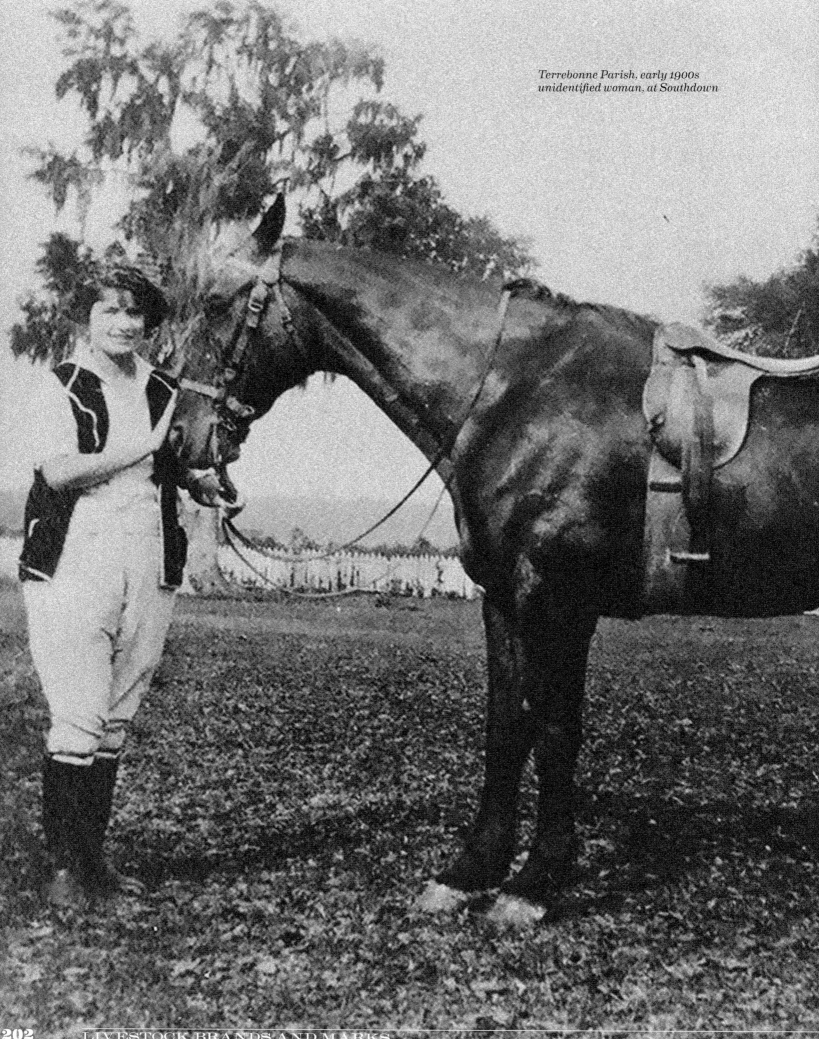

Terrebonne Parish, early 1900s unidentified woman, at Southdown

612
D:B.

State of Louisiana
Parish of Terrebonne.

The fire brand of Desire
Boudreaux of the Parish of
Terrebonne is D:B.

Recorded Mch 11/87.

H, M. Wallis
Dy. Clerk

613
HM

The State of Louisiana
Parish of Terrebonne

The fire brand of Henry
Moore of the Parish of
Terrebonne is HM.

Recorded Aug 13/87

E.W. Condon
Clerk

614

State of Louisiana
Parish of Terrebonne

The fire brand of Laurent Lacassagne, a resident of the City of New Orleans, Louisiana, & owning property in the parish of Terrebonne, La., is

Recorded August 17/87.

E. F. Condon
Clerk of Court
Terrebonne

No. 614:
Laurent Lacassagne

VB

No. 615:
Valery Boudeloche

State of Louisiana
Parish of Terrebonne
January 28, 1881

615.

VB The fire brand of the late Valery Boudeloche recorded July 27th 1869 on folio 23 of this book is this day and hereafter transferred to & claimed by Gedeon Boudeloche of this Parish, a property owner of said Parish — the said Gedeon Boudeloche being a son of the late Valery Boudeloche & claims the brand of his late Father for convenience & to prevent errors & mistakes in branding cattle —

Recorded Jany 28/88.

C. M. Condon
Clerk

S. 5.

616

The State of Louisiana
Parish of Tensas W

The Fire Brand of Paul
Samani, a resident of the
Parish of Tensas, State
of Louisiana is S 5.

Recorded July 30/88.

J. P. Condon
Clerk

No. 617:
Washington Gagnon

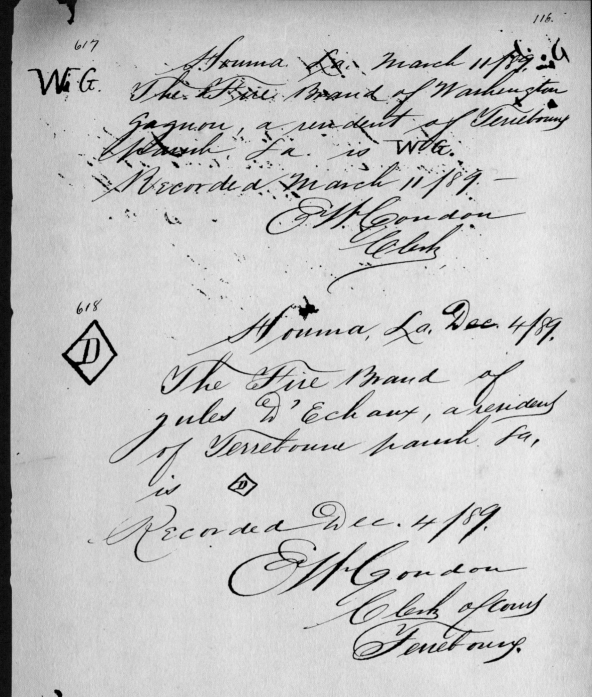

No. 618:
Jules D'Echaux

MEC. Houma. La. Feby 19/90.

The Fire Brand of Mrs. Mary E. Casey, wife of Thomas H. Casey, duly separated in property from her said husband by judicial decree, residing in the parish of Terrebonne. La, is **MEC**.

Recorded Feby 19/90

E. M. Condon
Clerk of Court
Terrebonne.

No. 620: Thomas Singleton

No. 621: Thomas Foucheux

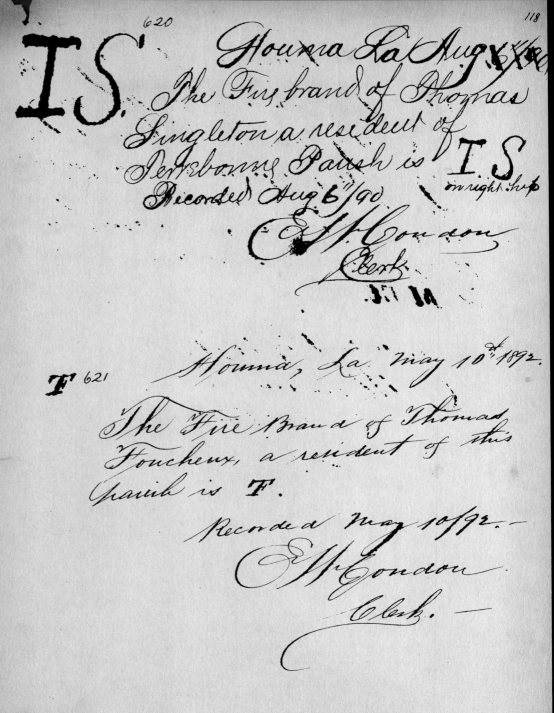

IS 620

Houma La Aug 6th/90

The Fire brand of Thomas Singleton, a resident of Terrebonne Parish is **IS** on right hip

Recorded Aug 6"/90

E H Condon
Clerk

T 621

Houma, La. May 10th 1892.

The Fire Brand of Thomas Foucheux, a resident of this Parish is **T**.

Recorded May 10/92.—

E H Condon
Clerk.—

Fire Brands Book One, pages 118 & 119

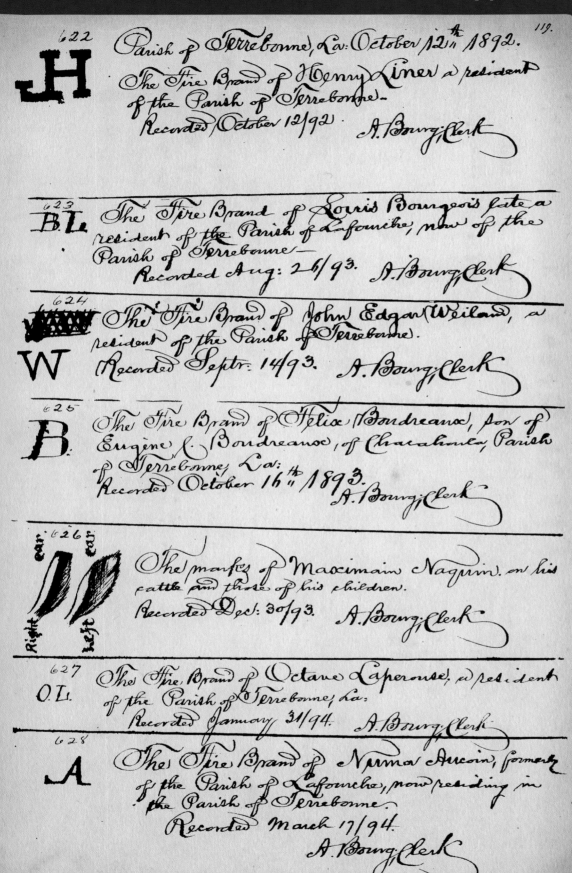

622. Parish of Terrebonne, La: October 12th 1892.
The Fire Brand of Henry Liner a resident of the Parish of Terrebonne—
Recorded October 12/92. A. Bourg, Clerk

623. The Fire Brand of Louis Bourgeois late a resident of the Parish of Lafourche, now of the Parish of Terrebonne—
Recorded Aug: 26/93. A. Bourg, Clerk

624. The Fire Brand of John Edgar Weiland, a resident of the Parish of Terrebonne.
Recorded Septr. 14/93. A. Bourg, Clerk

625. The Fire Brand of Felix Boudreaux, son of Eugene C. Boudreaux, of Chacahoula, Parish of Terrebonne, La:
Recorded October 16th 1893. A. Bourg, Clerk

626. The marks of Maximain Naquin on his cattle and those of his children.
Recorded Dec: 30/93. A. Bourg, Clerk

627. The Fire Brand of Octave Laperouse, a resident of the Parish of Terrebonne, La:
Recorded January 31/94. A. Bourg, Clerk

628. The Fire Brand of Numa Aucoin, formerly of the Parish of Lafourche, now residing in the Parish of Terrebonne.
Recorded March 17/94. A. Bourg, Clerk

No. 622: Henry Liner
No. 623: Louis Bourgeois
No. 624: John Edgar Weiland
No. 625: Felix Boudreaux
No. 626: Maximain Naquin
No. 627: Octave Laperouse
No. 628: Numa Aucoin

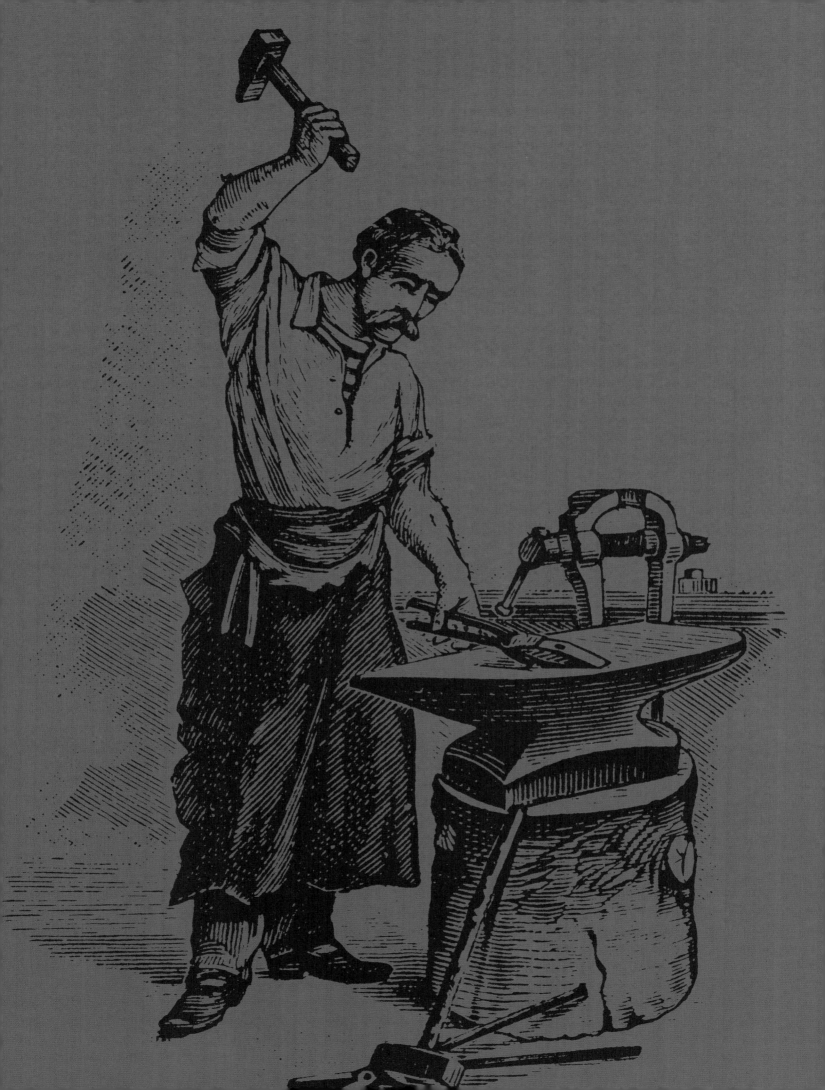

12 The fire brand of J. P. Hotard a resident of the Parish of Terrebonne, La.
Recorded April 17th 1895.
A. Bourg, Clerk

CJC The fire brand of Charles J. Champagne, a resident of the Parish of Terrebonne, La.
Recorded April 29th 1895.
A. Bourg, Clerk

MN The Fire Brand of Maximin Naquin, a resident of the Parish of Terrebonne, La.
Recorded June 13th 1895.
A. Bourg, Clerk

GX The fire Brand of François Gouaux, a resident of the Parish of Terrebonne, La.
Recorded Decr. 12/95.
A. Bourg, Clerk

bp The Fire Brand of François Dumesnil, a resident of the Parish of Terrebonne.
Recorded April 6/96.
A. Bourg, Clerk

JJ The Fire Brand of Joachim Porche, a resident of the Parish of Terrebonne.
Recorded April 20/96.
A. Bourg, Clerk

AO The Fire Brand of Mrs. Azema Gros, wife of Edward Neal of the Parish of Terrebonne, La.
Recorded May 12th 1896.
A. Bourg, Clerk

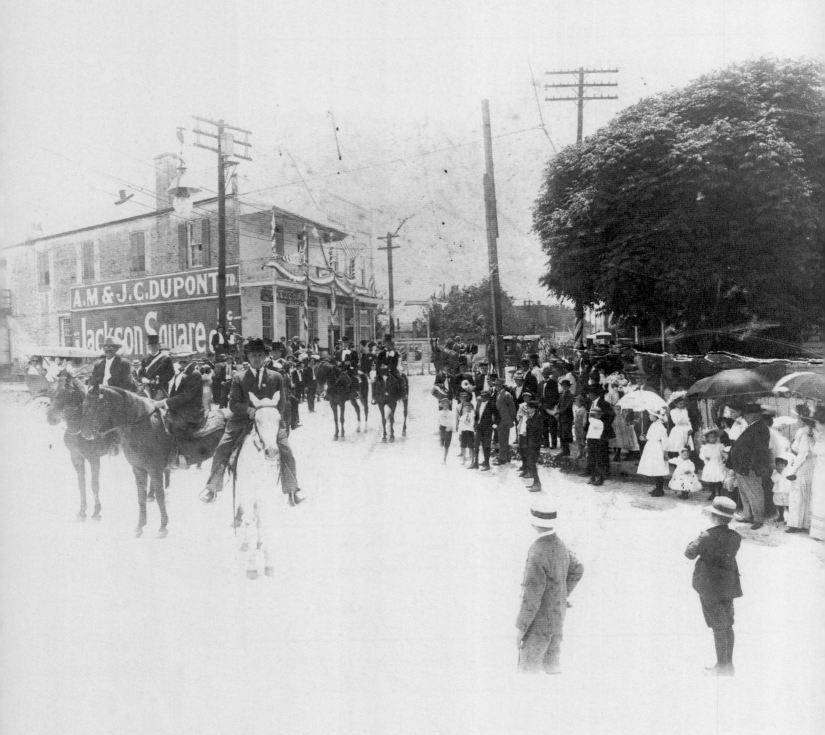

William Jean Pierre Cenac, age 25, on white horse during Fourth of July Parade, Main Street, Houma, 1909. Others in foreground, from left, are Edgar Lirette, Henry Bourg, and Jules Lirette. Note early automobile left background

214 LIVESTOCK BRANDS AND MARKS

No. 636: The Fire-Brand of Anoudet Lirette residing on Lower Little Caillou, in the Parish of Terrebonne, La. Recorded Septr. 3/96. A. Bourg, Clerk

No. 637: The Fire Brand of Wallace Picou, a resident of Lower Little Caillou, in the Parish of Terrebonne, La. Recorded Septr. 25/97. A. Bourg, Clerk

No. 638: The Fire Brand of Neuville LeBlanc a resident of Bayou Little Caillou, in the Parish of Terrebonne, La. Recorded October 28/97. A. Bourg, Clerk

No. 639: The fire brand of Ernest Bonvillain a resident of Bayou Black in the Parish of Terrebonne, La. Recorded March 29/98. E. Winslow, Dy Clerk

No. 640: The fire brand of Ernest Bonvillain a resident of Bayou Black in the Parish of Terrebonne La. Recorded July 5/98. E. Winslow, Dy Clerk

No. 641: The fire brand of Joseph F. Daspit a resident of Bayou Black in the Parish of Terrebonne, La. Recorded September 19/98. E. Winslow, Dy Clerk

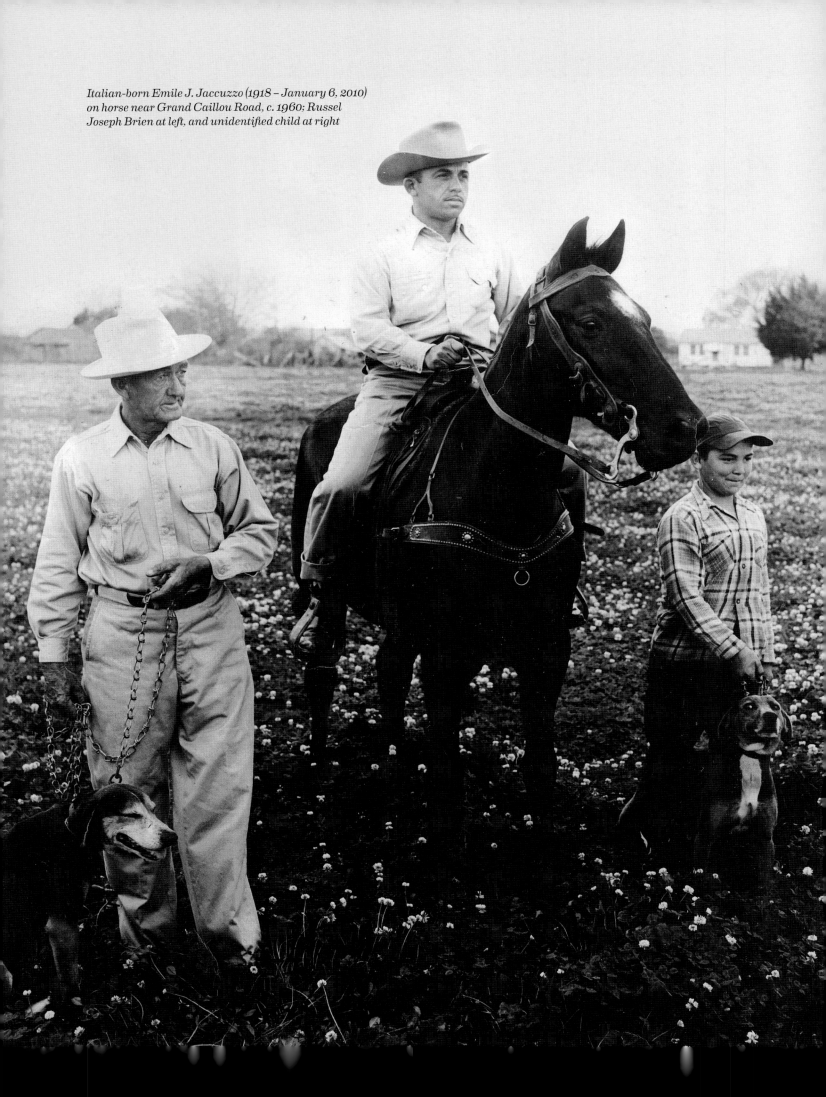

Italian-born Emile J. Jaccuzzo (1918 – January 6, 2010) on horse near Grand Caillou Road, c. 1960; Russel Joseph Brien at left, and unidentified child at right

642

ZB The fire brand of Alphonse Z. Boudreaux, of Little Caillou, in the Parish of Terrebonne, La.
Recorded June 16/99. E. W. Winylow, D'y Clerk

643

FB The fire brand of Forestal Boudreaux of Little Caillou, in the Parish of Terrebonne, La.
Recorded September 12, 1899. E. W. Winylow, D'y Clerk

644

The fire-brand of Félicien Belanger of Canal Belanger, in the Parish of Terrebonne.
Recorded July 13th, 1900.
C. A. Celestin, Clerk

645

The fire-brand of Abraham Blum and Robert Verret, of the Parish of Terrebonne, La.
Recorded Sept. 18th, 1900.
C. A. Celestin, Clerk

Shaffer and Sons unregistered brand

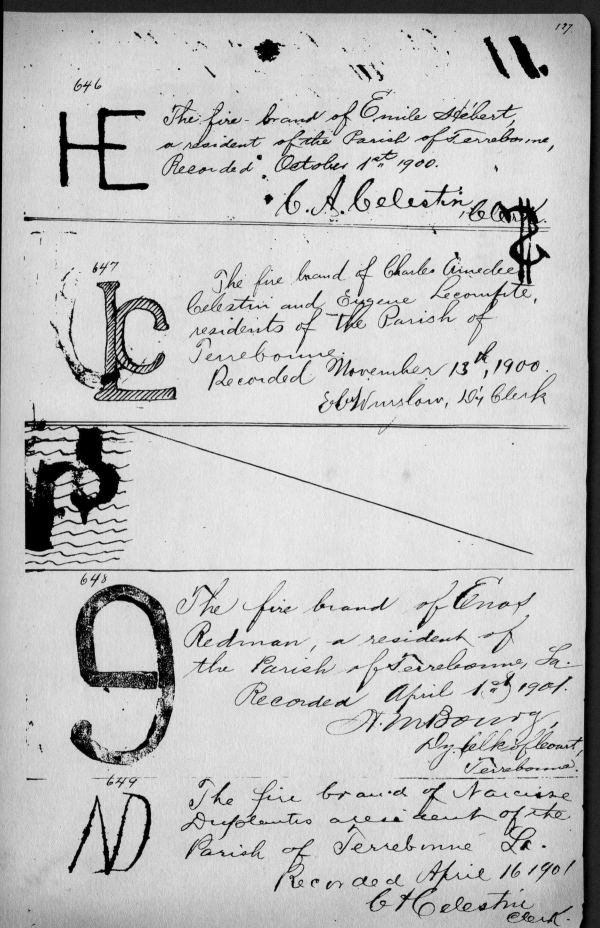

No. 646:
Emile Hebert

No. 647:
Charles Amedee Celestin
& Eugene Lecompte

No. 648:
Enos Redman

No. 649:
Narcisse Duplantis

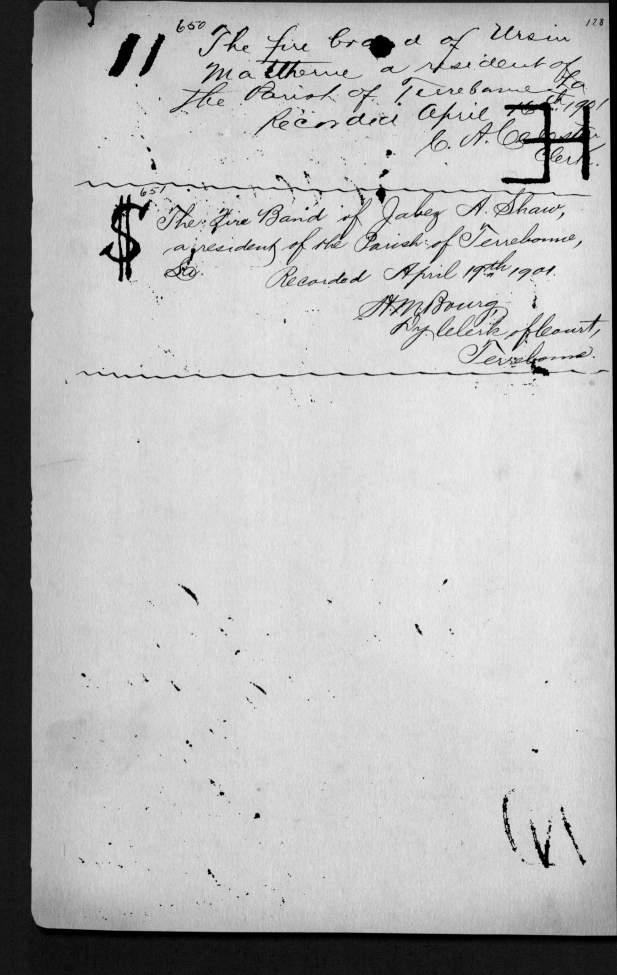

No. 650:
Ursin Matherne

650 The fire brand of Ursin Matherne a resident of the Parish of Terrebonne La
Recorded April 16th 1901
C. A. Caldwell
Clerk.

No. 651:
Jabez A. Shaw

651 The Fire Brand of Jabez A. Shaw, a resident of the Parish of Terrebonne, La.
Recorded April 19th 1901.
H. M. Bourg
Dy Clerk of Court,
Terrebonne.

Fire Brands Book One, pages 128 & 129

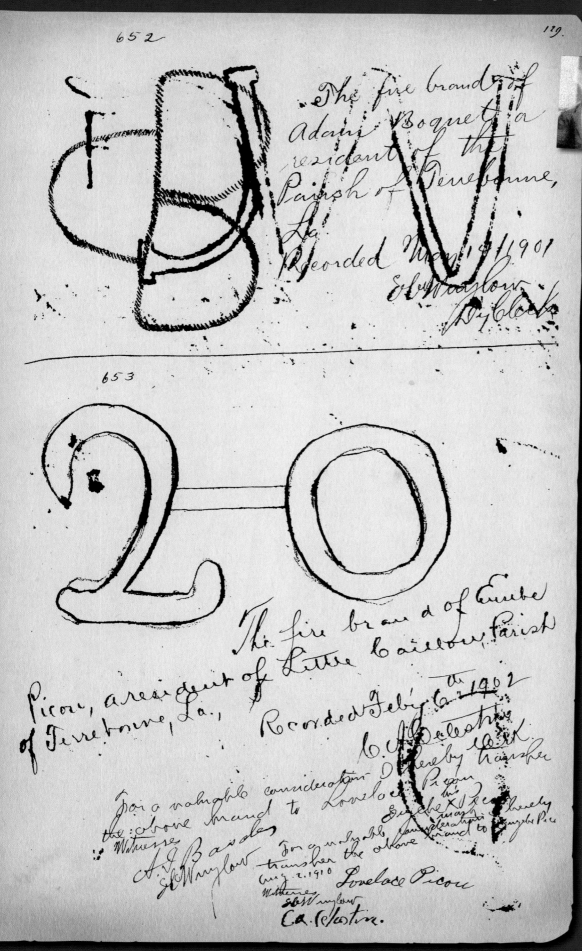

652

The fire brand of Adam Boquet, a resident of the Parish of Terrebonne, La. Recorded Nov 19 1901
E.W. Taylor
Dy Clerk

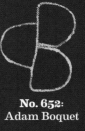

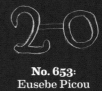

No. 652:
Adam Boquet

653

The fire brand of Eusebe Picou, a resident of Little Caillou, Parish of Terrebonne, La., Recorded Feby 6th 1902
C. A. Celestin

For a valuable consideration I hereby transfer the above brand to Lovelace Picou
Witness
A. J. Bordes
E. W. Taylor

Eusebe X Picou
his mark

For a valuable consideration I hereby transfer the above brand to Eusebe Picou
Aug 2, 1910 Lovelace Picou
Witness
E. W. Taylor
C. A. Celestin

No. 653:
Eusebe Picou

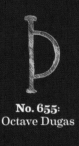

No. 654:
Wilfrid Guidry

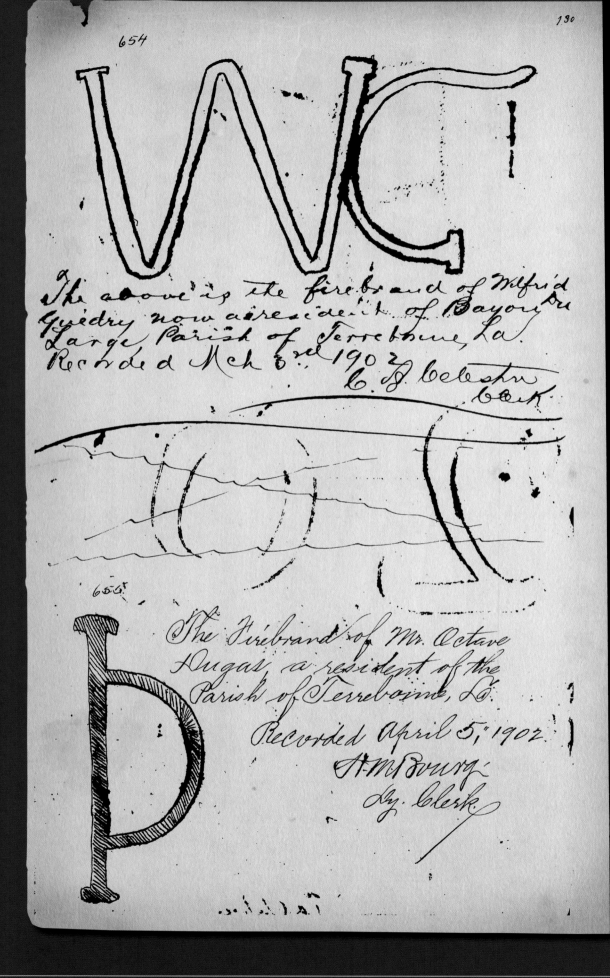

No. 655:
Octave Dugas

656

The fire brand of C. P. Smith, of the Parish of Terrebonne, La.
Recorded May 7th, 1902.
E. B. Winslow
Dy Clerk

No. 656:
C. P. Smith

657

The fire brand of George Neal, of the Parish of Terrebonne, La.
Recorded June 18, 1902.
E. B. Winslow
Dy Clerk

No. 657:
George Neal

658

The fire brand of Winston Taylor, of the Parish of Terrebonne, La.
Recorded Jany. 14th, 1903.
E. B. Winslow,
Dy. Clerk

No. 658:
Winston Taylor

659

The fire brand of Henry Clay Jolet, of the Parish of Terrebonne, La.
Recorded April 23, 1903.
E. B. Winslow
Dy Clerk

No. 659:
Henry Clay Jolet

No. 660:
Octave Aucoin

No. 661:
Dalmas Joseph Breaux

No. 662:
Dalmas Joseph Breaux

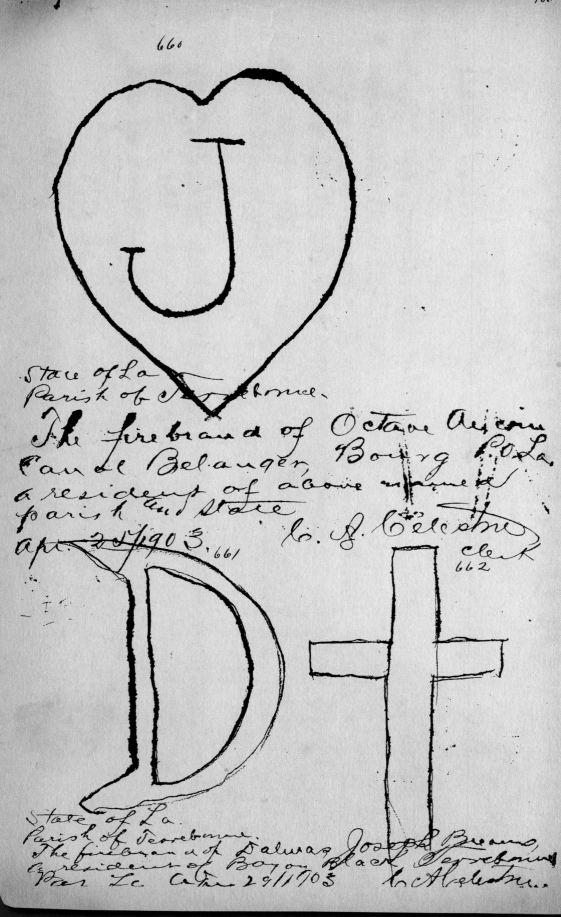

663 State of Louisiana
Parish of Terrebonne
This is the fire-brand of Alcide Carlos, a resident of Bayou Terrebonne, La.

Houma La. July 3rd 1903.

C. B. Celestin
Clerk

No. 663:
Alcide Carlos

Terrebonne Parish, La., March 29, 1940

We, the undersigned sole heirs of the late Amedee Hebert and his wife, Amy Detiveaux, for a valuable consideration, do hereby sell and assign to and unto: Miss Margaret Hebert, also an heir of the said Amedee Hebert and wife, all of our right, title and interest in and to that certain fire-brand (cattle brand), registered in the name of Amedee Hebert in Brand Book "A", under the No. 664 and being 2 H's joined together, thus: ℍ.

Witnesses:

Request for transfer from Amedeé Hebert to Margaret Hebert; see Brand No. 664 on page 226.

No. 664:
Amedeé Hebert
(see transfer on page 225)

No. 665:
Joachim Porche

No. 666:
J. P. Landry

No. 667:
Lovelace Picou

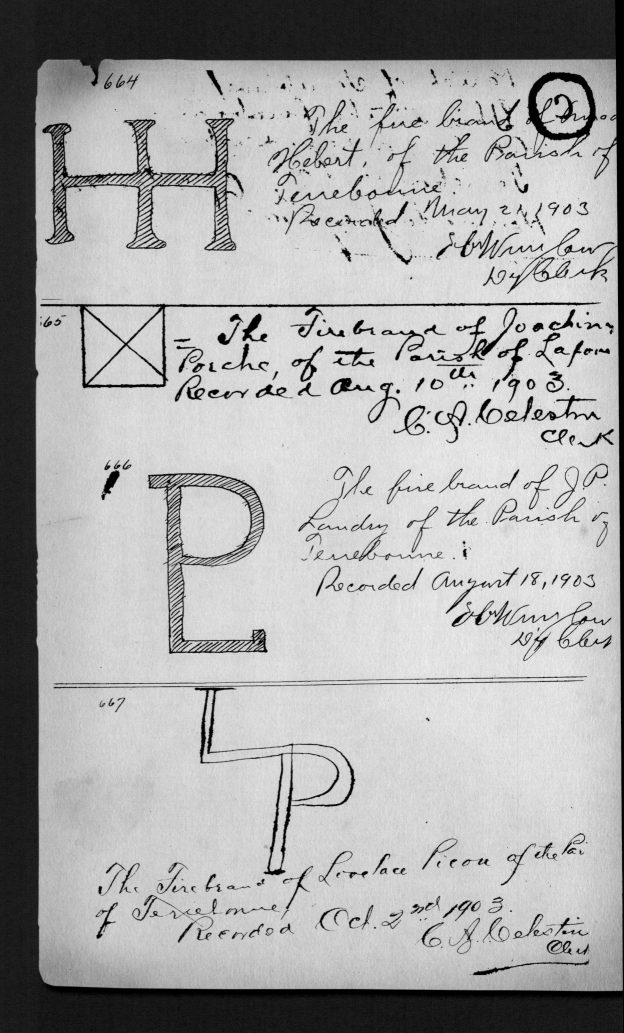

668

The fire brand of Gustave Doiron of the Parish of Terrebonne.
Recorded Oct. 29, 1903
J. B. Winslow
Dy Clerk

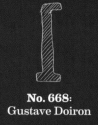

No. 668: Gustave Doiron

669

JLG

This is the Fire Brand of J. L. Guidroz, a resident of the Parish of Terrebonne, La.
Recorded October 31st 1903.
C. A. Celestin
Clerk of Court

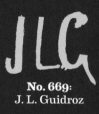

No. 669: J. L. Guidroz

670

E

The firebrand of Etienne Clerville Billiot of the Parish of Terrebonne. Being the same brand used by his father, Etienne Billiot, No 87 of this record.
Recorded Dec. 19, 1903
J. B. Winslow
Dy Clerk

No. 670: Etienne Clerville Billiot

671

HB

The firebrand of J. Honorius Brien of Bayou Du Large, Terrebonne Parish, La.
Recorded Dec. 26th 1903
C. A. Celestin
Clerk.

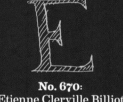

No. 671: J. Honorius Brien

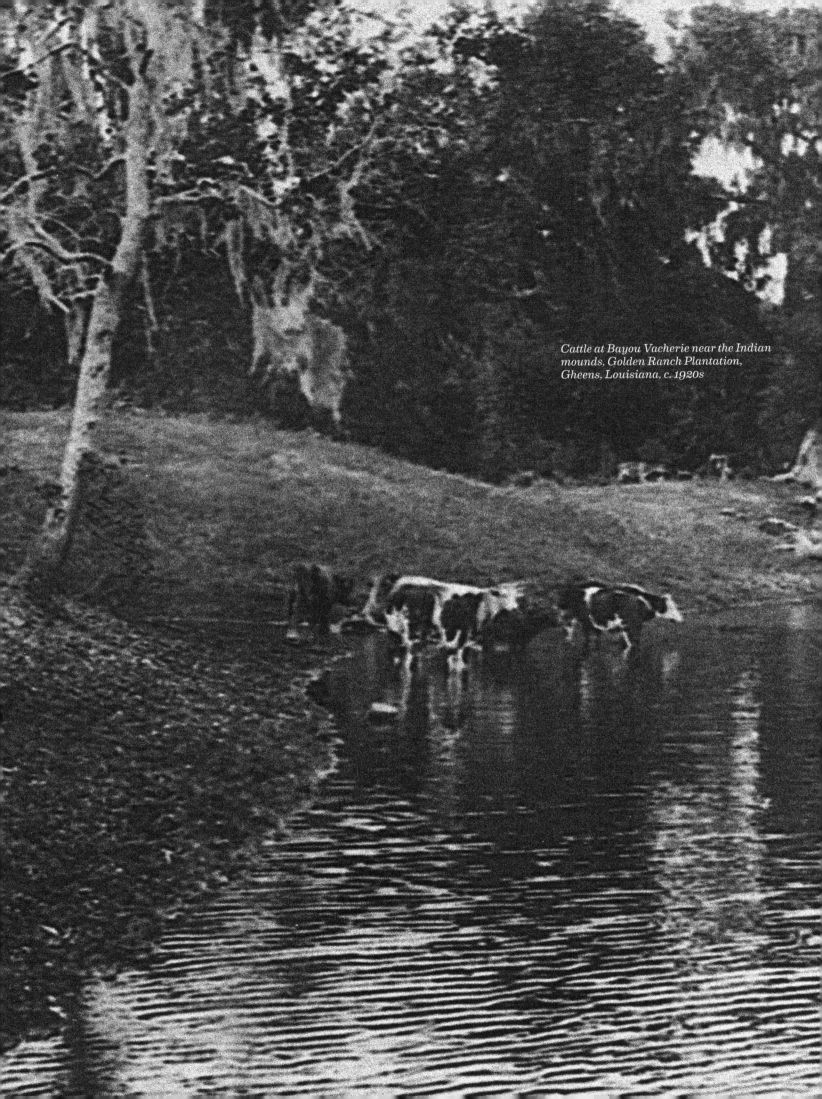

Cattle at Bayou Vacherie near the Indian mounds, Golden Ranch Plantation, Gheens, Louisiana, c. 1920s

672

L R

The fire brand of Leo Robichaux, of the Parish of Terrebonne.

Recorded Feb. 26th, 1904

E. B. Winslow
D'y Clerk

673

B F

The fire brand of Henry Breaux, of the Parish of Terrebonne, La.

Recorded March 2nd 1904.

E B Winslow
Deputy Clerk of Court, Terrebonne

674

e e

The fire brand of Ellis Esheté, of the Parish of Terrebonne.

Recorded March 12th, 1904

E. B. Winslow
D'y Clerk

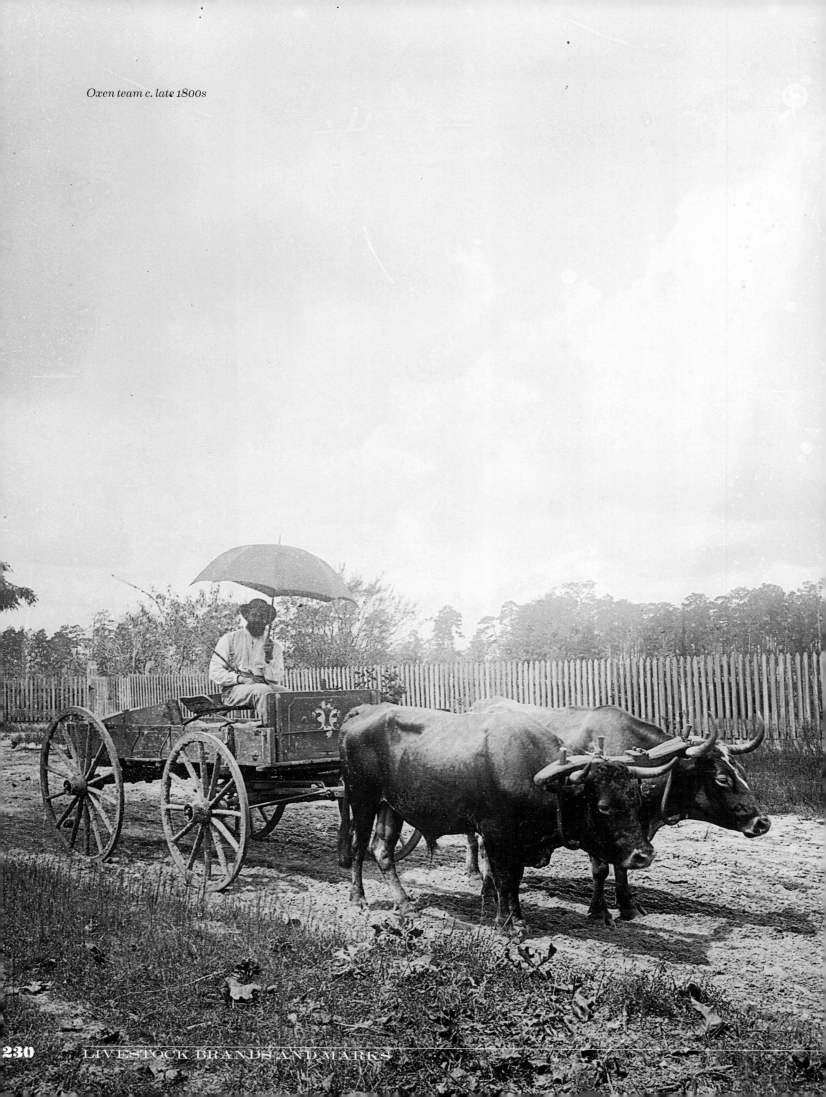
Oxen team c. late 1800s

675

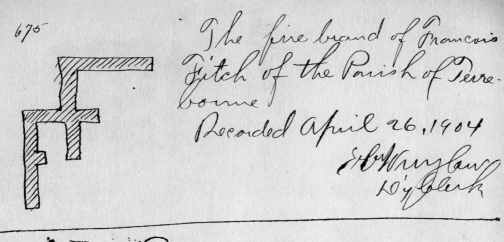

The fire brand of François Fitch of the Parish of Terrebonne

Recorded April 26, 1904

E. B. Winslow
Dy Clerk

No. 675: François Fitch

676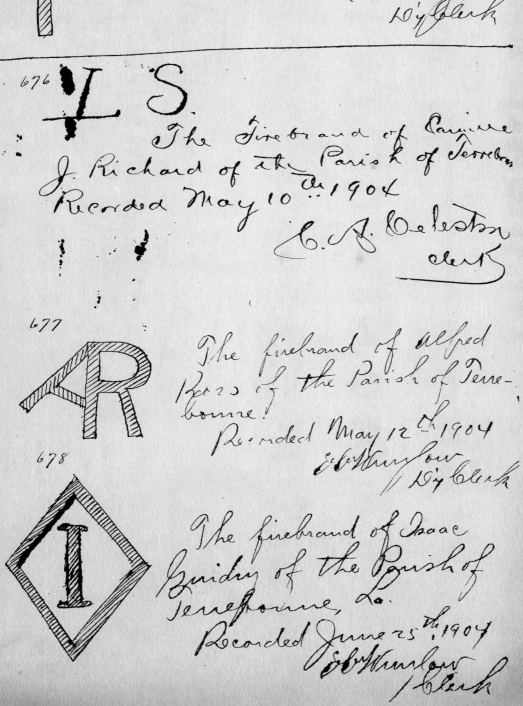

The firebrand of Camille J. Richard of the Parish of Terrebonne

Recorded May 10th 1904

C. A. Celestin
Clerk

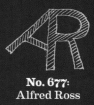
No. 676: Camille J. Richard

677

The firebrand of Alfred Ross of the Parish of Terrebonne.

Recorded May 12th 1904

E. B. Winslow
Dy Clerk

No. 677: Alfred Ross

678

The firebrand of Isaac Guidry of the Parish of Terrebonne, La.

Recorded June 25th 1904

E. B. Winslow
Clerk

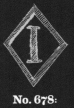
No. 678: Isaac Guidry

No. 679:
Reginald Blanchard
& Orland Blanchard

No. 680:
Eugène C. Boudreaux

No. 681:
Joseph Carro

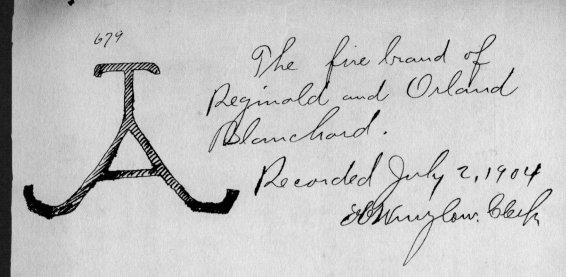

679. The fire brand of Reginald and Orland Blanchard. Recorded July 2, 1904. H. Winslow, Clerk.

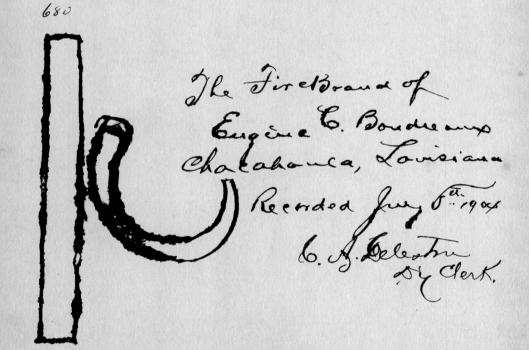

680. The Fire Brand of Eugène C. Boudreaux, Chatahoula, Louisiana. Recorded July 5th, 1904. C. A. Celestin, Dy. Clerk.

681. The firebrand of Joseph Carro, of the Parish of Terrebonne. Recorded Sept. 10, 1904. H. Winslow, Clerk.

682 This brand null made in error.
J.B. Wurylow
Clerk

683 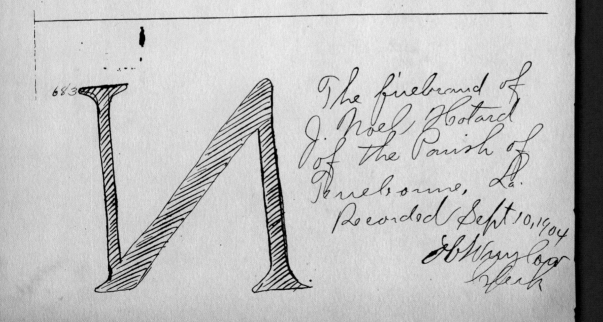 The firebrand of J. Noel Hotard of the Parish of Terrebonne, La.
Recorded Sept 10, 1904
J.B. Wurylow
Clerk

Herbert and Marie Himel's unregistered brand c. 1950s

234 LIVESTOCK BRANDS AND MARKS

685

The firebrand of Valerie Pontiff of Boing P.O. Parish of Terrebonne, La.

Recorded Nov. 23, 1904

J.S. Wurzlow
Clerk

686

State of Louisiana }
Parish of Terrebonne. }

Before me, the undersigned authority, this day personally come and appeared: Abell Thibodaux, of this parish, who being duly sworn, deposes and says: That he is the sole heir and legal representative of Marcelin Thibodaux and Marie Malbrough both deceased; his father & mother; that his father Marcelin Thibodaux owned a cattle brand which was registered in the Book of Brands of the Parish of Terrebonne on May 24, 1839, at page 40; that he has adopted said brand as his own and makes this affidavit in order to register same and give public notice thereof. Said brand being the letters "J.I."

Sworn to and subscribed before } (Signed) Abell Thibodaux
me this 3rd day of April, } his x mark
A. D., 1905.

(Signed) E.C. Wurzlow, Clerk (L.S.)

Recorded April 3rd, 1905. J.S. Wurzlow
Clerk.

The Firebrand of André Bourg, of the Parish of Terrebonne La.

Recorded April 8 1902.

C. A. Celeston
Dy Clerk.

No. 687:
André Bourg

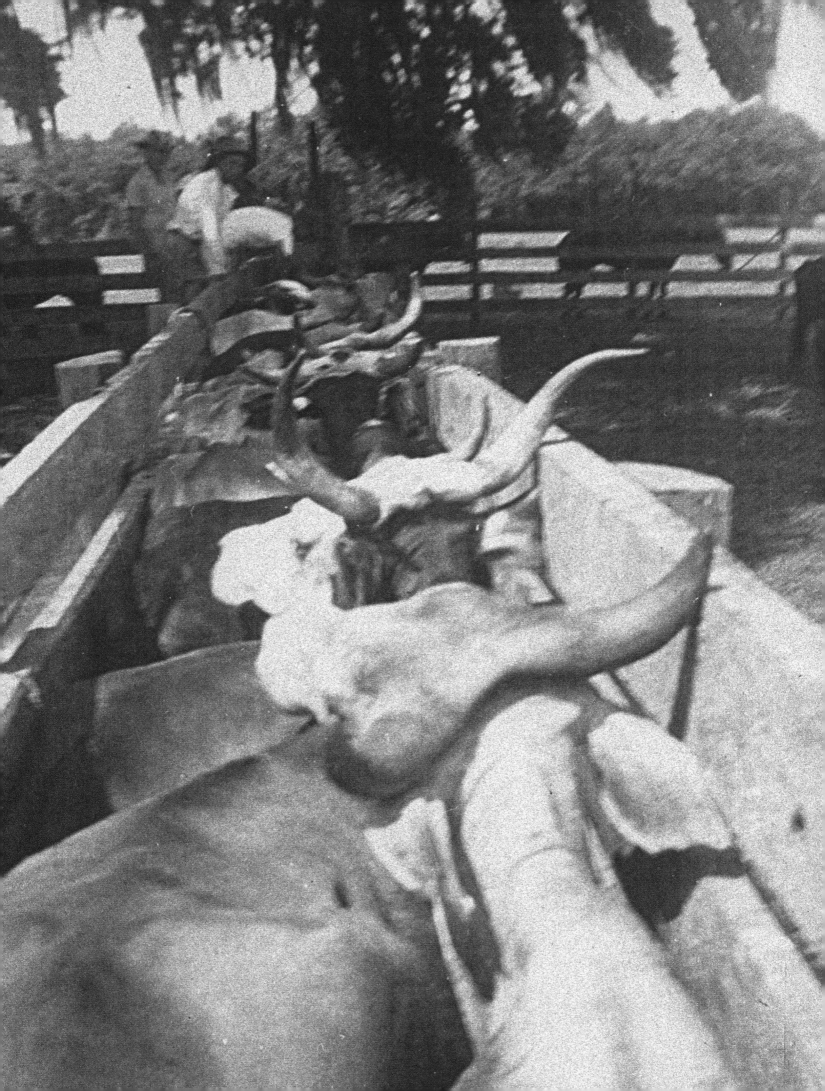

688

25

State of Louisiana
Parish of Terrebonne.

Before me, the undersigned authority, this day personally appeared: Octave Daigle, of the Parish of Terrebonne, who declared that he has this day adopted as his cattle brand the No 25, being the same brand registered April 17, 1850, by Carrie Blaise Deoux, his uncle.

Signed before me this (Signed) (Octave x Daigle
12th day of April A.D. his mark
1905

(Signed) JB Winglow
 Clerk

Recorded April 12, 1905

JB Winglow
Clerk

No. 688:
Octave Daigle

Opposite page, working cattle during a pen-up, Golden Ranch Plantation, Gheens, Louisiana, c. 1955

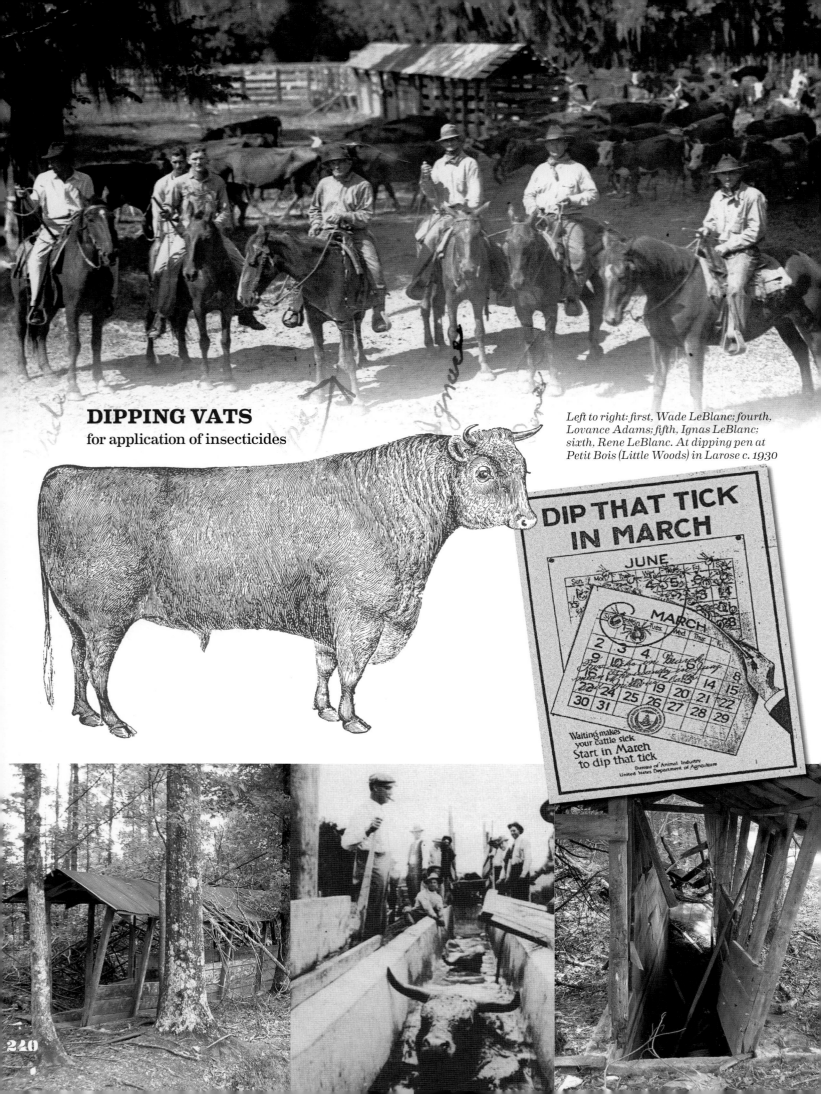

DIPPING VATS
for application of insecticides

Left to right: first, Wade LeBlanc; fourth, Lovance Adams; fifth, Ignas LeBlanc; sixth, Rene LeBlanc. At dipping pen at Petit Bois (Little Woods) in Larose c. 1930

Fire Brands Book One, pages 150 & 151

684

The firebrand of Olezime Dupré, of Point au Chien, Parish of Terrebonne and Lafourche.
April 20, 1905

No. 689:
Olezime Dupré

690

The firebrand of Wilson LeBoeuf of Bourg P.O. La. Parish of Terrebonne La.
May 10th 1905
C. A. Celestin

No. 690:
Wilson LeBoeuf

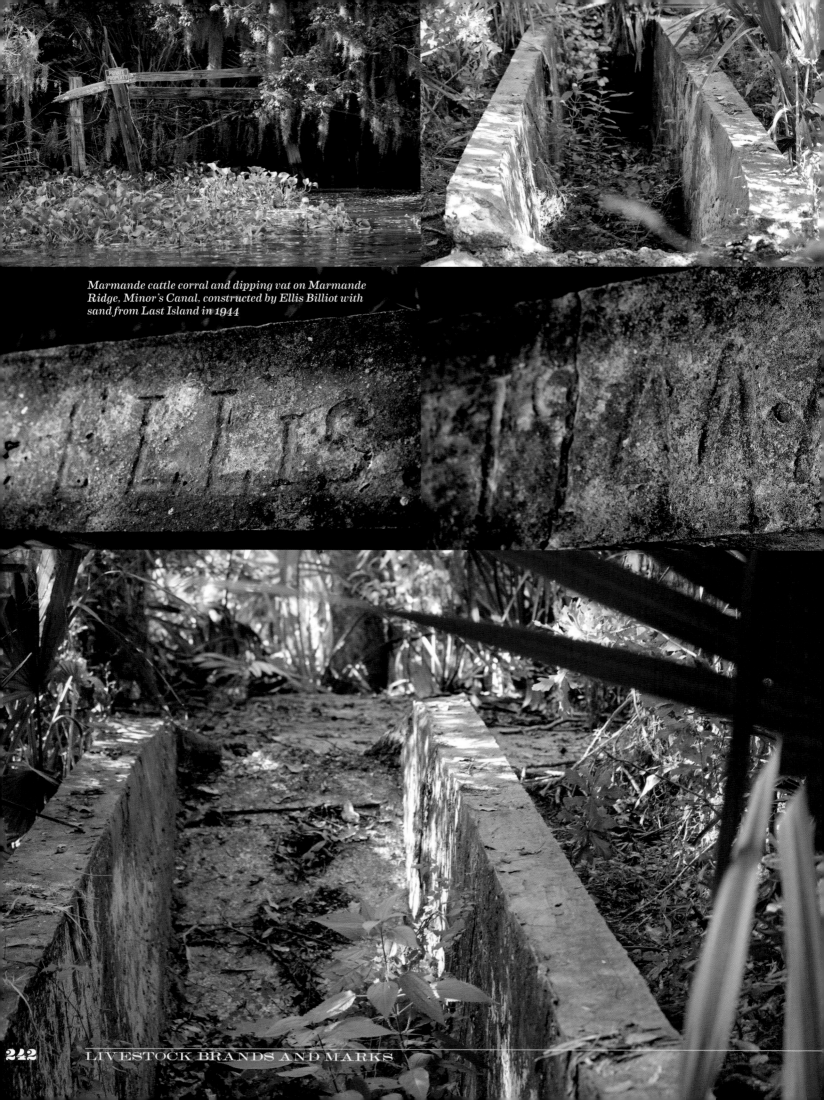

Marmande cattle corral and dipping vat on Marmande Ridge. Minor's Canal, constructed by Ellis Billiot with sand from Last Island in 1944

691. The firebrand of Benjamin Dumesnil of Humphreys Bayou Black, Parish of Terrebonne, La. Recorded May 11, 1905
J. B. Winglow, Clerk

No. 691: Benjamin Dumesnil

692. The firebrand of Jack Daniels of Chacahoula, La. Recorded May 11, 1905
J. B. Winglow, Clerk

No. 692: Jack Daniels

693. The Firebrand of Joseph Gabriel Bourg of Montegut, P.O. La. Recorded May 26/08
C. J. Celestin, Dy Clerk

No. 693: Joseph Gabriel Bourg

No. 694:
Trasimond Bergeron

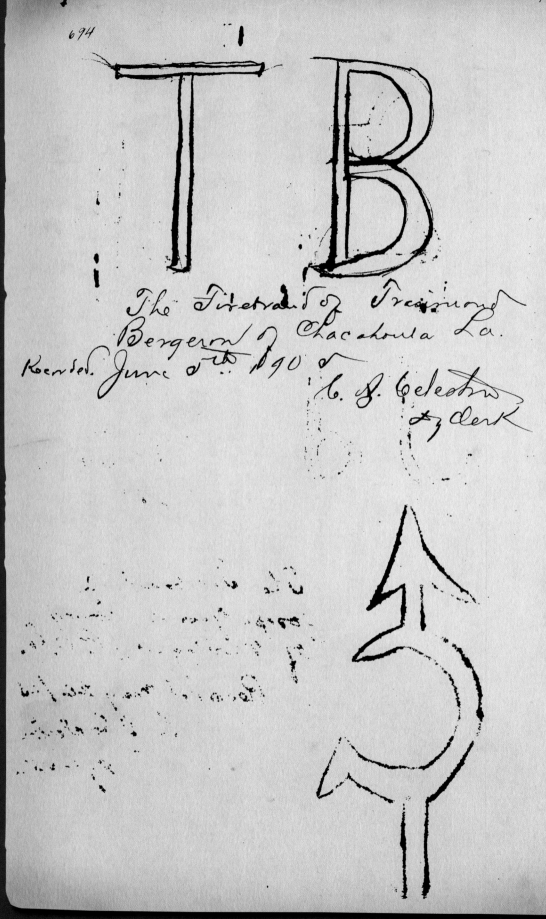

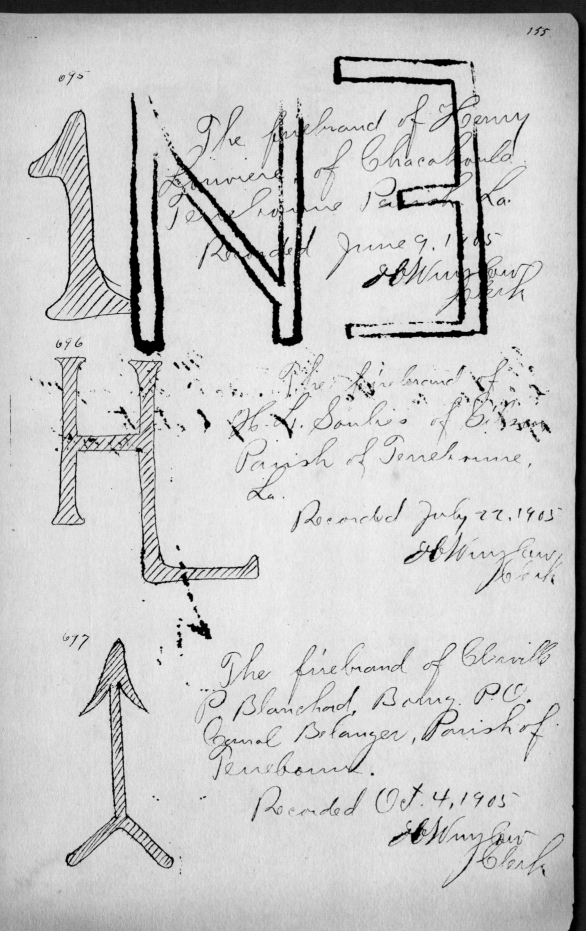

No. 695:
The firebrand of Henry Louviere of Chacahoula, Terrebonne Parish, La.
Recorded June 9, 1905.
J. H. Wurzlow, Clerk

No. 696:
The firebrand of H. L. Soulies of Gibson, Parish of Terrebonne, La.
Recorded July 22, 1905.
J. H. Wurzlow, Clerk

No. 697:
The firebrand of Clerville P. Blanchard, Bourg. P.O. Canal Belanger, Parish of Terrebonne.
Recorded Oct. 4, 1905.
J. H. Wurzlow, Clerk

No. 695:
Henry Louviere

No. 696:
H. L. Soulies

No. 697:
Clerville P. Blanchard

No. 698:
Timothy Niblett

The firebrand of Timothy Niblett of Chacahoula, La. Recorded February 17th 1906.

C. A. Celeston
Dy Clk.

Fire Brands Book One, pages 156 & 157

699.

EL

The fire brand of Etienne LeBoeuf of Canal Belanger, Bourg P.O. La.
Recorded Feb. 27, 1906
J. C. Wurzlow
Clerk

No. 699:
Etienne LeBoeuf

700

PI

The firebrand of "Polinaire" Billiot of Point au Barre Montegut P.O. La.
Recorded March 19", 1906
J. C. Wurzlow
Clerk

No. 700:
Polinaire Billiot

701

CN

The firebrand of Clairville Neal of Little Caillou, Daspit P.O. La.
Recorded March 28th, 1906
C. A. Celestin
Dy Clk

No. 701:
Clairville Neal

LIVESTOCK BRANDS AND MARKS

No. 702:
D. A. Theriot

No. 703:
Hyman Ellender

No. 704:
Volcar Fanguy

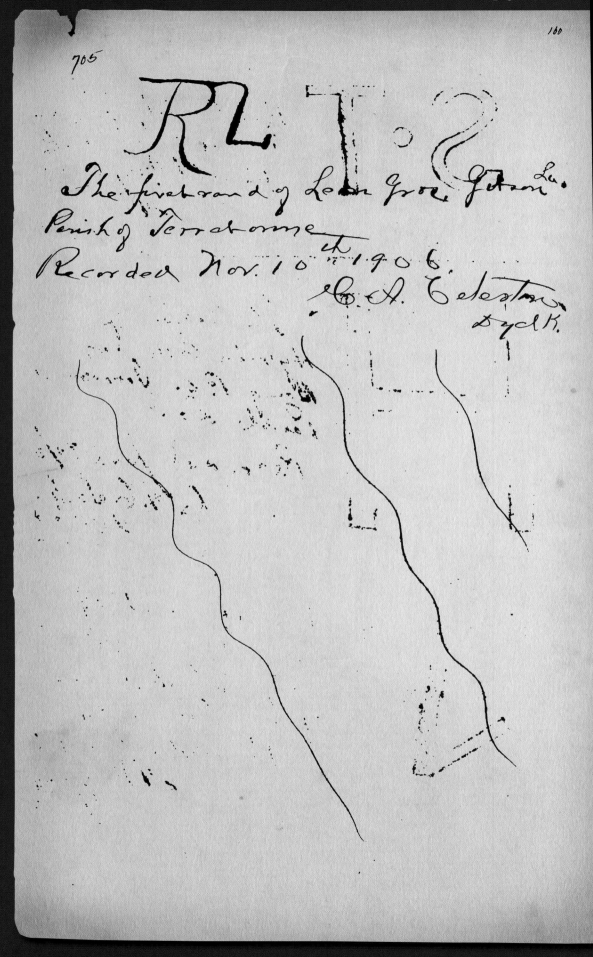

No. 705: Leon Gros

The fire brand of Leon Gros Gibson La.
Parish of Terrebonne
Recorded Nov. 10th 1906.
C. A. Celeston
Dy Clk.

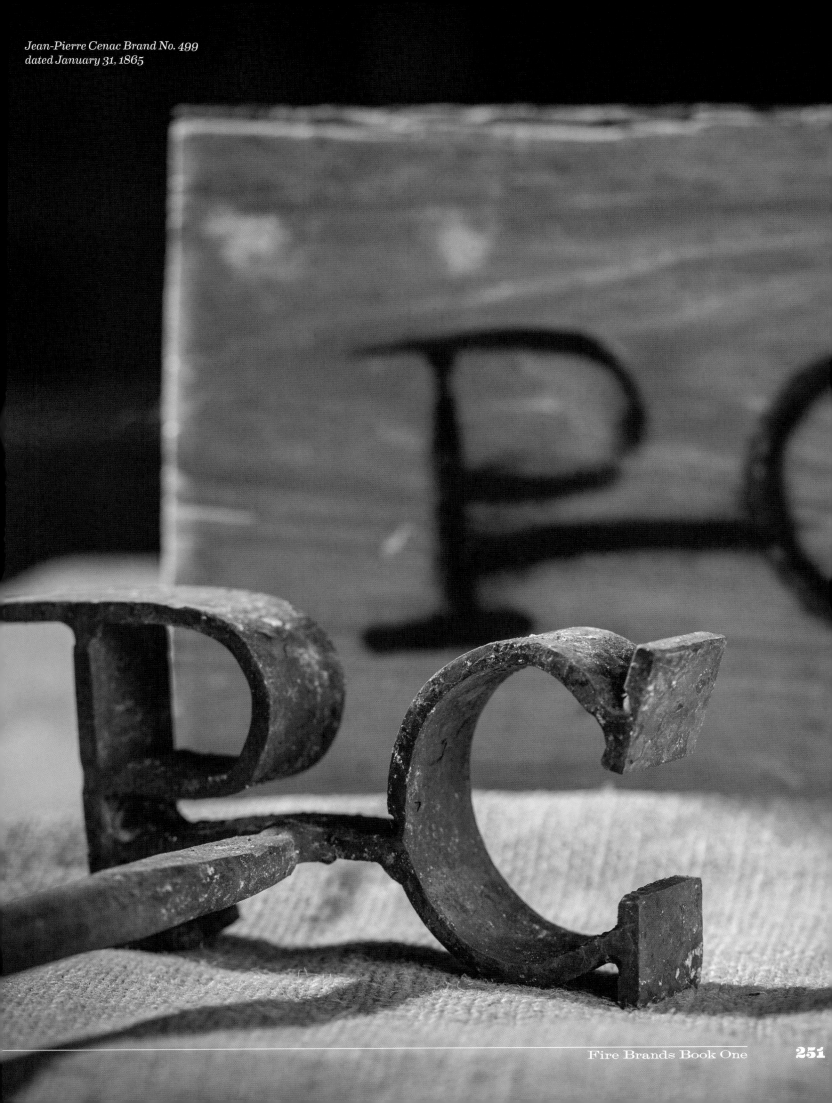

*Jean-Pierre Cenac Brand No. 499
dated January 31, 1865*

No. 706:
Caliste LeBoeuf

No. 707:
F. Eugene Shepherd

706

The firebrand of Caliste LeBoeuf of the Parish of Terrebonne.

Recorded Sept. 5, 1906

707

The firebrand of F. Eugene Shepherd of the Parish of Terrebonne, La. Chacahoula —

Recorded Oct. 22nd 1906.

708

SG

The fire brand of
Estilette Giroir, of the
Parish of Terrebonne, La.
Recorded Nov. 23, 1906
LeBlanc Dep. Clerk

709

JL

The Firebrand of Joseph LeBoeuf of the
Parish of Terrebonne, La.
Recorded Dec. 3, 1907.
C. A. Celestin
Dy Clerk.

No. 710:
W. E. Mount & A. Melancon

Request for transfer from Joseph Lebouef to James Lebouef: see Brand No. 709 on page 253.

710

Firebrand of W. E. Mount & A. Melancon

December 24th 1907

STATE OF LOUISIANA,
PARISH OF TERREBONNE.

Before me, the undersigned authority, this day personally came and appeared: James LeBoeuf, to me personally known, a resident of the Parish of Terrebonne, State of Louisiana, who, upon being first duly sworn, did depose and say: that he is the son of Joseph LeBoeuf, who died in the Parish of Terrebonne, Louisiana, about four years ago; that the said Joseph LeBoeuf had registered in his name a fire-brand composed of the letters "JL", and appearing in Brand Book "A" of the Parish of Terrebonne under the number 709; that there are no cattle in existence at the present time which belonged to the said Joseph LeBoeuf or to his estate; that affiant has adopted the above designated brand for himself, with the consent of the widow and heirs of the said Joseph LeBoeuf; and that he, affiant, will henceforth use said brand for the marking of his cattle.

his
Joseph X LeBoeuf
mark

Sworn to and subscribed before me at Houma, La., this 15th day of October, A.D. 19—

Clerk of Court.

Witnesses:
Claude Menas
Ernest Ellender

711 **JH** The firebrand of Felix
Hebert, of the Parish of
Terrebonne, La.
Recorded July 31, 1906
 JC Winslow
 Clerk

712 **CV** The firebrand of Celestine
Vidal, of the Parish of
Terrebonne. Residence
Bayou Cane.
Recorded Feb. 1, 1907
 JC Winslow
 Clerk

713 **PS** The firebrand of Paul
Scott, Bourg P.O., Parish
of Terrebonne, La.
Recorded Feb. 5, 1907
 JC Winslow
 Clerk

714 **L2** The firebrand of George
Washington Levron, Bourg
P.O., General Belanger,
Parish of Terrebonne, La.
Recorded Feb. 9, 1907
 JC Winslow
 Clerk

No. 715:
Willie Ruffin

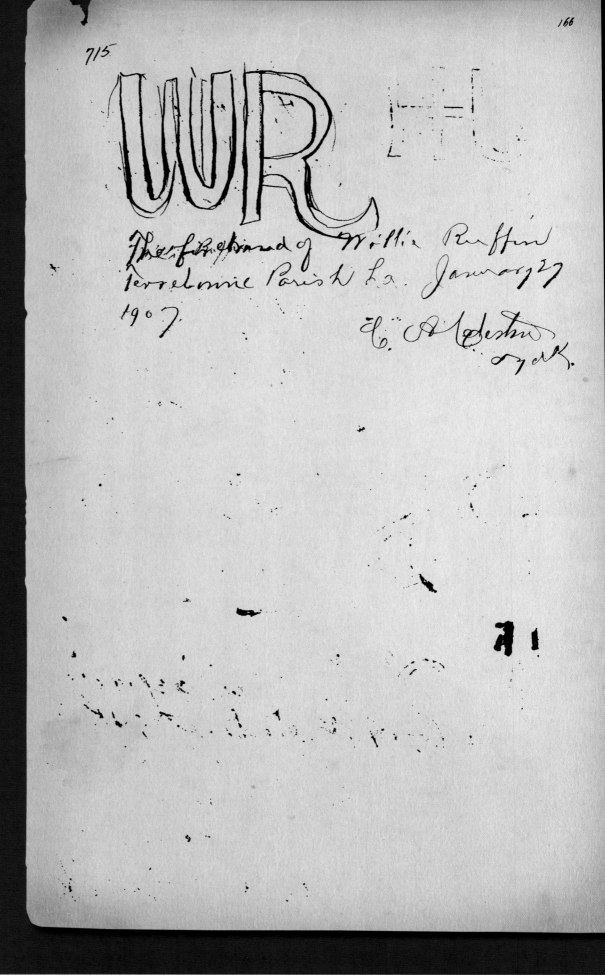

716

GS

The firebrand of George Savoie, of Bury P.O., Daniel Belanger Parish of Terrebonne La.
February 9th 1907

717

A

The firebrand of Abe Loewenstein of Isle of Cuba Plantation, Terrebonne Par. La.
Feb. 11th 1907
C. A. Celestin, Dy Clerk

718

IR

The firebrand of Mrs. Irma Rhodes of Terrebonne Pa. L,
Feb. 23 1907
C. A. Celestin, Dy Clerk

719

⊥ 7

The firebrand of George Lombas of Bayou Blue Terrebonne Parish La
Feb 23rd 1907
C. A. Celestin, Dy Clerk

No. 716:
George Savoie

No. 716:
Abe Loewenstein

No. 718:
Irma Rhodes

No. 719:
George Lombas

No. 720:
Theodule DesRoches

No. 721:
Robert Verret

No. 722:
Wilfred Hebert

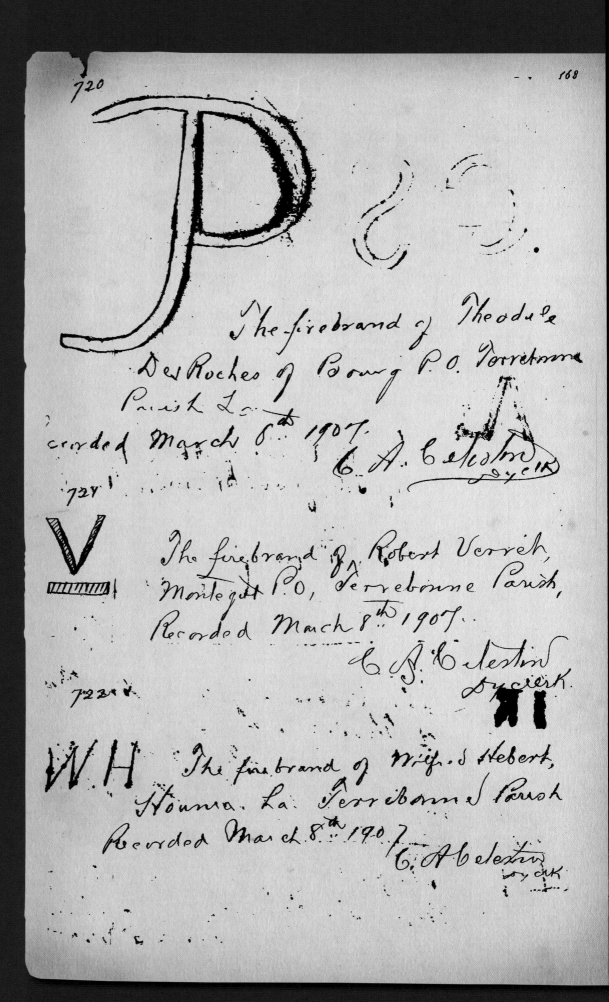

LIVESTOCK BRANDS AND MARKS

723

RN

The firebrand of Rose Naquin and her husband, Clement Naquin, of Montegut P.O., Parish of Terrebonne, La.

Recorded March 8, 1907

No. 723: Rose Naquin & Clement Naquin

724

AN

The firebrand of Antoinette Naquin, of Montegut P.O., Parish of Terrebonne, La.

Recorded March 8, 1907

No. 724: Antoinette Naquin

725

UB

The firebrand of Eulalie Billiot, of Montegut P.O. Parish of Terrebonne, La.

Recorded March 8th, 1907

No. 725: Eulalie Billiot

726

OD

The firebrand of Onesipe Dardare, of Montegut P.O., Parish of Terrebonne, La.

Recorded March 8th, 1907

No. 726: Onesipe Dardare

No. 727:
Oliver Bergeron

No. 728:
Harry Breaux

No. 729:
Simon Billiot

727 The firebrand of Oliver Bergeron, of Isley P.O., Parish of Terrebonne, La. Recorded March 26, 1906

J. E. Wurzlow, Clerk

728 The firebrand of Harry Breaux, of Bourg P.O., Chapel Belanger Parish of Terrebonne La.

Recorded March 30, 1907

J. E. Wurzlow, Clerk

729 The firebrand of Simon Billiot of Montegut P.O., Parish of Terrebonne La.

Recorded April 1st, 1907

C. A. Celestin D. y. C.

Parish of Terrebonne } State of Louisiana.

Be it remembered that on the fifteenth day of June in the forty sixth year of the Independence of the United States of America, (A.D. 1822) we, William S. Watkins, Senior Justice of the Peace, and Leandre B. Thibodaux, Justice of the Peace, within and for said Parish, have this day counter-signed this page number One hundred and Seventy, as the last of this book A. Register of Brands, in this Parish.

In testimony whereof we have hereunto set our hand and affixed our Seal, on the date above written.

Ne varietur.

Wm. S. Watkins Senior
Justice of the peace —

L. B. Thibodaux

FIRE BRANDS

APRIL 20, 1907

2
―
730 - 1061
―
R.A. Bazet, Clerk

Parish of Terrebonne

Terrebonne Parish Clerks of Court

Charles Amedee Celestin

Edwin Clarence Wurzlow

Robert Pierre Blanchard

Joseph Aycock	1846-1856
Henry Newell	1856-1864
Joseph O. Duplantis	1864-1866
Henry F. Belanger	1866-1868
Richard W. Francis	1868-1872
Anthony Drayton	1872-1874
Aubin Bourg	1874-1876
Edward W. Condon	1876-1892
Aubin Bourg	1892-1898
Francis Xavier Bourg	1898-1900
Charles Amedee Celestin	1900-1904
Edwin Clarence Wurzlow	1904-1919
Robert Pierre Blanchard	1919-1920
Adam Oliver Hebert	1920-1924
Randolph August Bazet	1924-1964
I. Robert "Bobby" Boudreaux	1964-2012
Theresa A. Robichaux	2012-

Adam Oliver Hebert

Randolph August Bazet, Sr.

I. Robert "Bobby" Boudreaux

Theresa A. Robichaux

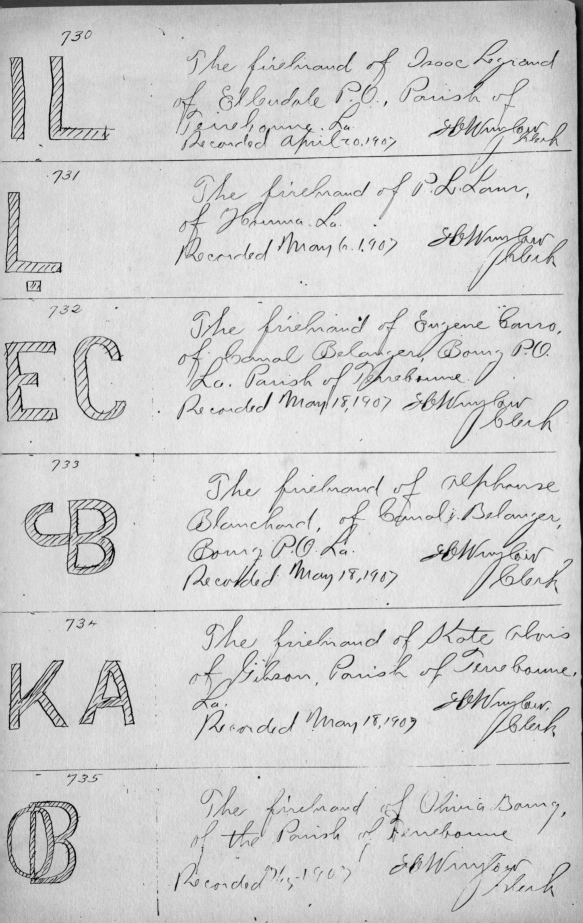

No. 730:
Isaac Legrand

No. 731:
P. L. Laws

No. 732:
Eugene Carro

No. 733:
Alphonse Blanchard

No. 734:
Kate Alvis

No. 735:
Olivia Bourg

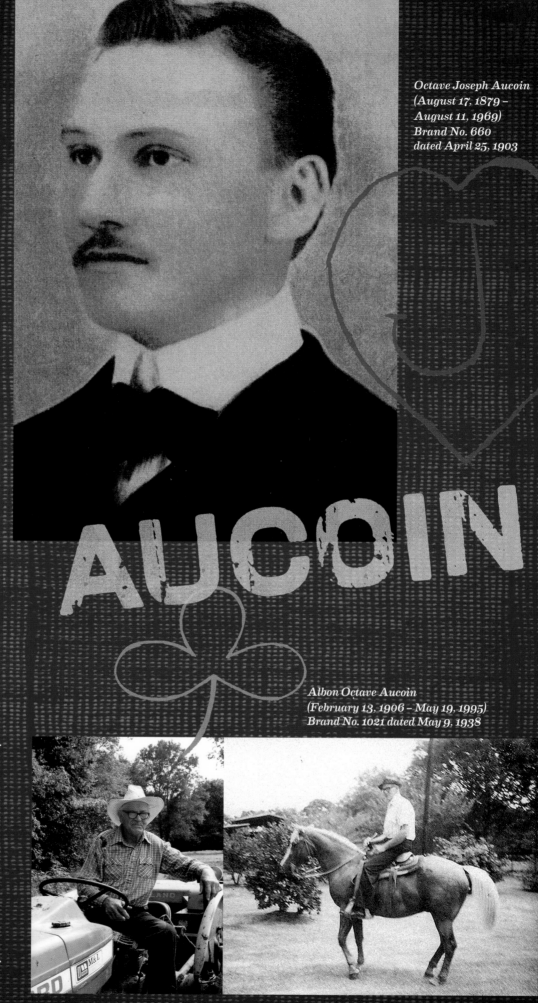

*Octave Joseph Aucoin
(August 17, 1879 –
August 11, 1969)
Brand No. 660
dated April 25, 1903*

*Silvani Numa Aucoin
(April 1, 1846 –
March 23, 1925)
Brand No. 628
dated March 17, 1894*

AUCOIN

*Roy Anthony Aucoin, Sr.
(June 5, 1908 –
October 12, 1988)*

*Albon Octave Aucoin
(February 13, 1906 – May 19, 1995)
Brand No. 1021 dated May 9, 1938*

*Roy Anthony Aucoin, Sr.
Brand No. 1132
dated May 1, 1946*

Fire Brands Book Two, page 3

No.	Brand	Description
736	JB	The firebrand of Jules Boquet, Bourg P.O., Canal Belanger, Parish of Terrebonne, La. July 15, 1907. S.E. Winslow, Clerk
737	(brand)	The firebrand of George Freeman of the Parish of Terrebonne La. Recorded March 17, 1908. S.E. Winslow, Clerk
738	BR	The firebrand of Amadee Brien, of Theriot P.O., Parish of Terrebonne, La. March 28, 1908. S.E. Winslow, Clerk
739	AF	The firebrand of Albert Aucoin, Houma P.O., a resident of Bayou Dularge, Parish of Terrebonne. S.E. Winslow, Clerk
740	JL	The firebrand of John LeBlanc, of Houma P.O., a resident of Bayou Dularge, Parish of Terrebonne, La. Right ear split. S.E. Winslow, Clerk
741	OB	The firebrand of Obin Breaux, Humphreys P.O., Bayou Black, Parish of Terrebonne. Recorded April 18, 1908. S.E. Winslow, Clerk
742	C4	The firebrand of Edward Clement of the Parish of Terrebonne, Humphreys P.O., Bayou Black. Recorded April 20, 1908. S.E. Winslow, Clerk

No. 736: Jules Boquet

No. 737: George Freeman

No. 738: Amadee Brien

No. 739: Albert Aucoin

No. 740: John LeBlanc

No. 741: Obin Breaux

No. 742: Edward Clement

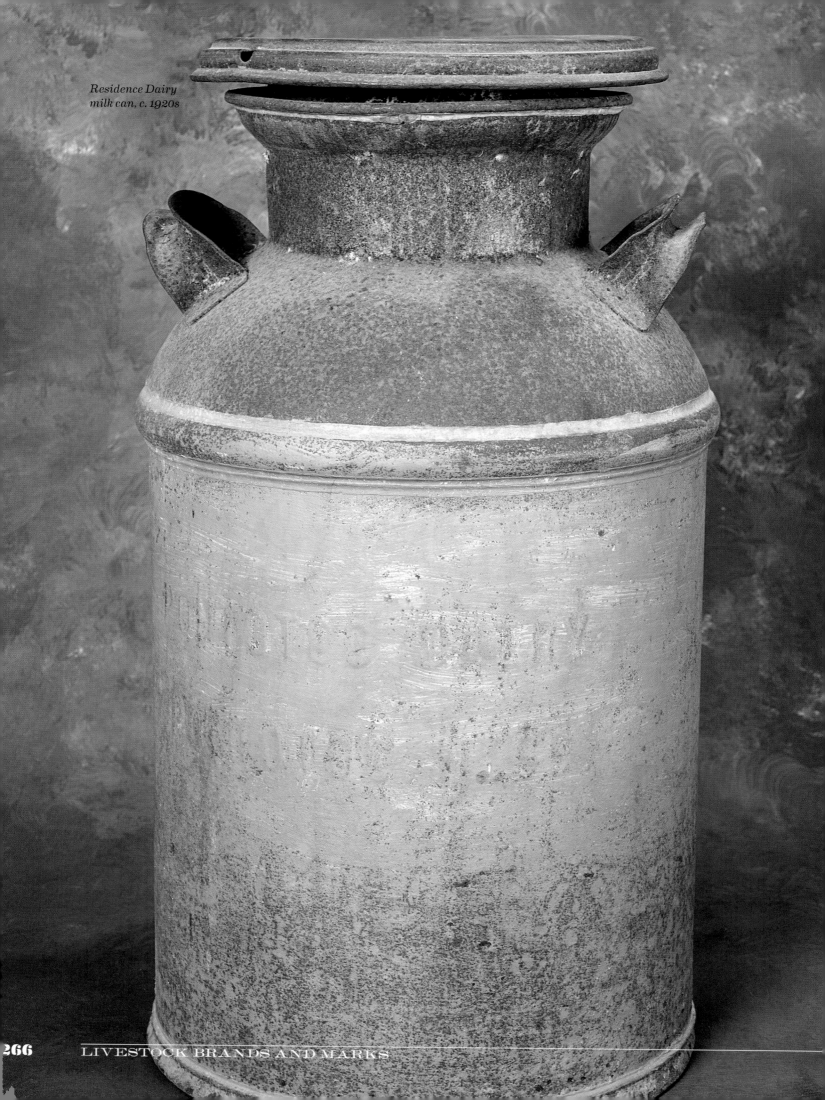

Residence Dairy milk can, c. 1920s

266 LIVESTOCK BRANDS AND MARKS

Fire Brands Book Two, page 5

743 MR	The firebrand of Mathilda Robinson, Ormond P.O., Bayou Black, Parish of Terrebonne, La. Recorded May 2, 1908. S.B. Winslow, Clerk
744 AD	The firebrand of Armand Duplantis, of Bayou Cane, Parish of Terrebonne, La. Recorded May 7, 1908. S.B. Winslow, Clerk
745 AC	The firebrand of Alphonse Collins, Gibson P.O., Parish of Terrebonne, La. Recorded May 12, 1908. S.B. Winslow, Clerk
746 ZI	The firebrand of Willie Lecompte, of Bourg P.O., Parish of Terrebonne, La. Recorded June 13, 1908. S.B. Winslow, Clerk
747 6	The firebrand of Mrs. Annette Stoufflet, Houma P.O., Parish of Terrebonne, La. Recorded June 20, 1908. S.B. Winslow, Clerk
748 R7	The firebrand of René Hebert, Humphrey P.O. Terrebonne Parish, La. Recorded June 25th, 1908. C. A. Celestin, by J.K.

No. 743: Mathilda Robinson

No. 744: Armand Duplantis

No. 745: Alphonse Collins

No. 746: Willie Lecompte

No. 747: Annette Stoufflet

No. 748: René Hebert

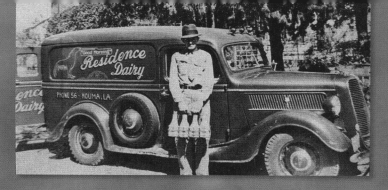

Residence Dairy

Residence Plantation's history began with large landowner Robert Ruffin Barrow, who is recorded as owning all or parts of 17 plantations in Terrebonne Parish and one in Assumption Parish. He built his home at the 500-acre Residence Plantation in 1840 on the eastern outskirts of Houma on the left descending bank of Bayou Terrebonne. Wilson Gaidry, Sr., who had married into the Barrow family, acquired Residence acreage in 1909, and began a dairy on part of the property. The dairy was discontinued in 1968.

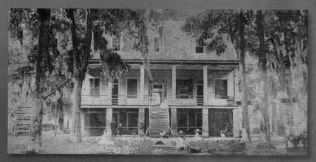

Top, the dairy's 1934 Ford delivery truck and driver Aurelie Ledet, c. late 1930s. Below, W.J. Gaidry, Sr. aboard a mule-drawn delivery wagon c. 1920. Above, a photo of the original Barrow home at Residence, taken May 23, 1887

A milk bottle from Residence Dairy

Brand	Entry
749 — **10**	The firebrand of Emile Naquin of Point au Chien (Montegut P.O.) Parish of Terrebonne. Recorded June 30, 1908. S.S. Winslow, Clerk
750 — **T3**	The firebrand of Telemarque Matherne, of Bayou Blue (Boring P.O.) Parish of Terrebonne, La. Recorded June 30, 1908. S.S. Winslow, Clerk
751 — **Ⓝ**	The firebrand of James Neal, of Bayou Pointe-au-chiens, Montegut P.O. Parish of Terrebonne, La. Recorded July 7th, 1908. C.A. Celeston, Ay Clk
752 — **WE**	The firebrand of William Ewing of Gibson P.O. Parish of Terrebonne, La. Recorded August 17, 1908. S.S. Winslow, Clerk
753 — **•B•**	The firebrand of Wallace Belanger, of Cambel Belanger Boring P.O., La. Recorded August 17, 1908. S.S. Winslow, Clerk
754 — **11**	The firebrand of Ulgere Boudreaux, Chacahoula, Parish of Terrebonne, La. Recorded October 31, 1908. S.S. Winslow, Clerk

755

The firebrand of Willis
Henry of the Parish of
Terrebonne. La.
Recorded Nov. 28, 1908 S. E. Winslow
 Clerk

No. 755:
Willis Henry

756

The firebrand of Louis Duplantis;
of the Parish of Terrebonne.
Recorded March 3, 1909 S. E. Winslow
 Clerk

No. 756:
Louis Duplantis

757

The firebrand of Joseph Rodriguez,
of the Parish of Terrebonne

C. A. Celestin
 Dy Clerk
Recorded March 11/09

No. 757:
Joseph Rodriguez

758

The firebrand of Amadee
Lajaunie, Theriot P. O. Parish
of Terrebonne. La.
Recorded April 14, 1909
 S. E. Winslow Clerk

No. 758:
Amadee Lajaunie

759

The firebrand of Oleus DesRoches.
Bourg. P. O. La.

Recorded May 29/09
 C. A. Celestin Dy. clerk.

No. 759:
Oleus DesRoches

760

Thes firebrand of Gillis
Porche, of the Parish of
Lafourche. La.
Recorded August 30, 1909
 S. E. Winslow clerk.

No. 760:
Gillis Porche

761 N3	The firebrand of Norbert Boudreaux of the Parish of Terrebonne, La. Recorded Nov. 8, 1909
762 Hh	The firebrand of Harvey Hebert of Bourg P.O., Parish of Terrebonne. Recorded March 23, 1910
763 VC	The firebrand of Alces Duplantis of the Parish of Terrebonne. Recorded May 20, 1910
764 3	The firebrand of Theophile Giroir of the Parish of Terrebonne. Recorded June 18, 1910
765 R	The firebrand of Ralph C. Bacon of the Parish of Terrebonne — Ch. Celestin Dy. Clk. Recorded Nov. 11th/10
766 JP	The firebrand of John Piazza of Houma, La. Recorded Nov. 17, 1910

Request for transfer from Zenon Bourg to Francis Bourg; see Brand No. 768 on page 275.

Houma, La., June 22, 1916

I hereby sell and convey and transfer my brand B L to Francis Bourg, for a valuable consideration

Zenon Bourg

Duly recorded in Brand Book No. 2 Oct. 26th 1916

H. W. Wright Clerk

Fire Brands Book Two, page 13

No. 767: Gabriel LeBoeuf

G.L

767

The firebrand of Gabriel LeBoeuf, of Montegut P.O. La. Parish of Terrebonne, Louisiana.

Recorded Dec. 29th/10 E. A. Celestin, Dy Clerk

This brand transferred Gustave Duval(?) [illegible] 1936, by the [illegible], both deceased.

No. 768: Zenon Bourg (see transfer on page 274)

B1

768

The firebrand of Zenon Bourg of Canal Belanger. La. Parish of Terrebonne. La.

Recorded March 27th/11 C. A. Celestin, Dy Clerk

This brand transferred to Francis Bourg, June 22/16 by Zenon Bourg

No. 769: Joseph Babin

J
B

769

The firebrand of Joseph Babin, of Bayou Blue, Parish of Terrebonne, La.

Recorded July 3, 1911 J. S. Winslow, Clerk

No. 770: Amy Ruffin

R

770

The firebrand of Amy Ruffin of Bull Run Plantation. Parish of Terrebonne, La.

Recorded Jan. 16. 1912 J. S. Winslow, Clerk

No. 771: Mrs. Admar Thibodaux & Children

A

771

The firebrand of Mrs Admar Thibodaux & children, Humphreys P.O. Bayou Black, Parish of Terrebonne, La.

Recorded May 24, 1912 J. S. Winslow, Clerk

No. 772: Philogene Engerron

PE

772

The firebrand of Philogene Engerron of Chauvin P.O. Parish of Terrebonne, La.

Recorded June 4, 1912 J. S. Winslow, Clerk

No. 773: Appolinaire Rudolph Badeaux

E8

773

The firebrand of Appolinaire Rudolph Badeaux of Gibson, Terrebonne Parish, La.

Recorded June 3, 1912 J. S. Winslow, Clerk

No. 774: James Redman

JR

774

The firebrand of James Redman, Bourg P.O. Parish of Terrebonne, La.

Recorded June 5. 1912 J. S. Winslow, Clerk

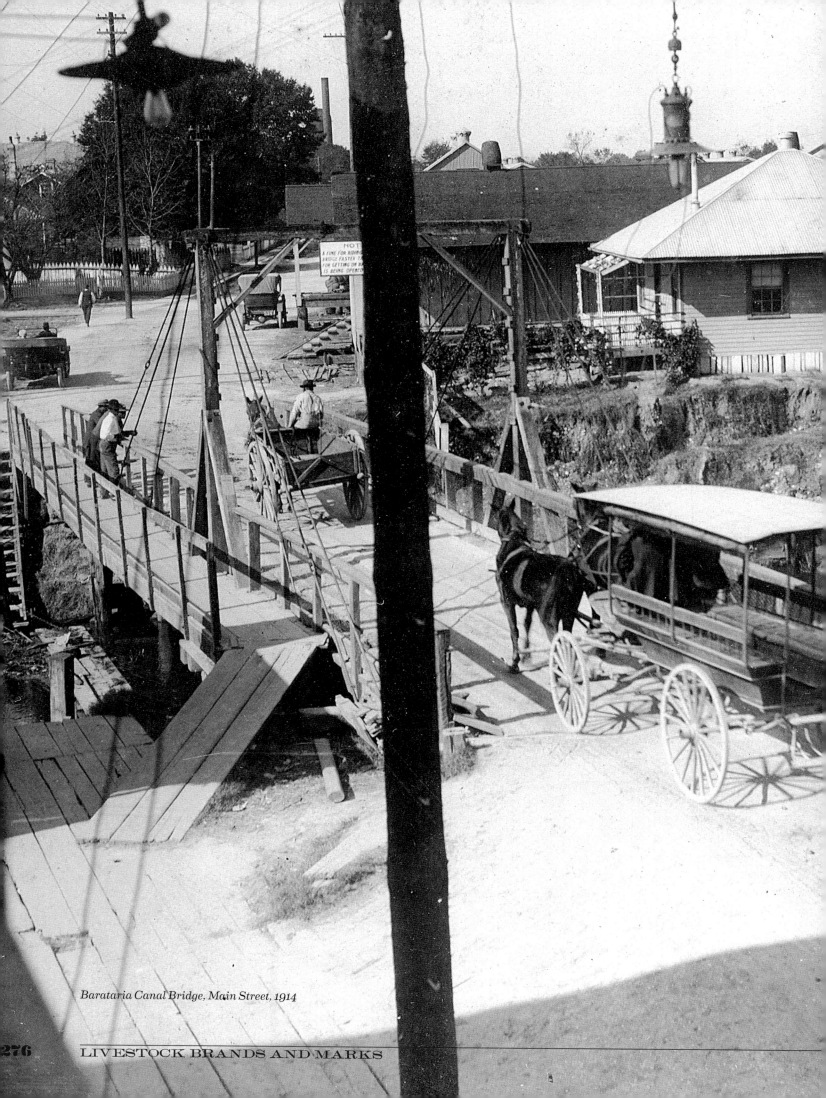

Barataria Canal Bridge, Main Street, 1914

LIVESTOCK BRANDS AND MARKS

Fire Brands Book Two, page 15

No. 775: Jordan Rollins — R8
The firebrand of Jordan Rollins, Gibson, Parish of Terrebonne, La.
Recorded July 5, 1912

No. 776: John Cotton — J.C.
The firebrand of John Cotton, Little Caillou, Parish of Terrebonne, near old Dasfit P.O.
Recorded July 12/12

No. 777: Esteve Defilice — ED
The firebrand of Esteve Defilice, Chauvin P.O., Parish of Terrebonne, La.
Recorded Aug. 23, 1912

No. 778: George Toups — AP
The firebrand of George Toups, a resident of Bayou Black, La.
Recorded Sept. 14th 1912

No. 779: Desire Guice — DG
The firebrand of Desire Guice, Chauvin P.O., Lower Little Caillou, Parish of Terrebonne, La.
Recorded Sept. 24, 1912

No. 780: Gustave Laperouse — JR
The firebrand of Gustave Laperouse of Montegut P.O., Parish of Terrebonne, La.
Recorded May 15, 1913

No. 781: Mrs. John Smith — S
The firebrand of widow John Smith of Little Caillou, Parish of Terrebonne.
Recorded June 21, 1913

No. 782: Argyle P. & M. Co. Ltd. — AB
The firebrand of Argyle P. & M. Co. Ltd. of the Parish of Terrebonne, La.
Recorded Aug. 18, 1913

783 CD

The firebrand of J. C. Dupont of the Parish of Terrebonne, La.
Recorded Oct 16, 1913
E. C. Wurzlow, Clerk

No. 783: J. C. Dupont

784 M

The firebrand of Tom Mattingly Jr. of Houma, Parish of Terrebonne, La.
Recorded March 2, 1914
E. C. Wurzlow, Clerk

No. 784: Tom Mattingly Jr.

785 HK

The firebrand of Elie Klingman, Post-office, Houma, La. No. 1
Recorded June 24, 1914
E. C. Wurzlow, Clerk

No. 785: Elie Klingman

786 EFK

The firebrand of Elie Klingman, Post office, Houma, La. No. 2
Recorded June 24, 1914
E. C. Wurzlow, Clerk

No. 786: Elie Klingman

787 $

The firebrand of Leonce Gautreaux of Houma P.O., Parish of Terrebonne, La. Residence: Woodlawn Plantation.
Aug 7, 1914
E. C. Wurzlow, Clerk

No. 787: Leonce Gautreaux

788 J

The firebrand of Dr. Wm Jastremski of Montegut, La.
Recorded Aug 11, 1914
E. C. Wurzlow, Clerk

No. 788: Dr. Vincent Jastremski

No. 789: Joseph W. Dupont

No. 790: Eba J. Braud

No. 791: Robert Ruffin Barrow Jr.

No. 792: J. E. Landry

No. 793: Naida Pelegrin

784
W D — The firebrand of Joseph W. Dupont of Khoghaula, Parish of Terrebonne, La.
Recorded Aug. 11, 1914
E. W. Winslow, Clerk

790 — The firebrand of Eba J. Braud, of Schriever, Parish of Terrebonne, La.
Recorded Aug. 13, 1914
E. W. Winslow, Clerk

791 — The firebrand of R. R. Barrow of the Parish of Terrebonne. P. O. Houma, La.
Recorded August 18, 1914
E. W. Winslow, Clerk

792
R D — The firebrand of J. E. Landry, of Montegut, Parish of Terrebonne, La.
Recorded Sept. 30, 1914
E. W. Winslow, Clerk

793
N P — The stock brand of Naida Pelegrin, Southdown Plantation, Parish of Terrebonne, La.
Recorded May 12, 1915
E. W. Winslow, Clerk

LIVESTOCK BRANDS AND MARKS

Fire Brands Book Two, pages 18 & 19

794
Ђ

The firebrand of Theophile Duplantis of Little Caillou, La. Parish of Terrebonne
Recorded May 18th, 1915
C. A. Celestine D'y Clerk

Ђ
No. 794:
Theophile Duplantis

795
⊖

The firebrand of Dr. P. E. Parker, of Bourg, Parish of Terrebonne, La.
Recorded March 15, 1916
S. A. Wurzlow Clerk

⊖
No. 795:
Dr. P. E. Parker

796
TOP

The firebrand of George L. Cenac, of Houma, La.
Recorded March 16, 1916
S. A. Wurzlow Clerk

TOP
No. 796:
George L. Cenac

797
RP

The firebrand Royal Patterson, of Gibson, La.
Recorded March 17, 1916
S. A. Wurzlow Clerk

RP
No. 797:
Royal Patterson

798
TF

The firebrand of Alex. A. Lirette, of Montegut, La. This brand belonging to Eugene Fields formerly transferred to said A. Lirette.
Recorded April 24, 1916
S. A. Wurzlow Clerk

TF
No. 798:
Alex A. Lirette

799
⊖

The firebrand of Arthur P. Duplantis, of Houma, Parish of Terrebonne, La.
Recorded April 24, 1916
S. A. Wurzlow Clerk

⊖
No. 799:
Arthur P. Duplantis

800
D3

The firebrand of Th. C. Duplantis, of Houma, Parish of Terrebonne, La.
S. A. Wurzlow Clerk

D3
No. 800:
H.C. Duplantis

Arthur P. Duplantis
Brand No. 799
dated April 24, 1916

LIVESTOCK BRANDS AND MARKS

801 — B6

The cattle brand of Gilbert A. Boudreaux, Ashland Plantation, Bayou Caillou, Parish of Terrebonne, La. P.O. Houma, La.
Recorded May 15, 1916

No. 801: Gilbert A. Boudreaux

802 — PL

The Cattle brand of L. H. Dupri-Busquite Plt. Little Caillou, Parish of Terrebonne, La. Houma P.O. La.
Recorded May 16th, 1916

No. 802: L. H. Dupri

803 — 9I

The cattle brand of Philomene Callahen of Houma, La.
Recorded May 27, 1916

No. 803: Philomene Callahan

804 — X2

The firebrand of Gibson Autin of the Parish of Terrebonne, La. P.O. Houma, La.
Recorded July 3, 1916

No. 804: Gibson Autin

805 — C3

The firebrand of James Chauvin of Houma, Parish of Terrebonne, La.
Recorded July 7, 1916

No. 805: James Chauvin

806 — A3

The firebrand of Cyprien Louis Arsenaux, of Gibson, La.
Recorded Aug. 31, 1916

No. 806: Cyprien Louis Arsenaux

William "Willie" Clutee, waterboy on the Golden Ranch Plantation, Gheens, Louisiana, c. 1920s

LIVESTOCK BRANDS AND MARKS

807 — **A⌐**
The cattle brand of Arnaud Caillouet, of Ashland Plantation, Houma P.O., Parish of Terrebonne, La.
Recorded October 14, A.D. 1916
S.A. Wurzlow, Clerk

808 — **IZ**
The firebrand or cattle brand of Clay Savoie of Montegut P.O., Parish of Terrebonne, La. Recorded Oct. 23, 1916
S.A. Wurzlow, Clerk

809 — **BI**
Houma, La. June 22, 1916
I hereby sell and transfer my brand B.I. to Francis Bourg, for a valuable consideration.
(Signed) Zenon Bourg
Recorded June 22, 1916 — S.A. Wurzlow, Clerk

810 — **A4**
The cattle brand of Albert Olivier of Chacahoula, La.
Recorded Dec. 12, 1916
S.A. Wurzlow, Clerk

810 — **OX**
The cattle brand of Octave Boudreaux, of Chacahoula, Parish of Terrebonne, La.
Recorded Jan. 11, 1917
S.A. Wurzlow, Clerk

811 — **B2**
The cattle brand of Augustin J. Bergeron, Bayou Black (P.O. Houma), Louisiana. Recorded April 5, 1917
S.A. Wurzlow, Clerk

No. 812:
Mrs. Livie Guidry

No. 813:
Oscar C. Daspit

No. 814:
Robert Lagarde

No. 815:
William F. Ross

No. 816:
Willis Pelegrin

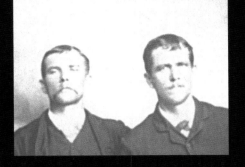

Twins Ernest (October 31, 1857 – November 1, 1930) and Wallace (October 31, 1857 – July 16, 1925) Ellender, Brand No. 821 dated June 29, 1917

Fire Brands Book Two

No. 817:
Willie Eshte

No. 818:
Octave Dupre

No. 819:
Davis LeBoeuf

No. 820:
Thomas Ellender Sr. (II)

No. 821:
Ernest Ellender
& Wallace Ellender

No. 822:
Joseph Ellender

817 — W2 — The cattle brand of Willie Eshte, Bayou Boeuf, Houma P.O., Parish of Terrebonne, La. Recorded May 31, 1917. S.L. Wurzlow, Clerk

818 — D4 — The cattle brand of Octave Dupre, of Point au Chien, Montegut P.O., La. Recorded June 8, 1917. S.L. Wurzlow, Clerk

819 — 31 — The cattle brand of Davis LeBoeuf, of the Parish of Terrebonne, La., P.O. Montegut. Recorded June 8, 1917. S.L. Wurzlow, Clerk

820 — TE (II) — The cattle brand of Thomas Ellender, Sr. of the Parish of Terrebonne, La., P.O. Montegut, La. (adopted from Thomas Ellender I, Book G no. 42). Recorded June 29, 1917. S.L. Wurzlow, Clerk

821 — Ǐ — The cattle brand of Ernest Ellender and Wallace Ellender (Ernest Ellender on left hip and Wallace Ellender on the right hip), P.O. Bourg, La. Recorded June 29, 1917. S.L. Wurzlow, Clerk

822 — JE — The cattle brand of Joseph Ellender, of Montegut P.O., Parish of Terrebonne, La. Recorded June 29, 1917. S.L. Wurzlow, Clerk

Fire Brands Book Two, pages 26 & 27

823
AC — The cattle brand of Albert Cenac, of Houma, Parish of Terrebonne, La.
Recorded October 16th A.D. 1917
E. W. Winslow, Clerk

No. 823: Albert Cenac

824
Jo — The cattle brand of John Robichaux, of Bourg P.O., Parish of Terrebonne, La.
Recorded Oct. 20, 1917
E. W. Winslow, Clerk

No. 824: John Robichaux

825
EL — The cattle brand of Eugene L. Lecompte, of Houma, La.
Recorded Oct. 30, 1917
E. W. Winslow, Clerk

No. 825: Eugene L. Lecompte

826
JM — The cattle brand of J. L. McIntire of Gibson, Parish of Terrebonne, La.
Recorded Dec. 1st A.D. 1917
E. W. Winslow, Clerk

No. 826: J. L. McIntire

827
D3 — The firebrand or cattle brand of Octave Dufresne of Bayou Blue, Parish of Terrebonne, La. P.O. Bourg, La.
E. W. Winslow, Clerk

No. 827: Octave Dufresne

ELLENDER

Among the large Terrebonne Parish families that registered multiple brands in the parish courthouse are the Ellenders. The family founder in Terrebonne was Thomas Elinger (spellings varied), of German ancestry probably born in Lebanon, Ohio in 1818. After arriving in Terrebonne in the late 1830s, he married Terrebonnean Catharine Roddy of Little Caillou in 1840. They had eight sons and one daughter: Henry, Joseph, Thomas, Jr., George, James, twins Ernest and Wallace, David and Elizabeth. Tom's brand registration is No. 280, dated May 1841.

The elder Tom was a yeoman farmer who never owned slaves. He first bought land along lower Bayou Terrebonne in 1874, and in 1880 purchased Hardscrabble plantation, previously called Caillou Field, which had been a part of Robert Ruffin Barrow's Point Farm. The sons expanded their land holdings in 1889 by purchasing Hope Farm, about three miles upstream on Bayou Terrebonne from Hardscrabble. The future longtime U.S. Senator Allen J. Ellender, Wallace's son, was born at Hardscrabble on September 24, 1890 in a plain Acadian cottage. (As a child he was nicknamed *Sous-Sous*, from the French for "Little Pennies.")

In 1897 the Ellenders owned 2,900 acres of land, with 300 acres in sugar cane and 175 in corn. Their lands produced 5,000 tons of sugar cane in 1896. They owned 90 mules, comprising 45 teams, to work at Hardscrabble and Hope Farm.

The Terrebonne Sugar Refinery was founded in 1883 at Montegut. When the company reorganized in 1891, the business became the Lower Terrebonne Refining and Manufacturing Company. The Ellenders subsequently became part-owners after 1891. In 1901, the *Southern Manufacturer* described the Montegut mill as "one of the largest and most complete sugar factories in the world."[22] The enterprise was foreclosed in 1928, then closed and dismantled in 1972, later reassembled in Guatemala.

The Ellender family lived close to the land, and their multiple brands on record show their reliance on livestock necessities required to run the plantations and farms.

From left, son Henry (October 18, 1843 – 1861), father Thomas (1818 – May 17, 1884), and daughter Elizabeth (August 9, 1841 – March 23, 1894). Photo c. 1860

Brand No. 280, the record of Thomas Elinger dated May 17, 1841

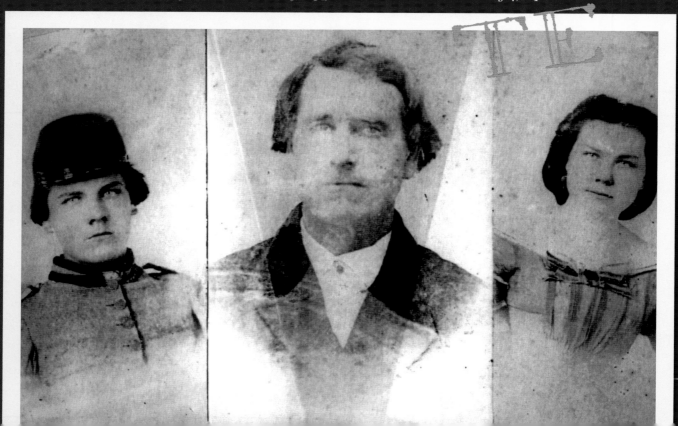

No. 828: O4 — Oliver Lecompte

The cattle brand of Oliver Lecompte of the Parish of Terrebonne, 10th ward. P.O. Thenot, La.
Recorded Jan. 5, 1918
E. W. Winslow, Clerk

No. 829: L5 — Elphege Lapeyrouse

The cattle brand of Elphege Lapeyrouse, of Chamonix, P.O. Little Caillou, Parish of Terrebonne, La.
Recorded March 6, 1918
E. W. Winslow, Clerk

No. 830 — T. J. Ellender Jr. & Wilson Ellender

The cattle brand of T. J. Ellender Jr., and Wilson Ellender; shoulder for T. J. Ellender Jr., & hip for Wilson Ellender. P.O., Montegut, La.
Recorded April 6th A.D. 1918
E. W. Winslow, Clerk

No. 831: AK — Alidore Kraemer

The cattle brand of Alidore Kraemer, of the Parish of Terrebonne, La., P.O., Schriever, La.
Recorded April 13th 1918
E. W. Winslow, Clerk

No. 832: ƎD — Edward Savoie

The cattle brand of Edward Savoie, of the Parish of Terrebonne, La. P.O. Houma, La.
Recorded April 13th 1918
E. W. Winslow, Clerk

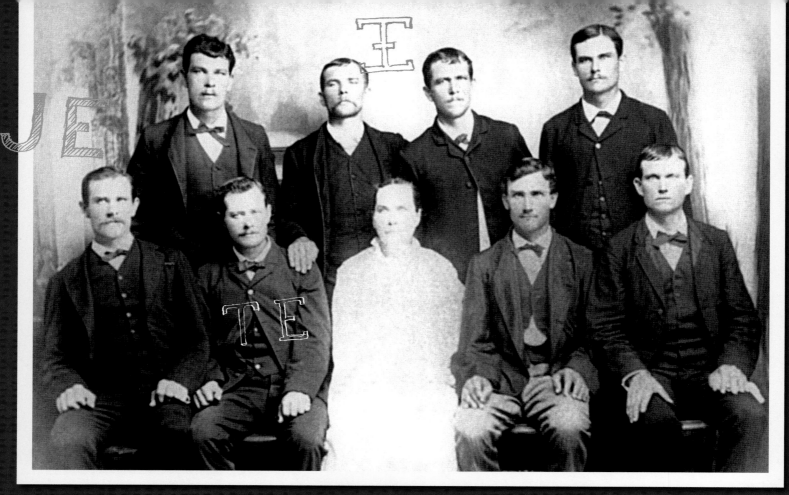

Thomas and Catharine Roddy Elinger's children (standing, from left) James, twins Ernest and Wallace, David, (sitting, from left) Joseph, Thomas, Elizabeth, William, George. That photo's brand information: Joseph: No. 822 dated June 29, 1917. Thomas: No. 820 dated June 29, 1917. Ernest and Wallace: No. 821 dated June 29, 1917. Photo c. 1880s

Hyman Ellender,
No. 703 dated June 30, 1906

Carl Ellender,
No. 982 dated March 30, 1935

Wilson E. Ellender
(shared brand with T.J. Ellender, Jr.),
No. 830 dated April 6, 1917

Paul Ellender,
No. 959 dated June 13, 1930

Wallace R. Ellender,
No. 951 dated September 9, 1929

Fay Chauvin (husband of Josephine
Ellender, Thomas Elinger's granddaughter),
No. 857 dated September 27, 1919

LIVESTOCK BRANDS AND MARKS

833 — **14**

The cattle brand of Volzie Blanchard, of the Parish of Terrebonne, La.
Chauvin P.O. La.
Recorded 4/23/1918
　　　　　　　　E. W. Naylor
　　　　　　　　　Clerk

834 — **JE**

The cattle brand of James E. Jones, of the Parish of Terrebonne, La.
Houma, P.O. La.
Recorded May 11, 1918
　　　　　　　　E. W. Naylor
　　　　　　　　　Clerk

835 — **N2**

The cattle brand of Mrs. Roger Naquin, a resident of the Parish of Terrebonne, La.
Bourg, P.O. La.
Recorded May 14, 1918
　　　　　　　　E. W. Naylor
　　　　　　　　　Clerk

836 — **L6**

The cattle brand of Joseph L. Lyons, of the Parish of Terrebonne, La.
Houma P.O. La.
Recorded May 25, 1918
　　　　　　　　E. W. Naylor
　　　　　　　　　Clerk

837 — **13**

The cattle brand of Cleophas Duplantis, of the Parish of Terrebonne, La.
Houma P.O. La.
Recorded June 11, 1918
　　　　　　　　E. W. Naylor
　　　　　　　　　Clerk

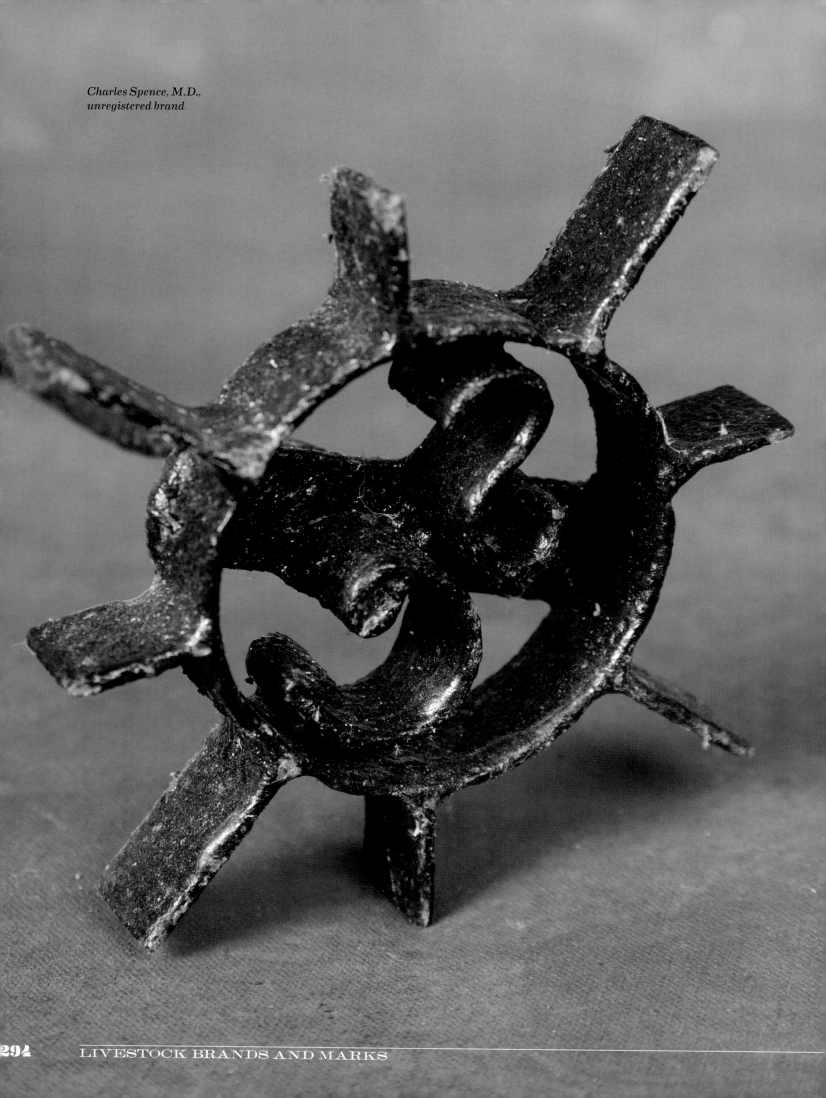

Charles Spence, M.D., unregistered brand

LIVESTOCK BRANDS AND MARKS

No. 839: Albert Landry — L4

The firebrand or cattle brand of Albert Landry, of Mr. Jn Terrebonne, (Bayou Coteau).
Recorded July 16, 1918.
E. W. Wurzlow, Clerk

No. 840: Jean Baptiste Duplantis — JD

The firebrand of Jean Baptiste Duplantis, formerly, now transferred to Auguste Duplantis.
Houma P.O. La.
Re-Recorded July 27th A.D., 1918
E. W. Wurzlow, Clerk

No. 841: Alcide Sonnier — AS

The firebrand of Alcide Sonnier, of the Parish of Terrebonne, La.
Gray P.O., La.
Recorded Aug. 20th A.D., 1918
R. P. Blanchard, Dy. Clerk

No. 842: Dorien Kraemer — CK

The firebrand of Dorien Kraemer, of the Parish of Terrebonne, La.
Houma, P.O. La.
Recorded Aug. 31st A.D., 1918.
Clerk

No. 843: Mrs. Edmond Hebert

The firebrand of Mrs. Edmond Hebert, of the Parish of Terrebonne, La.
Humphreys P.O. La.
Recorded Dec. 21st A.D., 1918.
E. W. Wurzlow, Clerk

844

The firebrand of Frederick Levron of the Parish of Terrebonne.
Montegut P.O., La.
Recorded February 25, A.D., 1919.

E.B. Wurzlow
Clerk

845

The firebrand of Clarence Roddy, of the Parish of Terrebonne, La.
Chacahoula P.O., La.
Recorded February 27, 1919.

E.B. Wurzlow
Clerk

846

The firebrand of C. P. Smith, of the Parish of Terrebonne, La.
Houma P.O., La.
Recorded Apr. 9, A.D., 1919.

R. P. Blanchard
D'y Clerk

847

The firebrand of Odressy Buquet, of the Parish of Terrebonne, La.
Chacahoula P.O. La.
Recorded May 17, 1919.

R. P. Blanchard
D'y Clerk

848

The firebrand of William Price, of the Parish of Terrebonne, La.
Montegut P.O. La.
Recorded June 7, 1919.

R. P. Blanchard
D'y Clerk

No. 844: Frederick Levron

No. 845: Clarence Roddy

No. 846: C. P. Smith

No. 847: Odressy Buquet

No. 848: William Price

The fire, or cattle brand of Aurelie E. Brien, of the Parish of Terrebonne, La.
Bourg P. O., La.

Recorded June 14, 1919. R. P. Blanchard D'y Clerk

850

The fire, or cattle brand of Lineas Ledet, of the Parish of Terrebonne, La.
Chauvin P. O., La.
Recorded June 25, 1919.
R. P. Blanchard
D'y Clerk

851

The fire brand of Albert Welch, of the Parish of Terrebonne, La.
Houma P. O., La.
Recorded July 10, 1919.
R. P. Blanchard
D'y Clerk

852

The fire brand of Henry Cotton, of the Parish of Terrebonne, La.
Chauvin P. O., La.
Recorded July 11, 1919.
R. P. Blanchard
D'y Clerk

853

The fire-brand of Ulysse Brunet, of the Parish of Terrebonne, La.
Bourg P. O., La.
Recorded August 8, 1919.
R. P. Blanchard
D'y Clerk

No. 852:
Henry Cotton

No. 853:
Ulysse Brunet

WILLIAM EDENBORN became important to the cattle industry via an indirect route. He was born in Prussia in 1848 and was orphaned at age 14. He apprenticed as a wire maker before coming to America in 1866 and settling first in St. Louis. Although Edenborn did not invent barbed wire, he patented a machine in 1883 that lowered the cost of the product considerably. U.S. Steel was born when Edenborn sold his businesses to J.P. Morgan for about $100 million at the end of the nineteenth century. Edenborn is credited with encouraging ranchers to fence their lands by producing a "humane" wire with smaller, duller barbs than had been produced before.

After building his fortune in wire and steel, he moved to Louisiana and pursued his passion for building railroads. Edenborn's Louisiana and Arkansas Railway linked New Orleans to Shreveport. At the same time, his million acres made him one of Louisiana's biggest landowners; he had extensive cypress logging operations. He was also chairman of the board of the Kansas City Southern Railroad. Edenborn and his wife Sarah owned two steamships, the S.S. *William Edenborn* and the S.S. *Sarah Edenborn*. He died in Shreveport in 1926 at age 78.

Edenborn Avenue in Metairie is a south Louisiana reminder of his historical prominence.

854

The firebrand of Alidore Picou, of the Parish of Terrebonne, La. Chauvin P.O., La.
Recorded Aug. 12, 1919
R. P. Blanchard
Dep. Clerk

No. 854: Alidore Picou

855

The firebrand of Loney Eschete, of the Parish of Terrebonne, La. Chauvin P.O., La.
Recorded August 22, A.D. 1919
R. P. Blanchard
Dep. Clerk

No. 855: Loney Eschete

856

The firebrand of Willie Robichaux, of the Parish of Terrebonne, Louisiana; Chauvin P.O., La.
Recorded Sept. 24, A.D., 1919
R. P. Blanchard
Deputy Clerk

No. 856: Willie Robichaux

857

The firebrand of Fay Chauvin, of the Parish of Terrebonne, Louisiana; Montegut, P.O., La.
Recorded Sept. 27th, A.D. 1919
R. P. Blanchard
Deputy Clerk

No. 857: Fay Chauvin

858

The firebrand of Peter Daigle, of the Parish of Terrebonne, Louisiana; Houma, P.O., La.
Recorded Oct. 3, A.D., 1919
R. P. Blanchard
Deputy Clerk

No. 858: Peter Daigle

Request for transfer from Aurelie Eschete to Neville Eschete; see Brand No. 859.

Houma, La. Feby 12, 1936

For a valueable consideration, receipt of which is hereby acknowledged, I hereby transfer to Neville Eschete, a resident of Terrebonne Parish, La., Chauvin P.O., the Fire Brand registered in my name under No. 859, shown on the opposite page hereof. I have also transferred to the said Neville Eschete all of the cattle now owned by me in Terrebonne Parish, La.

Witnesses:

Aurelie Eschete

Fire Brands Book Two, pages 40 & 41

859

The firebrand of Aurelie Eschete of the Parish of Terrebonne, La.
Chauvin P.O. La.

Recorded October 24 A.D., 1919
R.P. Blanchard
Dy Clerk

Transferred to Neville Eschete Feb. 12, 1936

No. 859: Aurelie Eschete

860

The firebrand of Wilson Authement of the Parish of Terrebonne, La.
Bourg P.O., La.

Recorded Nov. 4, A.D., 1919.
R.P. Blanchard
Dy Clerk

No. 860: Wilson Authement

861

The firebrand of Paul M. Cenac of the Parish of Terrebonne, La.
Houma, P.O., La.

Recorded Nov. 28, 1919
R.P. Blanchard
Acting Clerk

No. 861: Paul M. Cenac

862

The Firebrand of Laurence Pellegrin of the Parish of Terrebonne,
Chauvin P.O., Louisiana

Recorded Mar. 4, 1920
R.P. Blanchard

No. 862: Laurence Pellegrin

863

The firebrand of Louis Eshte, of the Parish of Terrebonne, La.
Chauvin P.O. La.

Recorded April 19, 1920
R.H. Bazet
Dy Clerk

No. 863: Louis Eshte

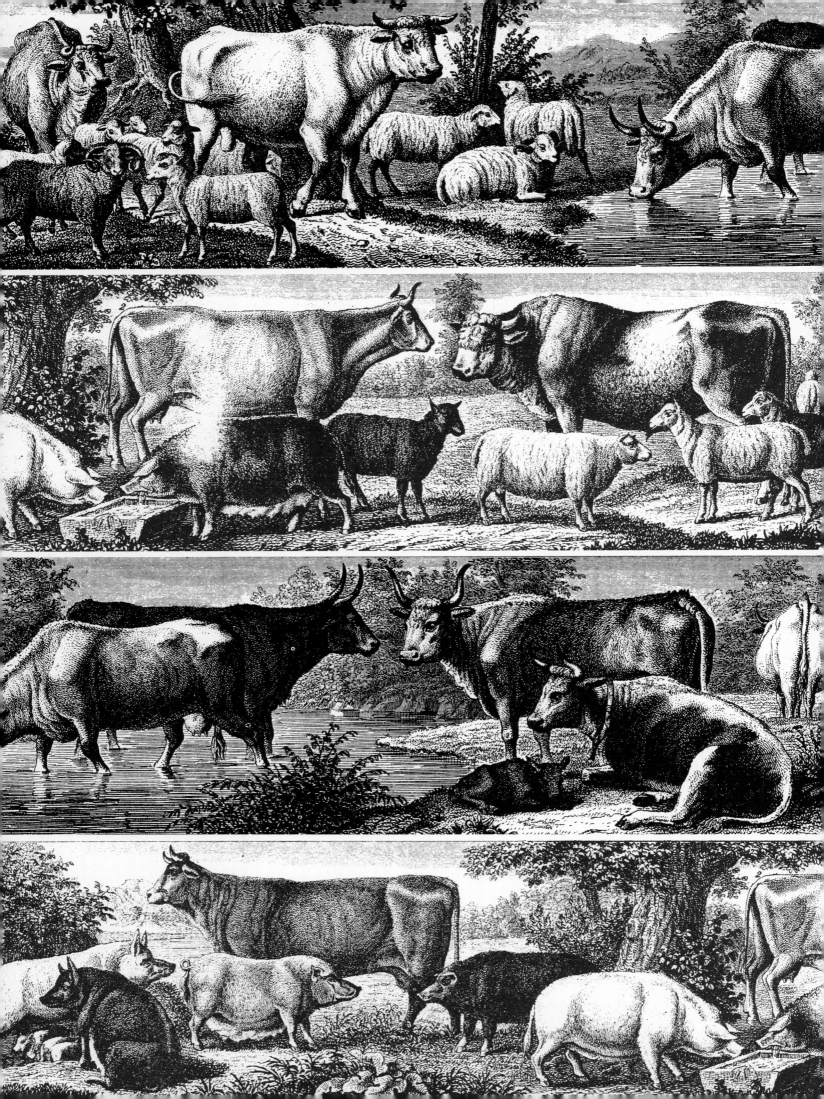

864	The firebrand of Edward Boyne of the Parish of Terrebonne, La. Montegut P.O. La. Recorded Apr 29, 1920. R A Bazet Dy Clerk	**No. 864:** Edward Boyne
865	The firebrand of John A. Boyne, of the Parish of Terrebonne, La. Montegut, P.O. La. Recorded Apr 29, 1920. R A Bazet Dy Clerk	**No. 865:** John A. Boyne
866	The firebrand of Enos J. Landry, of the Parish of Terrebonne, Montegut, P.O. La. Recorded May 8th 1920. R P Blanchard Clerk	**No. 866:** Enos J. Landry
867	The firebrand of Hewitt Angers of the Parish of Terrebonne, La. Houma, P.O. La. Recorded May 8, 1920. R A Bazet Dy Clerk	**No. 867:** Hewitt Angers
868	The Firebrand of Joseph White of The Parish of Terrebonne. Chauvin P.O. La. Recorded May 22, 1920. R P Blanchard Clerk	**No. 868:** Joseph White

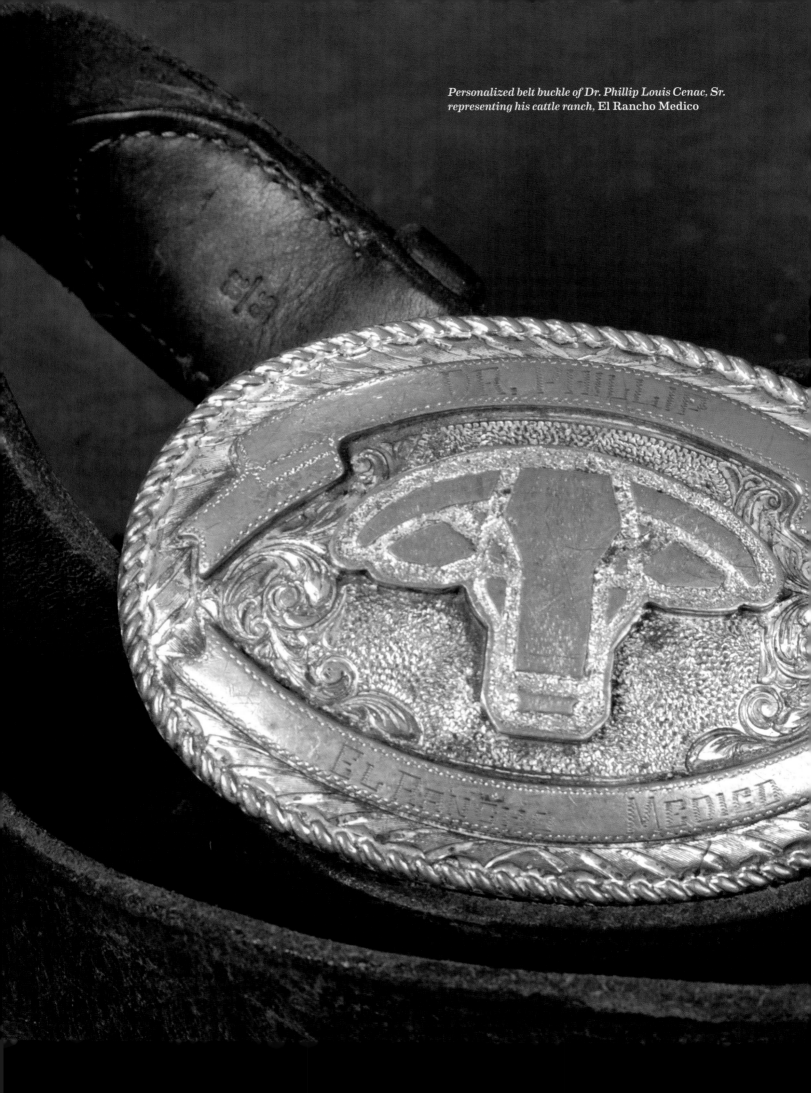

Personalized belt buckle of Dr. Phillip Louis Cenac, Sr. representing his cattle ranch, El Rancho Medico

869

SG

The Firebrand of Joseph Albert Gaston of the Parish of Terrebonne,
Montegut, P.O. La.
Recorded June 4th 1920
R.R. Blanchard Dy Clerk

870

RR

The fire brand of Eugene Whipple of the Parish of Terrebonne.
Bourg P.O., La.
Recorded June 7, A.D., 1920.
R H Bazet
Dy Clerk.

871

JW

The fire brand of James Williams of the Parish of Terrebonne, Houma P.O. State of Louisiana
La. A resident of this Parish
Duly Recorded June 14/1920

A.O.Nebaux
Clerk.

872

The Fire brand of Arthur Hotard of The Parish of Terrebonne,
Houma P.O. La.
A resident of this Parish Terrebonne State of La.
Recorded June 17th 1920.
R.R. Blanchard Dy Clerk

873

AR

The Fire Brand of Argus Chauvin Of the Parish of Terrebonne, State of Louisiana
P.O. address Houma P.O. La.
A resident of this Parish
Duly Recorded July 3/1920

A.O.Nebaux
Clerk of Court.

Request for transfer from
Octave Hebert to Dennis Marcel;
see Brand No. 878.

Houma, La. June 20, 1938.

For a valuable consideration this day paid to me by Dennis Marcel, address - Route 2, Box 66T Houma, La., I hereby transfer to the said Dennis Marcel the Fire Brand "⊗" registered in my name under No. 878.

Witnesses:

Octave his x Hebert
 mark

Fire Brands Book Two, pages 46 & 47

874 AJ

State of La, Parish of Terrebonne
The Fire Brand of Arthé Picou
P.O. Address Bourg P.O. La.
Parish of Terrebonne, a resident of this Parish
Recorded July 3/1920
A O Neubaux Clerk of Court

No. 874: Arthé Picou

875 N4

The State of La. Parish of Terrebonne
The Fire Brand of Clarence Pontiffe
P.O. address. Bourg P.O. Parish of Terrebonne
La. A resident of this Parish
Recorded Aug 3/1920
A O Neubaux Clerk of Court

No. 875: Clarence Pontiffe

876 D

State of Louisiana, Parish of Terrebonne
The Fire Brand of Elie Dubois
P.O. address Chauvin P.O. La.
A resident of this Parish
Recorded August 5/1920
A O Neubaux
Clerk of Court.

No. 876: Elie Dubois

877 P2

State of Louisiana, Parish of Terrebonne
The Fire Brand of Paul Marcel
A resident of the Parish of Terrebonne, State of
Louisiana, P.O. address, Houma, La.
Recorded August 12/1920
A O Neubaux
Clerk of Court.

No. 877: Paul Marcel

878 ⊗

State of Louisiana Parish of Terrebonne
The Fire Brand of Octave Hebert
A resident of the Parish of Terrebonne.
State of La. P.O. address Houma La.
Recorded August 14 A.D 1920
A O Neubaux
Clerk of Court

No. 878: Octave Hebert

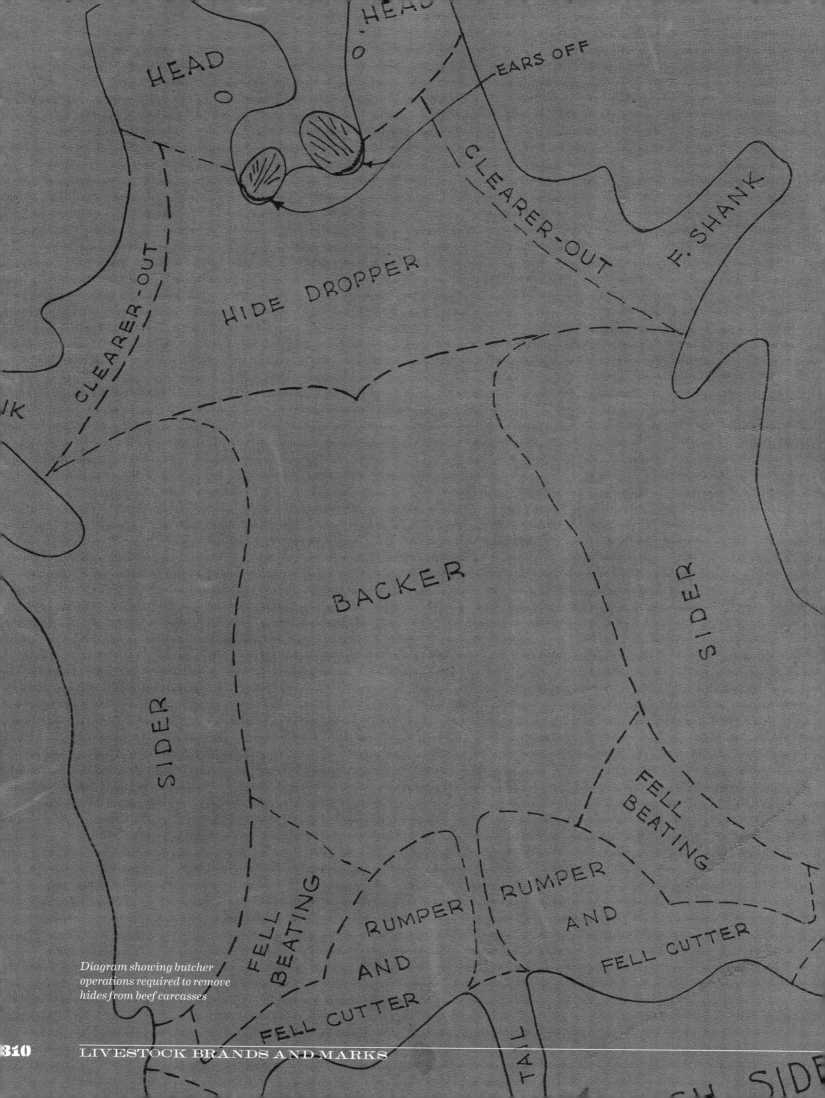

Diagram showing butcher operations required to remove hides from beef carcasses

A
879

State of Louisiana, Parish of Terrebonne,
The Fire Brand of Alfred Martin
A resident of the Parish of Terrebonne
State of Louisiana, P.O. address Bourg La

Recorded Aug 16/1920
 A O Hebert
 Clerk

880

State of Louisiana, Parish of Terrebonne,
The Fire Brand of Baker Falgout.
A resident of the Parish of Terrebonne.
State of Louisiana, P.O. address Bourg, La.

Recorded Oct 7th 1920
 A O Hebert
 Clerk.

No. 879: Alfred Martin

No. 880: Baker Falgout

9
881

State of Louisiana, Parish of Terrebonne
The Fire Brand of Price Robichaux
A resident of the Parish of Terrebonne La.
P.O. address Chauvin P.O. La.

Recorded Nov 4th A.D. 1920
 A O Hebert
 Clerk

No. 881: Price Robichaux

AB
882

State of Louisiana, Parish of Terrebonne.
The Fire Brand of Americus Bergeron
A resident of the Parish of Terrebonne, State of
Louisiana, P.O. address Montegut P.O. La.

Recorded Dec 31st A.D. 1920.
 A O Hebert
 Clerk.

No. 882: Americus Bergeron

P2
883

State of Louisiana, Parish of Terrebonne
The Fire Brand of Emile John Picou
A resident of the Parish of Terrebonne Chauvin
P.O. Boudreaux Canal Sta.

Recorded Jany 17/1921
 A O Hebert
 Clerk.

No. 883: Emile John Picou

Request for transfer from S. C Daspit to Louis J. Duplantis; *see Brand No. 884.*

> Houma, La. May 9, 1939.
>
> I hereby assign and transfer to Louis J. Duplantis all of my right, title and interest in and to the fire-brand "ZZ" registered in my name. I have no cattle branded with said brand and have no further use for same.
>
> S. C. Daspit
> Louis J. Duplantis
>
> Witnesses:
> H. O. Winslow
> H. J. Bodin
>
> Recorded May 9, 1939.
> H. O. Winslow
> Dy Clerk.

Request for transfer from Tim J. Lecompte to Roy P. Lirette; *see Brand No. 958, page 333.*

> Houma, La., July 9, 1938
>
> This is to certify that I, Tim J. Lecompte, for and in consideration of the sum of $1.00, cash in hand paid, do hereby convey and set over to Roy P. Lirette, a resident of the Parish of Terrebonne, the fire, or cattle, brand, No. 958, registered in my name, thus: "TL".
>
> Witness my hand at Houma, Parish of Terrebonne, La., in the presence of the undersigned competent witnesses, this 9th day of July, 1938.
>
> Tim J. Lecompte
>
> Witnesses:

Fire Brands Book Two, pages 50 & 51

22 — No. 884

State of Louisiana, Parish of Terrebonne.
The Fire Brand of Salvatore C. Daspit a resident of the Parish of Terrebonne P.O. address, Houma, La.
Recorded March 1/1921

A O Hebert
Clerk of Court

JY — No. 885

The fire brand of Etienne Carro, of the Parish of Terrebonne, La.
Bourg P.O.
Record March 19th 1921.

R A Bazet
Dy Clerk

EB — No. 886

The Fire Brand of Evans William Henri Of the Parish of Terrebonne, State of Louisiana
P.O. address Houma La.
Registered this 22cd day of March A.D. 1921

A O Hebert
Clerk of Court.

H — No. 887

The Fire Brand of J. Herbert Carlos. A resident Of the Parish of Terrebonne, State of Louisiana
P.O. address, Houma, La.
Registered May 16/1921

A O Hebert
Clerk of Court.

RS — No. 888

The Fire Brand of Rodgers Ringold a resident Of the Parish of Terrebonne, State of Louisiana.
P.O. address, Houma P.O. La. P.O. Box 263.

A O Hebert
Clerk of Court,
Registered May 16/1921

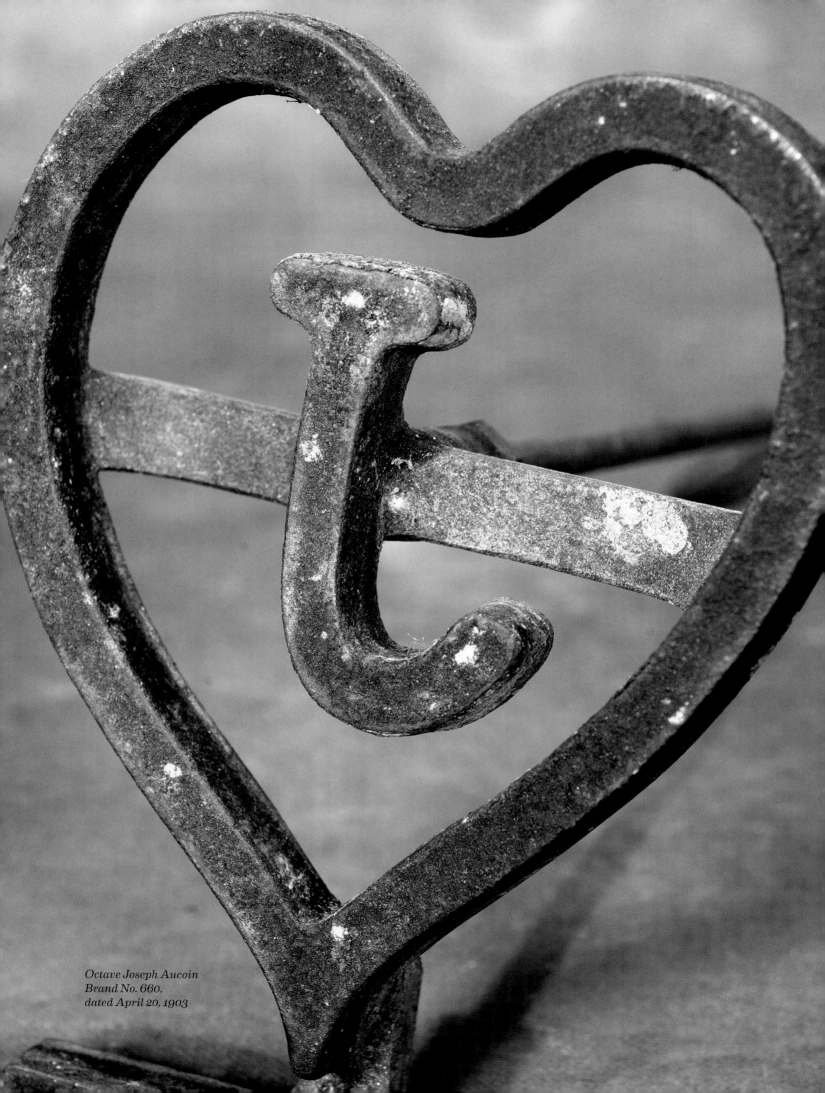

*Octave Joseph Aucoin
Brand No. 660,
dated April 20, 1903*

889 — The Fire Brand of Albert Chauvin, a resident of the Parish of Terrebonne, State of Louisiana. P.O. Address, Bourg, Louisiana.

A. P. Hebert
Clerk of Court

Registered May 16/1921

890 — The Fire Brand of Ernest J. Dubois, a resident of the Parish of Terrebonne, State of Louisiana. P.O. address, Bourg, La.

A. P. Hebert
Clerk of Court

Recorded May 30th A.D. 1921

891 — The Fire Brand of Clerville Matherne, a resident of the Parish of Terrebonne, State of Louisiana, P.O. address, Bourg, La.

Recorded June 6/1921

A. P. Hebert
Clerk

892 — The Fire Brand of Jos Boquet, a resident of the Parish of Lafourche, State of Louisiana, P.O. address Bourg, P.O. La.

Recorded June 6/1921

A. P. Hebert
Clerk

893 — The firebrand of Henry Dufrene, a resident of the Parish of St. Charles, La., Des Allemands P.O.

Recorded June 30th, 1921

R. A. Bazet
Dy Clerk

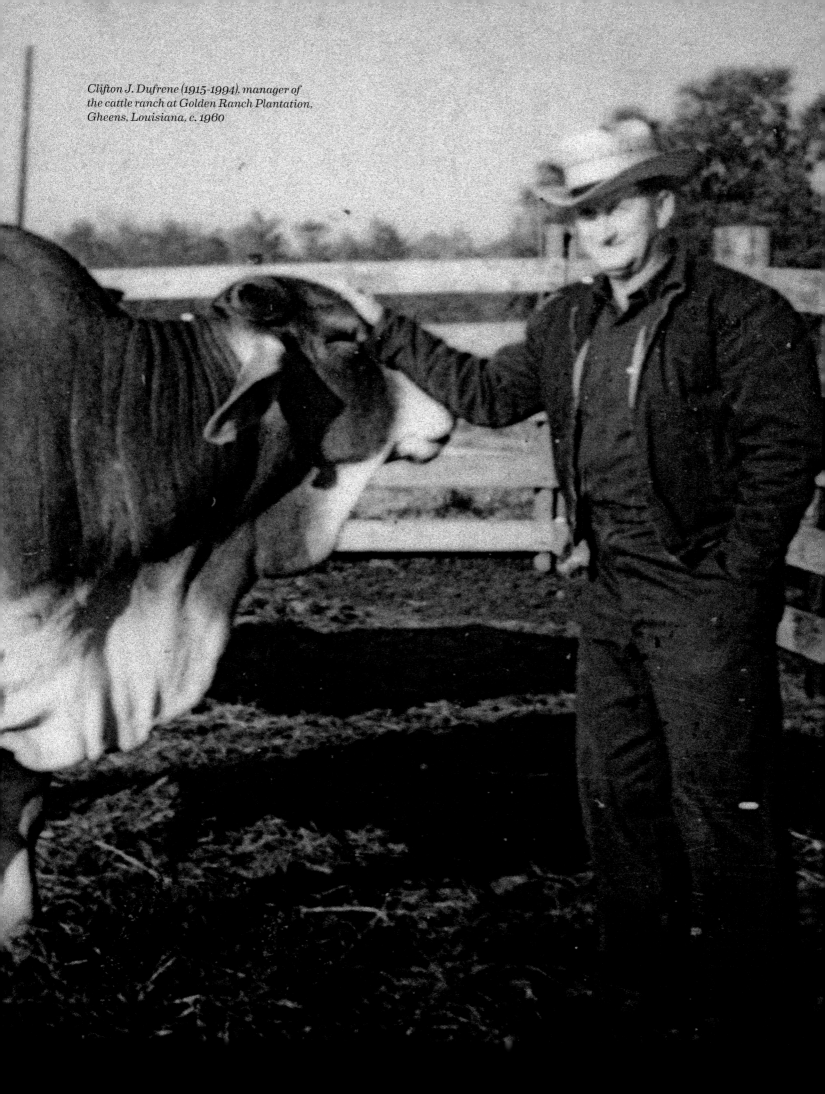

Clifton J. Dufrene (1915-1994), manager of the cattle ranch at Golden Ranch Plantation, Gheens, Louisiana, c. 1960

894 — LG

The fire-brand of Gilbert Lehman of the Parish of Terrebonne, La.
Houma P.O.
Recorded July 7th A.D. 1921.
R A Bazet Dy Clerk

No. 894: Gilbert Lehman

895 — OX

The fire-brand of Octave Chiasson of the Parish of Terrebonne, La. Montegut P.O.
Recorded July 11th A.D. 1921.
R A Bazet Dy Clerk

No. 895: Octave Chiasson

896 — BX

The firebrand of Amedee Benoit of the Parish of Terrebonne, La.
Dulac P.O.
Recorded July 20th A.D. 1921.
R A Bazet Dy Clerk

No. 896: Amedee Benoit

897 — EX

The firebrand of Eddie Martin of the Parish of Terrebonne, La.
Chauvin, P.O.
Recorded August 1st A.D. 1921.
R A Bazet Dy Clerk

No. 897: Eddie Martin

898 — L8

The firebrand Levy Trahan of the Parish of Terrebonne, La. Houma, La.
Recorded August 1st 1921
A N Cox
Clerk of Court

No. 898: Levy Trahan

Brand No. 903

BU

Fire Brands Book Two, page 57

| 899 LW | The Fire Brand Of Wallace Lecompte a resident of the Parish Of Terrebonne, State Of Louisiana, P.O. address: Houma, La. Via Bayou Dularge Route. Recorded April 29/1921. A.O. LeBard, Clerk |

LW
No. 899: Wallace Lecompte

| 900 KC. | The Fire Brand Of Theodore F. Kramer a resident of the Parish of Terrebonne, State of Louisiana, P.O. address, Houma La. Recorded Nov 30/1921. A.O. LeBard, Clerk |

KC.
No. 900: Theodore F. Kramer

| 901 J4 | The fire-brand of John Dover, a resident of the Parish of Terrebonne, La. Houma P.O. R.F.D. Bayou Dularge. Recorded Jan. 23/1922. R.A. Bazet, Dy Clerk |

J4
No. 901: John Dover

| 902 VI | The fire-brand of Edward Aucoin of the Parish of Terrebonne, Louisiana. Boury P.O., La. Recorded Feb. 24th 1922. R.A. Bazet, Dy Clerk |

VI
No. 902: Edward Aucoin

| 903 BU | The fire-brand of John D. Burnett of the Parish of Terrebonne. Houma P.O., La. Recorded March 11th 1922. R.A. Bazet, Dy Clerk |

BU
No. 903: John D. Burnett

Abel LeBlanc, Sr.
Brand No. 991,
dated July 25, 1935

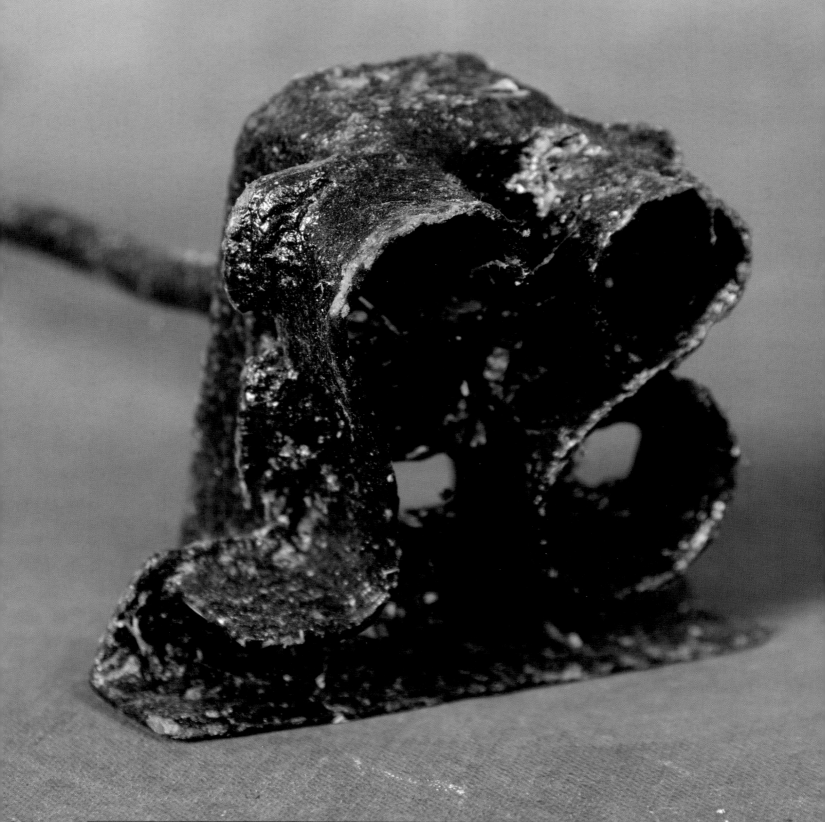

GF	The fire Brand of Elphege Picou Houma P.O. Parish of Terrebonne Louisiana Recorded May 2nd/1922 A.P. Hebert Clerk of Court	**No. 904:** Elphege Picou
905 A6	The firebrand of Arthur Laperouse of the Parish of Terrebonne Chauvin P.O. La. Recorded May 10th 1922 R A Bazet Dy Clerk	**No. 905:** Arthur Laperouse
906 G-J	The fire brand J. A. Guidry Parish of Terrebonne Montegut P.O. La. Recorded May 20/1922 A.P. Hebert Clerk of Court	**No. 906:** J. A. Guidry
907 6J	The firebrand of Thomas Miller, a resident of the Parish of Terrebonne, La. Chacahoula P.O., La. Recorded June 1st 1922 R A Bazet Dy Clerk	**No. 907:** Thomas Miller
908 4	The firebrand of Joe Dubois a resident of the Parish of Terrebonne, La. Chauvin P.O., La. Recorded June 12th 1922 Loist Belanger Dy Clerk	**No. 908:** Joe Dubois

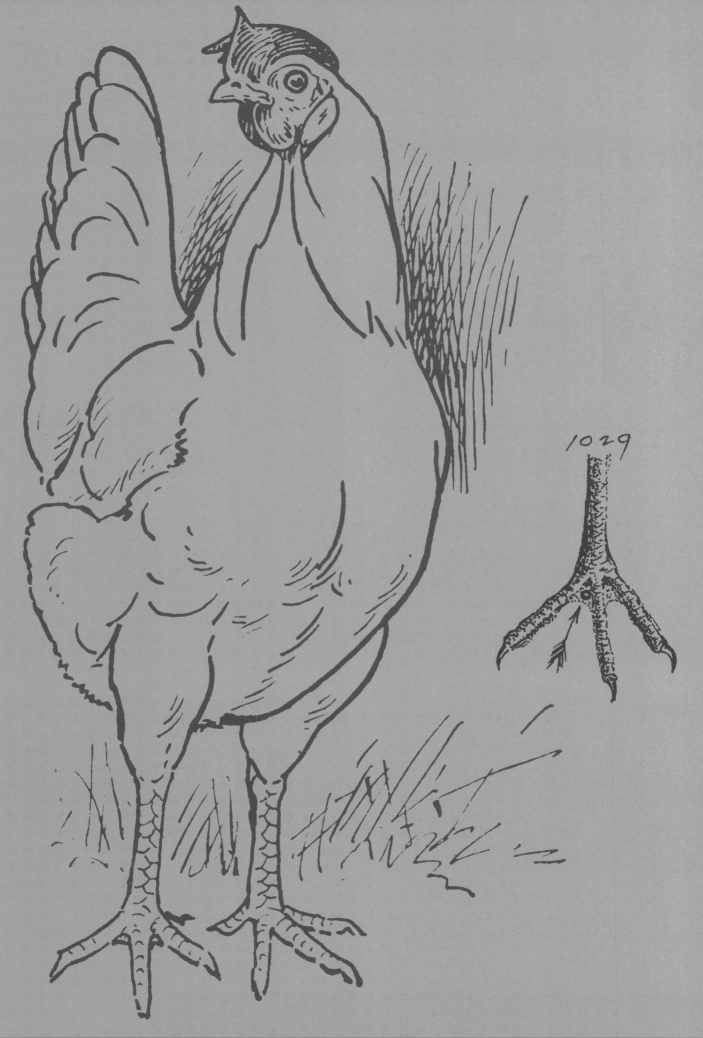

909. **M4**	The firebrand of Michel Dumond, a resident of the Parish of Terrebonne, La. Chauvin P.O., La. Recorded June 12th, 1922. Louis Belanger, Dy Clerk
910. **DP**	The firebrand of Davis Picou, a resident of the Parish of Terrebonne, La. Chauvin P.O., La. Recorded July 25th, 1922. R A Bazet, Dy Clerk
911. **ƎB**	The firebrand of Emily Belanger, a resident of the Parish of Terrebonne, La. Houma P.O. La. Recorded Sept. 21st 1922. R A Bazet, Dy Clerk
911. **NG**	The firebrand of Nicholas Gallet, a resident of the Parish of Terrebonne, La. P.O. address Montegut P.O. La. Recorded Oct 4th 1922. A. D. Ebert, Clerk of Court
912. **LL**	The firebrand of Joseph E. Landry and Gilbert Lehman, of the Parish of Terrebonne La. Postoffice: Montegut and Houma, respectively. Recorded Oct. 5th 1922. R A Bazet, Dy Clerk

No. 909: Michel Dumond

No. 910: Davis Picou

No. 911: Emily Belanger

No. 911: Nicholas Gallet

No. 912: Joseph E. Landry & Gilbert Lehman

No. 913:
Elam Picou

No. 914:
Wilson Duplantis

No. 915:
Wilfred Dupre

No. 916:
Wallace D. Duplantis

No. 917:
Lineas Authement

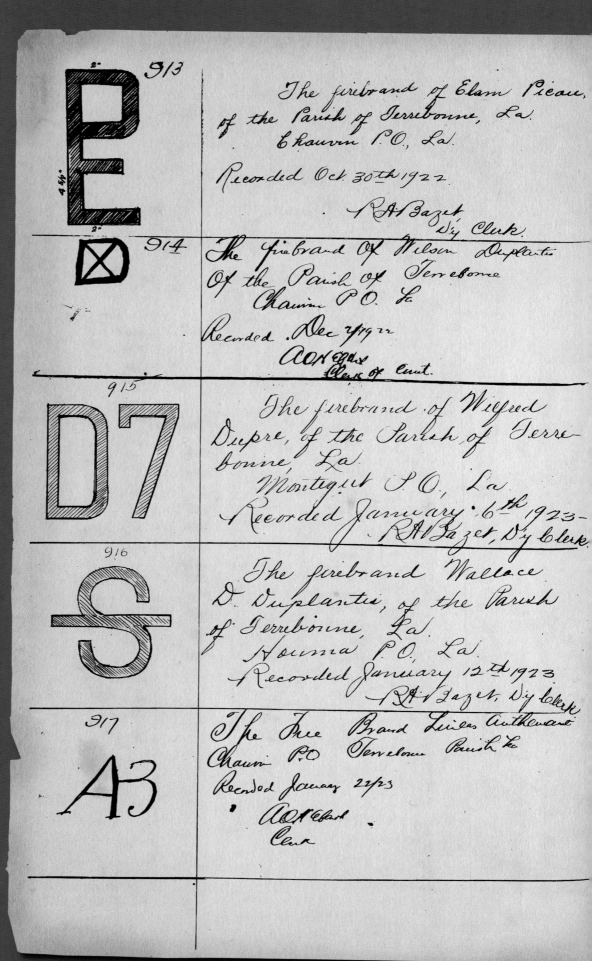

No.	Brand	Record
918	J	The firebrand of Julien Laperouse, of the Parish of Terrebonne, La. Chauvin P.O., La. Recorded January 26th 1923. R. A. Bazet, Dy. Clerk.
919	W3	The firebrand of Willie Prestonback of the Parish of Terrebonne, La. Houma, La. Recorded April 30th 1923. Lois Belanger, Dy. Clerk.
920	P3	The firebrand of Oscar L. Price, of the Parish of Terrebonne, La. Montegut P.O., La. Recorded May 29th 1923. R. A. Bazet, Dy. Clerk.
921	20	The firebrand brand of Emile P. Bascle, formerly, now of Andrew S. Bascle of Bourg P.O., La., who this day declared under oath that the said Emile P. Bascle, his grandfather, has been dead over 20 years; and that he, said Andrew S. Bascle has been using said brand in order to identify his cattle, and desires that the said brand be transferred to him, and further declares that henceforth this shall be the firebrand used by him. Andrew S. Bascle. Recorded and sworn to and subscribed before me this 30th day of August, 1923. R. A. Bazet, Dy. Clerk.

No. 922: Miguel Prosperie

No. 923: Charles Domangue

No. 924: Marguerite Dardard

No. 925: Celestine Roussel

No. 926: Alexis LeBoeuf

922.
MP — The firebrand of Miguel Prosperie of the Parish of Terrebonne, La. Montegut Postoffice.
Recorded September 24th 1923.
R. A. Bazet, Dy Clerk

923
CD — The firebrand of Charles Domangue, a resident of the Parish of Terrebonne, La. Houma Postoffice.
Recorded September 29, 1923.
R. A. Bazet, Dy Clerk

924
M — The firebrand of Marguerite Dardard a resident of the Parish of Terrebonne, La. Theriot Postoffice.
Recorded March 26th 1924.
R. A. Bazet, Dy Clerk

925
CR — The firebrand of Celestine Roussel, a resident of the Parish of Terrebonne, La. Montegut P.O.
Recorded April 30th 1924.
R. A. Bazet, Dy Clerk

926
A — The firebrand of Alexis LeBoeuf of the Parish of Terrebonne, La. Montegut P.O., La.
Recorded May 1st 1924.
R. A. Bazet, Dy Clerk

Fire Brands Book Two, pages 64 & 65

927 **J7**	The firebrand of Joseph Trahan of the Parish of Terrebonne, La., Chauvin Postoffice. Recorded October 6th 1923. Lois Belanger, Dy. Clerk
928 **Pd**	The firebrand of Joseph Blanchard of the Parish of Terrebonne, La. Chauvin P.O., La. Recorded May 9th 1925. R.H. Bazet, Clerk
929 **V7**	The firebrand of Mrs. Paul Deon, of the Parish of Terrebonne, La., Montegut Postoffice. Recorded May 16th 1925. Lois Belanger, Dy. Clerk
930 **P7**	The fire, or cattle brand, of Ernest Price, a resident of the Parish of Terrebonne, Louisiana, Chauvin P.O., La. Recorded July 24th 1925. R.H. Bazet, Clerk of Court
931 **O7**	The firebrand of Olinda Cotten, unmarried, and a resident of the Parish of Terrebonne, La. Chauvin P.O., La. Recorded September 2nd 1925. R.H. Bazet, Clerk

J7 — No. 927: Joseph Trahan
Pd — No. 928: Joseph Blanchard
V7 — No. 929: Mrs. Paul Deon
P7 — No. 930: Ernest Price
O7 — No. 931: Olinda Cotten

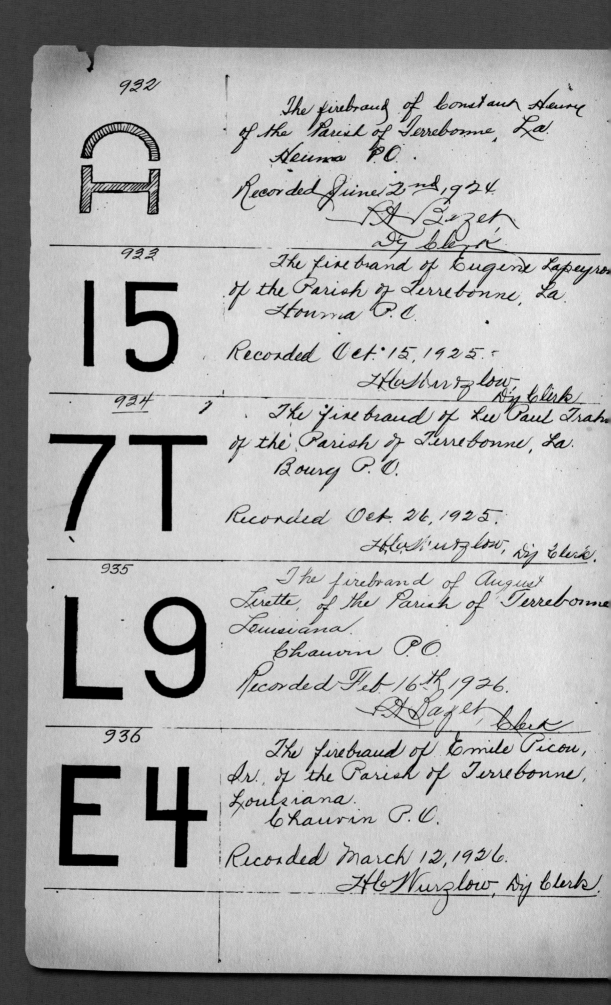

Fire Brands Book Two, pages 66 & 67

937
UP

The firebrand of Ulger J. Picou of the Parish of Terrebonne, La.; Houma P.O.

Recorded April 19th, 1926.

H.C. Wurzlow, Dy Clerk

938.
NHC

The firebrand of Pierre Cenac of the Parish of Terrebonne, La.; Houma P.O.

Recorded July 28, 1926.

H.C. Wurzlow, Dy Clerk

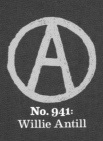

939
S6

The firebrand of Sidney J. Theriot of the Parish of Terrebonne, La., Chauvin P.O.

Recorded October 9th, 1926.

H.C. Wurzlow, Dy Clerk

940
F3

The firebrand of Frank Porche of the Parish of Terrebonne, La. Houma P.O., Box 95 (Bayou Blue)

Recorded Feb. 21st, 1927.

R.H. Bazet, Clerk

941
Ⓐ

The firebrand of Willie Antill of the Parish of Terrebonne, La. - Humphreys P.O., La.

Recorded May 26th, 1927.

R.H. Bazet, Clerk

No. 937: Ulger J. Picou
No. 938: Pierre Cenac Jr.
No. 939: Sidney J. Theriot
No. 940: Frank Porche
No. 941: Willie Antill

No. 942: Gustave Pitre — G3

No. 943: Jasper K. Wright — JK

No. 944: Nicholas White — NW

No. 945: Morgan Rogers — M7

No. 946: Andrew Authement — VA

942 — G3 — The firebrand of Gustave Pitre of the Parish of Terrebonne, La. Bourg P.O. La. Recorded February 27, 1928. H.C. Wurzlow, Dy Clerk

943 — JK — The firebrand of Jasper K. Wright of the Parish of Terrebonne, La. Houma P.O. La. Recorded June 1st, 1928. H.C. Wurzlow, Dy Clerk

944 — NW — The firebrand of Nicholas White of the Parish of Terrebonne, La. Houma, P.O. (Grand Caillou) P.O. Box 486. Recorded July 12th, 1928. P.A. Daspit, Clerk

945 — M7 — The firebrand of Morgan Rogers of the Parish of Terrebonne, Louisiana. Bourg P.O. La. Recorded August 16th, 1928. P.A. Daspit, Clerk

946 — VA — The firebrand of Andrew Authement of the Parish of Terrebonne, La. Chauvin P.O. La. Recorded Oct. 19, 1928. H.C. Wurzlow, Dy Clerk

LIVESTOCK BRANDS AND MARKS

Fire Brands Book Two, pages 68 & 69

947

∈C

Actual Size

The fire brand of Justillien Carrere of the Parish of Terrebonne, La.

Houma P.O. La.

Recorded October 23, 1928.

H. C. Wurzlow, Dy Clk.

948

JVL

The fire brand of Joseph Vincent LeBlanc of the County of Jefferson, State of Texas.

Port Arthur, Texas.

Recorded December 24th, 1928.

Lois Belanger
Deputy Clerk of Court

949

UC

The firebrand of Clyde Lirette of the Parish of Terrebonne, La.

Montegut P.O., La.

Recorded August 2nd, 1929.

R. H. Paget, Clerk

950

E9

The firebrand of Edward Verdin of the Parish of Terrebonne, La.

Bourg P.O., La.

Recorded Sept. 4, 1929.

R. H. Paget, Clerk

951

TT

The firebrand of Wallace R. Ellender of the Parish of Terrebonne, La.

Bourg, P.O., La.

Recorded Sept. 9th, 1929.

R. H. Paget, Clerk

No. 947: Justillien Carrere

No. 948: Joseph Vincent LeBlanc

No. 949: Clyde Lirette

No. 950: Edward Verdin

No. 951: Wallace R. Ellender

LC
No. 952:
Lelia Lecompte

7L
No. 953:
Gustave J. Lapeyrouse

JL
No. 954:
Johnny Lecompte

HF
No. 955:
Henry Price

⟨B⟩
No. 956:
Felix A. Bonvillain

952
The firebrand of Lelia Lecompte, widow of Joseph Bourg, of the Parish of Terrebonne, La.
Montegut P.O., La.
Recorded September 24th, 1929.
R.H. Dagét, Clerk

953
The firebrand of Gustave J. Lapeyrouse of the Parish of Terrebonne, La.
Chauvin P.O., La.
Recorded Oct 19th, 1929.
H.C. Wurzlow, Dy Clerk

954
The firebrand of Johnny Lecompte of the Parish of Terrebonne, La.
Montegut P.O., La.
Recorded Nov. 8th, 1929.
H.C. Wurzlow, Dy Clerk

955
The firebrand of Henry Price of the Parish of Terrebonne, La.
Chauvin P.O., La.
Recorded Mch. 18, 1930.
H.C. Wurzlow, Dy Clerk

956
The firebrand of Felix A. Bonvillain of the Parish of Terrebonne, Louisiana.
Houma P.O., Louisiana.
Recorded April 8th, 1930.
R.H. Dagét, Clerk

Fire Brands Book Two, pages 70 & 71

957

The firebrand of Marcellin V. Marmande, a resident of the Parish of Terrebonne, Louisiana.
Theriot P.O., La.
Recorded May 24th, 1930.
R. H. Daspit, Clerk.

No. 957:
Marcellin V. Marmande

958

The firebrand of Tim J. Lecompte, a resident of the Parish of Terrebonne, La.
Montegut P.O., La.
Recorded May 31st, 1930.
R. H. Daspit, Clerk

No. 958:
Tim J. Lecompte
(see transfer on page 312)

959

The firebrand of Paul Ellender, a resident of the Parish of Terrebonne, La.
Montegut P.O., La.
Recorded June 13th, 1930.
H. Cloward, Dy Clerk.

No. 959:
Paul Ellender

960

The firebrand of Paul Prosperie, a resident of the Parish of Terrebonne, Louisiana.
Montegut P.O., La.
Recorded July 15th, 1930.
R. H. Daspit, Clerk.

No. 960:
Paul Prosperie

961

The firebrand of Theodore S. Lapeyrouse, a resident of the Parish of Terrebonne, La.
Houma P.O., Little Caillou Route.
Recorded Oct. 1st, 1930.
R. H. Daspit, Clerk.

No. 961:
Theodore S. Lapeyrouse

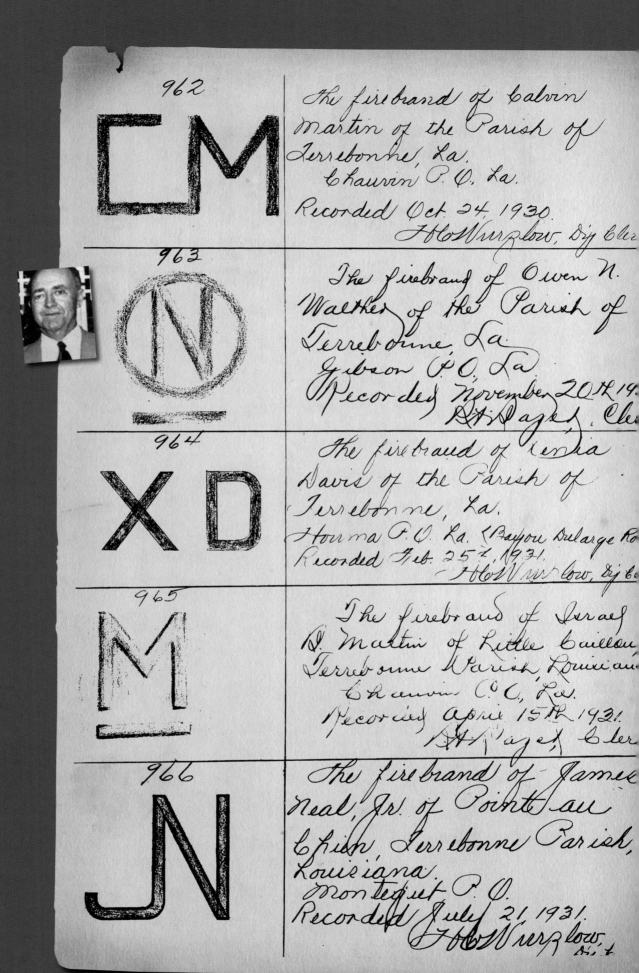

No. 962: Calvin Martin

No. 963: Owen N. Walther

No. 964: Xenia Davis

No. 965: Israel B. Martin

No. 966: James Neal Jr.

967

The firebrand of Leon, Clovis and Emile Charpentier of the Parish of Terrebonne, La. (Houma P.O. Little Caillou Route) Recorded Sept. 4th 1931.

C+

No. 967: Leon Charpentier, Clovis Charpentier, & Emile Charpentier

968

The firebrand of Mrs. Mary LeBoeuf, widow of Octave J. Brunet of the Parish of Terrebonne, La. (Montegut P.O.) Recorded Sept. 19, 1931.
T. H. Winslow, Dy Clerk

MHL

No. 968: Mary LeBoeuf

969

The firebrand of Alcide Authement of the Parish of Terrebonne, La. Chauvin P.O. La. Recorded April 28, 1932.
T. H. Winslow, Dy Clerk

A

No. 969: Alcide Authement

970

The firebrand of George D. Lyons of the Parish of Orleans, La. 1014 Eleanore St., New Orleans, La. Recorded May 14, 1932.
T. H. Winslow, Dy Clerk

□K

No. 970: George D. Lyons

971

The firebrand of Wenzel A. Guidry of the Parish of Terrebonne, La. Montegut P.O. La. Recorded Oct. 18th, 1932.
T. H. Winslow, Dy Clerk

W7

No. 971: Wenzel A. Guidry

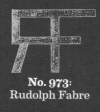

No. 972:
Jervis P. LeBoeuf

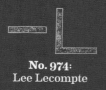

No. 973:
Rudolph Fabre

No. 974:
Lee Lecompte

No. 975:
Edgar Rhodes

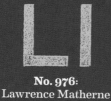

No. 976:
Lawrence Matherne

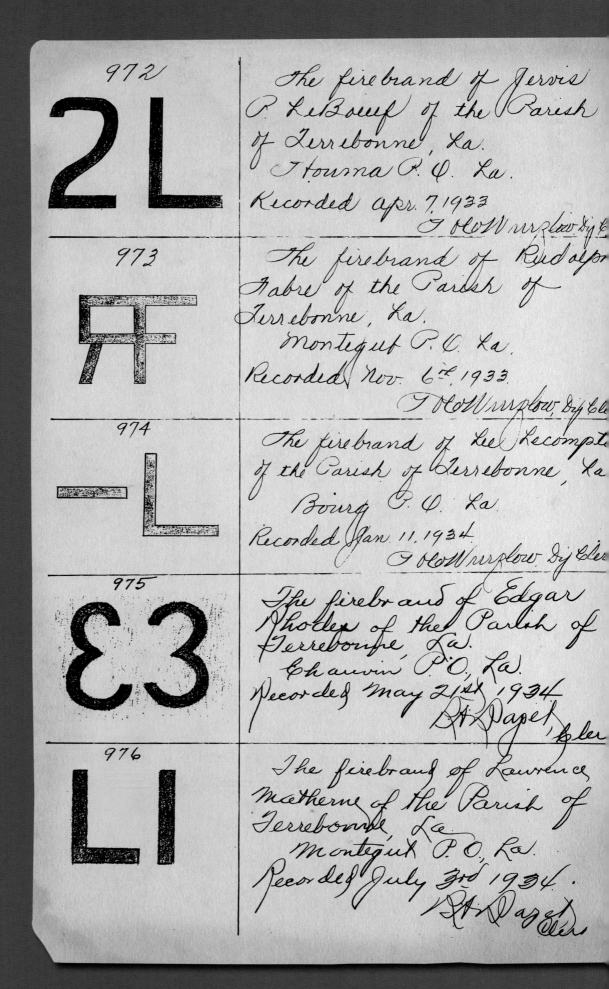

LIVESTOCK BRANDS AND MARKS

Fire Brands Book Two, pages 74 & 75

977 WD	The firebrand of Whitney Dupre of the Parish of Terrebonne, La. Chauvin P. O. La. Recorded Oct. 2, 1934. H. C. Winslow, Dy Clerk
978 H7	The firebrand of Howard Henry of the Parish of Terrebonne, La. Bourg P. O. La. Recorded Oct. 6, 1934. H. C. Winslow, Dy Clerk
979 ◇	The firebrand of Maggie Eschete, wife of Ephie Marie. Houma P. O., La. Recorded Nov. 13th 1934. R. A. Bazet, Clerk
980 SO	The firebrand Sylvere Olivier of the Parish of Terrebonne. Upper Bayou Black. Houma P. O. Recorded Jan. 11th 1935 R. A. Bazet, Clerk
981 NP	The firebrand of Norman Picou of the Parish of Terrebonne. Houma P. O. Recorded Feb. 13th, 1935. H. C. Winslow, Dy Clerk

No. 977: Whitney Dupre

No. 978: Howard Henry

No. 979: Maggie Eschete

No. 980: Sylvere Olivier

No. 981: Norman Picou

No. 982: Carl Ellender

No. 983: Clovis Portier

No. 984: Junius Guidry

No. 985: Lucian Pellegrin

No. 986: Eldred Hebert

982 — The fire or cattle brand of Carl Ellender of the Parish of Terrebonne, La. Recorded March 30th, 1935.

983 — The firebrand of Clovis Portier of the Parish of Terrebonne, La. Recorded April 1st, 1935.

984 — The firebrand of Junius Guidry of the Parish of Terrebonne, La. Montegut P.O. Recorded April 17th, 1935.

985 — The firebrand of Lucian Pellegrin, of the Parish of Terrebonne, La. Houma P.O. Little Caillou Road. Recorded May 7th, 1935.

986 — The firebrand of Eldred Hebert, of the Parish of Terrebonne, La. Bourg P.O., La. Recorded May 23, 1935.

LIVESTOCK BRANDS AND MARKS

No. 987: Fay Pellegrin

The fire, or cattle, brand of Fay Pellegrin of the Parish of Terrebonne, La.
Houma P.O.
Recorded May 28th, 1935
R H Dazet, Clerk

No. 988: Oliva Pelegrin

The fire, or cattle, brand of Oliva Pelegrin of the Parish of Terrebonne, La.
Montegut, P.O., La.
Recorded May 28th, 1935
R H Dazet, Clerk

No. 989: Gilbert Martin

The fire, or cattle, brand of Gilbert Martin of Bourg P.O., Parish of Terrebonne, La.
Recorded June 1st, 1935.
J H Wurzlow, Dy Clerk

No. 990: Emile Hebert

The fire, or cattle, brand of Emile Hebert of the Parish of Terrebonne, La.
Bourg Postoffice.
Recorded July 26th, 1935.
R H Dazet, Clerk

No. 991: Abel LeBlanc

The fire, or cattle, brand of Abel LeBlanc, presently a resident of the Parish of Lafourche but who intends to remove to the Parish of Terrebonne and reside on property recently purchased by him from Aurelie Brien on Bayou Terrebonne about 12 miles below Houma.
Recorded July 29, 1935. R H Dazet, Clerk

LEBLANC

The LeBlancs who raise cattle in Terrebonne and Lafourche parishes are descendants of an ancestor who can be traced back to 1626 in Loudin, Mataize, Poitou-Charentes, France. Daniel LeBlanc sailed to the New World in 1648 and settled along Canada's eastern coast on the north bank of the Port-Royal River (now Annapolis River). He and his wife Marie Francois Gaudet had six sons and a daughter, all born at Port-Royal. Five of his children were parents of 35 sons. Daniel owned 20 cattle, 35 sheep, nine hogs, and 18 arpents of land when he died in 1693.

By 1755, Daniel's progeny in Canada comprised the largest extended family in Acadia, spread among all the main Acadian communities. The Great Deportation of the 1750s scattered the members of the huge family, involuntarily, to New England, Maryland, Virginia, and eventually to Louisiana. His first descendants arrived in Louisiana from Halifax, Nova Scotia, in February 1755. Etienne LeBlanc, his wife, and their seven children settled in St. James Parish along the Mississippi River. Their son Mathurin and his wife moved to upper Bayou Lafourche in 1790.

Abel LeBlanc, a ninth generation descendant of Daniel LeBlanc, first raised cattle in Lafourche's Larose and Lockport, and then in Terrebonne Parish's Montegut and Lower Bayou Blue until his death in 1971. His grandchildren are carrying on that way of life in Terrebonne and Avoyelles parishes.

Bayou Blue, Terrebonne Parish, 1925

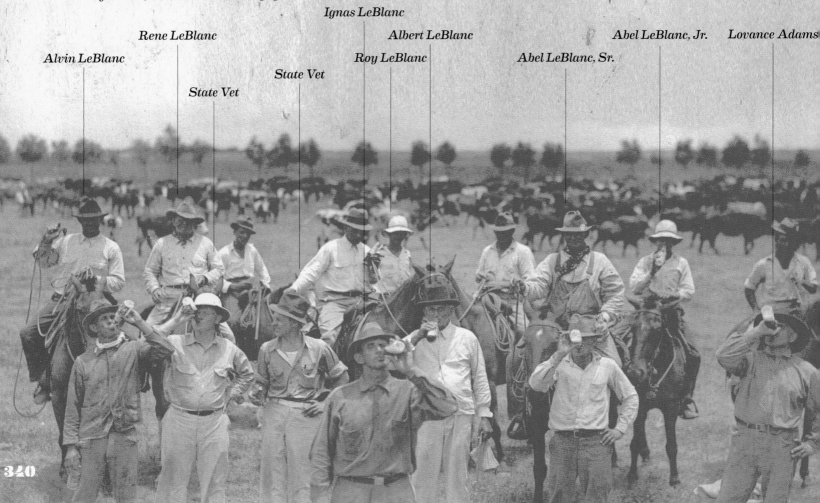

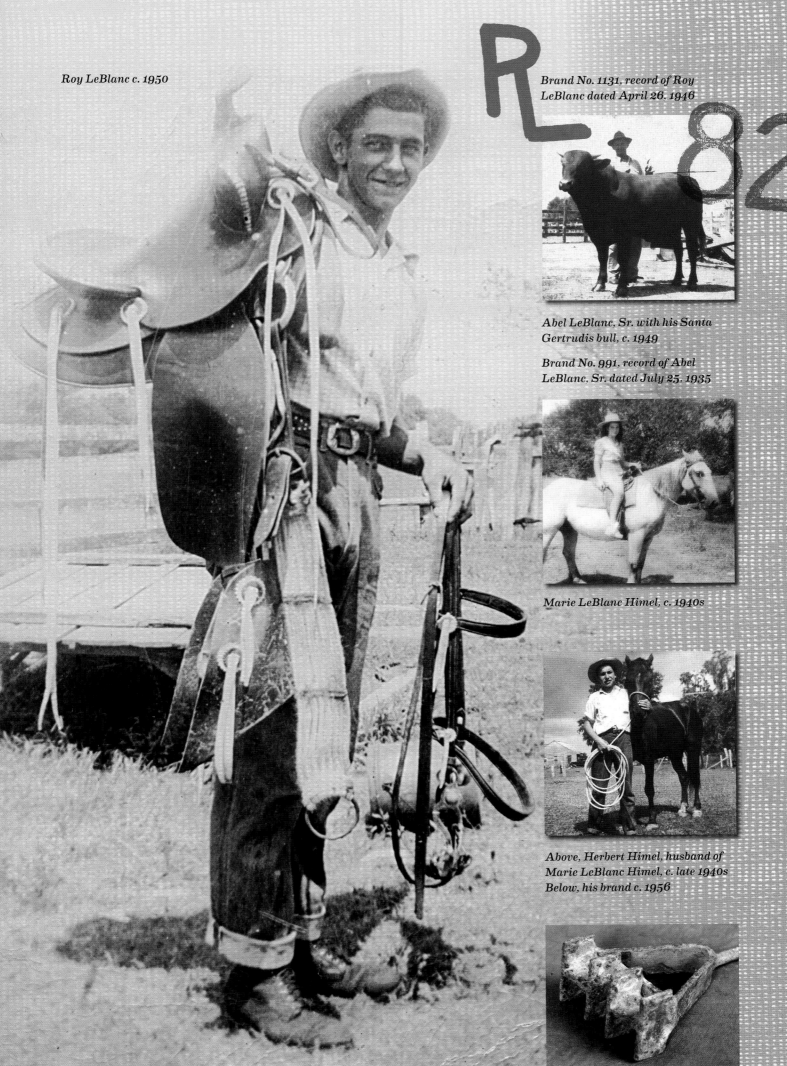

Roy LeBlanc c. 1950

Brand No. 1131, record of Roy LeBlanc dated April 26, 1946

Abel LeBlanc, Sr. with his Santa Gertrudis bull, c. 1949

Brand No. 991, record of Abel LeBlanc, Sr. dated July 25, 1935

Marie LeBlanc Himel, c. 1940s

Above, Herbert Himel, husband of Marie LeBlanc Himel, c. late 1940s
Below, his brand c. 1956

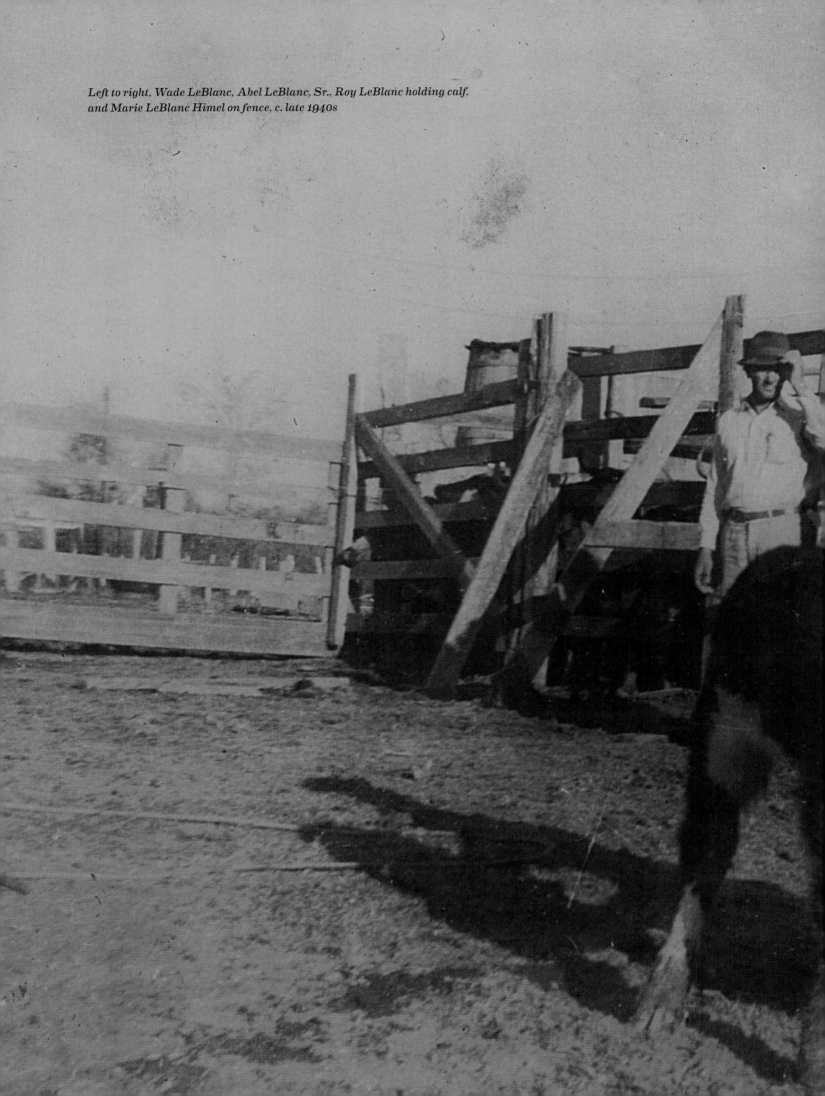

Left to right, Wade LeBlanc, Abel LeBlanc, Sr., Roy LeBlanc holding calf, and Marie LeBlanc Himel on fence, c. late 1940s

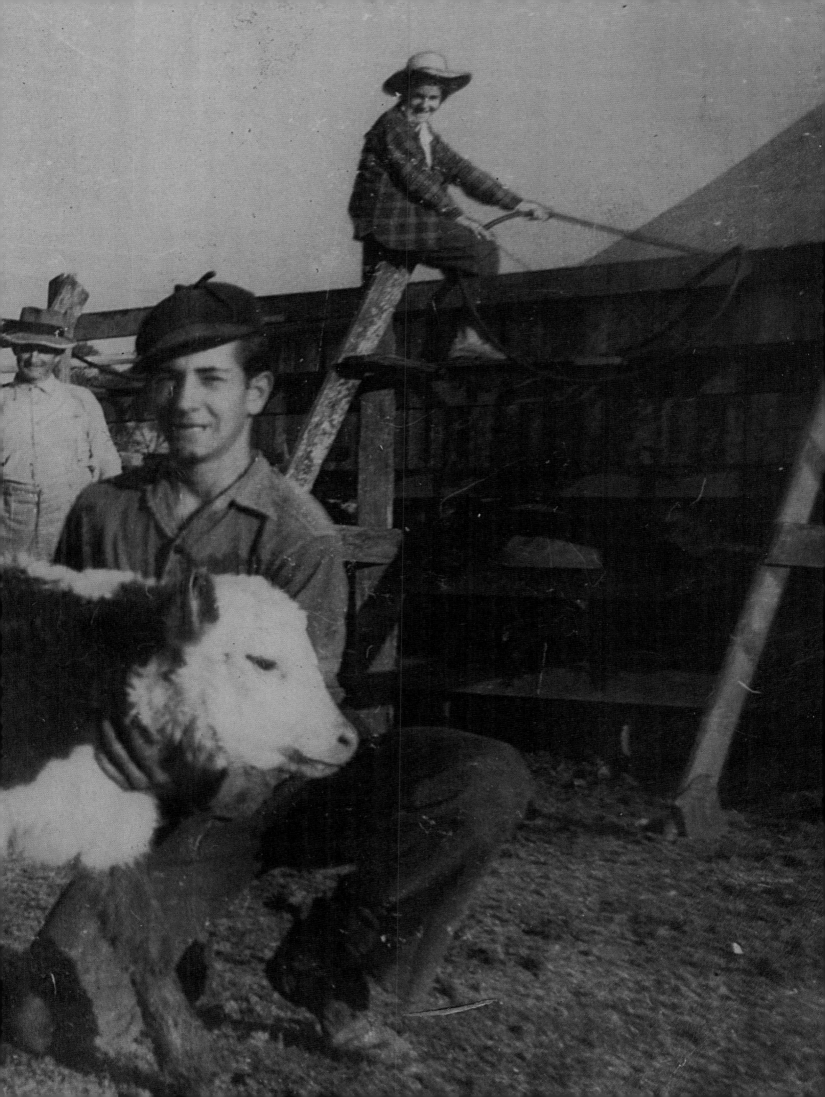

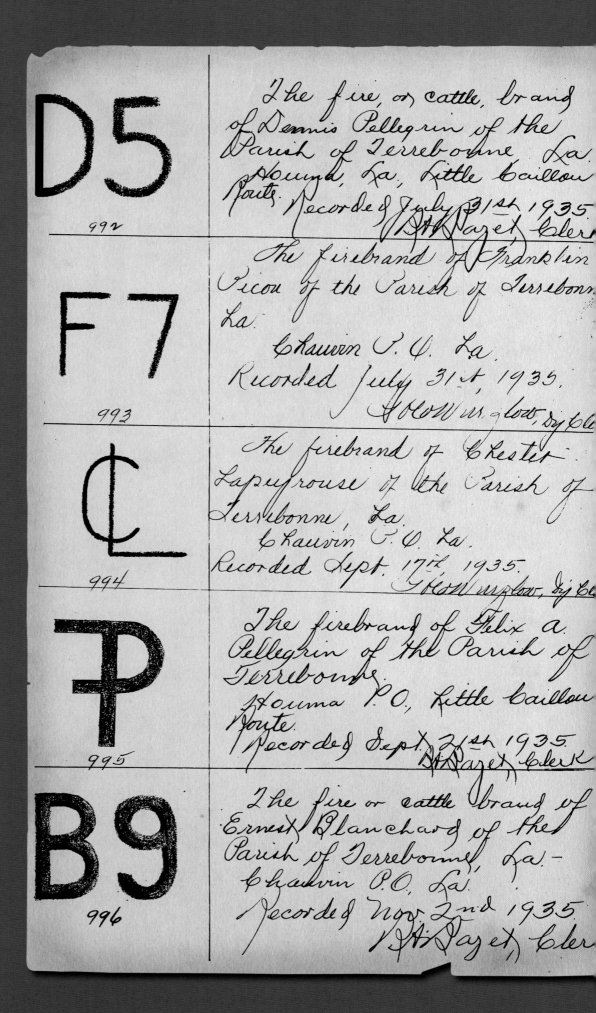

No. 992: Dennis Pellegrin

No. 993: Franklin Picou

No. 994: Chester Lapeyrouse

No. 995: Felix A. Pellegrin

No. 996: Ernest Blanchard

Fire Brands Book Two, pages 78 & 79

No. 997: Aubry Joseph Domangue

The firebrand of Aubry Joseph Domangue of the Parish of Terrebonne, La.
Boudreaux Canal (Little Caillou)
Recorded Nov. 4th, 1935.
R. H. Payet, Clerk.

No. 998: Louis Martin

The firebrand of Louis Martin of Little Caillou, Terrebonne Parish, Louisiana.
Chauvin P.O.
Recorded Nov 9th, 1935
R. H. Payet, Clerk

No. 999: Allen A. Crochet

The firebrand Allen A. Crochet of Houma, Terrebonne Parish, Louisiana.
Houma P.O.
Recorded March 10th, 1936
H. C. Winglow, Dy Clerk.

No. 1000: Alvin Nelton

The firebrand of Alvin Nelton of Terrebonne Parish, Louisiana.
Montegut. P.O.
Recorded March 27th, 1936.
H. C. Winglow, Dy Clerk.

No. 1001: Estate of L. H. Jastremski

The firebrand of Est. L. H. Jastremski of Terrebonne Parish, La. Registered at the request of J. S. Jastremski.
Houma P.O. La.
Recorded March 27th, 1936.
H. C. Winglow, Dy Clerk.

1002
JB

No. 1002:
Lyes J. Bourg

The fire, or cattle, brand of Lyes J. Bourg, a resident of the Parish of Terrebonne, Louisiana.
Montegut P.O., La.
Recorded May 9th, 1936.
L. H. Dayet, Clerk

1003
A7

No. 1003:
Alvin Sevin

The firebrand of Alvin Sevin of the Parish of Terrebonne, Louisiana.
Chauvin P.O., La.
Recorded June 29th, 1936.
L. H. Dayet, Clerk

1004
3L

No. 1004:
Gustave A. Lapeyrouse

The firebrand of Gustave A. Lapeyrouse of the Parish of Terrebonne, Louisiana.
Chauvin P.O. La.
Recorded Sept. 21st 1936.
J. H. Winglow, Dy Clerk

1005
WL

No. 1005:
Wilsey LeBlanc

The firebrand of Wilsey LeBlanc of the Parish of Terrebonne, La.
Chauvin P.O.
Recorded Sept. 30th, 1936.
L. H. Dayet, Clerk

1006
E6

No. 1006:
Eddie Soudellier

The firebrand of Eddie Soudellier of the Parish of Terrebonne, La.
Chauvin P.O.
Recorded Oct. 24, 1936.
J. H. Winglow, Dy Clerk

LIVESTOCK BRANDS AND MARKS

Brand	Entry
1007 — A9	The firebrand of Arnold Chauvin, a resident of the Parish of Terrebonne. Chauvin P.O. La. Recorded Dec. 7th, 1936. H.C. Winslow, Dy Clerk
1008 — LW	The firebrand of Linton White, a resident of the Parish of Terrebonne. Chauvin P.O. La. Recorded Jany 12th, 1937. H.C. Winslow, Dy Clerk
1009 — A8	The firebrand of Abel Blanchard of the Parish of Terrebonne. Chauvin P.O. La. (Boudreaux Canal) Recorded January 22, 1937. H.C. Winslow, Dy Clk.
1010 — EO	The firebrand of Mrs. Elizabeth O'Donnell of the Parish of Terrebonne. Gibson P.O. La. Recorded Feb. 16, 1937. H.C. Winslow, Dy Clerk
1011 — C9	The firebrand of Lawrence Chauvin of Little Caillou, Parish of Terrebonne La. Houma P.O., Little Caillou Route. Recorded May 18, 1937.

No.	Brand	Description
1012	DL	The firebrand of Elie Picou of Houma, Parish of Terrebonne, Louisiana. Recorded May 19th, 1937. L. H. Dayet, Clerk
1013	FS	The firebrand of Fragius Sevin of Chauvin P.O., Terrebonne Parish, Louisiana. Recorded June 14, 1937. H. C. Winslow, Dy Clerk
1014	OS	The firebrand of Oneal Sevin of lower Little Caillou, Terrebonne Parish, Louisiana. Chauvin P.O. La. Recorded July 19th, 1937. L. H. Dayet, Clerk
1015	L8	The firebrand of Leroy Belanger of Houma, Terrebonne Parish, Louisiana. Recorded Aug. 27, 1937. H. C. Winslow, Dy Clerk
1016	RG	The firebrand of Raoul Gautreaux of Chauvin P.O., Terrebonne Parish, La. Recorded Oct. 22, 1937. H. C. Winslow, Dy Clerk

No. 1012: Elie Picou
No. 1013: Fragius Sevin
No. 1014: Oneal Sevin
No. 1015: Leroy Belanger
No. 1016: Raoul Gautreaux

LIVESTOCK BRANDS AND MARKS

Fire Brands Book Two, pages 82 & 83

Brand	Entry
1017 **J 6**	The firebrand of John Heber of Bourg P.O., Parish of Terreb. Louisiana. Recorded Nov. 2nd, 1937. H.C. Winslow Dy. Clerk
1018 **BG**	The firebrand of Octave Bergeron of Chauvin, La., Parish of Terrebonne, Louisiana. Recorded January 24th 19— Lois Belanger Dy. Clerk of Court
1019 **VH**	The firebrand of Virgil He— of Chauvin P.O. La., Parish of Terrebonne. Recorded April 11th, 1938. H.C. Winslow Dy. Clerk of Court
1020 **DT**	The firebrand of Davis Tra— of Montegut P.O. La., Parish of Terrebonne. Recorded April 16, 1938. H.C. Winslow Dy.
1021 ♣	The firebrand of Albon O. Aucoin of Bourg P.O. La., Parish of Terrebonne. Recorded May 9th, 1938. H.C. Winslow Dy. Clerk of Court

J 6
No. 1017:
John Hebert

BG
No. 1018:
Octave Bergeron

VH
No. 1019:
Virgil Hebert

DT
No. 1020:
Davis Trahan

♣
No. 1021:
Albon O. Aucoin

No. 1022:
Louis Mestayer

No. 1023:
Jessie Falgout

No. 1024:
Theo Henry

No. 1025:
Couvillion & Tassin

No. 1026:
Ray Guidry

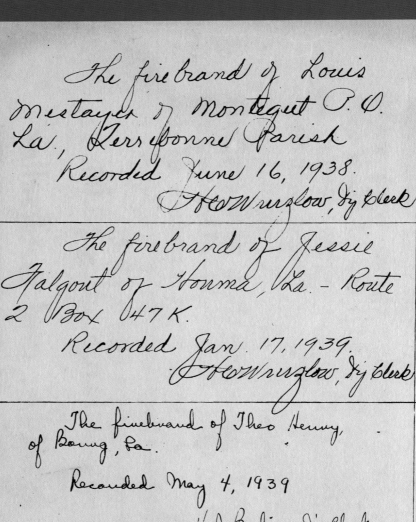

Fire Brands Book Two, pages 84 & 85

The firebrand of Euclie Trahan, of Bayou Coteau, Terrebonne Parish, Louisiana. Houma, La., Route 2, Box 12L. Recorded July 7th, 1939. H Payet, Clerk of Court

E 5

No. 1027:
Euclie Trahan

The firebrand of Voorhies Authement, of the Parish of Terrebonne, Louisiana. Houma, La., Schriever Route. Recorded August 19th, 1939. H Payet, Clerk

No. 1028:
Voorhies Authement

The chicken brand of Felicien Pitre, of the Little Caillou section of Terrebonne Parish, 11 miles below Houma. The said brand being a round hole punched through the web between the right and middle toe of the right foot. Recorded Aug. 29, 1939. H Payet, Clerk

No. 1029:
Felicien Pitre

The firebrand of Albert Peter LeBoeuf of the Parish of Terrebonne, Louisiana. Montegut, Louisiana. Recorded February 8th, 1940. H J Bodin, Dy Clerk of Court

XI

No. 1030:
Albert Peter LeBoeuf

The firebrand of J. Reginald Blanchard and John Howard Blanchard, of Houma, Terrebonne Parish, Louisiana. Recorded Feb. 21st, 1940. H Payet, Clerk

JIC

No. 1031:
J. Reginald Blanchard
& John Howard Blanchard

No. 1032:
Clamile Barrios

No. 1033:
Conrad Robichaux

No. 1034:
Daniel B. Eells

No. 1035:
Lee L. Parras

No. 1036:
Edward Joseph Porche Jr.

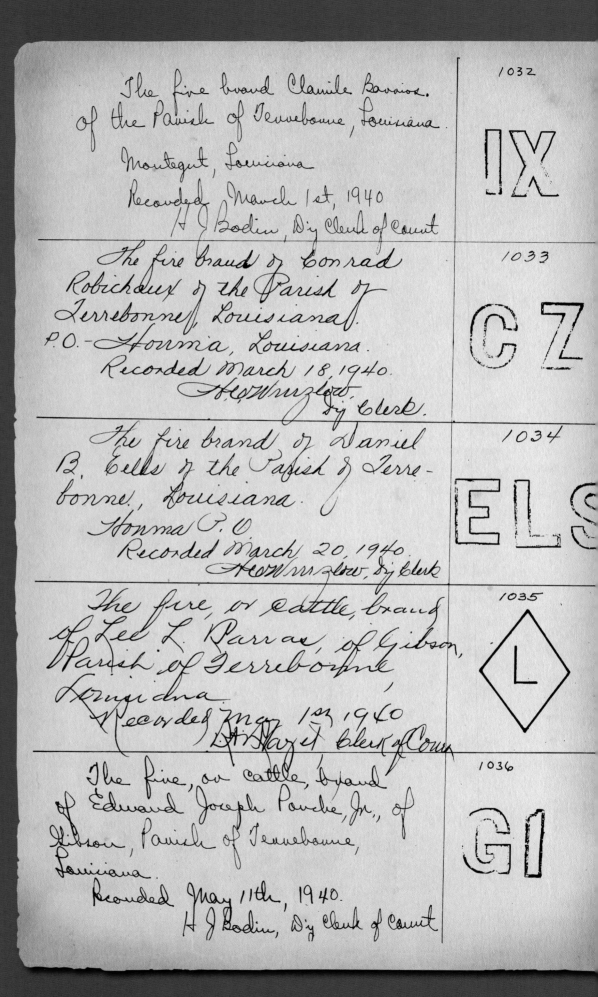

The fire brand of Ernest Joseph Dupre of Montegut, Parish of Terrebonne, Louisiana
Recorded May 20th, 1940.
H J Bodin, Dy Clerk of Court

No. 1037:
Ernest Joseph Dupre

The fire brand of Robert L. Waller, of Ellendale, Parish of Terrebonne, Louisiana.
Recorded July 17th, 1940
H J Bodin, Dy Clerk of Court

No. 1038:
Robert L. Waller

The fire, or cattle brand of Walter E. Champagne, of Bourg Terrebonne Parish, Louisiana
Recorded July 22, 1940.
A P Payet, Clerk

No. 1039:
Walter E. Champagne

The fire, or cattle brand, of Elmer Anthony Chauvin, of Daigleville, Terrebonne, Parish, Louisiana.
Recorded September 9th, 1940
H J Bodin, Dy Clerk

No. 1040:
Elmer Anthony Chauvin

The fire, or cattle, brand of Joseph Jabert, of the Parish of Terrebonne, La. Bourg P.O. La.
Recorded Oct. 17, 1940.—
A P Payet, Clerk

J9

No. 1041:
Joseph Jabert

MINOR

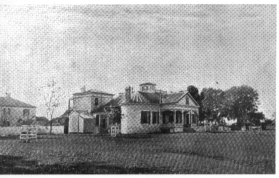

One-story Southdown House built by William John Minor, completed 1860 Photo c. 1881

Right, Southdown House with the second story added by Henry Chotard Minor in 1893

Henry Chotard Minor (September 29, 1841 – March 13, 1898)

Right, Southdown Refinery c. 1930

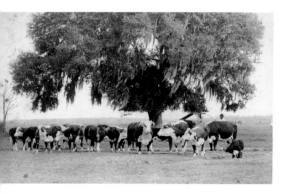

Southdown Herefords c. 1929

Southdown Sheep

Less common than cattle and equines among Terrebonne Parish livestock were sheep. However, they were particularly important to one local plantation, the name of which even coincides with the breed of sheep called Southdown.

William John Minor, born in Natchez in 1808, bought the plantation locals know as Southdown in 1828, and in 1858 began building the house that still stands on the outskirts of Houma. The first floor was completed in 1860 and William John died nine years later, in 1869. His son Henry Chotard Minor added the second floor in 1893.

Minor's land became home to a breed of sheep that had first been brought to the U.S. in 1803. The sheep were a breed that had originated in South Down, Lewes, East Sussex, England. They arrived to fulfill the task William had for them, the express purpose of eating weeds and grass between rows of sugar cane on the plantation. They undoubtedly bore the jaw and mouth markings of their owner, since they would have had to roam at will.

Before Minor's purchase of the property, the crop at Southdown was indigo grown by two Spaniards, Jose Llano and Miguel Saturino on their Spanish land grants of 1790

and 1798. Subseqently, the property was owned from 1821 to 1828 by Rezin and James Bowie of Alamo fame before Minor's purchase of the land.

Of English origin, the Minor family has a unique history concerning William John's grandfather, Stephen Minor. Born in Greene County, Pennsylvania on February 8, 1760, he had enlisted in Spanish forces as a very young man after arriving in New Orleans in 1780. Stephen was commissioned a captain of the Royal Spanish Army, and briefly served as governor of the Natchez District. He died on November 29, 1815 and was buried in Natchez City Cemetery.

Whether or not the sheep from the South Downs of East Sussex served their first intended purpose of weed suppressors among the sugar cane, they had to have been casual witnesses to many a gala affair and the arrival of scores of influential people at Southdown before the family lost ownership of the land in 1932.

One final burst of renown accrued to the Southdown properties after the sugar cane Mosaic disease crisis of the early 1920s. Minor relatives David Washington Pipes, Jr., Charles Conrad Krumbhaar and their field manager Elliot Jones brought back from the U.S. Department of Agriculture in Washington, D.C., seedlings of cane called POJ (Profestation of Java) 213 and POJ 36. They planted them on four acres of Southdown lands, and in 1927 they donated a fourth of all the POJ they had to the American Sugar Cane League. The POJ varieties saved Louisiana's sugar industry.

The David Washington Pipes, Jr. (Mary Louise Minor) family, the last resident Minor descendants, moved out of the house in 1936. Southdown Sugar Mill closed in 1979 and was moved piece by piece to be reassembled in Guatemala.

Southdown Plantation Carnival float on Main Street, Houma, 1921

David Washington Pipes, Jr., of Southdown and his wife, Mary Louise Minor Pipes

Brand No. 1042, record of David W. Pipes, Jr., dated February 7, 1941

Southdown sheep c. 1929

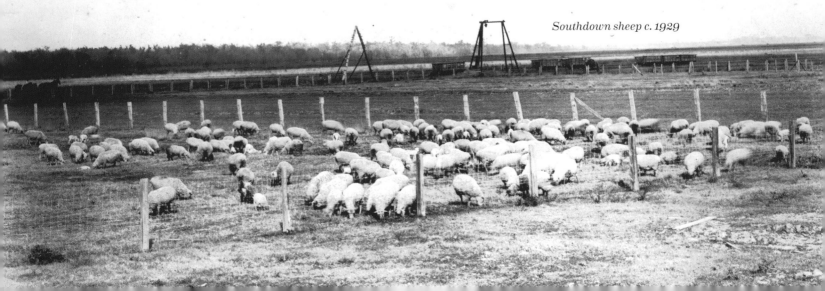

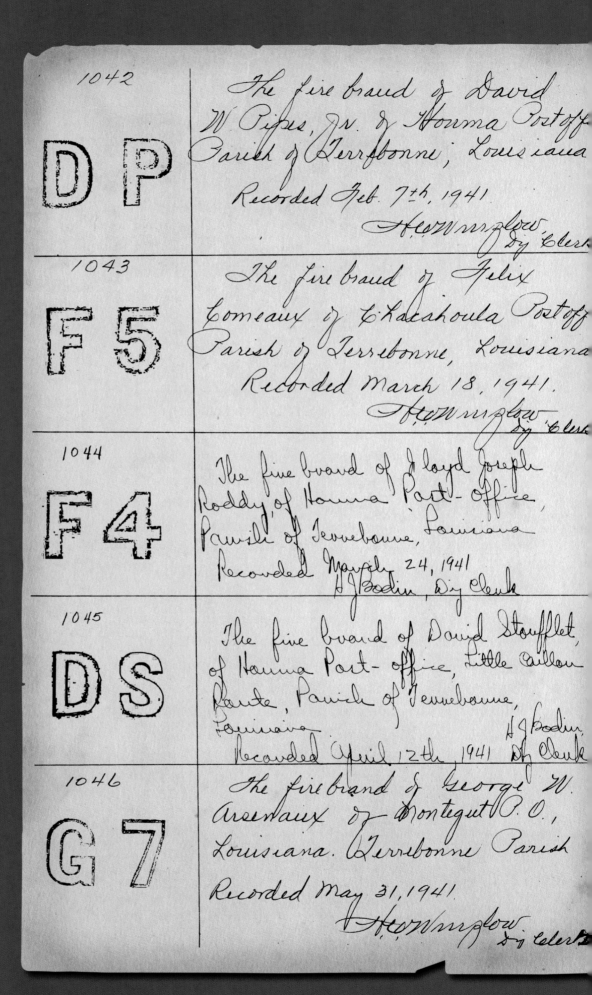

No. 1042: David W. Pipes Jr.
No. 1043: Felix Comeaux
No. 1044: Floyd Joseph Roddy
No. 1045: David Stoufflet
No. 1046: George W. Arsenaux

No.	Brand	Description
1047	B5	The fire brand of Bernard Fabre of Montegut P.O. La. Terrebonne Parish. Recorded June 6, 1941. — H.A. Winzlow, Dy Clerk
1048	YA	The fire brand Yvest Authement of Montegut P.O., La., Terrebonne Parish. Recorded June 28, 1941. — H.J. Bodin, Dy Clerk
1049	GT	The fire brand of George Trahan of Chauvin P.O., La., Terrebonne Parish. Recorded July 1st, 1941. — H.J. Bodin, Dy Clerk
1050	EG	The fire brand of Eugene Guidry of Bourg P.O., La., Terrebonne Parish. Recorded Aug 29th, 1941. — H.J. Bodin, Dy Clerk
1051	E	The firebrand of Elmer Dover of the Parish of Terrebonne, Louisiana. — Houma, Louisiana, Dularge Route. Recorded September 19th, 1941. — H. Paget, Clerk

No. 1047: Bernard Fabre

No. 1048: Yvest Authement

No. 1049: George Trahan

No. 1050: Eugene Guidry

No. 1051: Elmer Dover

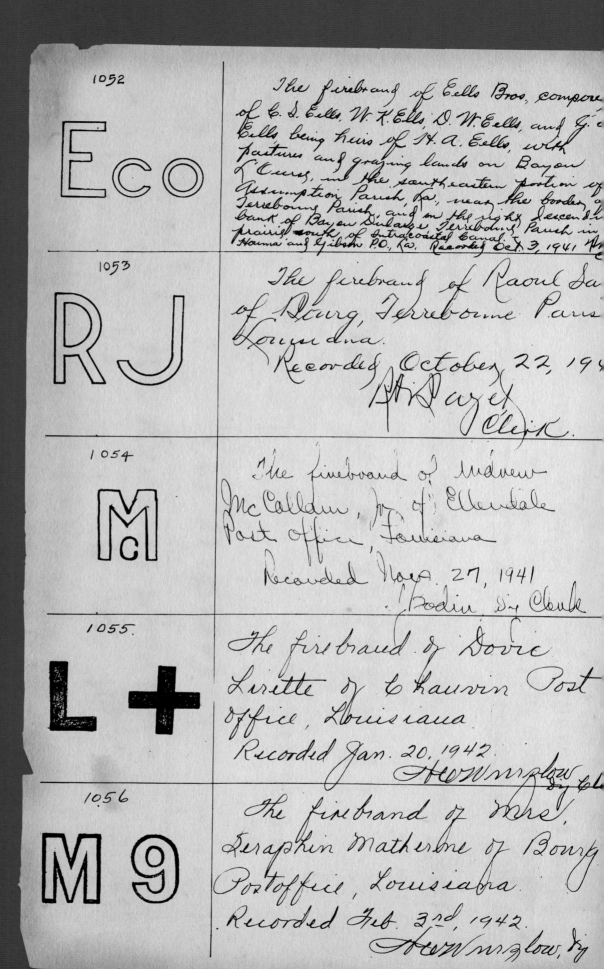

No. 1052: Eells Brothers Co.

No. 1053: Raoul Savoie

No. 1054: Andrew McCollam Jr.

No. 1055: Dovic Lirette

No. 1056: Mrs. Seraphin Matherne

1057	The firebrand of Henry Neal of Montegut P.O., Louisiana. Recorded Feb. 3rd, 1942. H.C.Wurzlow, Dy Clerk
1058	The firebrand of Josh Chauvin of Houma P.O. Louisiana. Recorded March 28th, 1942. H.C.Wurzlow, Dy Clerk
1059	The firebrand of Elysee Domingue of Chauvin P.O., Louisiana. Recorded April 13, 1942. H.C.Wurzlow, Dy Clerk
1060	The firebrand of Theodore C. Melancon of Berwick, La. Recorded May 18th, 1942. H.C.Wurzlow, Dy Clerk

Houma, La. Aug. 24, 1942. For a valuable consideration I hereby sell and assign the within Firebrand to Theodore C. Melancon — Theriot P.O. La. James J. Callahan
Witnesses: Marianne Yancey, H.C.Wurzlow

| 1061 2 inches | The firebrand of R. W. & O. R. Cocke of Ellendale P.O. La. Recorded June 16, 1942. H.C.Wurzlow, Dy Clerk |

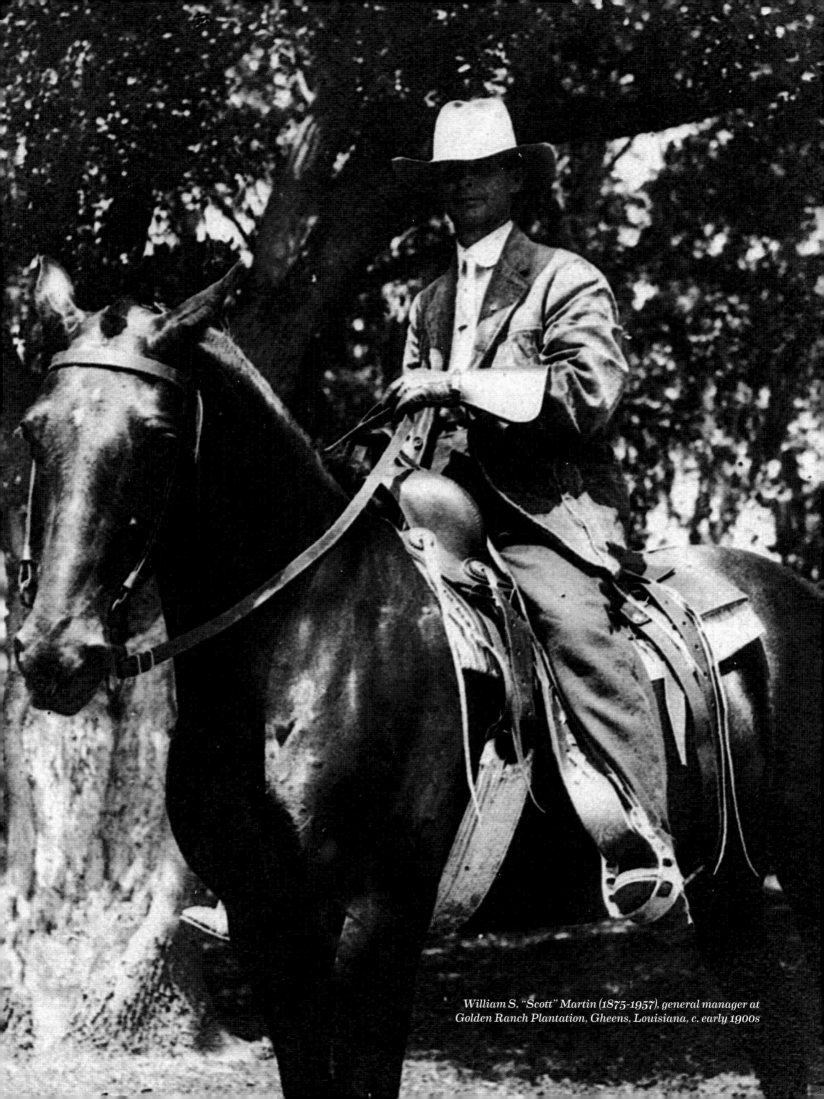

William S. "Scott" Martin (1875-1957), general manager at Golden Ranch Plantation, Gheens, Louisiana, c. early 1900s

FIRE BRANDS
3
1062 to 1861
PARISH OF TERREBONNE

Terrebonne Parish Sheriffs

Caleb B. Watkins	**1822**
P.H. Darce	**1832**
Reuben Bush	**1836**
Alexandre Lirette	**1838**
J.M. Voris	**1844**
Alexandre Lirette	**1846**
Martial Verret	**1850**
John H. Fields	**1854**
Joseph Auguste Gagne	**1854**
Aubin Bourg	**1855**
Leo Lirette	**1862**
Robert W. Bennie	**1864**
Albert G. Cage	**1866**
Frederick Marie	**1868**
William H. Keys	**1870**
	(dismissed July, 1872)
Amos Simms	**1872**
	(appointed July 27)
General Lyons	**1872**
	(December 27)
General Lyons	**1875**
	(1874 election contested; installed April '75)
Jordan Stewart	**1876**
Alfred Kennedy	**1878**
Thomas A. Cage	**1880**
John B. Budd	**1884**
Oscar Daspit	**1888**
A.W. Connely	**1892**
Olivia Hebert	**1915**
Ernest A. Dupont	**1916**
F.X. Bourg	**1924-1940**
Peter G. Bourgeois	**1940-1951**
Abel P. Prejean	**1951-1968**
Charlton Peter Rozands	**1968-1980**
Ronnie Duplantis	**1980-1984**
Charlton Peter Rozands	**1984-1987**
Jerry J. Larpenter	**1987-2008**
L. Vernon Bourgeois, Jr.	**2008-2012**
Jerry J. Larpenter	**2012**

No. 1062

J4

THE FIRE BRAND OF Mrs. Ella Luke, widow by first marriage of John Carlos, and widow by second marriage of Jules Lapeyrouse

ADDRESS Chauvin P.O. La.

RECORDED August 4, 1942.

H. W. Winslow, Dy CLERK

No. 1063

D6

THE FIRE BRAND OF Dennis Chiasson

ADDRESS Chauvin P.O. La.

RECORDED September 15, 1942.

H. W. Winslow, Dy CLERK

No. 1064

SA

THE FIRE BRAND OF Simpson Authement

ADDRESS Chauvin P.O. La.

RECORDED October 26, 1942.

H. W. Winslow, Dy CLERK

No. 1065

AX

THE FIRE BRAND OF Axon Authement

ADDRESS Chauvin P.O. La.

RECORDED October 29, 1942.

H. W. Winslow, Dy CLERK

No. 1066

F9

THE FIRE BRAND OF Nolan T. Falgout

ADDRESS Bourg, La.

RECORDED December 26, 1942.

H. W. Winslow, Dy CLERK

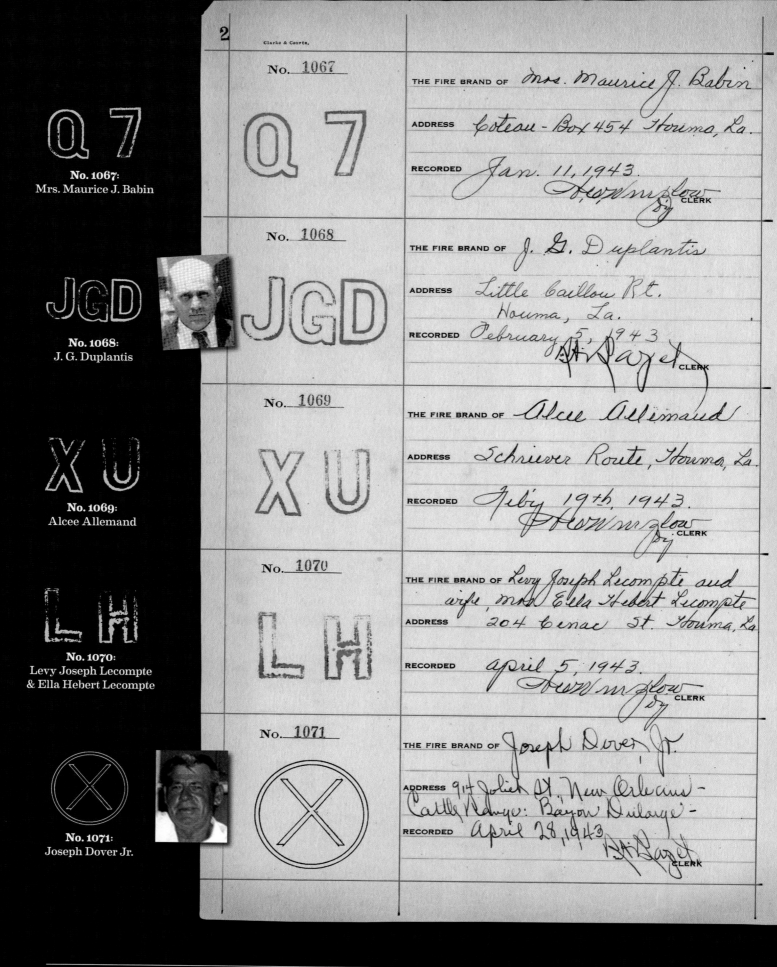

No. 1067: Mrs. Maurice J. Babin
The fire brand of Mrs. Maurice J. Babin
Address: Coteau - Box 454 Houma, La.
Recorded Jan. 11, 1943.

No. 1068: J. G. Duplantis
The fire brand of J. G. Duplantis
Address: Little Caillou Rt. Houma, La.
Recorded February 5, 1943

No. 1069: Alcee Allemand
The fire brand of Alcee Allemand
Address: Schriever Route, Houma, La.
Recorded Feb'y 19th, 1943.

No. 1070: Levy Joseph Lecompte & Ella Hebert Lecompte
The fire brand of Levy Joseph Lecompte and wife, Mrs. Ella Hebert Lecompte
Address: 204 Cenac St. Houma, La.
Recorded April 5, 1943.

No. 1071: Joseph Dover Jr.
The fire brand of Joseph Dover Jr.
Address: 914 Joliet St., New Orleans -
Cattle Range: Bayou Dularge -
Recorded April 28, 1943.

No. 1072 **T9**	THE FIRE BRAND OF Maurice Triche ADDRESS Bourg, Louisiana RECORDED May 22nd 1943 *BA Payet*, CLERK
No. 1073 **C8**	THE FIRE BRAND OF Cline Jabert ADDRESS Bourg, La. RECORDED June 7th, 1943 *Winslow*, CLERK
No. 1074 **VP**	THE FIRE BRAND OF Victor L. Prosperie ADDRESS Montegut, La. RECORDED July 2nd, 1943. *BA Payet*, CLERK
No. 1075 **EZ**	THE FIRE BRAND OF Elie Prosperie ADDRESS Montegut, La. RECORDED July 6th, 1943. *Winslow*, CLERK
No. 1076	THE FIRE BRAND OF Earl J. Guidry ADDRESS Bourg, La. RECORDED Aug. 6th, 1943. *Winslow*, CLERK

LIVESTOCK BRANDS AND MARKS

Three-pointed star brand registered in the early 1950s to Dr. Philip Louis Cenac, Sr.

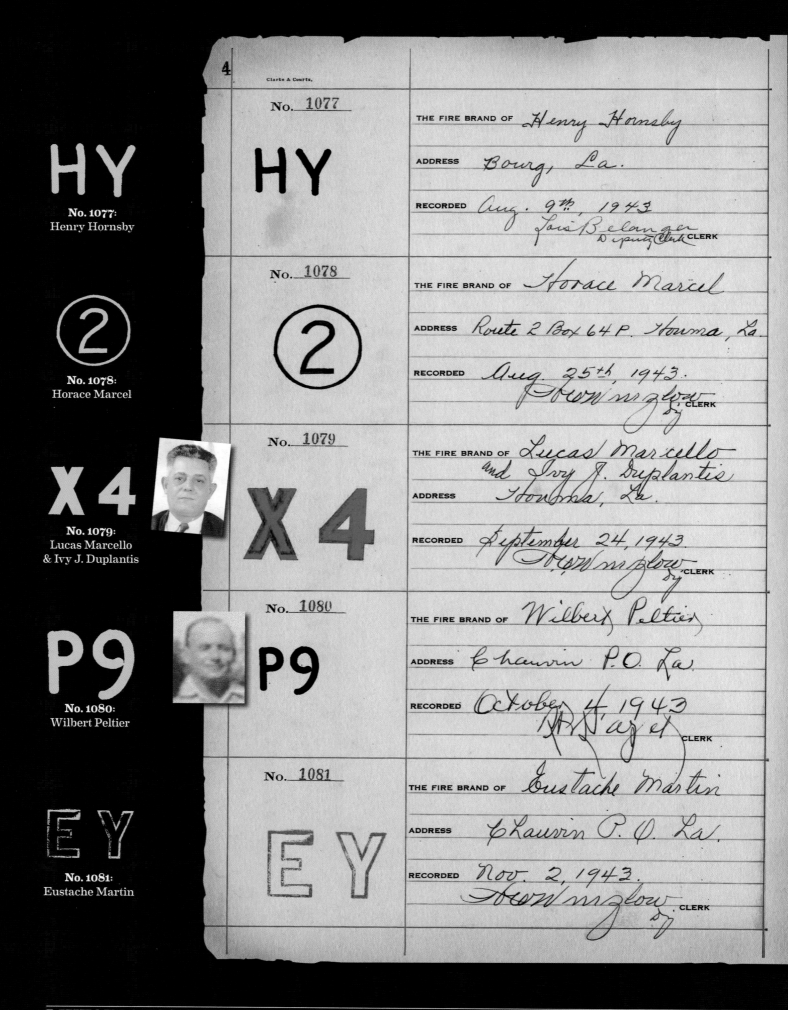

		
No. 1082	N7	THE FIRE BRAND OF Norton J. Bourg ADDRESS Montegut, La. RECORDED Nov. 13th, 1943. H. W. M. Glow, Dy CLERK
No. 1083	TTK	THE FIRE BRAND OF Paul King ADDRESS 1518 Sylvia St., Houma, La. RECORDED Dec. 1st, 1943. H. W. M. Glow, Dy CLERK
No. 1084	ML	THE FIRE BRAND OF Leon L. Martin ADDRESS Box 1031, Houma, La. RECORDED Dec. 13th, 1943. H. W. M. Glow, Dy CLERK
No. 1085	P4	THE FIRE BRAND OF Mrs. Alma H. Pierce ADDRESS 1215 Goode St., Houma, La. RECORDED Dec. 21st, 1943. H. W. M. Glow, Dy CLERK
No. 1086	JT	THE FIRE BRAND OF John Clovis Theriot, Jr. ADDRESS Ellendale, La. RECORDED Dec. 30th, 1943. H. W. M. Glow, Dy CLERK

No.	Brand	Owner	Address	Recorded
1087	LJ	Lea Johnson	312 Liberty St., Houma, La.	Jan. 6th, 1944
1088	EB	Ernest Blanchard	Grand Caillou Route, Houma, La.	Feb. 7th, 1944
1089	EW	Emile Collins	Chauvin P.O., La.	March 25, 1944
1090	WB	Walter Bond	Route Box 38, Houma, La.	April 12, 1944
1091	HO	Hayes A. LeBlanc	Montegut, La.	May 3rd, 1944

No. 1092

D9

THE FIRE BRAND OF Delvin J. Duplantis
ADDRESS Chauvin, La.
RECORDED June 6th, 1944.
CLERK

No. 1093

AP

THE FIRE BRAND OF Andrew Prosperie
ADDRESS Montegut, La.
RECORDED July 1st, 1944.
CLERK

No. 1094

AD

THE FIRE BRAND OF Anthony Dupre
ADDRESS Little Caillou Route, Houma, La.
RECORDED July 11th, 1944
CLERK

No. 1095

ER

THE FIRE BRAND OF J. Edward LeBlanc and Malvina Redmond (Partnership) -
ADDRESS Houma, La., Grand Caillou Route -
RECORDED July 12th, 1944.
CLERK

No. 1096

qL

THE FIRE BRAND OF Louis H. Prosperie
ADDRESS Route No. 1, Box 262, Montegut, La.
RECORDED July 22, 1944
CLERK

No.	Brand	Details
1097	NH	THE FIRE BRAND OF Lionel Hebert and Lawrence Naquin ADDRESS Montegut, La. Box 85 Route 1. RECORDED Sept. 5th, 1944.
1098	MP	THE FIRE BRAND OF Milka Pellegrin ADDRESS Houma, La., Little Caillou Rte. RECORDED Oct. 6th, 1944.
1099	S (underlined)	THE FIRE BRAND OF William Price ADDRESS Montegut, La. RECORDED October 12, 1944.
1100	X	THE FIRE BRAND OF Emery L. Stoufflet ADDRESS Montegut, La. RECORDED Oct. 23, 1944.
1101	C (underlined)	THE FIRE BRAND OF Evans Crochet ADDRESS Montegut P.O., La. RECORDED Nov. 13, 1944

No. 1102

HJ

THE FIRE BRAND OF Henry J. Crochet

ADDRESS Montegut P.O., La.

RECORDED Nov. 13, 1944

CLERK

No. 1103

P

THE FIRE BRAND OF Adam Paul Crochet

ADDRESS Montegut, P.O., La.

RECORDED Nov. 13, 1944

CLERK

No. 1104

HJ

THE FIRE BRAND OF Henry Joseph Blanchard

ADDRESS Schriever, La.

RECORDED Nov. 17, 1944

CLERK

No. 1105

57

THE FIRE BRAND OF Alvin J. LeBlanc

ADDRESS Montegut, La.

RECORDED Dec. 6th, 1944

CLERK

No. 1106

GE

THE FIRE BRAND OF George Authement

ADDRESS Chauvin, La.

RECORDED Dec. 29th, 1944

CLERK

No.	Brand	Fire Brand Of	Address	Recorded
1107	M1	Macon J. Stringer	Chauvin P. O., La.	Feb. 23rd, 1945
1108	DH	Dorestan Hingle	Schriever, La.	March 26, 1945
1109	F	Frederick Lirette	Route #2, Box 191 (Bayou Blue) Houma, La.	April 2nd, 1945
1110	IH	Irvin Paul Hebert	Gibson, La. Star Route Box 188	April 9th, 1945
1111	R2	Mrs. Rita Matherne, widow of James Neal, Jr.	Montegut, La.	April 12th, 1945

No. 1112	THE FIRE BRAND OF Reynold G. Laperouse
XX	ADDRESS Chauvin, La.
	RECORDED April 21st, 1945

No. 1113	THE FIRE BRAND OF Louis J. Guidry
LG	ADDRESS Houma, Dularge Route
	RECORDED May 25, 1945

No. 1114	THE FIRE BRAND OF Jack J. LeBoeuf
↑	ADDRESS 1601 E. Main St., Houma, La.
	RECORDED May 29th, 1945

No. 1115	THE FIRE BRAND OF Angelo Roberts Babin
A	ADDRESS Little Caillou Route, Houma, La.
	RECORDED June 1st, 1945

No. 1116	THE FIRE BRAND OF Mrs. Louis Prosperie
LP	ADDRESS Little Caillou Rte, Houma, La.
	RECORDED June 4, 1945 Marie W. Culli, Dy. CLERK

No.	Brand	Details
1117	DZ	THE FIRE BRAND OF Dovie Lapeyrouse ADDRESS Montegut, La. RECORDED June 23, 1945
1118	WT	THE FIRE BRAND OF Wallace Trahan ADDRESS Chauvin P.O., La. RECORDED June 29, 1945
1119	G2	THE FIRE BRAND OF Joseph Gregoire ADDRESS Dulac P.O., La. RECORDED July 3rd, 1945
1120	IF	THE FIRE BRAND OF Irvin Foret ADDRESS 205 Leona St., Houma, La. RECORDED July 16th, 1945
1121	L̲	THE FIRE BRAND OF Junius Lapeyrouse ADDRESS Chauvin P.O., La. RECORDED Dec. 28, 1945

No.	Brand	Fire Brand Of	Address	Recorded
1122	JT	John Baptiste Trahan	c/o Aurelie Eschete – Little Caillou, La.	Dec. 29, 1945 — J. Marian Yancey, D'y Clerk
1123	Ⓘ	Mrs. Milford Olivier	1601 E. Main St., Houma, La.	Feb. 19th, 1946 — A. Payet, Clerk
1124	TJ	Thaddeus Joseph Martin	Chauvin, Louisiana	March 11, 1946 — J. Marian Yancey, D'y Clerk
1125	BF	Brownell Foret	Chauvin, La.	March 13, 1946 — A. Payet, Clerk
1126	W	Denis White	Chauvin, La.	March 13, 1946 — J. Marian Yancey, D'y Clerk

No.	Brand	Owner
1127	GD	**The fire brand of** Garris Domangue **Address** Chauvin P.O., La. **Recorded** March 19, 1946 — Paget, Clerk
1128	AA	**The fire brand of** Arnold A. Autin **Address** Houma, La. **Recorded** March 28, 1946 — Paget, Clerk
1129	PA	**The fire brand of** Abel Price **Address** Chauvin, La. **Recorded** April 10, 1946 — J. Marian Yancey, Clerk
1130	A	**The fire brand of** Abel LeBlanc, Jr. **Address** Rt. 2 Houma, La. **Recorded** April 26, 1946 — J. Marian Yancey, Clerk
1131	RL	**The fire brand of** Roy LeBlanc **Address** Rt. 2 Houma, La. **Recorded** April 26, 1946 — J. Marian Yancey, Clerk

No. 1128: Arnold A. Autin

15

No. 1132

THE FIRE BRAND OF Roy A. Aucoin, Sr.

ADDRESS Bourg, Louisiana

RECORDED May 1, 1946.
J. Marian Yancey, CLERK

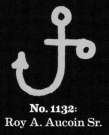
No. 1132:
Roy A. Aucoin Sr.

No. 1133

THE FIRE BRAND OF Merlin Robichaux

ADDRESS Chauvin, La.

RECORDED May 2, 1946
J. Marian Yancey, CLERK

No. 1133:
Merlin Robichaux

No. 1134

THE FIRE BRAND OF Willie Thibodaux

ADDRESS Chauvin, La.

RECORDED June 1st, 1946
B.H. Daigle, CLERK

No. 1134:
Willie Thibodaux

No. 1135

THE FIRE BRAND OF Gus Marie

ADDRESS 209 Leona St, Houma Louisiana

RECORDED June 27, 1946
J. Marian Yancey, CLERK

No. 1135:
Gus Marie

No. 1136

THE FIRE BRAND OF Marguerite Dubois

ADDRESS Chauvin, La.

RECORDED July 12th, 1946
B.H. Daigle, CLERK

No. 1136:
Marguerite Dubois

No. 1137:
Morris W. Callahan

No. 1138:
Julius Martin

The above was the last brand recorded in Terrebonne Parish. All subsequent brands were registered by the Louisiana Livestock Brand Commission in Baton Rouge.

No.	Brand	Details
1137	M-C	THE FIRE BRAND OF Morris W. Callahan ADDRESS 1013 School St. Houma, Louisiana RECORDED July 25, 1946 J. Marian Yancey, CLERK
1138	B-M	THE FIRE BRAND OF Julius Martin ADDRESS Little Caillou Rt. Chauvin, La. RECORDED August 1, 1946 J. Marian Yancey, CLERK
1139		
1140		
1141		

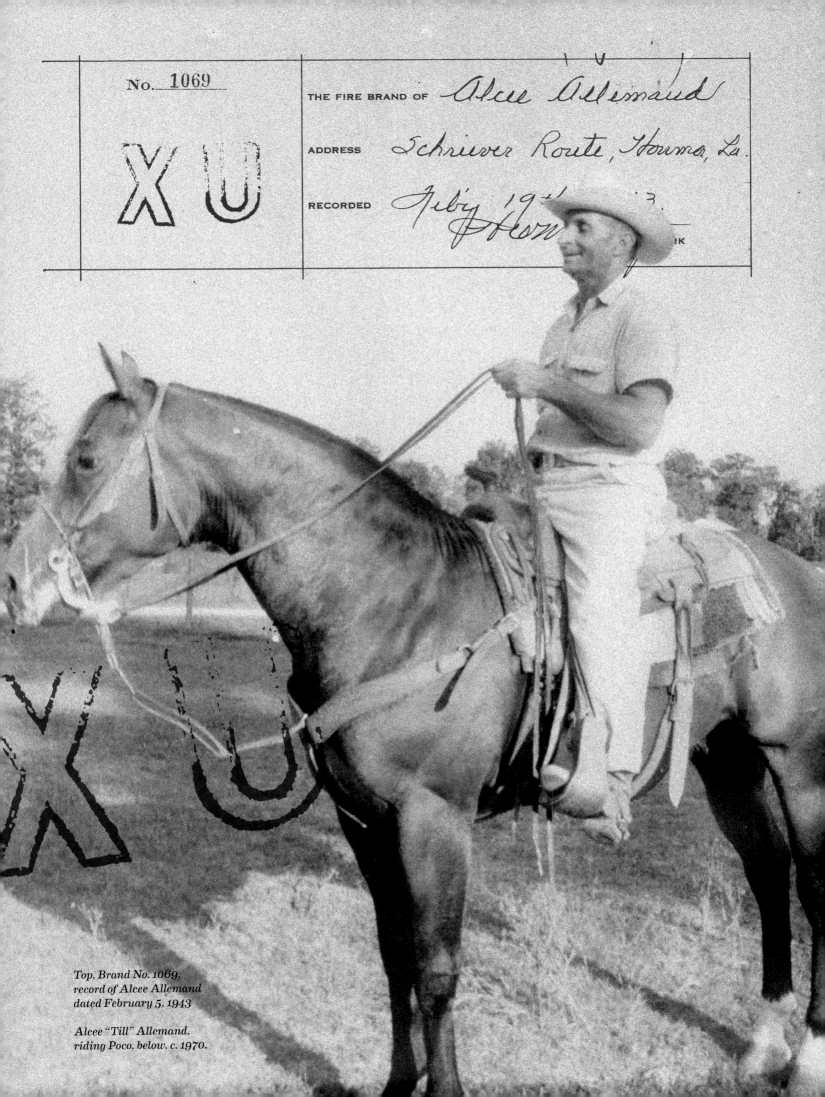

Top, Brand No. 1069, record of Alcee Allemand dated February 5, 1943

Alcee "Till" Allemand, riding Poco, below, c. 1970.

AFTERWORD

Cattle ranching has been integral to south Louisiana history and culture since the beginning of its European settlement. For example, the first known European colonist in south-central Louisiana, Andre Massé, established a cattle ranch along the Teche as early as 1746. (It is no doubt untrue, however, that the pioneer Grevemberg family registered two of its cattle brands as early as 1739—a claim repeated by various sources. As I have noted elsewhere, Louis and Barthélémy Grevemberg were born, respectively, in 1731 and 1753—which means that Louis would have been only six to eight years old when his brands were registered. And Barthélémy's brands would have been registered fourteen to sixteen years before his own birth!)

Other ranchers soon followed, raising cattle not only to feed themselves, but to feed the lower Louisiana colony and New Orleans in particular. Thus, in 1769 Spanish census takers observed that in the Teche region of Louisiana there were about seven times as many cattle as colonists.

A fair amount has been written about early cattle ranching in the Teche region of the Attakapas District and on the prairies of the Opelousas District—regions well-known as early sources of beef for the colony and fledgling state. Noted geographer Lauren C. Post delved deeply into the cattle industry of the Cajun prairies, discussing his findings in important articles in the *McNeese Review* and in the pages of his book, *Cajun Sketches from the Prairies of Southwest Louisiana* (1962).

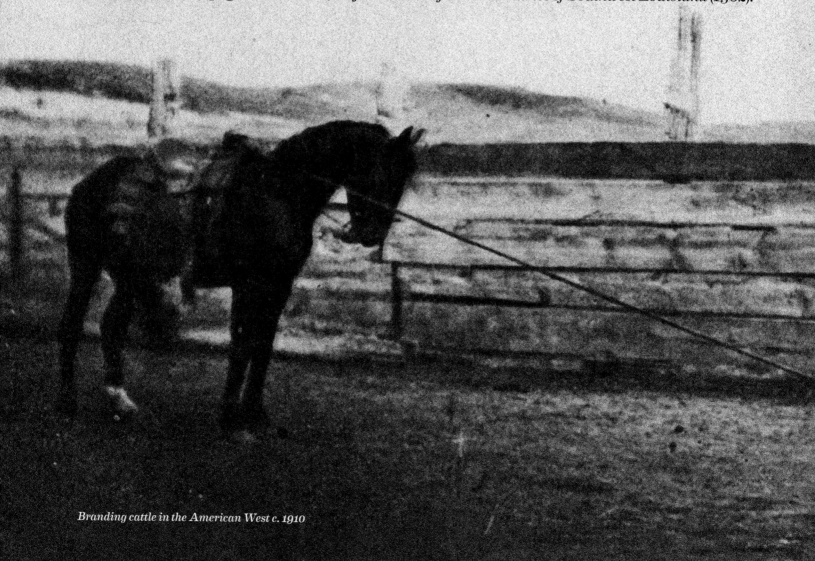

Branding cattle in the American West c. 1910

LIVESTOCK BRANDS AND MARKS

Carl A. Brasseaux added to Post's work in books like *The Founding of New Acadia: The Beginnings of Acadian Life in Louisiana (1987)* and *Acadian to Cajun: Transformation of a People (1992)*.

Much less has been written, however, about cattle ranching along the bayous and *chênières* of Terrebonne Parish. This volume seeks to remedy that deficit and in doing so to fill a notable gap in south Louisiana's historiographical record.

Today, cattle and other livestock still need to be identified. Sometimes this is done the old-fashioned way, with a fire brand. Sometimes it is done with digital tracking devices, such as high-tech ear tags containing radio frequency identification chips. In any event, the present mirrors the past, as revealed by the Terrebonne fire brand books. Like *The Brand Book for the Opelousas and Attakapas Districts*, now preserved in the Jefferson Caffery Louisiana Room of Dupré Library at the University of Louisiana at Lafayette, the Terrebonne books permit the modern researcher and reader to glimpse an important fragment of our local history. In turn, this glimpse informs us, like good history should, about the historical underpinnings of our present-day world.

Shane K. Bernard, Ph.D. holds degrees in History from the University of Louisiana at Lafayette and Texas A & M University. He writes about south Louisiana history and culture.

APPENDIX I:
Louisiana Livestock Brand Commission

Since its inception in 1944, the Louisiana Livestock Brand Commission has left a legacy of integrity and service to the livestock industries and the law enforcement community of Louisiana. Prior to 1944 brands were registered on a parish by parish basis causing much confusion and duplication of brands which livestock thieves learned to take advantage of. The Livestock Brand Inspectors of the commission are fully commissioned peace officers with arrest powers. Besides being law enforcement professionals, the officers of the commission are well versed in the livestock industry with some actually being cattle producers themselves or at one time in their life having been a producer or cowboy. It is this combination of talents that is required when investigating livestock thefts or dealing with livestock ownership disputes. Most other law enforcement officials have little to no expertise in livestock matters. The Brand Inspectors of the commission are an asset to other state, federal and local agencies in handling matters involving livestock. When a farm related theft has occurred the Brand Inspectors usually know where to start looking for related information and clues due to their understanding and contact with the industry somewhat as a narcotics agent knows where the likeliness of illegal narcotics trafficking may be taking place. It is this insight that is invaluable to other investigating law enforcement agencies. Brand Inspectors are granted extended search and seizure powers involving livestock sales records and warrantless searches due to the perishable and movable nature of livestock. Brand Inspectors are empowered with legislated authority to inspect hides and carcasses in slaughter facilities, enter property without a warrant with probable cause and demand some livestock sales records without a subpoena or warrant. These powers expedite investigations and serve as a real asset to other law enforcement agencies in the investigation of livestock theft.

In Louisiana nonpayment for livestock purchased is considered theft of livestock under certain circumstances. This law protects the farmer, rancher and cattle producer from unscrupulous livestock purchasers and dealers. It also gives the Livestock Brand Commission a valuable tool to investigate unethical and illegal practices which may leave a livestock producer without payment for their investment and work. If it were not for the Livestock Brand Commission and this law, these matters would most often become expensive litigation in an already overburdened court system with sometimes minimal results for the victim. This law has proven itself to be a deterrent to unethical livestock dealers and is championed by the honest and ethical livestock dealers.

Besides theft cases the Livestock Brand Commission inspects shipments of cattle and horses and files reports into a data base which may be referenced later should a theft or ownership dispute occur. Louisiana law requires that all livestock being placed before public auction must be inspected and cleared for sale by the commission. This alone is responsible for deterring thefts due to the likelihood of being caught during a brand inspection. Ownership disputes involving cattle is a common occurrence when cattle stray from their home pasture or become

mixed with another herd. Brand Inspectors have the authority and are usually able to settle these disputes satisfactorily thus taking the burden from the court system and saving cattlemen countless dollars of litigation. Along coastal Louisiana cattle are usually comingled after a storm due to flooding and fences being destroyed. Brand Inspectors will patrol the affected area as a theft deterrent and help sort through ownership disputes again lessening the burden on local authorities and the court system.

While the branding of livestock and cattle rustling may seem to be something of the nostalgic past, it is very real and still practiced. However, modern times have placed a new duty on the Livestock Brand Commission with the possibility of terrorism involving livestock. The possibility of terrorists attempting to place infectious diseases into the food chain via livestock is very real. The Brand Inspectors of the commission are the point men for the Louisiana Department of Agriculture & Forestry in planning against and recognizing the signs of this threat. Trained Brand Inspectors are ever vigilant in assessing the security of livestock facilities and recognizing indicators that may lend itself to terrorism thus helping make the food chain safe.

The Livestock Brand Commission serves as the central registry of livestock brands currently registering approximately 6,500 brands statewide. The commission ensures that brands are not duplicated and remain unique to the person, ranch or farm registering it. By legislative act the Brand Commission publishes a book of brands every five years.

Commission Director Carl Bennett

A recap of the activity of the Brand Commission over the past three years is as follows:

Year: 2010
414,247 head of livestock inspected and recorded.
203 Complaints investigated.
20 Criminal arrests affected.
$901,495.00 Value of property recovered or accounted for.

Year: 2011
367,715 Head of livestock inspected and recorded.
253 Complaints investigated.
63 Criminal arrests affected.
$742,977.00 Value of property recovered or accounted for.

Year: 2012
328,142 Head of livestock inspected and recorded.
241 Complaints investigated.
31 Criminal arrests affected.
$651,735.00 Value of property recovered or accounted for.

Front row, left to right, Deputy Commissioner Dr. Brent Robbins, Michelle Ribera, Director Carl Bennett and Brand Inspectors: Johnny Steib, E.B. Thompson, Carnie Burcham, Gary Dunn, John Terrell, Brent Hardy, Robbie Averett, Keith Fontenot; second row Jason Watts, Joey Norman, Jason LeGrande, Elizabeth Moreau, Scott Lee andw State Brand Recorder Liz Wilcox Photo taken 2008.

Appendix I

APPENDIX II:
The Terrebonne-Lafourche Livestock & Agricultural Fair Association, Inc.

The Terrebonne-Lafourche Livestock & Agricultural Fair Association, Inc. was established on August 16, 1939 when residents of the two parishes applied for incorporation for the purpose of "promotion and improvement of their livestock and agricultural resources by and through the staging of shows and fairs."

Officers at the time of incorporation were R.L. Waller, president; W.J. Gray, DVM, first vice-president; L.A. Borne, second vice-president; E.R. Theriot, third vice-president; R.J. Thibodeaux, secretary-manager; Dr. F.O. Wirt, treasurer.

Messrs. Waller (of Ellendale), Theriot, and Thibodeaux (both of Houma) were Terrebonne Parish residents. Dr. Wirt and Dr. Gray lived in Thibodaux, and Mr. Borne was from Raceland, all of Lafourche Parish.

Eight years later, Terrebonne and Lafourche formed separate associations with the same purposes as the original joint organization. The Terrebonne Livestock and Agricultural Fair Association was established by its Articles of Incorporation dated September 30, 1947.

Officers at incorporation in 1947 were Gibson J. Autin, Jr., president; Oscar R. (Reggie) Cocke, first vice-president; G.S. Harmount, second vice-president; Ernest R. Theriot, third vice-president; Arnold A. Autin, secretary-manager; Sheriff Peter Bourgeois, treasurer; and Board of Directors members M.J. Andrepont, Clifford P. Chauvin, Ruby J. Thibodaux, Temus Bonnette, Andrew J. Bernard, Whitney P. Broussard, Marie Louise LaCasse, County Agent Richard Sonnier, and Claude B. Duval, attorney. Attorney Ashby W. Pettigrew, Jr. drew up the legal documents for the Association.

This organization is still currently active. The most recent annual report of the corporation to the Secretary of State's office, dated October 6, 2012, lists Doug Triche as president.

Main Street fair, c. 1902

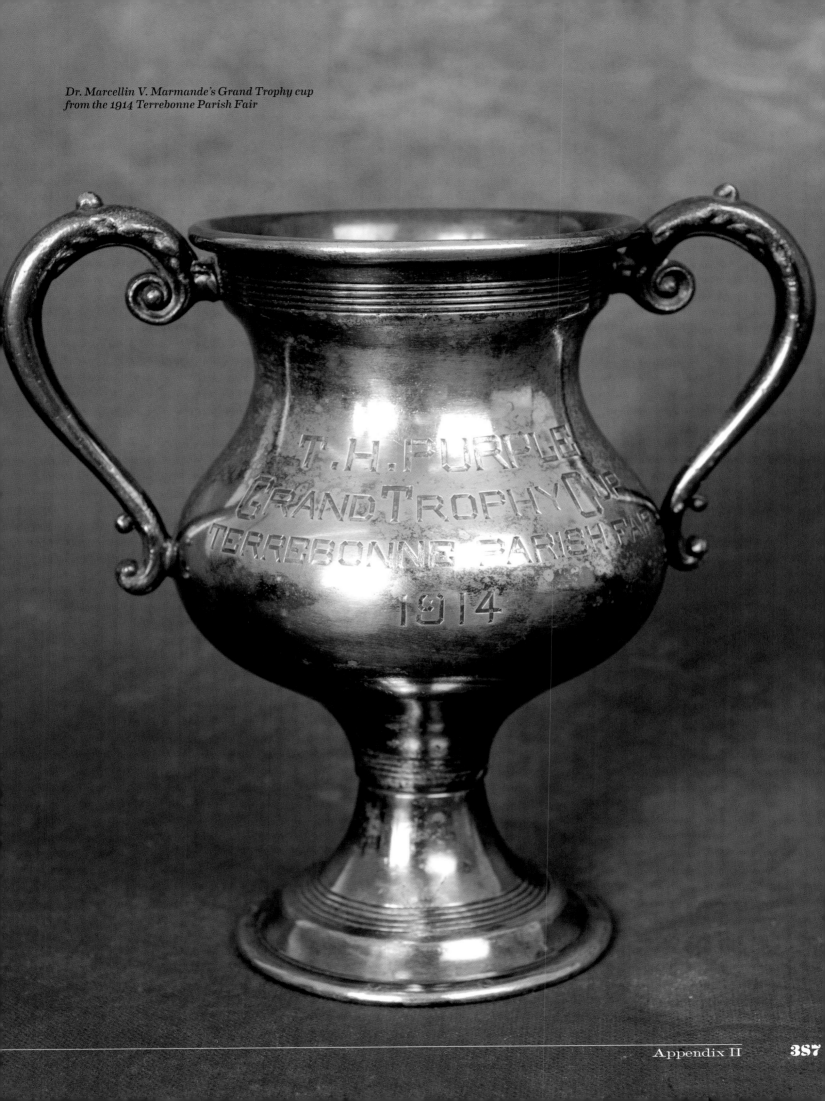

Dr. Marcellin V. Marmande's Grand Trophy cup from the 1914 Terrebonne Parish Fair

Appendix II

APPENDIX III:
About the Authors

Christopher E. Cenac, Sr., M.D., F.A.C.S, grew up in Houma, Louisiana, and graduated from the Louisiana State University system. He attended LSU undergraduate school on academic and athletic scholarships, and completed his residency in orthopedic surgery in 1976. He is a practicing orthopedic surgeon, and has served a term as Terrebonne Parish Coroner.

He published *Eyes of An Eagle*, a docu-novel that is biographical of his great-grandfather's life, and that provides a history of early Terrebonne Parish, Louisiana. It was a selected book of the Louisiana Bicentennial Commission, and has been placed in Terrebonne Parish public and Catholic schools as a historical resource. A pictorial history of Houma-Terrebonne, Louisiana, is his next planned project, to be followed by a history of medicine in southeast Louisiana.

Dr. Cenac is co-author of the Interprofessional Code approved by delegates of the Louisiana State Bar Association and the Louisiana State Medical Society in 1994. As a member of the Medical-Legal Interprofessional Committee, he was co-author of several published papers including "Subpoenas to Physicians: The Obligations and Consequences"; "Medical Review Panel Process"; and "The Physician as Witness." Professional affiliations are with the American Board of Orthopedic Surgery, as a Fellow in the American Academy of Orthopedic Surgeons, a Fellow in the American College of Surgeons, and a Fellow in the International College of Surgeons. He was appointed in 2003 by the Louisiana Supreme Court to the Judicial Campaign Oversight Committee and was reappointed in 2010. His current professional emphasis is expert testimony in the field of orthopedic surgery in medical-legal litigation at state and federal level judiciaries, and teaching professionalism and ethics to medical and law students, attorneys, and physicians.

He served as king of the Mystic Krewe of Louisianians in Washington, D.C. in 2003. Today his greatest personal interests are history and international travel. He and his wife Cindy reside at Winter Quarters on Bayou Black outside Houma, Louisiana. He has two sons and a daughter—two of whom are also physicians—eight grandchildren, and a widespread family both in and beyond Terrebonne Parish.

Claire Domangue Joller is a national and state award-winning writer. She received the first place award from the National Catholic Press Association in 2001 for her first year of *Bayou Catholic* newspaper columns in the Arts, Culture, and Leisure category. Her "Seeing Clairely" column also won a Louisiana Press Association award that year and for 2012.

She was the writer for Dr. Christopher E. Cenac, Sr.'s book *Eyes of An Eagle*, published in 2011.

A native of Terrebonne Parish, she first received statewide recognition during Nicholls State collegiate days with a sweepstakes prize from the Louisiana College Writers Society. After a short stint as English and journalism teacher, she variously worked as a newspaper section editor, public relations director for a children's home, technical writer for the environmental section of an engineering firm, development director for a Catholic high school, and editor of *Terrebonne Magazine*.

Two entries she submitted were selected to be among the 120 nonfiction "minutes" included in Pelican Publishing Company's 2007 anthology *Louisiana in Words*.

She lives in Houma, Louisiana, with her husband Emil. She has a daughter, two grandchildren, and a large extended family.

INDEX

Spelling variations of surnames have been adjusted in some cases to reflect standardized spellings. When spelling variations are notable, the name will appear as spelled in the original document and the contemporary spelling will be referenced. "Eschete," for example, is recorded as "Eshte" and "Chté" and "Ellender" as "Elinger." Capitalization also varies, especially on names like "LeBlanc" where the capitalization of the "B" may vary.

1822 Map of Louisiana: 18
1827 Map of Louisiana: 19
1830 Census: 102

A

Acadia: 15, 35, 340, 383
Acadian: 34, 36, 38, 102, 290
Adam, Lisa Kay: 66
Adams, Edgar Jr.: 61
Adams, Frederick: 61
Adams, Jacques: 88
Adams, Lovance: 4, 240, 340
Agricultural Appropriation Act: 60
Aguilar, Fernando: 144
Alford, Sharon Aucoin: 399
Allemand, Alcee: 364, 381
Allemand, Lorraine: 399
Alvis, Kate: 263
Andalusian: 38
Andra, Armand: 61
Anderson, Thomas: 175
Andrepont, M. J.: 386
Andrew Price School: 168, 169
Angers, Hewitt: 305
Angus: 39, 42
animus revertendi: 29
anthrax: 180
Antill, Willie: 329
Arcenaux, Lucin: 155
Ardoyne Plantation: 54, 55, 113, 159,
Argyle Plantation: 54, 140, 277
Argyle, P. & M. Co. Ltd.: 277
Arsenaud, Pierre: 34
Arsenaux, Cyprien Louis: 283
Arsenaux, George W.: 356
Arsenaux, Huberville: 96
Arsenaux, Marie: 170
 wife of Arsenaux, Huberville
Ashland Plantation: 53, 54, 55
Ashly, William: 94
Atchafalaya: 45, 46
Attakapas Country (District): 15, 34, 38, 382, 383
Aubrey, Charles Philip: 36
Aucoin: 102
Aucoin, Adeline: 97
Aucoin, Albert: 265
Aucoin, Albon Octave: 264, 349
Aucoin, Edward: 319
Aucoin, Jean Baptiste: 118
Aucoin, Leon: 87
Aucoin, Mike *et al*: 27
Aucoin, Octave Joseph: 224, 264, 314
Aucoin, Pat: 399
Aucoin, Roy Anthony Sr.: 264, 379
Aucoin, Roy Jr.: 399
Aucoin, Rudy: 399
Aucoin, Silvani Numa: 211, 264

Aucoin, Urbain: 143
Authement, Adolphe: 277
 transferred from Smith, John Mrs.
Authement, Alcide: 335
Authement, Andrew: 330
Authément, Antoine Gassien: 164
Authement, Augustin Mrs.: 106
 transferred from Henry, Bertelemi
Authement, Axon: 363
Authément, Gaspard: 118
Authement, George: 373
Authement, Lineas: 324
Authement, Michael Jude: 27
Authement, Simpson: 363
Authement, Voorhies: 351, 399
Authement, Wilson: 303
Authement, Yvest: 357
Autin, Arnold A.: 378, 386
Autin, Celeste: 399
Autin, Daniel C.: 399
Autin, Donel: 399
Autin, Gibson: 283
Autin, Gibson J. Jr.: 386
Averett, Robbie: 385
Aycock, Ernest L.: 174
Aycock, Joseph: 262
Ayot, Odressie: 165
Ayrshire: 42

B

Babin, Angelo Roberts: 375
Babin, Auguste: 125
Babin, François: 101
 transferred to Babin, Maximien
Babin, François Jr.: 157
Babin, François Omer: 166
Babin, Jean Augustin: 82
Babin, Jean Baptiste Sr.: 108
Babin, Joseph: 275
Babin, Joseph Thomas: 110
Babin, Léo Félicien: 166
Babin, Maurice J. Mrs.: 364
Babin, Maximien: 101
 transferred from Babin, François
Babin, Onésime: 122
Back Project Road: 60
backtag: 48
Bacon, Ralph C.: 273
Badeaux, Appolinaire Rudolph: 275
Badeaux, Eugène: 145
Badeaux, Ivy: 61
Baldwin, Sidney: 57
Balzamine Plantation: 16
Barataria Canal Bridge: 276
Barker, Howard: 27
Barras, Leufroy: 14, 70, 94
Barras, Leufroy E.: 121
Barras, Tiburse: 176
Barrilleaux, Alvin: 61
Barriolet, Malgloire: 178
 transferred to Bernard, Joseph
Barrios, Clamile: 352
Barrow, Davis &: 148
 see also Davis & Barrow
Barrow, R. R. Jr.: 42, 280
Barrow, Robert Hilliard II: 42
Barrow, Robertine: 142
Barrow, Robert Ruffin: 42, 47, 99, 130, 160, 268, 280, 290
Barrow, Robert Ruffin Jr.: 280
Barrow, William: 197
Bascle, A. J.: 183
Bascle, Andrew S.: 325
 transferred from Bascle, Emile P.

Bascle, Emile P.: 135, 325
 transferred to Andrew S. Bascle
Baton Rouge: 25, 45
Baudoin, Marcelline: 114
 also known as Hebert, Celestin Mrs.
Baye, Antoine: 73
Bayou Black: 54, 180, 190
Bayou Blue: 4, 54, 340
Bayou Cane: 54
Bayou Coteau: 54
Bayou Dularge: 54, 180
Bayou Lafourche: 340
Bayou L'Ourse: 54
Bayou Salé: 54, 160
Bayou Teche: 34, 45, 46
Bayou Teche Dispatches: 46
Bayou Terrebonne: 16, 52, 54, 57, 103, 268, 290
Bazet, Randolph August: 69, 70, 261, 262
Beausergent, Jean Baptiste: 80
 transferred to Guidry, Alexandre
"Beausoleil": 34, 36
Becnel, Pierre A.: 144
Bedford, George C.: 123
Belanger, Emily: 323
Belanger, Félicien: 217
Belanger, Henry Franklin: 170, 262
Belanger, Leroy: 348
Belanger, Lois: 70
Belanger, Wallace: 269
Bellanger, Annette H. Mrs.: 225
Bellanger, Hubert: 72
Bellanger, Marguerite: 79
 also known as Crochet, Julien Mrs.
Bellanger, Nicolas: 128
Bennett, Carl: 7, 66, 385
Bennett, Henderson: 195
Bennie, Robert W.: 362
Benoit, Amedee: 317
Benoit, Edward: 61
Benoit, Joseph: 83
 transferred to Guidry, Jean Baptiste
Benoit, Valcour: 61
Berger Brothers Livery: 140, 141
Berger, Henry: 141
Berger, John: 140, 141
 also known as Kepienberger, John
Berger, Peter: 140, 141
Bergeron, Alex: 9, 162
Bergeron, Americus: 311
Bergeron, Augustin J.: 285
Bergeron, Celestin: 86
Bergeron, Celestin Baptiste: 96
Bergeron, Celestin Vital: 157
Bergeron, Drausin: 123
Bergeron, Jean Baptiste: 79, 108
Bergeron, Jean Charles: 90
Bergeron, Jess: 7
Bergeron, Luvinia: 122
Bergeron, Marcelin: 80
Bergeron, Norbert: 151
Bergeron, Octave: 349
Bergeron, Oliver: 260
Bergeron, Pierre: 94
Bergeron, Rene: 61
Bergeron, Trasimond: 244
Bernard, Andrew J.: 386
Bernard, Joseph: 178
 transferred from Barriolet, Malgloire
Bernard, Shane K.: 7, 34, 46, 383
Bertheaud, Evariste: 154
Berwick Bay: 4

Besse, Jean: 81
 transferred from Dupré, Alexandre
Billiot, Alexandre: 154
Billiot, Dominique Henry: 166
Billiot, Ellis: 242
Billiot, Etienne: 82, 92
Billiot, Etienne Clerville: 227
Billiot, Eulalie: 259
Billiot, Frasie: 100
 wife of Billiot, Etienne
Billiot, Jeanne: 91
Billiot, Leon: 91
Billiot, Marguerite: 91
Billiot, Marie Domitile: 93
Billiot, Michel: 105
Billiot, Modeste: 114
Billiot, Philerome: 105
Billiot, Pierre: 81, 91
 see also Janne, Marie
 see also Billiot, Rosette
Billiot, Polinaire: 247
Billiot, Rosalie: 131
Billiot, Rosette: 90, 107
 daughter of Billiot, Pierre: 81, 91
Billiot, Simon: 260
Bisland & Shields: 98
Bisland, Fannie A.: 156
Bisland, George: 189
blacksmith: 4, 50, 51, 52, 53
Blanchard & Ranson: 131
Blanchard, Abel: 347
Blanchard, Alexis: 106
Blanchard, Alphonse: 263
Blanchard, Baptiste: 123
Blanchard, Beloni: 116
Blanchard, Belonie: 93
Blanchard, Clerville P.: 245
Blanchard, Emile: 61
Blanchard, Ernest: 344, 370
Blanchard, Firmin: 104
Blanchard, Henry: 61
Blanchard, Henry Joseph: 373
Blanchard, Hylair: 143
Blanchard, Hypolite: 116
Blanchard, John Howard: 351
Blanchard, Joseph: 327
Blanchard, J. Reginald: 351
Blanchard, Orland: 232
Blanchard, Pierre: 178
Blanchard, Reginald: 232
Blanchard, Robert P.: 70
Blanchard, Robert Pierre: 262
Blanchard, Silvere: 116
Blanchard, Volzie: 293
Blanchard, Wilbert: 61
Blum, Abraham: 217
Blum, Julius: 9, 162
Bodin, H. J.: 70
Bond, Walter: 370
Bonnette, Temus: 386
Bonvillain, Admar: 122
Bonvillain, Bannon: 171
Bonvillain, Emilie: 150
 widow of Guidry, Joseph Sr.
Bonvillain, Ernest: 215
Bonvillain, Evelina: 122
Bonvillain, Felix A.: 332
Bonvillain, Hubert: 117
Bonvillain, Norbert: 97
Bonvillain, Pierre Marcelin: 104
Bonvillain, Zephirin: 121
Boquet, Adam: 221
Boquet, Joseph: 315
Boquet, Jules: 265

Boquet, Jules Jr. Mr. and Mrs.: 399
Bordelon, R. Luke Dr.: 7
Borne, L. A.: 386
Boudeloche, Gedeon: 206
 transferred from Boudeloche, Valery
Boudeloche, Seraphin: 137
Boudeloche, Valeri: 95
Boudeloche, Valery: 206
 transferred to Boudeloche, Gedeon
Boudreaux, Alphonse Z.: 217
Boudreaux Canal: 54, 160
Boudreaux, Charles: 142
Boudreaux, Charles Maxile: 151
Boudreaux, Clay: 61
Boudreaux, Desire: 203
Boudreaux, Eugène C.: 232
Boudreaux, Felix: 211
Boudreaux, Florentin: 106
Boudreaux, Forestal: 217
Boudreaux, Gilbert A.: 283
Boudreaux, I. Robert "Bobby": 7, 262
Boudreaux, Isidore: 81, 128
 transferred to Dupré, Charles Isidore
Boudreaux, Jean Baptiste: 124, 151
Boudreaux, Joachim: 145
Boudreaux, Joseph: 81
Boudreaux, Joseph Florentin: 151
Boudreaux, Joseph Mrs. (widow): 74
 transferred to (1st) Boudreaux, Pelegrin;
 transferred to (2nd) LeBlanc, Simon
Boudreaux, Logan: 61
Boudreaux, Narcisse: 145
Boudreaux, Norbert: 273
Boudreaux, Octave: 285
Boudreaux, Pelegrin: 74
 transferred from Boudreaux, Joseph Mrs.; *transferred to* LeBlanc, Simon
Boudreaux, Renaud: 74
Boudreaux, Rosemond: 107
 transferred from Hebert, Louis Jean Baptiste
Boudreaux, Stanislas: 111
Boudreaux, Ulgere: 269
Bourg, André: 237
Bourg, Arthur Joseph: 173
Bourg, Aubin: 70, 155, 262, 362
Bourg, Auguste: 108
Bourg, Clarence: 61
Bourg, Druis: 399
Bourg, F. X.: 362
Bourg, Francis: 274, 275, 285
 transferred from Bourg, Zenon
Bourg, Francis Xavier: 70, 262
Bourg, Hacinth: 92
 transferred from Bourque, Charles
Bourg, Henry M.: 70, 214
Bourg, Jean Similien: 117
Bourg, Joseph: 332
 husband of Lecompte, Lelia
Bourg, Joseph Gabriel: 243
Bourg, Louis: 130
Bourg, Lyes J.: 346
Bourg, Norton J.: 369
Bourg, Olivia: 263
Bourg, Zenon: 274, 275, 285
 transferred to Bourg, Francis
Bourgeois, Bernard Jean-Pierre Caliste: 162, 199, 200
Bourgeois, Gertrude Laurentine: 162
 also known as Cenac, Gertrude
Bourgeois, Joseph Paul: 77
 husband of Thibodaux, Eugenie
Bourgeois, L. Vernon Jr.: 362
Bourgeois, Louis: 211

Bourgeois, Lucien: 142, 165
Bourgeois, Peter G.: 362, 386
Bourgeois, Rémi: 135
Bourgeois, Valfroid M.: 191
 husband of Knight, Josephine M.
Bourk, Jean Jr.: 15, 71
Bourque, Charles: 92
 transferred to Bourg, Hacinth
Bourque, Pierre: 14, 80
Boutelou, Vigorre: 119
Bowie, James: 355
Bowie, Rezin: 355
Bowie, Wade B.: 157
 transferred from Malborough, Henry
Boyne, Edward: 305
Boyne, John A.: 305
Brady, E. T. Sr.: 180
Brady, Timothy: 53
Braford: 42
Brahman: 42, 43
Brand Book, Opelousas and Attakapas Districts: 383
Brangus: 42, 43
Brashear: 4
Brasseaux, Dr. Carl: 7, 35, 383
Braud, Dominique: 111
Braud, Drausin: 130
Braud, Eba J.: 280
Braud, Joseph A.: 123
Braud, Joseph H.: 138
Braud, Pierre: 139
Braxton, Carter: 170
Breaux, Dalmas Joseph: 224
Breaux, Harry: 260
Breaux, Henry: 229
Breaux, J.B.: 399
Breaux, Obin: 265
Brien, Amadee: 265
Brien, Aurelie E.: 299
Brien, J. Honorius: 227
Brien, M. M.: 50
Brien, Russel J.: 216, 399
Broussard, Alexandre: 34, 36
Broussard, Jean Baptiste: 34, 36
Broussard, Joseph: 34, 36, 114
Broussard, Victor: 34, 36
Broussard, Whitney P.: 386
Brown, Columbus: 187
Brown, James: 201
brulees: 35
Brunet, Alcide: 61
Brunet, Louis: 61
Brunet, Octave T.: 335
 husband of LeBoeuf, Mary
Brunet, Pierre: 100
Brunet, Ulysse: 299
Budd, John B.: 362
Buford, Thomas: 122
Bull Run Plantation: 54
Buquet, Odressy: 297
Burcham, Carnie: 385
Burguieres, J. M.: 70
Burguieres, Jules Martial: 170
Burguieres, Leufroy: 171
Burnett, John D.: 319
Bush, Reuben: 362
butchering diagram: 310
Butler, Alexander: 195
Butler, Ann: 7

C

Cage, Albert G.: 362
Cage, G. W.: 167
Cage, T. M.: 167

Cage, Thomas A.: 362
Cage, W. R.: 167
Caillou Grove Plantation: 42
Caillouet, Arnaud: 285
Cajun: 39, 66, 168, 383
Calahan, Gédéon: 134
Calcasieu Parish: 15, 44
Calcasieu River: 44
Calhoun, N.M.: 70
Callagan, Luke: 61
Callahan, James J.: 359
 transferred from Melancon, Theodore C.
Callahan, Morris W.: 380
Callahan, Philomene: 283
Callahan, Sidney S.: 27
Callais, Erin: 7
Camargue: 30
Cameron Parish: 15
Campbell, Emeline: 177
Canal Bellanger: 54
Carian, Jean: 146
Carlin, Desiré: 146
Carlin, Hilaire: 133
Carlos, Alcide: 225
Carlos, J. Herbert (Hubert): 163, 313
Carlos, John: 363
 husband of Luke, Ella
Carlos, Marguerite Cenac: 163
Carlos, Marie Cenac: 163
Carlos, Salvador Sr.: 163
Carrere, Jean Pierre Sr.: 160, 163
Carrere, Justillien: 163, 331
Carro, Etienne: 313
Carro, Eugene: 263
Carro, Joseph: 232
Casey, Mary E.: 209
 wife of Casey, Thomas H.
Casey, Thomas H.: 198
Cassan, Lewis: 115
Castille, Connie: 7
cattle, types and history: 38-43
Causey, Curtis: 61
Celestin, Charles Amedee: 70, 219, 262
Celestin, Daniel Batiste: 188
Cenac & Blum: 161
Cenac, A. J. Jr.: 399
Cenac, Albert: 161, 289
Cenac, Alphonse J. Sr.: 161
Cenac, A. R. Jr.: 161
Cenac, Arlen B. Jr.: 7
Cenac, Arlen B. Sr.: 161
Cenac, Brent John: 9
Cenac, C. & Co.: 160, 162
Cenac, Caliste Charles: 162
Cenac, Cindy: 7, 388
Cenac, Cody Christopher: 27, 161
Cenac Collection: 13
Cenac, Christopher E. Jr. M.D.: 9
Cenac, Christopher E. Sr. M.D.: 4, 9, 13, 103, 388, 389
Cenac, Clark C.: 161
Cenac, Donald J.: 9
Cenac, Ernest Albert Jr.: 161
Cenac Farm Inc.: 27, 161
Cenac, George L.: 163, 281
Cenac, Gertrude Laurentine Bourgeois: 162
Cenac, Henri Phillipe: 9
Cenac, Jean Baptiste: 160, 163
Cenac, Jean Charles: 9, 162
Cenac, Jean-Pierre: 9, 160, 161, 163, 214, 251
Cenac, Jean-Pierre Jr.: 163

Cenac's livery stable: 9
Cenac, Marguerite: 163
 also known as Carlos, Marguerite
Cenac, Marie: 163
 also known as Carlos, Marie
Cenac, Marie Madeleine Bourgeois: 162
Cenac, Ovide (Ouide *sic*) J.: 28, 161
Cenac, Paul M.: 163, 303
Cenac, Philip Louis Sr. Dr.: 9, 27, 162, 306, 367
Cenac, Pierre: 159
Cenac, Pierre Jr.: 329
Cenac, Sarah Louise: 9
Cenac, Victorine Aimée: 163
 wife of Carrere, Jean Pierre Sr.
Cenac, Victorine Fanguy: 4, 103, 160
Cenac, William Jean-Pierre: 9, 160, 162, 214
Ceniquaire, Calice: 135
Ceres (Houma): 50, 51
Chacahoula: 45, 54
Champagne, Charles J.: 213
Champagne, Onésime: 111
Champagne, Walter E.: 353
Charbray: 43
Charolais: 43
Charpentier, Clovis: 335
Charpentier, Emile: 335
Charpentier, Leon: 335
Charpentier, Pierre: 111
Chatanier, Hyppolite: 99
Chatanier, Marie Reine: 73
Chauvin: 54
Chauvin, Albert: 315
Chauvin, Argus: 307
Chauvin, Arnold: 347
Chauvin, Clifford P.: 386
Chauvin, Elmer Anthony: 353
Chauvin, Eloy: 148
Chauvin, Fay: 292, 301
Chauvin, Hypolite (dit Zénon): 129
Chauvin, James: 283
Chauvin, Joseph: 61
Chauvin, Josh: 359
Chauvin, Lawrence: 347
Chauvin, Morris: 61
Chauvin, Theophile H.: 173
Chauvin, Ultere: 130
Chauvin, Zénon Jr.: 124
Chauvin, Zénon Pompulus: 157
Chiasson, Agna: 61
Chiasson, Anatole: 61
Chiasson, Dennis: 363
Chiasson, Gabriel: 111
Chiasson, Joseph André: 111
Chiasson, Morris: 61
Chiasson, Octave: 317
Chiasson, Pierre: 89
Chiasson, Robert: 61
chickens: 47
Chinampo: 39
Chté, Trasile: 129
 see also Eschete, Trasile
Civic Guard (Houma): 51, 141
Civil War: 15, 39, 44
Clark, Nat: 173
Clement, Alfred: 7
Clement, Early: 61
Clement, Edward: 265
Clement, Rene J.: 52, 53
Clement, Siméon: 110
Clément, Uzélien: 121
Clement, Warren Jr.: 7

Index **391**

Clerk of Court: 7, 14, 70
Clifton, Walker &: 100
 see also Walker & Clifton
Clulee, William "Willie": 284
Cobb, Thomas Blum: 9, 13
Cocke, O. R.: 359
Cocke, Oscar R. (Reggie): 386
Cocke, R. W.: 359
Cole, Lana Robichaux: 399
Coleman, Patrick: 158
Collins & Dederick: 137
 see also Dederick, Collins &
Collins, Alphonse: 267
Collins, Emile: 370
Columbus, Christopher: 29, 38
Comeaux, Eustache: 117
Comeaux, Felix: 356
Comeaux, Jean: 79
compulsory branding: 25
Comte, François: 123
Concord Plantation: 190
Condon, Edward W.: 70, 262
Connely, A. W.: 362
Connely, Arthur W.: 171
Cooper, A. & Son: 51
Cooper, B. & Brother: 51
cooperative farm: 56
Corbit, Isaac: 99
Coronado, Francisco: 38
Corriente: 39
Cortes, Hernando: 29, 38
coteaus: 35
Cotten, Olinda: 327
Cotton, Henry: 298, 299
Cotton, John: 277
Courteau: 15, 97
Courteau, François: 97
courthouse: 14, 25, 62, 290
Couvillion & Tassin: 350
Crane, Jill: 7
Creole: 39
Crescent Farm: 42, 113, 140
Criollo: 39
Crochet, Adam Paul: 373
Crochet, Allen A.: 345
Crochet, August: 52
Crochet, Elmer: 52
Crochet, Evans: 372
Crochet, Ezra: 52
Crochet, Henry J.: 373
Crochet, Julien Mrs. (widow): 15, 79
 also known as Bellanger, Marguerite
Crochet, Léandre: 88
Crochet, Sterling: 61
Cuba: 38
Cuba, Isle of Plantation: 54, 57
Cuba, Santiago de: 16,
Culli, Marie W.: 70
Cunningham, John: 88
cypress: 28

D

Daigle, Emile: 51
Daigle, Joseph Jr.: 100
Daigle, Louis: 61
Daigle, Mathurin: 96
Daigle, Octave: 239
 transferred from Deoux, Comie Blaise
Daigle, Peter: 301
Daigle, Pierre Michael: 77
Daigle, Ursin: 61
Daigleville: 54
Daniels, Jack: 243
Darby, William: 34

Darcé, Joseph J.: 95, 109
Darcé, Leon: 139
Darce, P. H.: 362
Darcé, Philippe H.: 105
Darcé, Similien: 136
Darcé, Sosthene A. Jr.: 175
Dardard, Marguerite: 326
Dardare, Onesipe: 259
Dardart, Charles: 114
Dardart, Paulin: 105
Dardau, Alexandre: 142
Darsey, Peggy: 7
Daspit, Joseph F.: 215
Daspit, Justin: 114
Daspit, Marcelus: 115
Daspit, Oscar: 157, 362
Daspit, Oscar C.: 286
Daspit, Robert: 132
Daspit, Salvatore C.: 312, 313
 transferred to Duplantis, Louis J.
Daunis, Théophile: 154
Dauterive, Antoine Bernard: 34, 35, 36
Dauterive Compact: 34, 35, 36
Davis & Barrow: 148
 see also Barrow, Davis &
Davis, Dan: 399
Davis, Don: 7
Davis, Jim: 7
Davis, Xenia: 334
D'Echaux, Jules: 208
Dederick, Collins &: 137
 see also Collins & Dederick
Dedrick, Noah: 187
Defilice, Esteve: 277
Delaporte, Alfred Joseph: 70
Delaporte, Jean: 83
 transferred to Verret, Marguerite
Delatte, Felix A. Jr.: 161
DeLeon, Ponce: 38
Deon, Paul Mrs.: 327
Deoux, Comie Blaise: 133, 239
 transferred to Daigle, Octave
Deroche, Calvin: 61
Desroches, Gustave: 275
 transferred from LeBoeuf, Gabriel
DesRoches, Oleus: 271
DesRoches, Theodule: 258
Devillers, Mathilde: 176
Dick, Philip: 172
Dill, James J.: 53
Dill, William: 156
dipping vats: 240
dogs: 47
Doiron, Gustave: 227
Domangue, Aubry Joseph: 345
Domangue, Charles: 326
Domangue, Elvie Fanguy: 4, 103
Domangue, Garris: 378
Domangue, Joida: 53
Domingo, Antoine: 107
Domingo, Antonio: 119
Domingo, Francisco: 101
Domingo, Manuel: 119
Domingue, Elysee: 359
donkey: 152, 153
Donner: 54
Dover, Elmer: 357
Dover, John: 319
Dover, John Jr.: 399
Dover, Joseph Jr.: 55, 364
Drayton, Anthony: 262
Dubois, Elie: 309
Dubois, Ernest J.: 315

Dubois, Joe: 321
Dubois, Marguerite: 379
Dubois, Olivier: 114
 transferred to Robertson, J.
Dubois, Ulysse: 109
 transferred from Leboeuf, Romain
Ducros Plantation: 57
Duet, Louis: 61
Dufrene, Clifton J.: 316
Dufrene, Henry: 315
Dufresne, Octave: 289
Duga, Jean: 34, 36
Dugas, Ambroise: 95
Dugas, Henry: 93
Dugas, Jean Baptiste Placide: 105
Dugas, Jean Pierre Mrs. (widow): 107
Dugas, Joseph Elie: 136, 142
 see also Verret, Stephanie
Dugas, Octave: 222
Dugas, Pierre B.: 128
Dugas, Sainville: 148
Dugas, Théotisse: 101
Dugas, Usébe: 106
Dulac: 54, 160
Dumesnil, Benjamin: 243
Dumesnil, François: 213
Dumiot, Charles: 51
Dumond, Michel: 323
Dumont, Morris: 108
 transferred from Thibodaux, Pierre
Dunn, Gary: 385
Duplanti, Alexis: 97
Duplanti, Jean Baptiste: 73
 transferred to Duplantis, Auguste
Duplanti, Jean Baptiste Jr.: 107
Duplanti, Joseph: 98, 116
Duplanti, Marcelin: 118
Duplantis, Alces: 273
Duplantis, Armand: 267
Duplantis, Arthur P.: 281, 282
Duplantis, Auguste: 73, 295
 transferred from Duplanti, Jean Baptiste
Duplantis, Cleophas: 293
Duplantis, Delvin J.: 371
Duplantis, Dolly: 7
Duplantis, H.C.: 281
Duplantis, Ivy J.: 368
Duplantis, J. G.: 364
Duplantis, Jean Baptiste: 295
Duplantis, Jean Baptiste Jr.: 158
Duplantis, John. Mrs.: 225
Duplantis, Joseph O.: 262
Duplantis, Joseph Oleus: 156
Duplantis, Louis: 271
Duplantis, Louis J.: 312, 313
 transferred from Daspit, Salvatore C.
Duplantis, Marcelle: 165
Duplantis, Narcisse: 219
Duplantis, Ronnie: 362
Duplantis, Theophile: 281
Duplantis, Wallace D.: 324
Duplantis, Wayne: 7
Duplantis, Wilson: 324
Dupont, Emile: 141
Dupont, Ernest A.: 362
Dupont, J. C.: 279
Dupont, Joseph W.: 280
Dupré, Alexandre: 81
 transferred to Besse, Jean
Dupre, Anthony: 371
Dupré, Basile: 93
Dupré, Charles: 72
Dupré, Charles Isidore: 81, 128

 transferred from Boudreaux, Isidore
Dupré, Colastie: 144
Dupre, Ernest Joseph: 353
Dupré, Gérome: 92
Dupré, Jean Jr.: 87
Dupré, Marcellin: 150
Dupré, Marie: 117
Dupré, Mathurin Fortune: 80
Dupre, Octave: 288
Dupré, Olezime: 241
Dupre, Reggie: 399
Dupre, Wallace: 61
Dupre, Whitney: 337
Dupre, Wickles: 61
Dupre, Wilfred: 324
Dupré, Zéphirin Isaac: 128
Dupri, L. H.: 283
DuRoy, Charles Lemichel: 105
DuRoy, Charles W.: 176
Duthu, Isidore: 138
 transferred from Young, Thomas H. Dr.
Duval, Claude B.: 386
Duval, J. B. Dr.: 141

E

ear tattoos: 48
Edenborn, Sarah: 300
Edenborn, William: 300
edict (1770): 46
Edward, Roberson: 197
Edwards, C. D.: 155
Eells Brothers Co.: 358
Eells, Daniel B.: 352
Egyptian: 29
Eichhorn, Mary Lou: 7
El Rancho Medico: 306
Elinger, later spelled as Ellender.
Elinger, Catharine Roddy: 290, 292
Elinger, David: 290, 292
Elinger, Elizabeth: 290, 292
Elinger, Ernest: 290, 292
Elinger, George: 290, 292
Elinger, Henry: 290
Elinger, James: 290, 292
Elinger, Joseph: 290, 292
Elinger, Thomas: 120, 290, 292
Elinger, Thomas Jr.: 290
Elinger, Wallace: 290, 292
Elinger, William: 292
Ellendale Plantation: 54, 55
Ellender, Albert P. D.D.S.: 7
Ellender, Allen J., U. S. Sen.: 60, 290
Ellender, Carl: 292, 338
Ellender, Ernest: 287, 288
Ellender, Helen Calhoun Donnelly: 60
Ellender, Hyman: 249, 292
Ellender, Joseph: 288
Ellelnder, Josephine: 292
 wife of Chauvin, Fay
Ellender, Paul: 292, 333
Ellender, T. J. Jr.: 291
Ellender, Thomas Sr. (II): 288
Ellender, Wallace: 287, 288
Ellender, Wallace R.: 292, 331
Ellender, Wilson: 291, 292
Engeron, Pierre Urbain: 105
Engerran, Eugène: 130
Engerron, Philogene: 275
English cattle: 39
English Common Law: 16
entradas: 38
Eschete, Aurelie: 302, 303
 transferred to Eschete, Neville

Eschete, Ellis: 229
see also Esheté, Ellis
Eschete, Loney: 301
Eschete, Louis: 303
see also Eshte, Louis
Eschete, Maggie: 337
wife of Marie, Ephie
Eschete, Neville: 302, 303
transferred from Eschete, Aurelie
Eschete, Octave: 4, 52
Eschete, Rudy: 399
Eschete, Trasile: 129
see also Chté, Trasile
Eschete, Willie: 288
see also Eshte, Willie
Esheté, Ellis: 229
see also Eschete, Ellis
Eshte, Louis: 303
see also Eschete, Louis
Eshte, Willie: 288
see also Eschete, Willie
Este, Israel: 61
European breeds: 42
Evest, Eddie: 9
Ewing, William: 269
Exnisios, Louis: 149
Eyes of an Eagle: 13, 388, 389
Eymard, Hyppolite *(children of)*: 150

F

Fabre, Bernard: 357
Fabre, Rudolph: 336
Falgout, Baker: 311
Falgout, Heloise: 103
Falgout, Jessie: 350
Falgout, Marcellin: 150
Falgout, Nolan T.: 363
Falgout, St. James: 146
Fanguy, Antoine: 103
Fanguy, Edmond: 4, 12, 13, 103, 104
Fanguy, Charles: 4, 103
Fanguy, Victorine: 103, 160
wife of Cenac, Jean-Pierre
Fanguy, Vincent: 103
Fanguy, Volcar: 249
Fanguy, William: 4, 103, 136
transferred from Wolf Brothers
Farm Security Administration: 57
Fernandez, John J.: 61
Fernandez, Wayne: 7
Farrell, Dr. R. Keith: 47
farrier: 50, 51, 52
federal government: 56, 60, 103
Field, Edwin R.: 139
Fields, Eugène: 158, 281
transferred to Lirette, Alex A.
Fields, John H.: 362
Fields, Justillien: 188
Fitch, François: 231
flesh brands: 29, 47
Fletcher, Clement: 172
Fletcher, Patterson: 104
Florida Cracker cattle: 39
Folse, Drausin: 145
Fontenot, Keith: 385
Fontenot, Stanislas: 94
Foolkes, John: 51
Forest, Paul: 111
Foret, Brownell: 377
Foret, Irvin: 376
Foret, Rosémond: 132
Foucault, Denis-Nicolas: 36
Foucheux, Thomas: 210
Fournier, Dustin L.: 27

France: 30, 38, 43, 103, 160, 180, 340
Francis, Louisa W.: 173
wife of Francis, Richard W.
Francis, Richard W.: 173, 262
see also Francis, Louisa W.
Frédéric, Charles: 15, 133
Fredericks, Eddie Sr.: 61
free man of color: 15, 133
free woman of color: 15, 114
freedman: 15, 167, 170
Freeman, George: 265
freeze brands: 47

G

Gagliano, Joseph: 61
Gagné, Joseph A.: 137, 362
Gagnon, Washington: 208
Gaidry, Adolphe: 155
Gaidry, Wilson Sr.: 268
Gallet, Nicholas: 323
Gaston, Joseph Albert: 307
Gaubert, André: 93
Gaubert, Denis: 399
Gaubert, Mary Sarah: 121
Gaudet, Alfred: 61
Gaudet, Marie Francois: 340
wife of LeBlanc, Daniel
Gauthrot, Pierre Gregoire: 72
Gautreaux, Jean Valery: 125
Gautreaux, Leonce: 279
Gautreaux, Raoul: 348
Gautreaux, Trasimond O.: 166
Gendron, Jean Baptiste: 172
genetics: 43
Gerbeau, Emile: 182
Gerbeau, Pierre: 116
Gibson: 54, 102, 180, 181
Giroir, Auguste: 116
Giroir, Estilette: 253
Giroir, Theophile: 273
Golden Ranch Plantation: 228, 238, 239, 284, 316, 360
Gordon, Tilghman: 172
Gouaux, François: 213
Grand Caillou: 54, 103, 160
Gray, W. J.: 386
Greeks: 29
Greenwood Plantation: 140
Gregoire, Eulalie (Verdin): 89
Gregoire, Jean Baptiste (Verdin): 89
Gregoire, Joseph: 89, 376
Gregoire, Marguerite (Verdin): 88
Gregoire, Marie: 88
Gregoire, Mélanie (Verdin): 89
Gregoire, Pauline (Verdin): 90
Gregoire, Ursin (Verdin): 89
Gregoire, Victor (Verdin): 89
Grevemberg, Barthélémy: 35, 382
Grevemberg, Louis: 382
Griffin, Mona: 7
Griffin, Nancy: 190
wife of Wright, Holden
Grinage, Francis: 148
Gros, Abel: 61
Gros, Alex: 61
Gros, Azema: 213
wife of Neal, Edward
Gros, Benny: 61
Gros, Leon: 250
Guatemala: 290, 355
Guéno, Joachim: 131
Guice, Desire: 277
Guidroz, J. L.: 227

Guidry, Adele W.: 150
daughter of Guidry, Jean Baptiste: 83
Guidry, Alexandre: 80
transferred from Beausergent, Jean Baptiste
Guidry, Armand: 61
Guidry, Clerville: 136
Guidry, Earl J.: 365, 367
Guidry, Edwin: 61
Guidry, Ernest: 191
Guidry, Eugene: 357
Guidry, Eugéne: 123
Guidry, Euphrosin: 144
Guidry, Isaac: 231
Guidry, J. A.: 321
Guidry, Jean Baptiste: 83
transferred from Benoit, Joseph;
see also Guidry, Adele W.: 150
Guidry, Joseph Jr.: 150
Guidry, Joseph Sr.: 150
husband of Bonvillain, Emilie
Guidry, Junius: 338
Guidry, Livie Mrs.: 286
wife of Hebert, Hilaire
Guidry, Louis J.: 375
Guidry, Moise: 151
Guidry, Ray: 350
Guidry, Sherwin: 102
Guidry, Wenzel A.: 335
Guidry, Wilfrid: 222
Guilbeau, Joseph: 34, 36
Guillot, Francois: 143
Guillot, Herbert: 61
Guillot, Victor: 143
Gulf Coast: 62
Gulf Intracoastal Waterway: 52
Guyol, Francis M.: 14, 70

H

Hail, James: 120
Hains, Bernard E.: 115
Hains, Edward: 115
Hains, Eugénie: 114
Hains, Franklin: 115
Hains, Gilford A.: 115
Hains, John: 114
Halbert, Jacques: 139
Hamilton, Allen: 53
Hamilton Brothers' Machine Shop: 53
Hamilton, Peter: 52, 53
Hamilton, Willie: 52, 53
Hammond, William Mrs.: 95
also known as Saulnier, Marguerite
Hardy, Brent: 385
Hardy, Florent Jr.: 7, 66
Harland, John: 150
Harmount, G.S.: 386
Harris, Jerry: 177
Hardscrabble Plantation: 290
Harvey, Thedrick Jr.: 196
Hatch, Winslow: 155
Haubert, Jean Baptiste Clophore: 119
Hebert, Adam Oliver: 70, 262
Hebert, Alexandre: 121
Hebert, Amedeé: 174, 225, 226
transferred #550 to Hebert, Harvey J.;
father of Hebert, Margueritte;
transferred #664 to Hebert, Margueritte
Hebert, Ariel J.: 225
Hebert, Celestin Mrs.: 114
also known as Baudoin, Marcelline
widow of Hebert, Celestin

Hebert, Celian: 225
Hebert, Edmond: 121
Hebert, Edmond Mrs.: 295
Hebert, Eldred: 338
Hebert, Emile: 219, 225, 339
Hebert, Etienne V.: 109
transferred to Hebert, Louis
Hebert, Felix: 255
Hebert, Harvey: 174, 273
Hebert, Harvey J.: 225
Hebert, Hilaire: 286
husband of Guidry, Livie
Hebert, Irene: 142
Hebert, Irvin Paul: 374
Hebert, Jean Baptiste: 96, 106
Hebert, Jean Louis: 97
Hebert, John: 349
Hebert, Joseph O.: 114
Hebert, Jules P. Jr.: 399
Hebert, Levis A.: 225
Hebert, Lionel: 372
Hebert, Louis: 109
transferred from Hebert, Etienne V.
Hebert, Louis B.: 225
Hebert, Louis Jean Baptiste: 107
transferred to Boudreaux, Rosemond
Hebert, Margueritte (Margaret): 174, 225, 226
daugher of Detiveaux, Amy;
daughter of Hebert, Amedeé
Hebert, Marie: 225
Hebert, Martin: 128
Hebert, Martin A.: 109
Hebert, Maxiliaire: 123
Hebert, Michel: 159
Hebert, Nelo: 225
Hebert, Octave: 308, 309
transferred to Marcel, Dennis
Hebert, Olivia: 362
Hebert, René: 267
Hebert, Virgil: 349
Hebert, Wilfred: 258
Helmick, Dr. Alexander S.: 167
Henri, Evans William: 313
Henry, Bertelemi: 106
transferred to Authement, Augustin Mrs.
Henry, Charles M. Mrs. (widow): 91
Henry, Constant: 328
Henry, François Constant: 91
Henry, Guillaume Celestin: 74
Henry, Howard: 337
Henry, Jean Baptiste Jr.: 90
transferred to (1st) Thibodaux, J. (widow of);
transferred to (2nd) Trahan, Marin
Henry, Jean Baptiste Theodore: 90
Henry, Léandre: 133
Henry, Léon: 148
Henry, Sylvain: 146
Henry, Theo: 350
Henry, Willis: 271
Heppler, Alexander: 121
herders: 30
Herbert, Emile: 61
Hereford: 39, 42, 354
Himel, Herbert: 234, 341
Himel, Herbert J.: 27
Himel, Ivay: 27
Himel, Marie: 234
Himel, Marie LeBlanc: 7, 341, 342
Himel, Neville: 61
Hingle, Dorestan: 374
Hispaniola: 38

Hoffman, Washington: 143
Honduras Plantation: 42
hornlessness: 39
Hope Farm: 290
Hornsby, Henry: 368
horse: 38, 65
Hotard, Arthur: 307
Hotard, Euphrosin: 146
Hotard, J. Noel: 233
Hotard, J. P.: 213
hot-iron brand: 28, 47, 48, 50
Houma: 54
 see also Main Street
Houma Courier: 141
Howard, Louisa C.: 125
 widow of Price, Isaac M.
Hue, Albert: 61
Humphreys: 54
Hutchinson, Linda Aucoin: 399
hybrid: 39, 42, 43, 153

I

Iberia Parish: 15
Imlay, Franklin: 118
Imlay, Jackson: 118
Imlay, Suzane: 118
impression brand: 28, 29
Indian: 39, 97, 102
Inman, Thomas: 109, 120
Isle of Cuba Plantation: 54, 57

J

Jabert, Cline: 365
Jabert, Joseph: 353
Jaccuzza (Jaccuzzo), Emile: 27, 216
Jackson, Sarah Cenac M.D.: 9
Jacob, Earl: 61
Jacob, Ignac: 51
Jacob, Valsin: 144
Janne, Marie: 82
 see also Billiot, Pierre: 81, 91
Jastremski, Leon H. Dr.: 54, 345
Jastremski, Vincent Dr.: 279
jaw brands: 47
jaw tattoos: 48
JDT Partnership: 27
Jinkins, Charles: 118
Johnson, H. M.: 70
Johnson, Lea: 370
Johnson, Robert B.: 182
Jolet, Henry Clay: 223
Joller, Claire Domangue: 4, 103, 389
Joller, Emil: 7, 389
Jones, Bill: 30, 66
Jones, Elliot: 355
Jones, Jackson: 175
Jones, James E.: 293
Jorge, Juan: 35
Jule, Babtiste: 175
Julia Plantation: 57

K

Kansas City Southern Railroad: 300
Kappel, Henry Charles: 50, 51
Kennedy, Alfred: 362
Kentucky: 39
Keys, William H.: 362
King, Paul: 369
Kliebert, Brierre: 61
Klingman, Elie: 279
Knight, Alcide C.: 174
Knight, James M.C.: 121
Knight, Josephine M.: 191
 wife of Bourgeois, Valfroid M.

Knight, William H.: 164
Knight, William O.: 174
Kraemer, Alidore: 291
Kraemer, Dorien: 295
Kraemer, Vincent: 7
Kraemer, Ying: 7
Kramer, Theodore F.: 319
Krumbhaar, Charles Conrad: 355

L

Labat, Narcisse: 174
Labit, Anachette: 135
Labit, Henri Surville: 106
Labit, Jacques: 97
Lacassagne, Laurent: 205
LaCasse, Marie Louise: 386
Lafayette Parish: 15, 383
Lafourche Interior Parish: 16, 18, 20, 54
Lafourche Parish: 4, 15, 16, 18, 20, 54, 340, 386
Lagarde, Robert: 286
Lajaunie, Adolphe: 109
Lajaunie, Amadee: 271
Lake Charles: 44, 45
Lallanne, Dominique: 134
 transferred from Leblanc, Joseph Adrien
Lambert, Leufroy: 149
Lamplough, Jack: 7
Landry, Adley P. Jr.: 27
Landry, Albert: 295
Landry, Andrew: 61
Landry, Enos J.: 305
Landry, George: 61
Landry, J. E.: 280
Landry, J. P.: 226
Landry, Joseph E.: 323
Landry, Joseph Marcelin: 99, 108
 transferred from Sevin, Valentin
Landry, Junius: 61
Landry, Lucien: 144, 164
 transferred from Martin, Jean C.
Landry, Richard F.: 27
Landser, Thomas: 42
Laperouse, Arthur: 321
Laperouse, Gustave: 277
Laperouse, Julien: 325
Laperouse, Octave: 211
Laperouse, Reynold G.: 375
Lapéruse, Severin: 106
Lapeyrouse, Chester: 344
Lapeyrouse, Dovie: 376
Lapeyrouse, Elphege: 291
Lapeyrouse, Eugene: 328
Lapeyrouse, Gustave A.: 346
Lapeyrouse, Gustave J.: 332
Lapeyrouse, Jules: 363
 husband of Luke, Ella
Lapeyrouse, Junius: 376
Lapeyrouse, Paul: 399
Lapeyrouse, Theodore S.: 333
Laporte, Marie Magdeleine: 103
Larpenter, Jerry J.: 362
Larose: 340
LaRose, Brian: 399
Larrieu, Jean: 154
LaSalle: 38
Lascaux Cave: 43
Laseigne, Pierre: 123
Lavaca Bay (Texas): 38
Lawless, Solomon C.: 124
Laws, P. L.: 263
LeBlanc: 102

LeBlanc, Abel Sr.: 4, 320, 339, 340, 342
LeBlanc, Abel Jr.: 4, 186, 340, 378
Leblanc, Albert: 4, 340
Leblanc, Alvin: 4, 340
LeBlanc, Alvin J.: 373
LeBlanc, Andrew: 61
Leblanc, Ambroise Felicien: 98
 transferred from Leblanc, Jean Martin;
 transferred to Leblanc, Michel N.
Leblanc, Auguste: 95, 123
LeBlanc, Betty: 7
LeBlanc, Charles: 76
 husband of Malborough, Magdelaine
LeBlanc, Clay: 61
LeBlanc, Conrad Sr.: 61
Leblanc, Daniel: 138
LeBlanc, Etienne: 340
Leblanc, François A.: 146
LeBlanc, Guillaume: 95
LeBlanc, Harry: 61
LeBlanc, Hayes A.: 370
Leblanc, Ignas: 4, 240, 340
LeBlanc, J. Edward: 371
LeBlanc, Jean François: 88
Leblanc, Jean Martin: 98
 transferred to (1st) Leblanc, Ambroise Felicien;
 transferred to (2nd) Leblanc, Michel N.
Leblanc, Jean Napoleon: 98
LeBlanc, John: 265
Leblanc, Joseph: 107
Leblanc, Joseph Adrien: 70, 134
 transferred to Lallanne, Dominique
Leblanc, Joseph Jr.: 98
Leblanc, Joseph Phylagony: 95
LeBlanc, Joseph Vincent: 331
LeBlanc, Marie Francois Gaudet: 340
LeBlanc, Mathurin: 340
Leblanc, Michel N.: 98
 transferred from Leblanc, Ambroise Felicien
LeBlanc, Nelson: 61
LeBlanc, Neuville: 215
LeBlanc, Pierre Gracien: 90
LeBlanc, Randy: 7
LeBlanc, Rene: 4, 240, 340
LeBlanc, Roy: 4, 340, 341, 342, 378
LeBlanc, Simon: 74
 transferred from Boudreaux, Pelegrin
Leblanc, Simon P.: 137
LeBlanc, Sylvain: 193
LeBlanc, Wade: 240, 342
LeBlanc, Wilsey: 346
LeBoeuf: 102
LeBoeuf, Albert Peter: 351
LeBoeuf, Alexis: 326
LeBoeuf, Caliste: 252
LeBoeuf, Davis: 288
LeBoeuf, Enese: 61
LeBoeuf, Etienne: 247
Leboeuf, Gabriel: 91
LeBoeuf, Gabriel: 275
 transferred to Desroches, Gustave
LeBoeuf, J. Jacques: 74
LeBoeuf, Jack J.: 375
LeBoeuf, James: 253, 254
 transferred from LeBoeuf, Joseph
Leboeuf, Jean Marie: 132
LeBoeuf, Jervis P.: 336
LeBoeuf, Joseph: 253, 254
 transferred to LeBoeuf, James
Leboeuf, Marie Bazilise: 118
 wife of Rodrigues, Francis

Leboeuf, Marie Magdeleine: 83
 also known as Tivet, Sebastien Mrs.
LeBoeuf, Mary: 335
 widow of Brunet, Octave T.
Leboeuf, Maurice: 124
Leboeuf, Reola: 61
Leboeuf, Romain: 109
 transferred to Dubois, Ulysse
LeBoeuf, Wilson: 241
Leche, Richard Gov.: 60
Lecompte, Delphin: 111
Lecompte, Ella Hebert: 364
Lecompte, Eugene: 219
Lecompte, Eugene L.: 289
Lecompte, Johnny: 332
Lecompte, Lee: 336
Lecompte, Lelia: 332
 widow of Bourg, Joseph
Lecompte, Levy Joseph: 364
Lecompte, Oliver: 291
Lecompte, Tim J.: 312, 333
 transferred to Lirette, Roy P.
LeCompte, Troy: 61
Lecompte, Wallace: 319
Lecompte, Willie: 267
Ledet, Aurelie: 268
Ledet, Columbus: 61
Ledet, Daniel Mr. and Mrs.: 399
Ledet, Lineas: 299
Ledet, McLean: 61
Lee, Samuel: 144
Lee, Scott: 385
Legendre, Auguste: 147
Legrand, Isaac: 263
LeGrande, Jason: 385
Lehman, Gilbert: 323
Lejeune, Antoine M.: 111
Lejeune, Pierre Amand: 104
Lenain, Julien: 125
Leonard, Jean Baptiste: 139
Leonard, Norman: 61
Leriche, L. A.: 179
Lester, George L.: 147
Levron, Al: 7
Levron, Frederick: 297
Levron, George Washington: 255
Levron, Saturnin: 101
Limousin: 43
Liner, Henry: 211
Liner, Rudolph J. et al: 27
Linostrom, Elias: 120
lip tattoo: 48
Lirette: 102
Lirette, Alex A.: 158, 281
 transferred from Fields, Eugène
Lirette, Alexandre: 104, 362
Lirette, Anoudet: 215
Lirette, August: 328
Lirette, Clyde: 331
Lirette, Dovic: 358
Lirette, Edgar: 214
Lirette, Frederick: 374
Lirette, Henry: 100
Lirette, Jules: 214
Lirette, Leo: 362
Lirette, Nicholas Mrs.: 94
 also known as Malborough, Marie Josephe
Lirette, Roy P.: 312
Llano, Jose: 354
Lockport: 340
Loevinstein, Herman: 145
Loewenstein, Abe: 257
logging industry: 28

Lombas, George: 257
Longhorn: 38, 39
Louisiana and Arkansas Railway: 300
Louisiana Cowboys: 4, 30, 31, 66
Louisiana Department of Agriculture and Forestry: 5, 49, 66, 180, 385
Louisiana Livestock Brand Commission: 7, 25, 26, 48, 65, 180, 380, 384, 385
Louisiana Pineywoods cattle: 39
Louisiana Purchase: 16, 34
Louviere, Armogène: 131
Louviere, Henry: 245
Lovell, Russell J.: 27
Ludevine: 15, 96
Luke, Ella: 363
 widow of Carlos, John;
 widow of Lapeyrouse, Jules
Luke, Raymond: 147
Lyman, Edwin: 97
Lyons, George D.: 335
Lyons, George D. Jr. M.D.: 399
Lyons, General: 362
Lyons, Joseph L.: 293

M

Magnon, Euphroisine B.: 105
Main Project Road: 57, 60
Main Street (Houma, LA): 9, 50, 51, 52, 62, 65, 140, 160, 214, 276, 355, 386
Mainville, Louis: 147
Malborough/Malbrough: 102
Malborough, François: 76
Malborough, Henry: 157
 transferred to Bowie, Wade B.
Malborough, J. Guillaume: 78
Malborough, Magdelaine: 76, 110
 widow of Leblanc, Charles;
 transferred to Robichaux, Jean Baptiste
Malborough, Marie Josephe: 94
 widow of Lirette, Nicholas
Malbrough, Antoine: 96
Malbrough, Benjamin: 95
Malbrough, Etienne: 105
Man, Major: 177
Mansun, Jeremiah: 121
Marcel, Dennis: 308, 309
 transferred from Hebert, Octave
Marcel, Horace: 368
Marcel, Paul: 309
Marcello, Lucas: 368
Marie, Allen J.: 27
Marie, Ephie: 377
 husband of Eschete, Maggie
Marie, Frederick: 362
Marie, Gus: 379
Marie, Jackie A.: 27
Marmande, Marcellin V. Dr.: 333, 387
Marmande, Marvin Jr.: 7, 27
Marmande, Marvin Sr.: 7
Marmande Ridge: 242
Maronge, François: 78
Marquette, Charles: 51
Marquette, Henry Beauregard: 51
Mars: 102
Mars, Jean: 149, 184
 transferred to Whipple, Walter
Martin, Alfred: 311
Martin, Calvin: 334
Martin, Chrejustin: 115

Martin, Damien: 98
Martin, Eddie: 317
Martin, Eustache: 368
Martin, Evariste Mrs.: 185
Martin, Gilbert: 339
Martin, Israel B.: 334
Martin, Jean C.: 144, 164
 transferred to Landry, Lucien
Martin, Joachim: 129
Martin, Julius: 25, 380
Martin, Justin: 158
Martin, Leon L.: 369
Martin, Louis: 345
Martin, Phillip: 61
Martin, Thaddeus Joseph: 377
Martin, William S. "Scott": 360
Martinez, A. J.: 61
Massé, Andre: 382
Matherne, Clerville: 315
Matherne Farms: 27
Matherne, Lawrence: 336
Matherne, Rita: 374
 see also Neal, James Jr.
 widow of Neal, James Jr.
Matherne, Seraphin Mrs.: 358
Matherne, Telemarque: 269
Matherne, Ursin: 220
Mattingly, Tom Jr.: 279
maverick: 49
Maverick, Samuel A.: 49
Mazarac, Barney: 27
McClelland, David: 175
McClung, L.M.T.: 156
McCollam, Andrew Jr.: 358
McCollam, Edmund: 7
McGaw, Hiram: 123
McGraw, Hirman: 50
McIntire, J. L.: 289
McIntyre, Daniel C.: 201
McMaster, Alexander: 118
McNeese Review, The: 46
mechanization: 56, 62
Melancon, A.: 254
Melancon, Philippe: 83
Melancon, Theodore C.: 359
 transferred to Callahan, James J.
Melancon, Yvest: 61
Merrit, Philip: 173
Mestayer, Louis: 350
Mexican cattle: 38
Mexico: 30, 39, 43
Michel, P. F.: 134
microchips: 48
Middle Ages: 29, 43
Middleton, Clinton D.: 170
Milhomme, Joseph: 92
Miller, Thomas: 321
Millet, Donald J.: 66
Minor, Henry Chotard: 354
Minor, Stephen: 355
Minor, William: 354, 355
Minor, William John: 354
Minor's Canal: 242
Mississippi River: 35, 44, 45, 46, 340
Mississippi, University Press of: 4, 7
Missouri Exposition: 42
Montegut: 52, 54, 70, 290, 340
Montegut, Gabriel: 70
Moore, Henry: 203
Moore, Maholda: 122
Moreau, Elizabeth: 385
Morgan's Louisiana and Texas Railroad: 45

Morrison, Phoebe Chauvin: 102
Morvant, Joachim: 61
Morvant, Louis: 61
Mount, W. E.: 254
Moutardier, Florentin: 125
mule: 65, 152, 153, 161, 268
Mushaway, John J.: 70
Myer, Bernard: 156
Myrtle Grove Plantation: 42, 190

N

Nameoka Plantation: 54, 55, 159
Napoleonic Civil Code: 16
Naquin, Adrien: 96
Naquin, Alcé: 178
Naquin, Alfred J.: 176
Naquin, Antoinette: 259
Naquin, Clement: 259
Naquin, Emile: 269
Naquin, Felonise: 101
Naquin, François: 101
Naquin, Hippolite: 94
Naquin, Jean Charles: 83
Naquin, Jean Marie: 86
Naquin, Joseph: 143
Naquin, Lawrence: 372
Naquin, Leslie: 61
Naquin, Maximain: 211
Naquin, Maximin: 213
Naquin, Oneil: 61
Naquin, Oneil Jr.: 61
Naquin, Roger Mrs.: 293
Naquin, Rose: 259
Naquin, Vanny: 61
Nash, Herrick: 188
Natchez: 354, 355
Navarre, Clarence: 61
Navarre, Louis: 61
Navarre, Jean Baptiste: 129
Navarre, Jean Charles: 124, 135
Navarre, Marcellin: 135
Navarre, Sylvère: 124
Neal, Clairville: 247
Neal, Edward: 213
 husband of Gros, Azema
Neal, George: 223
Neal, Henry: 359
Neal, James: 269
Neal, James Jr.: 334, 374
 see also Matherne, Rita
Neal, Lester: 27
Neil, Druby *et al:* 27
Negros, free: 102
Nelton, Alvin: 345
New Deal: 56, 66
New Orleans: 7, 16, 30, 34, 35, 36, 54, 103, 355, 382
Newell, Henry: 262
Niblett, Timothy: 246
Nicholls State University Archives: 4, 13, 398, 399
Nixon, George: 53, 176
Nolan, Lynn: 7
Nolan, William T.: 7
Norman, Joey: 385
Nova Scotia: 34, 340
Nubian: 38

O

O'Donnell, Elizabeth: 347
Old Beef Trail: 44
Old Spanish Trail: 44, 45
Olivier, Albert: 285

Olivier, Amanda: 9
Olivier, Curtis: 61
Olivier, Emerile: 154
Olivier, Milford Mrs.: 377
Olivier, Sylvanie: 151
Olivier, Sylvere: 337
Oncale, Junius: 61
Oncale, Maurice: 61
Opelousas: 15, 35, 44, 382, 383
Ordoyne, Adam: 61
Ordoyne, Noray: 61
Ordroneau, Etienne: 120
O'Reilly, Alejandro Gov.: 16, 35, 46
Orleans Parish: 54
O'Rourke, Andrew: 187
Ourse, Lynn: 61
Ortego, Steve: 7
oxen: 29, 38, 62

P

Palodura Ranch: 126-127
Parker, Faye: 7
Parker, P. E. Dr.: 281
Parker, Samuel: 196
Parr, Leo: 51
Parras, Lee L.: 352
Part, Jean Baptiste Adrien: 131
Part, Pierre L.: 122
Patterson, Royal: 281
Paye, Thomas: 134
Payne, Oberton: 193
Pelegrin, Adolphe: 101
Pelegrin, Fortune: 104
Pelegrin, Laurent: 101
Pelegrin, Naida: 280
Pelegrin, Oliva: 339
Pelegrin, Willis: 286
Pellegrin, Dennis: 344
Pellegrin, Fay: 339
Pellegrin, Felix A.: 344
Pellegrin, Laurence: 303
Pellegrin, Lucian: 338
Pellegrin, Milka: 372
Pelligrin, William: 61
Peltier, Wilbert: 368
Perce, William F.: 149
Percle, Claude: 61
Perero, Alva: 61
Persac, Adrien: 16
Pertuit, Charleston: 61
Pertuit, Edmond: 61
Pettigrew, Ashby W. Jr.: 386
Pharr, John: 196
Pharr's (steamer) Line: 45
Philipps, Salomon: 147
Piazza, John: 273
Pichoff, Laurent: 107
Picou: 102
Picone, Anthony V.: 141
Picou, Alidore: 301
Picou, Arthé: 309
Picou, Davis: 323
Picou, Elam: 324
Picou, Elie: 348
Picou, Elphege: 321
Picou, Emile John: 311
Picou, Emile Sr.: 328
Picou, Ernest: 198
Picou, Eusebe: 221
Picou, Franklin: 344
Picou, Joseph: 167
Picou, Lovelace: 226
Picou, Norman: 337

Picou, Ulger J.: 329
Picou, Wallace: 215
Pierce, Alma H.: 369
Pineywoods: 39, 46
Pipes, David Washington Jr.: 355, 356
Pipes, Mary Louise Minor: 355
Pitre, Felicien: 351
Pitre, François: 115
Pitre, Gustave: 330
Pitre, Hippolite: 86
Pitre, Hypolite: 124
Pitre, Jean Marie: 86
Pitre, Louis: 99
plantations, list of: 54
Plessent, Carmelite: 174
Ploton, Jean Baptiste: 51
poachers: 25
Poché, Charlette: 7
Point au Barré: 54
Point Farm Plantation: 42, 290
Pointe-aux-Chenes: 54
Pointe Coupee Parish: 15
Police Jury: 20, 21, 22, 23
Pollard, Isham: 70
Polled Shorthorn: 39
Pontiff, Adolphe: 135
Pontiff, Louis Jacques: 145
Pontiff, Oville: 125
Pontiff, Valerie: 235
Pontiffe, Clarence: 309
Porche: 102
Porche, Amédée: 154
Porche, Edward Joseph Jr.: 352
Porche, Evariste: 70
Porche, Frank: 329
Porche, Furcy: 121
Porche, George: 51, 52
Porche, Gillis: 271
Porche, Henry Clay: 51, 52, 179
Porche, James: 51, 52
Porche, Joachim: 99, 213, 226
Porche, Schuyler: 182
Portier, Clovis: 338
Portier Gorman Publications: 7
Portier, Trasimond: 171
Post, Lauren C.: 46, 66, 382
Potts, John C.: 150
Powell, Christian L.: 70
prairie: 30, 34, 38
Prejean, Abel P.: 362
Prejean, Tyler: 27
Prejeant, Smith: 61
Prestonback, Willie: 325
Price, Abel: 378
Price, Andrew School: 168
Price, Ernest: 327
Price, Henry: 332
Price, Isaac M.: 125
 husband of Howard, Louisa C.
Price, Oscar L.: 325
Price, William: 297, 372
Prosperie, Andrew: 371
Prosperie, Elie: 365
Prosperie, Louis H.: 371
Prosperie, Louis Mrs.: 375
Prosperie, Miguel: 326
Prosperie, Paul: 333
Prosperie, Victor L.: 365
Pugibet, Jean: 43

Q
Quatrevingt, Alfred Marvin: 27
Quick, William: 147

R
reading of brands: 49
recorder: 14, 70
Redman, Enos: 219
Redman, James: 15, 167, 275
Redmond, Malvina: 371
Rees, Grover: 35
Refinery: 52, 290, 354
resettlement programs: 56
Residence Dairy: 266
Residence Plantation: 42, 51, 268
resolution: 21, 22, 23, 24
retinto (criollo): 39
Rhodes, Edgar: 336
Rhodes, Irma: 257
Ribera, Michelle: 385
Richard: 102
Richard, Camille J.: 231
Richard, Jean Baptiste: 87
Richard, Joseph P.: 138
Richard, Todd: 399
Ringold, Rodgers: 313
Rio Bravo River (Texas): 39
Robbins, Brent Dr.: 385
Roberta Grove Plantation: 190
Robertson, J.: 114
 transferred from Dubois, Olivier
Robichaud: 102
Robichaux, Auguste: 143
Robichaux, Conrad: 352
Robichaux, Jean: 94
Robichaux, Jean Baptiste: 76, 119
 see also Malborough, Magdelaine
Robichaux, Jean Baptiste Honoré: 119
Robichaux, John: 289
Robichaux, Joseph Narcisse: 145
Robichaux, Leo: 229
Robichaux, Lucien: 121
Robichaux, Merlin: 379
Robichaux, Onézipe: 167
Robichaux, Price: 311
Robichaux, Theresa A.: 7, 262
Robichaux, Willie: 301
Robicheaux, Jean Baptiste: 110
Robinson, Mathilda: 267
Roddy: 102
Roddy, Beady: 61
Roddy, Catharine: 290
 wife of Elinger, Thomas
Roddy, Clarence: 297
Roddy, Floyd Joseph: 356
Roddy, Gene: 163
Roddy, George: 115
Roddy, Henry: 115
Roddy, John: 79
Roddy, Joseph: 61
Roddy, Rodney: 163
Rodrigue, Augustin: 61
Rodrigue, George Foundation: 4, 7, 30
Rodrigues, Francis: 82, 118
 see also Leboeuf, Marie Bazilise
Rodriguez, Joseph: 271
Roger, Auguste: 77
Roger, François: 183
Roger, Léon: 156
Rogers, Morgan: 330
Rogers, Robert: 61
Rollins, Jordan: 277
Rollins, Wilson: 189
Romans: 29
Roosevelt, Franklin D.
 U. S. President: 56

Root, B.: 109
Root, Benj: 119
Rosale Plantation: 42
Rose, A. S.: 51
Ross, Alfred: 231
Ross, Felice: 195
Ross, William: 117
Ross, William F.: 286
Rougelot, Alfred: 70
Rougeleot, Augustin Alfred: 149
Roundtree, William: 125
Rourke, Hugh O.: 179
Roussel, Celestine: 326
Roussel, Pierre B.: 104
Rozands, Charlton Peter: 362
Ruffin, Amy: 275
Ruffin, Willie: 256
running iron: 47

S
Sabine River: 38, 44
St. Bridgitte Plantation: 16
St. Charles Parish: 54, 103
St. George Plantation: 57
St. James Parish: 340
St. Landry Parish: 15
St. Louis Cypress Company: 52, 53
St. Martin, Armand: 197
St. Martin Parish: 15
St. Martinville: 34, 46
St. Mary Parish: 15, 54
St. Tammany Parish: 15
Samani, Paul: 207
Sampson, T. H.: 199
Santa Gertrudis: 9, 42, 43
Santiago de Cuba: 16
Santo Domingo: 38
Sargent, P. M.: 99
Saturino, Miguel: 354
Saulé, Valentin: 151
Saulet, Estelle: 166
Saulnier, Marguerite: 95
 widow of Hammond, William
savanna: 34
Savoie, Clay: 285
Savoie, Edward: 291
Savoie, George: 257
Savoie, Raoul: 358
Savoy, Joseph: 61
Schoenberg, Jean Charles: 107
Schouest, Robert: 61
Schriever: 16, 54, 56, 57, 60, 66, 140, 168
Schwing, Mary R.: 193
Scott Carroll Designs, Inc.: 7
Scott, Paul: 255
Sealsfield, Charles: 38
Sevin, Alvin: 346
Sevin, Fragius: 348
Sevin, Leroy R.: 399
Sevin, Oneal: 348
Sevin, Valentin: 99, 108
 transferred to Landry, Joseph Marcelin
Shaffer and Sons: 218
Shaffer, Etta Lee: 113
Shaffer, John Dalton: 113
Shaffer, John J. Captain: 113
Shaffer, John Jackson: 113
Shaffer, John Jackson III: 113
Shaffer, Julia: 113
Shaffer, M. Lee Jr.: 7
Shaffer, M. Lee III: 7
Shaffer, Milhado Lee: 113
Shaffer, Minerva: 113

Shaffer, William A.: 110, 112
Shaw, Jabez A.: 220
sheep: 30, 47, 48, 340, 354, 355
Shepherd, F. Eugene: 252
Shields, Bisland &: 98
 see also Bisland & Shields
Shinn, John: 141
Shorthorn: 39, 42
Silvi, Victor: 87
Simbrah: 43
Simmental: 43
Simmoneaux, Leonney: 61
Simms, Amos: 362
Simpson, Tatus L.: 132
Singleton, Thomas: 150, 210
slaves: 102
Smith, Annah: 109
Smith, C. P.: 223, 297
Smith, George: 182
Smith, John Mrs.: 277
 transferred to Authement, Adolphe;
 widow of Smith, John
Smith, Kenneth William: 399
Smith, Stafford: 193
Smith, T. Baker: 28
Soigné, Jean Charles: 131
Soniat, Judy: 7
Sonier, Willie: 61
Sonnier, Alcide: 295
Sonnier, Richard: 386
Soudellier, Eddie: 346
Soulies, H. L.: 245
South, Martha: 399
Southdown Plantation: 52, 53, 54, 64, 153, 202, 354, 355
Southdown Refinery: 354
Southdown Sugar Mill: 355
Spaniards: 30, 354
Spanish cattle: 30, 38, 39
Spanish land grants: 354
Spence, Charles M.D.: 294
squeeze chutes: 48
stamp iron: 47
Stansberry, Albert: 139
State Constitution of 1845: 14, 70
Steib, Johnny: 385
Stewart, Jordon: 362
Stoufflet, Alfred: 165
Stoufflet, Annette: 267
Stoufflet, David: 356
Stoufflet, Edmund: 165
Stoufflet, Emery L.: 372
Strada, Russell: 9, 160
Strain, Mike D.V.M.: 5
Stringer, Macon J.: 374
Swamp Act of 1804: 103
Swine: 30, 47, 340

T
Tabor, Claire Triche: 7
tags: 48, 383
Tanner, B. F.: 148
 husband of Tanner, Maria Louisa
Tanner, Maria Louisa: 148
 wife of Tanner, B. F.
Tanoos, Stella Carline: 7
Tardy, Antoine: 154
Tassin, Couvillion &: 350
tattoos: 48
Taylor, Jupiter: 183
Taylor, Winston: 223
Teche region: 382
Tenney, Norman: 61
Terrebonne Association, Inc.: 60

Terrebonne Farms: 56, 57, 60, 61, 66
Terrebonne Livestock Fair: 9, 386, 387
Terrebonne Sugar Refinery: 52, 290
 also known as Lower Terrebonne Refining and Manufacturing Co.
Terrebonne Times: 51, 53, 141, 161
Terrell, John: 385
Territory of Orleans: 16, 17
Texas: 7, 30, 38, 39, 42, 43, 44, 45, 49, 54, 126, 180
Texas Longhorn Breeders Association of America: 38
theft: 24, 65, 384, 385
Theriot: 54
Theriot, Augustave: 172
Thériot, Augustin: 154
Theriot, Charles: 130
Theriot, Clifton: 7, 13
Theriot, D. A.: 249
Theriot, E. R.: 386
Thériot, Elphège: 154
Theriot, Emilien: 139
Theriot, Ernest R.: 386
Thériot, Felix: 154
Thériot, Ferdinand: 164
Thériot, François: 132
Theriot, John Clovis Jr.: 369
Theriot, John Taylor: 189
Theriot, Joseph Theogene: 134
Theriot, Justilien: 120
Theriot, Michel: 120
Theriot, Michel Jr.: 120
Theriot, Michel Orelien: 120
 transferred to Thibodaux, M. A.
Theriot, O. J.: 51
Theriot, Sidney J.: 329
Theriot, Ulysse: 183
Thibodaux, Abel: 116, 235
 transferred from Thibodaux, Marcelin
Thibodaux, Admar Mrs.: 275
Thibodaux, Aubin: 78
Thibodaux, Bannon Goforth: 16, 76
Thibodaux, Benjamin: 108
Thibodaux, Brigite Guerin: 78
 wife of Francois Thibodaux;
 see also Francois Thibodaux
Thibodaux, Claiborne: 75
Thibodaux, Cleferphe: 61
Thibodaux, Eddie: 27
Thibodaux, Eléonore Nattalie: 125
Thibodaux, Elmire: 76
Thibodaux, Eugenie: 77
 wife of Bourgeois, Joseph Paul
Thibodaux, François: 78, 123
Thibodaux, Henry Claiborne: 70
Thibodaux, Henry M.: 75
Thibodaux, Henry Schuyler: 16, 75
 also known as Father of Terrebonne Parish
Thibodaux, J. (widow of): 90
 transferred from Henry, Jean Baptiste Jr.
 transferred to Trahan, Marin
Thibodaux, Joseph: 61
Thibodaux, Leandre B.: 75
Thibodaux, Leufroy: 108
Thibodaux, M. A.: 120
 transferred from Theriot, Michel Orelien
Thibodaux, Marcelin: 116, 235
 transferred to Thibodaux, Abel
Thibodaux, Nicolas: 108
Thibodaux, Olivier: 34, 36
 also spelled Tibaudau
Thibodaux, Pierre: 108
 transferred to Dumont, Morris

Thibodaux, Robert Sr.: 61
Thibodaux, Ruby J.: 386
Thibodaux, Voltaire: 70
Thibodaux, Willie: 379
Thibodeaux, R. J.: 386
Thibodeaux, Steve A.: 27
Thompson, E. B.: 385
Three Christian Crosses: 29
Tigerville: 54, 180
Timbalier Island: 54
Tivet, Sebastien: 93
Tivet, Sebastien Mrs.: 83
 also known as Leboeuf, Marie Magdeleine
Toups: 102
Toups, Eugène: 116
Toups, George: 9, 162, 277
Toups, Milton: 61
Trahan, Auguste Victor: 155
Trahan, Augustin: 110
Trahan, Davis: 349
Trahan, Davis Jr.: 399
Trahan, Enola LeBouef: 399
Trahan, Etienne: 110
Trahan, Euclie: 351
Trahan, Faussard: 114
Trahan, Gail: 7
Trahan, Garland: 7
Trahan, George: 357
Trahan, Ivy: 61
Trahan, John Baptiste: 377
Trahan, Joseph: 327
Trahan, Lee Paul: 328
Trahan, Levy: 317
Trahan, Marin: 90
 transferred from Thibodaux, J. (widow)
Trahan, Michel Surville: 130
Trahan, Simonet: 119
Trahan, Wallace: 376
Tremoulet, Casimir: 133
Triche: Claire René: 27
Triche, Colleen Marie: 27
Triche, Debbie H.: 7, 27
Triche, Doug: 386
Triche, Jessie John: 27
Triche, Lloyd J.: 27
Triche, Maurice: 365
Troxclair, Adam: 158
Tyson, John: 86
Tyler, John U. S. President: 103

U

Ulloa, Antonio de, Governor: 35
Umberfield, John D.: 128
United States Department of Agriculture: 49
Usé, Auguste: 110
Usé, Jean Martial: 147
Usey, Harry: 61
Usey, Nelson: 61
Usey, Oliver: 61

V

vacheries: 30
vachers: 30
Verdin see also Gregoire
Verdin: 102
Verdin, Edward: 331
Verdin, Ursin: 151
Verdun, Alexandre: 88
Vermilion Parish: 15
Verret, A.: 70
Verret, Adolphe: 70, 92, 110
Verret, Alexandre: 117

Verret, Auguste: 87
Verret, Celesie: 117
Verret, Heloise: 117
Verret, Jacques: 77
Verret, John Robert: 70
Verret, Joseph: 117
Verret, Louis: 100
Verret, Marguerite: 83
 transferred from Delaporte, Jean
Verret, Martial: 122, 362
Verret, Melasie: 117
Verret, Pierre: 90
Verret, Robert: 119, 217, 258
Verret, Stephanie: 136, 142
 wife of Dugas, Joseph Elie
 see also Dugas, Joseph Elie
Vickers, Abraham: 173
Vicknair, Davis J.: 61
Vidal, Celestine: 255
Voris, J. M.: 362

W

W-4 Farm: 181
Waguespack, Amilcas: 61
Waguespack, Clement: 61
Waguespack, Fanard: 61
Waguespack, Jean: 137
Walker & Clifton: 100
 see also Clifton, Walker &
Walker, Johnny: 52
Waller, Robert L.: 353, 386
Wallis, Cornelius C.: 110
Wallis, Hugh Henry: 136
Wallis, Hugh Maxwell Jr.: 70
Wallis, Jesse C.: 118
Walther, Ben: 181
Walther, Dick C. D.V.M.: 27, 181, 399
Walther, Dan: 181
Walther, Glenn: 181
Walther, Henry Dr.: 179, 180, 181
Walther, John: 181
Walther, Owen N.: 180, 334
Walther, Philippe: 116, 180
Walther, Stanley: 180
Walther, H. store: 181
War of 1812: 103
Warren, J. W. Dr.: 141
Washington, Denis: 171
Washington, George: 171
Waterproof Plantation: 140, 190
Watkins, Caleb B.: 16, 98, 362
Watts, Jason: 385
Waubun Plantation: 56, 57, 140
Weiland, John Edgar: 211
Welch, Albert: 299
Wells, Ken: 7
wheelwright: 50, 51, 52, 53
Whipple, Eugene: 307
Whipple, Keith M.: 7
Whipple, Walter: 149, 184
 transferred from Mars, Jean
White, Arthenea Rebecca: 177
White, Denis: 377
White, Joseph: 305
White, Linton: 347
White, Nicholas: 330
Whitney, Washington: 122
Wilcox, Elizabeth: 7, 385
wild cattle: 24, 30, 38, 39, 46
Williams, James: 307
Williams Lumber Company: 28
Winder, Van: 100
Wirt, F. O. Dr.: 386
"witness" trees: 28

Wolf Brothers: 136
 transferred to Fanguy, William
Wood, John F.: 137
Woodlawn Plantation: 54, 55
Woolens, Granville: 171
World War I: 180
World War II: 24, 65
Wright: 102
Wright, Abraham: 190
Wright, Abraham Elisha: 190
Wright, Ellen: 190
Wright, Elward: 190
Wright, Eva Marie: 190
Wright, Holden E.: 190
 husband of Griffin, Nancy
Wright, Holden Otis: 190
Wright, Ida: 190
Wright, Jasper K.: 330
Wright, Jasper K. Jr.: 190
Wright, Joanne Laura: 190
Wright, John Edward: 190
Wright, John Mrs.: 191
Wright, Laura: 190
Wright, Lester E.: 190
Wright, Margaret Florence: 190
Wright, Maria Elia: 190
Wright, Mary Callahan: 190
Wright, Nancy Charlotte: 190
Wright, Nancy Griffin: 190
Wright, Thomas Elward: 190
Wright, William: 53, 172, 190
Wright, William A. Jr.: 51, 190
Wright, William A. Sr.: 190
Wright, William K. Jr.: 190
Wright's Livery Stable: 51, 190
Wurzlow, Edwin Clarence: 14, 70, 262
Wurzlow, H. C.: 70
Wurzlow, Helen: 66

Y

Yancey, Gretchen Autin: 399
Yancey, J. Marian: 25, 70
Yates, Steve: 7
Young, Thomas H. Dr.: 138
 transferred to Duthu, Isidore

Z

Zebu bull: 41, 42

CREDITS

Unless otherwise noted, photos and maps are in the Cenac Collection at the Nicholls State Archives, Thibodaux, Louisiana. Research of these materials may be arranged by contacting the Archives and Special Collections Department at Allen J. Ellender Memorial Library on the Nicholls State University campus in Thibodaux.

Cover, courtesy Randy and Betty LeBlanc, Marie Himel, Debbie Himel Triche, Claire Triche Tabor

Front end sheet, wall of brands courtesy of Warren Clement, Jr.

Page across from copyright page, branding photo by Anne Ryan, *USA Today*; top ad from *Courier de la Louisiana*, New Orleans, edition of September 10, 1841; smaller ad from Houma *Civic Guard*, April 25, 1868

Acknowledgements pages, artwork from *Harper's Weekly*, October 20, 1866

Foreword page, record courtesy Terrebonne Parish Consolidated Government

Page 14, top right, record courtesy Terrebonne Parish Consolidated Government

Page 14, drawing from R.A. Bazet Collection, courtesy Nicholls State University Archives

Page 14, middle photo from Thomas Blum Cobb and Mara Currie, *Images of America: Houma*

Page 14, bottom photo of Courthouse from the R.A. Bazet Collection, courtesy Nicholls State University

Page 15, records courtesy Terrebonne Parish Consolidated Government

Page 16, artwork by Adrien Persac, courtesy Nicholls State University Archives

Page 16, middle photo, courtesy Nicholls State University Archives

Page 16, three records courtesy Terrebonne Parish Consolidated Government

Page 17, map courtesy Florent Hardy, Ph.D, Louisiana State Archives

Pages 18-19, Carey & Lea maps courtesy Historic New Orleans Collection

Pages 20-25, records courtesy Terrebonne Parish Consolidated Government

Page 28, middle image courtesy Kenneth Smith, T. Baker Smith, Inc., *A Century of Solutions*

Page 28, bottom, courtesy Polly Tolman Smith, Louisiana State Museum

Page 30, top photo courtesy Anne Ryan, *USA* Today, branding at Pasamonte Ranch, Clayton, New Mexico; bottom photo from Louisiana Digital Library, courtesy Louisiana Sea Grant, photo by Jerry Lognion

Pages 32-33, sea of grass photo courtesy Louisiana Digital Library, Louisiana Sea Grant, photo by Brad Weimer

Page 34, map courtesy Historic New Orleans Collection

Page 36, Compact document courtesy Shane K. Bernard, Ph.D.

Page 38, top photo, courtesy photographer Imke Lass

Page 38, middle photo, courtesy Jeannette Beranger, American Livestock Breed Conservancy

Page 39, top photo, courtesy North American Corriente Association

Page 39, Longhorn owned by Hubbell/Hudson/Valentine Partnership in Bowling Green, Kentucky; photo courtesy Laura Standley, editor, *Texas Longhorn Trails*

Page 39, Pineywoods and Florida Cracker photos courtesy Jeannette Beranger, American Livestock Breed Conservancy

Page 39, Shorthorn photo courtesy Tracy Duncan, ShorthornCountry.org

Page 42, top photo, William Barrow Floyd, *The Barrow Family of Old Louisiana*, 1963

Page 42, Brahman photo courtesy Chris Shivers, American Brahman Breeders Association

Page 42, R.R. Barrow photo, William Barrow Floyd, *The Barrow Family of Old Louisiana*, 1963

Page 42, bottom records courtesy Terrebonne Parish Consolidated Government

Page 43, top photo courtesy John Ford, Santa Gertrudis Breeders International

Page 43, Brangus photo courtesy Brittni Drennan, International Brangus Breeders Association

Page 43, Simmental and Simbrah photos courtesy Steve McGuire, American Simmental Association

Page 43, Limousin photo courtesy Kay Weaber, North American Limousin Foundation

Pages 44-45, map courtesy Jill Crane, catalog librarian, St. Mary's University

Page 46, top photo, Louisiana Department of Agriculture and Forestry

Page 46, Pineywoods photo courtesy Jess Brown, Cowpen Creek Farm, Poplarville, Mississippi

Page 46, bottom record courtesy Terrebonne Parish Consolidated Government

Page 47, top two photos courtesy Carl Bennett, Louisiana Livestock Brand Commission

Page 47, freeze branding photo courtesy Al Lemieux

Page 47, bottom record courtesy Terrebonne Parish Consolidated Government

Page 48, all photos, Carl Bennett, Louisiana Livestock Brand Commission

Page 50, top ad from Houma *Ceres* of December 25, 1858; middle ad from Houma *Civic Guard* of June 9, 1866; bottom ad from Houma *Ceres* of December 25, 1858; all courtesy Nicholls State University Archives

Page 50, bottom photo from Helen Wurzlow, *I Dug Up Houma-Terrebonne*

Page 51, top ad from Houma *Ceres* of December 25, 1858; middle ad from Houma *Civic Guard* of April 25, 1868, both courtesy Nicholls State University Archives; bottom ad from *Waterways Edition of 1910*

Page 51, Daigle photo from *Houma Courier Magazine Edition of 1906*; Dumiot and Porche photos from Helen Wurzlow, *I Dug Up Houma-Terrebonne*

Page 52, all photos from Helen Wurzlow, *I Dug Up Houma-Terrebonne*

Page 53, top photo from Helen Wurzlow, *I Dug Up Houma-Terrebonne*

Page 53, Clement photo and brand courtesy Warren Clement, Jr.; Foolkes ad from *Terrebonne Times* of August 21, 1897, courtesy Nicholls State University Archives

Page 54, Jastremski photo from *Houma Courier Magazine Edition of 1906*

Page 55, Woodlawn and Ashland photos from Helen Wurzlow, *I Dug Up Houma-Terrebonne*; Ardoyne and Ellendale photos from *The Southern Manufacturer, Terrebonne Edition, 1901*

Page 55, record courtesy Terrebonne Parish Consolidated Government

Pages 56-57 except St. George and Ducros photos, all photos from *Homes and Cornfields on Terrebonne Project, Schriever, Louisiana*, Wolcott, Marian Post, photographer, courtesy U.S. Library of Congress

Page 57, St. George photo courtesy Joe and Tegwin Weigand

Pages 58-59, all photos from Homes and Cornfields on Terrebonne Project, Schriever, Louisiana, Wolcott, Marian Post, photographer, courtesy U.S. Library of Congress

Page 60, top photo from *Homes and Cornfields on Terrebonne Project, Schriever, Louisiana*, Wolcott, Marian Post, photographer, courtesy U.S. Library of Congress

Page 60, middle photo courtesy Nicholls State University Archives

Page 61, photo from *Homes and Cornfields on Terrebonne Project, Schriever, Louisiana*, Wolcott, Marian Post, photographer, courtesy U.S. Library of Congress

Page 62, top photo, R.A. Bazet Collection, courtesy Nicholls State University Archives

Page 62, bottom photo courtesy Louisiana State Museum Library, George Mugnier Collection

Page 63, top photo courtesy State Library of Louisiana

Page 64, photos from R.A. Bazet Collection, courtesy Nicholls State University Archives

Page 65, ad from *Houma Courier* of February 18, 1899, courtesy Nicholls State University Archives

Page 65, middle photo, Assumption

LIVESTOCK BRANDS AND MARKS

Parish Collection, courtesy Nicholls State University Archives
Page 65, bottom photo from Helen Wurzlow, *I Dug Up Houma-Terrebonne*, courtesy A. Deutsche O'Neal, Sr.
Page 66, photo courtesy Denis Gaubert Collection
Page 103, record courtesy Terrebonne Parish Consolidated Government
Pages 112-113, photos courtesy M. Lee Shaffer, Jr. and M. Lee Shaffer III
Page 113, four generations photo from Helen Wurzlow, *I Dug Up Houma-Terrebonne*
Page 140, livery stable photo from *Houma Courier Magazine Edition of 1906*; John Berger photo courtesy Dan Davis
Page 140, inset photo from Thomas Blum Cobb and Mara Currie, *Images of America: Houma*
Page 141, ads, top left from *Terrebonne Times* of September 29, 1900; middle ad from *Houma Courier* of April 13, 1901; bottom ad from Houma *Civic Guard* of October 28, 1865, courtesy Nicholls State University Archives
Page 141, both Berger photos courtesy Dan Davis; top right and bottom right photos from Helen Wurzlow, *I Dug Up Houma-Terrebonne*
Page 153, top right photo from Martin L. Cortez Collection, courtesy Nicholls State University Archives
Page 153, bottom photo, W.E. Butler Collection, courtesy Dr. Don Davis
Page 161, Albert Cenac ad from *The Southern Manufacturer, Terrebonne Edition, 1901*
Page 161, snapshots courtesy A.J. Cenac, Jr.
Page 163, butcher documents from R.R. Barrow Collection, courtesy Nicholls State University Archives
Pages 168-169, U.S. Library of Congress, Wolcott, Marion Post photographer
Pages 180-181, all photos courtesy Dr. D.C. Walther
Page 190, all photos courtesy Brian W. LaRose
Page 228, photo courtesy Clifton P. Theriot
Page 232, photo courtesy Louisiana State Museum Library, George Mugnier Collection
Page 238, photo courtesy Clifton P. Theriot
Page 240, top photo courtesy the LeBlanc family
Page 240, bottom right and bottom left photos courtesy Jess Brown, Cowpen Creek Farms, Poplarville, Mississippi
Page 242, photos courtesy Marvin Marmande, Sr. and Marvin Marmande, Jr.
Page 262, photos courtesy Theresa A. Robichaux, Terrebonne Parish Clerk of Court
Page 264, photos courtesy Roy Aucoin, Jr., Pat Aucoin, Rudy Aucoin, and Sharon Aucoin Alford
Page 266, milk can courtesy Pete Fonseca
Page 268, top left photo and bottom left photo from Wilson and Wanda Gaidry in Thomas Blum Cobb and Mara Currie's *Images of America: Houma*
Page 268, house photo, R.R. Barrow Collection, courtesy Nicholls State University Archives
Page 268, milk bottle courtesy Pete Fonseca
Page 276, R.A. Bazet Collection, courtesy Nicholls State University Archives
Page 284, photo courtesy Clifton P. Theriot
Page 287, photos courtesy Albert Ellender, D.D.S.
Page 290, photos courtesy Albert Ellender, D.D.S.
Page 292, photos courtesy Albert Ellender, D.D.S.
Page 300, photo from the *Times-Picayune* of May 6, 2012
Page 316, photo courtesy Clifton P. Theriot
Pages 340-343, photos courtesy Randy LeBlanc, Marie LeBlanc Himel, Debbie Himel Triche, Claire Triche Tabor
Page 354, top left photo, *American Bankers Association Report, 1891*
Page 354, Minor photo from Helen Wurzlow, *I Dug Up Houma-Terrebonne*
Page 354, bottom left photo from R.A. Bazet Collection, courtesy Nicholls State University
Page 355, middle photos from Helen Wurzlow, *I Dug Up Houma-Terrebonne*
Page 355, bottom photo, R.A. Bazet Collection, courtesy Nicholls State University Archives
Page 360, photo courtesy Clifton P. Theriot
Page 381, photo courtesy Lorraine Allemand
Page 382, photo courtesy Denis Gaubert
Page 385, photo courtesy Carl Bennett, Louisiana Livestock Brand Commission
Page 386, certificate courtesy Tom Schedler, Louisiana Secretary of State
Page 386 photo, R.A. Bazet Collection, courtesy Nicholls State University Archives
Page 387, trophy courtesy Marvin Marmande, Sr. and Marvin Marmande, Jr.
Page 400, photo courtesy Jess Brown, Cowpen Creek, Poplarville, Mississippi
Back end sheet, wall of brands courtesy Warren Clement, Jr.

PHOTO CONTRIBUTORS

Sharon Aucoin Alford
Lorraine Allemand
Pat Aucoin
Roy Aucoin, Jr.
Rudy Aucoin
Voorhies Authement, Jr.
Celeste Autin
Daniel C. Autin
Donel Autin
Mr. and Mrs. Jules Boquet, Jr.
Druis Bourg
J.B. Breaux
Russel J. Brien
A.J. Cenac, Jr.
Lana Robichaux Cole
Dan Davis
John Dover, Jr.
Reggie Dupre
Rudy Eschete
Denis Gaubert
Jules P. Hebert, Jr.
Linda Aucoin Hutchinson
Paul Lapeyrouse
Brian LaRose
Mr. and Mrs. Daniel Ledet
George D. Lyons, Jr., M.D.
Todd Richard
Leroy R. Sevin
Kenneth William Smith
Martha South
Davis Trahan, Jr.
Enola LeBouef Trahan
D.C. Walther, D.V.M.
Gretchen Autin Yancey

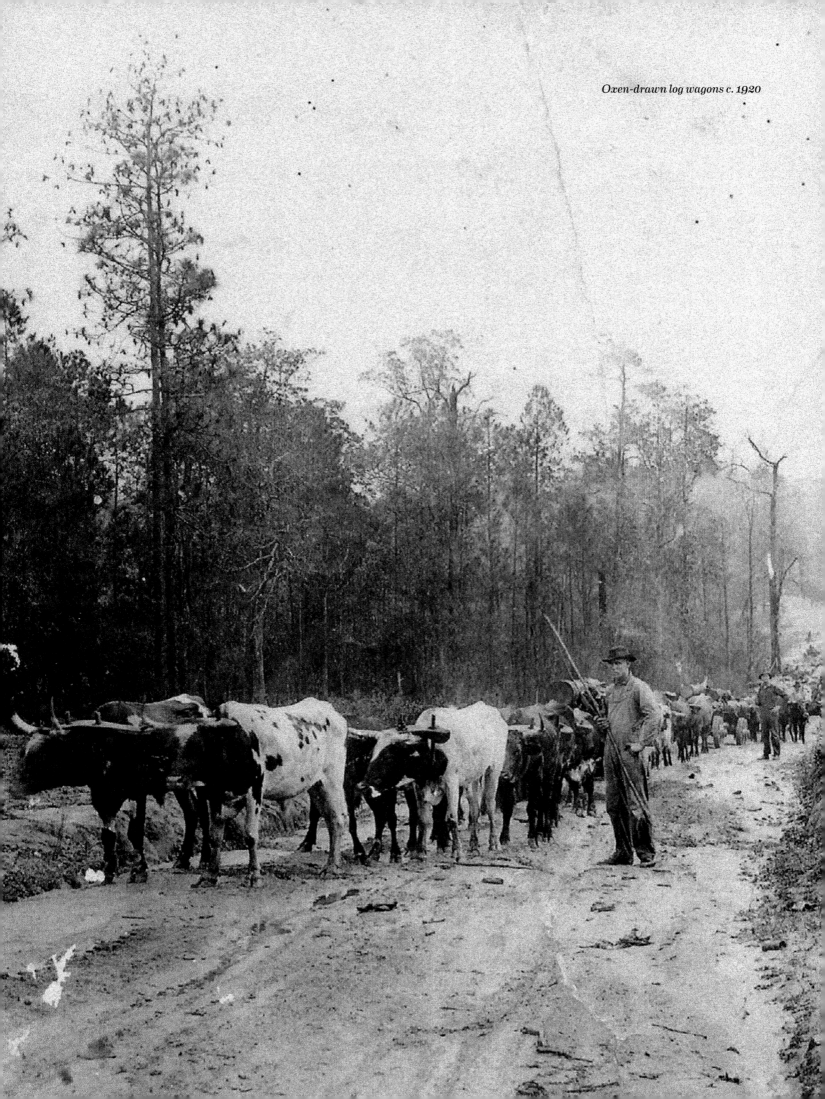

Oxen-drawn log wagons c. 1920

Livestock Brands and Marks is a treasure for anyone with an interest in livestock or Louisiana history. It must be remembered that the registered brand originally intended to establish ownership of livestock in many cases became an "Armoiries" or coats of arms for many Louisiana families. Many of these brand records are tucked away in basements and storage rooms of parish courthouses. Some have been discarded or destroyed. This book breathes new life into this significant part of Louisiana and Terrebonne Parish history and explores a little known segment of our unique culture. My family brand, the "7HL" has been handed down over five generations and dates from the 1800s.

 Mike Strain DVM, *Commissioner of the Louisiana Department of Agriculture and Forestry*

Wild cattle on the Cajun Savannah—who knew? Surely, a luminous career as an orthopedic surgeon might have been enough for most people. But Chris Cenac has taken up the role of historian and writer—and lucky for us all that he's done so. Like his previous book, *Eyes of an Eagle, Livestock Brands* is a treasure chest of bayou country history and lore, full of insight and surprises that shed light on the pioneering families who sculpted the rich, French-accented culture that defines South Louisiana. Cenac's tenacity as a researcher and a serendipitous trip to a courthouse have not only filled in some vital gaps in our history—they've produced a remarkable and highly readable book that will be prized for decades to come.

 Ken Wells, *journalist and novelist*

A 1948 fictionalized oil company promotional film popularized the enduring stereotype of the people of our marsh parishes as little more than swamp hillbillies. More than 60 years later, Dr. Cenac has revealed a different and untold Louisiana story about our pioneer families and the lands they call home. As a reference professional whose heritage lies deep in Lafourche Interior and Attakapas, I cannot stress strongly enough the historic and cultural significance of *Livestock Brands and Marks: An Unexpected Bayou Country History*. As a descendant of those who left their marks on their livestock and their land, I am grateful to Dr. Cenac for showing me part of my family's own forgotten story— uniquely our own and hitherto untold.

 M.L. Eichhorn, *reference associate, Williams Research Center, The Historic New Orleans Collection*

The depth of research in *Livestock Brands and Marks* challenges our romantic image of the American cowboy. Here, the wild, wild, West is replaced with a wild, wet, South. Celebrating the Cajun cowboy, Dr. Cenac reminds us that America's earliest cowboys were Cajun. The archival images, oral history, and replication of the early brand books, make this work not only an engaging read, but also an archival treasure.

 Conni Castille, *documentarian, director of* T-Galop: A Louisiana Horse Story

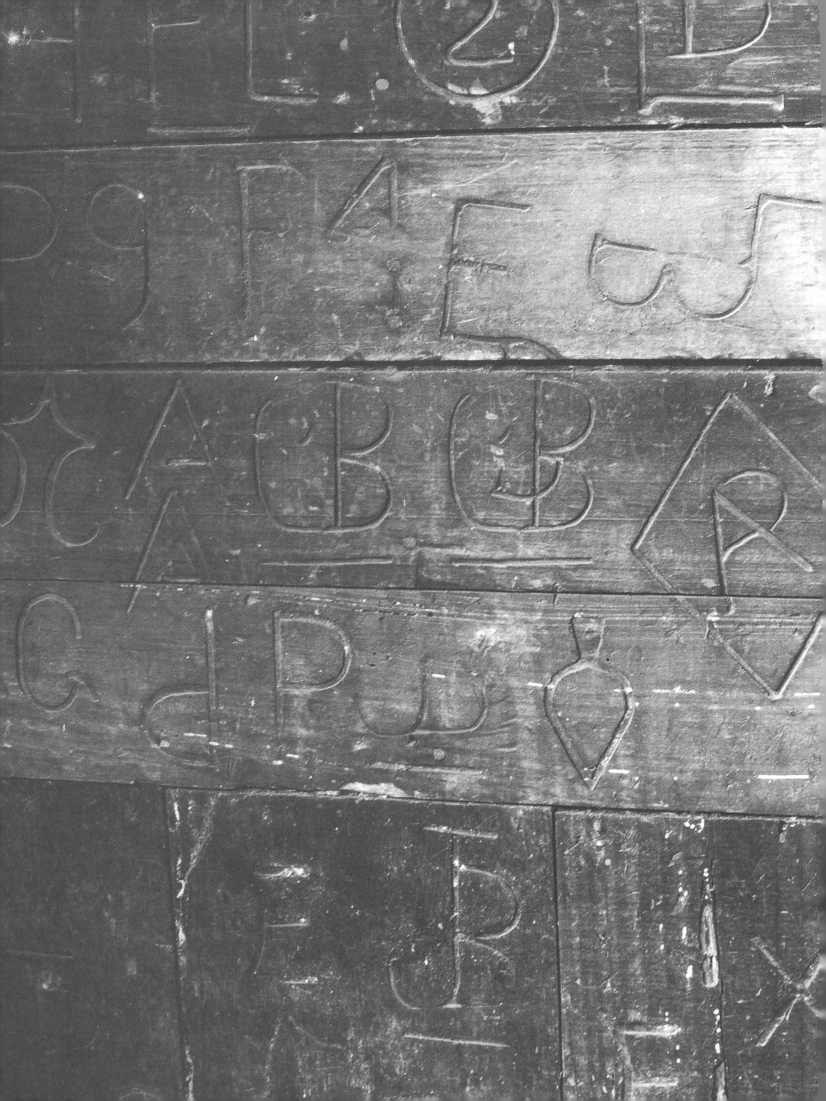